HIRSCHFELD

ON LINE

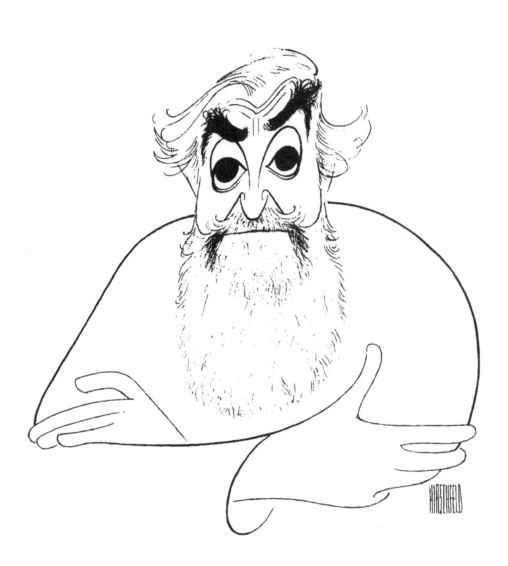

HIRSCHFELD

ON LINE

Al Hirschfeld

APPLAUSE

NEW YORK • LONDON

AN APPLAUSE ORIGINAL

HIRSCHFELD ON LINE

Editor and Publisher: Glenn Young
Managing Editor: Gregory Collins
Interior Design: Sue Knopf of Graffolio
Photo Editor: Louise Kerz Hirschfeld
Rights Coordinator: Robert Ward
Jacket Design: Gregory Collins
Image Coordinator: John Alston
Production Director: Paul Sugarman
Publicity Director: Kay Radtke

The Publisher gratefully acknowledges the support and assistance of Margo Feiden and her exemplary staff in
assembling many of the drawings for this volume.

Permission to reproduce photographs has been graciously extended by PETER BASCH, RALPH A. BROOKS, EILEEN DARBY, SUSAN W.
DRYFOOS FILM *THE LINE KING: THE AL HIRSCHFELD STORY*, TIMES HISTORY PRODUCTIONS, DIVISION OF *THE NEW YORK TIMES*
AND CASTLE HILL PRODUCTIONS, ESTATE OF TRUDE FLEISCHMAN, LEO FRIEDMAN/THE BILLY ROSE COLLECTION, SIDNEY J.
GLUCK, HERBERT PHOTOS, INC, YOUSUF KARSH/WOODFIN CAMP & ASSOCIATES, DIDIER LEPAUW, ANNIE LEIBOVITZ, TRACY
MARLOWE, ARNOLD NEWMAN, JAY SEYMOUR/WAGNER INTERNATIONAL, ANITA AND STEVE SHEVETT, PAMELA STANFIELD, CARL
VAN VECHTEN/THE BILLY ROSE COLLECTION, HOLLAND WEMPLE/NYC MUNICIPAL ARCHIVES, DAVID A. ZICKL,
whose copyright © to the work is asserted here.

Library of Congress Cataloging-In-Publication Data

Library of Congress Catalog Card Number: 98-88469

British Library Catalogue in Publication Data

A catalogue record for this book is available from the British Library.

APPLAUSE BOOKS

211 West 71st Street
New York, NY 10023
Phone (212) 496-7511
Fax (212) 721- 2856

CONTENTS

ACKNOWLEDGMENTS

Without the dedicated services
of Louise Kerz (my wife)
who selected the drawings
and
Glenn Young (the publisher)
who selected the words
and
Robert Lantz (my agent)
who extracted contemporary
money from the publisher,
this book would never
have been printed.

My profound thanks
also to the proprietors
of *The New York Times* for
permission to reprint most
of the drawings which appeared
originally in their newspaper
and
thanks to Lynn Surry
of the Margo Feiden Gallery
for ferreting forgotten drawings
along with all those unseen workers
who took my drawings
and turned them into a book.

To my darling wife Louise,
professional archivist
and amateur photographer.

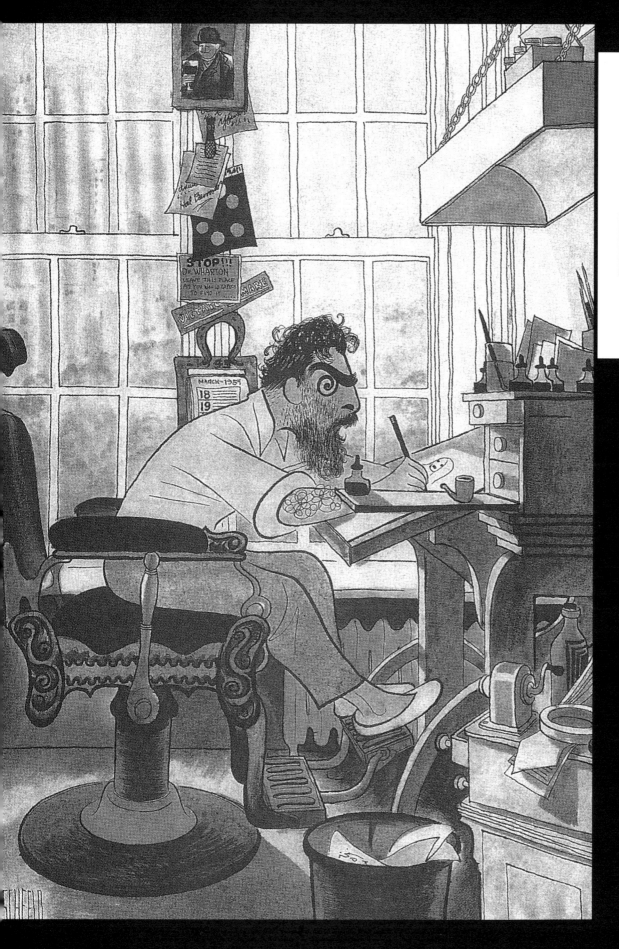

ON
HIRSCHFELD

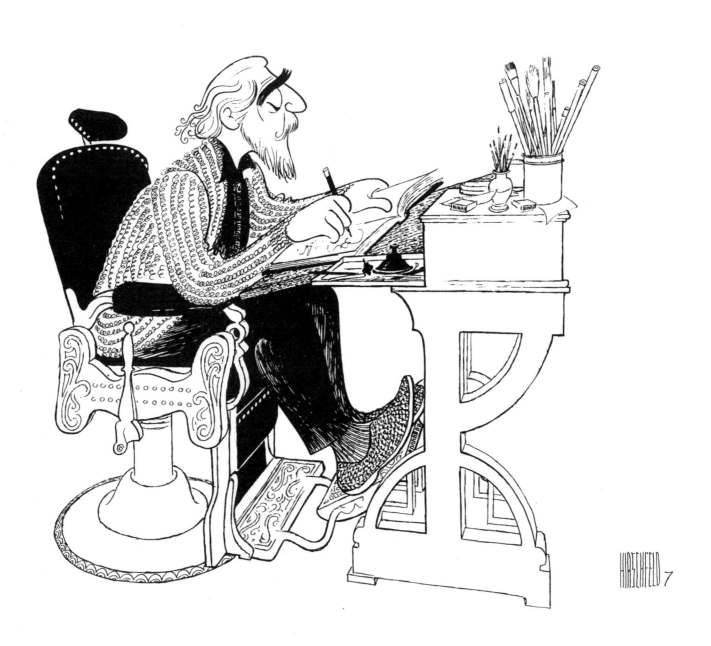

The Broadway Artist

by Mel Gussow

In a career that spans the 20th century, Al Hirschfeld has drawn a panoply of performing artists, from Sacha Guitry in 1926 to the star of this week's Broadway opening. A one-man continuum, he is a link with the theatrical past and a harbinger of assurance that the theater will have a future. At 95, he shows no sign of letting up, or losing his creative edge. Refining his line, he is, in fact, at the very top of his form.

Hirschfeld's elegant presence on the aisle for opening nights is comforting, reminding one of the residual glamour of theater. Eternally stage-struck, he has seen almost every play or musical that has opened on Broadway during his lifetime. This means that he has probably been to more shows than anyone else in the history of theater. Who can come close? No critic, not William Hazlitt or George Jean Nathan; not Shakespeare, Shaw or Noel Coward. There is simply no contender, not even Mr. and Mrs. Ira Katzenberg, those legendary non-professional first-nighters who for so many years never missed a Broadway opening. He is the longest running theatergoer in New York. If an actor looks across the footlights and spots Hirschfeld, he can believe in the immutability of theater. He is, as his wife Louise Kerz says, "the logo of the American theater."

As the theater has changed, Hirschfeld has remained durable, and responsive to all new movements. By keeping up with the times, he has never been out of fashion, drawing events in the experimental as well as the commercial theater, while always maintaining his rigorous standards. In recent years, he has been called upon to draw massed choruses of cats, a masked phantom, and a chandelier, but he balked at helicopters, refusing to put one in his drawing for *Miss Saigon*. For Hirschfeld, a machine can never be a star of a Broadway musical.

Speaking as a self-made man, he is convinced that "the artist invents his own life," although that invention can be a response to a publicly imposed image. In other words, we are what we allow others to make of us. Very early in his career, he became Hirschfeld the Broadway artist, and he has not veered from that role. Things happened and a career evolved. He never set out to become a caricaturist or to spend most of his life in and around the theater. Part of this was fortuitous; the rest was taking advantage of opportunity.

As a child growing up in St. Louis, Hirschfeld answered to the nickname Babe, and later his friends called him Flash, or, alternately, the Flash, both of which seem so antithetical to his present venerable appearance. Temperamentally, however, the nicknames continue to be applicable. His mature visage has grown on him so that it is impossible to imagine him looking any other way. But the attributes that earned him the name Babe remain important aspects of his personality, as demonstrated by the irrepressible eagerness with which he goes to the theater night after night. As for Flash, that was a reference to the fact that he would run rather than walk, and to the astonishing speed and accuracy with which he executed his art. It was a name particularly favored by Brooks Atkinson, the longtime *New York Times* drama critic and Hirschfeld's staunchest theatrical companion. Atkinson had noticed that Hirschfeld's lines became "nimbler and more mischievous" over the years. Today, he still works briskly and with panache, with quick, careful strokes capturing creativity in performance.

Over the years, his artistic reputation has grown enormously. His drawings are in major collections and he has been honored with many museum retrospectives. The museum director Lloyd Goodrich has said that Hirschfeld's work is that "of a highly sophisticated artist, who uses the graphic medium to create rich and vital designs." The drawings "are in themselves great theater." But because he is so prolific and because his work appears regularly in the *Times* and other periodicals, there is still a feeling in some quarters that his is not a high art. To diminish him on this ground is a bit like disparaging Dickens for writing his novels in serial form or dismissing Toulouse-Lautrec as a café sketch artist. What is important is not the manner of dissemination but the originality of the work. There is no one quite like Hirschfeld. Through his eyes, we have a complete and imaginative picture of the performing arts, in particular the theater, in this century.

Henri Bergson could have been speaking about Hirschfeld when he wrote, in his essay on laughter, that certain caricatures "can be more lifelike than portraits." In Hirschfeld's case, the caricatures can even be more lifelike—or at least more animated—than the person. Ray Bolger, for one, repeatedly told the artist that he tried to imitate the figure in his portrait of him, a dancer with amazingly elastic limbs. This was, of course, an impossible task.

Though the drawings can look realistic, they are often a leap into fantasy, representing the perfection a performer dreams of achieving.

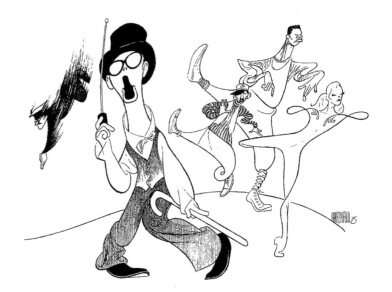

The humorous commentary in his work should not be confused with criticism, and the intention is never to hold a subject up to ridicule. No matter how amusing a drawing may be, the subject seldom will express disapproval of the likeness (as long as he is able to laugh at himself). Many years ago, Allen Funt, the creator of *Candid Camera,* was offended by the way Hirschfeld portrayed him—one of the rare occasions when this has happened. Funt said that the drawing made him look like a monkey. Hirschfeld refused to take credit. That, he said, was "God's work."

It is also God's work that Julie Harris has pin eyes and no

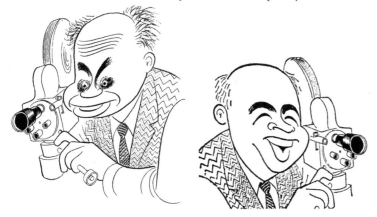

nose, for that is how she appears in Hirschfeld drawings. In stark contrast, Carol Channing has targets for eyes and a cavernous mouth. In the Hirschfeld view, Bernadette Peters is a large jaw surmounted by a thicket of tumbling hair and Julie Andrews has a tiny tilted nose above a low-slung chin. As Norma Desmond, Glenn Close had a Japanese mask for a face. John Gielgud is always sniffing the air. Hirschfeld's drawings are a matter of body as well as face. Standing still, Gwen Verdon has a hip that does a sharp right turn, Tommy Tune is a top-hatted Jiminy Cricket with legs like twisted picture wire, and Bill Irwin's knees are so knocked that they look locked.

Hirschfeld is doubly inspired by larger-than-life personalities, those he affectionately calls "glandular actors" or "exploded ventricles"—people like Zero Mostel, the Marx Brothers and Charlie Chaplin. Hirschfeld's Mostels are all masterpieces: a sausage holding a cane in *Rhinoceros;* a walrus enveloped in a toga in *A Funny Thing Happened on the Way to the Forum;* a bristle-bearded Humpty Dumpty with heaven-

gazing eyes in *Fiddler on the Roof;* and, in a diabolical turnabout in a Hirschfeld "unlikely casting" series, Mostel as Peter Pan, an anthropomorphic dirigible strewing stardust as it floats through the sky.

Then there is his self-portrait, Hirschfeld's Hirschfeld, for many years a dark, bushy-browed, foreboding figure in the background of murals, scowling as he entered a café or a theater in the company of his petite, angelic-looking second wife, the late Dolly Haas (delicate bangs, two dots for eyes, one dot for her mouth). In the artist's 1958 view of Harry's Bar in Venice, half of Hirschfeld is seen through a swinging door, looking like a KGB agent about to pounce. Inside the restaurant are Orson Welles, Frank Lloyd Wright and, sharing a table, the unlikeliest of literary couples, a burly Ernest Hemingway facing a purse-mouthed Truman Capote. Sometimes, especially when he envisions himself at an opening night, Hirschfeld's Hirschfeld achieves a kind of benignity. With age, all sense of the sinister has been abandoned as the self-portrait has moved increasingly close to Father Christmas (out for an evening on the town). This is the image that now greets us in his drawings and in person. As usual, he remains philosophical and seemingly unperturbed by the aging process. "I was always the

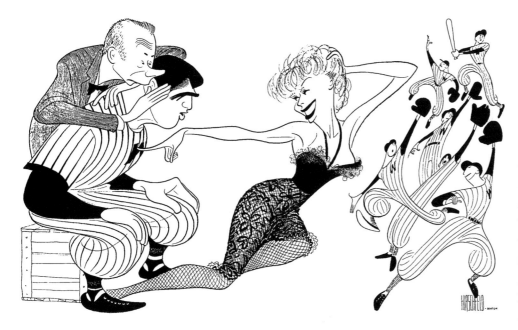

suit, the kind favored by French auto mechanics. With his crow-quill pens, Higgins India ink, and Japanese brushes within reach, he is at his drawing table, so deeply rutted from cutting paper on it that the surface looks like wooden corduroy. On the table is a half-finished portrait of Cole Porter, a frequent subject during and after the composer's lifetime. When the drawing is completed, it will be printed in the *Times,* the newspaper that for so many years—in the words of Dolly Haas—gave her husband "an exhibition every Sunday."

youngest in every crowd," he says. "Now I'm the oldest."

Wherever one turns in Hirschfeld's house (on the upper East Side of Manhattan), there are drawings of famous people, framed in the hallways, on tiles surrounding a fireplace, and on ceramic plates. All of them bear that famous fence-post signature **HIRSCHFELD**. Even the buzzer on the door outside his home is autographed; one buzzes his signature in order to enter. Although the house is filled with other art, most of it sculpture and masks collected during his travels in Polynesia, this is very much a Hirschfeld habitat. Behind the grand piano in the living room is a panoramic mural of some of the most celebrated people of their time: Marlene Dietrich, George Bernard Shaw, Clark Gable, Tallulah Bankhead, Albert Einstein. They have all come together for an imaginary soirée, which could have taken place in this room. Because Hirschfeld's friends include many of the subjects of his drawings, guests in the house have often found themselves shadowed by their own images.

Climbing the stairs to the artist's studio, one passes by other celebrities caught by his pen at the height of their stardom. At work in his studio, as occurs seven days a week, Hirschfeld is sitting in a Koken barber chair, just like the one he sat in as a boy getting a haircut in St. Louis. The chair is a recent replacement for one he bought for ten dollars many years ago on the Bowery. He likes the fact that he can raise and lower the seat; the chair suits his body English. At home, Hirschfeld dresses informally. Often he wears a blue jump-

He puts aside his drawing and, on request, takes down one of many scrapbooks from a nearby shelf. The book is flimsy with age, and the newspaper clippings it contains are yellowed, but the drawings themselves jump off the page just as they did when they were first published in the 1920s and 1930s. Turning the pages, Hirschfeld identifies the shows and the stars without referring to the captions, even though some of the people have become obscure with the passage of time.

"This is *Sweet Adeline,*" he says. "And that's Charlie Butterworth. That's Lester Allen in *Top Speed,*" he says about the next picture. "In vaudeville, he used to sing, 'When my sweetie walks down the street, all the little birds go tweet tweet tweet.'" Several pages later there is a drawing of *Girl Crazy,* picturing Willie Howard, Victor Moore, and Ethel Merman, making her Broadway debut. Looking at Hirschfeld's first Merman, with her sparrowlike mouth set in the chubbiest of cheeks, one can almost hear her singing, loudly. That picture elicited a discussion about the differences between *Girl Crazy* and *Crazy for You,* the revised version of the Gershwin musical. When it came time to draw a picture of *Crazy for You* for the *Times,* he insisted on featuring George and Ira Gershwin as the heavenly co-creators. For him, they were the stars of the show.

"Ah, this is my favorite: the worst play of my life, *Little Napi.*" His eyes widened at the memory of this short-lived 1931 play, in which Ernest Truex played Napoleon. For almost 70 years, Hirschfeld has cherished that show as a

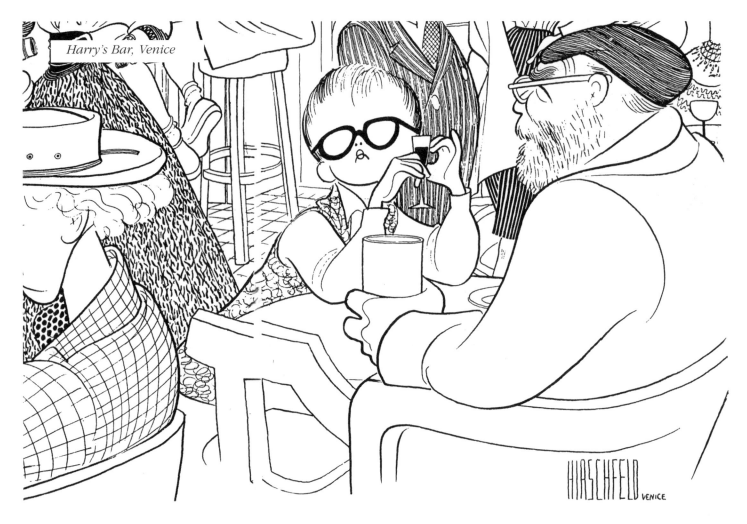

Harry's Bar, Venice

standard by which to measure the meretricious, but as a pragmatist he is always ready to see it superseded. Moving past his portraits of Jimmy Stewart, Fred Astaire, Helen Hayes, and George M. Cohan, he suddenly comes upon a drawing of Conway Tearle and remembers that in a review Heywood Broun had called Tearle "the world's worst actor," and that Tearle had sued the critic. "Broun damn near lost the case," Hirschfeld recalls. "But the Supreme Court ruled that the critic has that right. The following year, Tearle came into New York in another play and the legal department at the old World said to Heywood, "Listen, we're not telling you what to write, but be careful what you say because it will look like malice and he probably has a very good chance to collect if he sues again.' So Broun started off his review by saying, 'Mr. Tearle is not up to his usual performance.'"

Hirschfeld reached into a cabinet and took out some of his early watercolors. In them, one could identify a natural talent somewhat akin to that of Maurice Prendergast. There is no way to estimate how far he would have gone if he'd continued in that line. But he has no regrets about his choice of profession. Nor should we. "I consider what I'm doing very important," he says. "The fact that most people don't, doesn't make any difference to me. I'm only responsible for what I do. Either I accomplish the thing as best I know how, and I'm satisfied with it, or I don't."

Affirming the fact that he is an artist, not a journalist, he has steadfastly refused to accept editing. Many years ago,

Lester Markel, the legendary, fire-breathing editor of the *Sunday Times,* questioned the tone of Hirschfeld's caricatures. He said that when he went to the theater he saw beautiful and handsome people on stage. Then when he picked up the *Times* and looked at the Hirschfelds, these same people had been turned into "animals." Hirschfeld adamantly refused to change or to prettify his drawings, suggesting that if Markel did not like his work he could hire a photographer. For once in his life, Markel backed down. Hirschfeld recalled, "Writers may accept that, but not artists. You don't like it? Fine. Don't use it. But they wouldn't say, 'Turn the head a little bit this way,' or 'Move the finger over here.' They're not going to take a pencil and draw over it or paint out what they don't like in the drawing. An artist lives by his reputation."

It is a high honor for a performer to be drawn by him—a sign of arrival in the profession. For those who have been Hirschfelded frequently, the drawings can become the narrative of a career. This is very much the case with Carol Channing, who undoubtedly holds the record for the number of times anyone has been drawn by him. Miss Channing has filled the walls of her Los Angeles home with Hirschfelds of herself.

While watching shows in rehearsal or at previews, he makes notes on a small sketch pad. To an outsider, the characters in the artist's sketch pad would be virtually unrecognizable. These are reminders to himself. If he is at a public performance rather than a rehearsal, he draws with a stub of a pencil on a piece of paper in his pocket. He refers to these

visual notes as hieroglyphics, a secret language or code that only he can read. Equally important to him are his descriptive jottings, as for the Broadway revival of *Guys and Dolls* starring Nathan Lane and Faith Prince: "hat pulled down," "tough guy," "giant gangster," "dimpled knees, "pinstripe." For Lane, he wrote "Jewish Italian," "putty," and "Sue Me." The first was a reference to the character's hypothetical ethnicity, the second to his nose, the third to his most identifiable song. From the outset, Hirschfeld planned to have Lane in his drawing look as if he were singing "Sue Me," as Faith Prince would be singing "Take Back Your Mink."

"I try to put down as accurately as I can the things that are visually exciting to me: certain movements of hands, the way the actors sit, cross their legs, or look at each other. Costumes sometimes help"—and so does the scenery. He is so engrossed in his process that he does not concentrate on the show itself. Having seen and drawn *Guys and Dolls* many times before, he certainly knew what was happening on stage, but for unfamiliar plays and musicals he is often at a loss. When he went to a bare rehearsal room to see William Finn's *Falsettos,* he had no idea of the story line. Because the actors moved so many chairs around the room, he thought the show was a "ballet with chairs." When he came home from a run-through of Ariel Dorfman's *Death and the Maiden,* his wife asked him what the play was about and he answered, "Germany after the war," instead of, as was the case, Chile after dictatorship. Seeing Gene Hackman bound

and gagged in a chair onstage, he assumed that the actor was playing the role of an ex-Nazi general. When Hirschfeld returns to a show on opening night, he is often surprised. As he sketches, he is thinking about performance and characterization and not about context.

When he was in his studio making his *Guys and Dolls* drawing, he remembered that Lane shrugged his shoulders as he sang "Sue Me." To be sure of the actor's appearance when he made that gesture, Hirschfeld went into the bathroom adjoining his studio and looked into the mirror. He threw his arms wide, shrugged and said "Sue me" to his mirror image. It was clearly a case of miscasting: a white-bearded, patriarchal Nathan Detroit. Acting as director, Hirschfeld quite often will cast himself as his own model, miming female as well as male roles in order to remind himself how performers look on stage. To double-check his memory, he also played Ms. Prince, crooking her hand in the air. At the last minute, he extended the actress's mink boa so that it snaked all the way across the bottom of the drawing, leading right into the Hirschfeld signature.

The next-to-last thing he does is to put in the NINAs. Nina, of course, is a reference to his daughter, whose name has appeared in every one of his drawings since she was born (in 1945), tucked into folds of clothing, facial features, or scenic effects. The last thing he does is to put a number next to his signature indicating the number of NINAS that appear in that particular drawing. His admirers spend hours

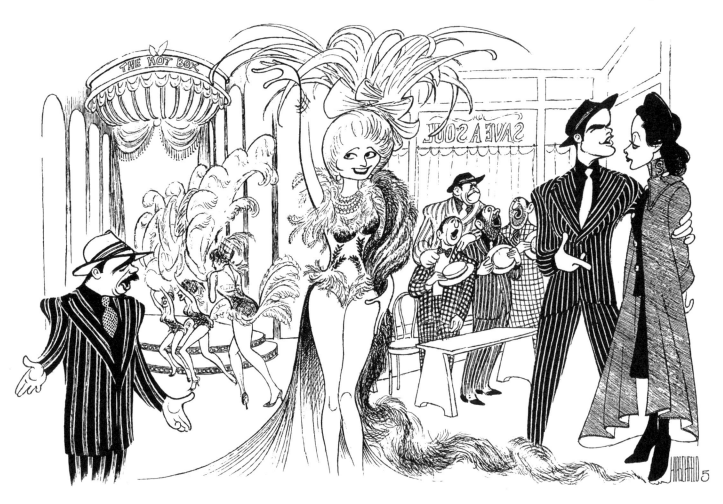

trying to find the NINAS. Several weeks after the *Guys and Dolls* drawing was printed in the *Times,* I visited him in his studio and asked him to find the NINAs—five, according to the number next to his name. "There's one," he said immediately, pointing to Ms. Prince's hair, and he soon found another in her bow. The third and fourth were hidden in the feathers of the dancer. But, as hard as he tried, he could not find the fifth. "Good God," he said. "You could drive people crazy with this." And then, with a "Sue Me" shrug, he added, "It looks like I made a mistake." Peering closely, he suddenly found the elusive NINA, in the middle of Ms. Prince's mink. His relief was palpable.

Hirschfeld works on assignment and also accepts commissions for portraits. This means that he has drawn oilmen and politicians, brides and bar-mitzvah boys, and family groups. Asked why he continues to accept this time-consuming work, he smiles and answers, "Greed, I suppose." Money is certainly a factor, but not a major one. He also does it because he loves to draw, and these portraits keep him at his drawing board between theatrical assignments. The commissions, he says, can offer a challenge. "To capture a John Paul Getty is just as interesting as trying to capture Chaplin," he says. "They're both problems to be solved." One of the oddities of his career is that as much as he enjoys drawing stars, he would not do them unrequested. Without an assignment, he would not simply sit down and sketch someone for the fun of it. If he were not a Broadway artist, he might draw pictures of people on the street or on subways. "The people in the street are much more theatrical-looking than the ones on stage," he says. "You've got these girls with mascara, walking around in their underwear, and fellows with spiked green hair."

In 1941, in a step away from Broadway, he published *Harlem,* an extraordinary book of drawings with text by William Saroyan. In the book, he pictures an intense, kaleidoscopic view of black life of the times: high-kicking dancers, jazz musicians at late night jam sessions, couples out for a stroll on Lenox Avenue, children at play, street-corner preachers and politicans, drug peddlers, prostitutes—a medley of high and low life. With humor, Hirschfeld speaks of this book as one of his failures. Published on the eve of Pearl Harbor in a limited edition of 1000 copies, it sold only several hundred before the publisher went bankrupt. It is now a highly prized collector's item. If that book had been a success, it might have encouraged the artist to move in a different direction. His career as a caricaturist is at least partly a response to what has been demanded of him.

From the first, he has not been happy with the label "caricaturist," preferring to

J. Paul Getty

think of himself as a "characterist." One afternoon, while having tea at his drawing board, he spoke to me about his art, and about the snobbery that exists in the arts. "Caricature has always been looked upon as something inferior," he said. He defended the form in principle but expressed criticism of some of its practitioners. "Early caricaturists derived their humor from exaggerating anatomical defects. If somebody had a big nose, they'd make it bigger, which I don't think is witty. Big heads and little bodies—I don't know what is so funny about that." That is one reason he has reservations about the literary caricatures of David Levine.

He distinguished between cartoons and caricatures. "A cartoon has a literary connotation," he said. "A caricature is abstract. It doesn't tell a story. 'The spirit of Jewish consciousness' or 'knitting a sweater'—that's the work of a cartoonist. It wouldn't be difficult to describe a cartoon, but it can be difficult to describe a caricature. In the Renaissance, the drawings of Michelangelo were called 'characters,' which was the root of 'caricature.' I always thought of El Greco as a great caricaturist, and also Picasso, Modigliani, and Matisse." Coincidentally, that day I had with me a book of El Greco drawings with text by the playwright Fernando Arrabal. Hirschfeld studied them with great admiration. "Look at that drawing," he said. "It's pure caricature, the elongated body and hands. I just love El Greco's exaggeration of reality—it never goes overboard. That's a tendency in grotesque caricature, but I've never found it terribly exciting."

Broadening his discussion of art, he said, "Because we're used to technological progress, we have a tendency to apply it to art, where there is no progress. We expect art to improve, but a work of art is a work of art, and that's it. Nobody is going to write anything in English that will make Shakespeare obsolete. The form changes, but the work of art remains. El Greco and Michelangelo are always going to be as good. When paint was invented, it changed the atmosphere of art. Easel painting became accessible to anybody who could afford to buy a tube of paint. You were no longer in a cave with primitive colors." Saying that, he remembered his visit to the caves of Lascaux. "The Lascaux drawings are the size of this wall, and there's a horse that is absolutely the greatest drawing I've ever seen," he said. "It's done with primitive means, but nobody is ever going to improve on it. You can do it in three dimensions, make it a hologram, put a little white on the tip of the horse's nose, but it's not going to be any better than that." Hirschfeld has rigorously limited himself to the barest necessities.

"Like the man in the cave?"

"Absolutely," he answered. "I just wish I could draw as well as that."

In searching for Hirschfeld's artistic forebears, one necessarily looks to Hogarth, Daumier, and Cruikshank, but, unlike Hirschfeld, they drew savage and often grotesque portraits. Perhaps closer to him in their gentle mockery are caricaturists of the last 19th and early 20th century, people like Carlo Pellegrini ("Ape" in *Vanity Fair*), Max Beerbohm, and Edmond Xavier Kapp. In his 1926 book *A History of Caricature,* Bohun Lynch, himself a caricaturist, could have had Hirschfeld in mind when he wrote about Kapp, "He is a perfectly serious artist, whose drawings, quite apart from their merits as satiric portraits and commentaries on his contemporaries, have a definite aesthetic interest; and can be judged therefore by quite different standards from those in which satire, or humour, or deviltry, or revelations alone are the dominant quality." One basic difference between Hirschfeld and these other caricaturists is that the main body of his work has been in a single area, the performing arts, while his predecessors moved freely from political to literary personalities.

The late English cartoonist Mel Calman, a friend of Hirschfeld's, was an astute analyst of his work. "There is no malice in it," he said, "and yet it's not bland. He's very witty." Calman contrasted Hirschfeld to Gerald Scarfe and others in England, who "have enormous fun with the peculiarities of the person's physiognomy. It's interesting, but there's no compassion. With Al, he seems to be able to get the essence of the person so that it almost replaces the person. The Carol Channing one has in one's head is Al's drawing of her. I can't think of anyone else who has done that. That really puts him up quite close to Lautrec."

In the United States, the art of theatrical caricature once was a lively arena, populated by artists like Ralph Barton and Al Frueh, both of whom drew regularly for *The New Yorker,* and Miguel Covarrubias, Don Freeman, and, of course, Hirschfeld. However, with the increased popularity of theatrical photography, caricaturists were less in evidence. For a brief period of time in the 1980s, Hirschfeld's work appeared less frequently in the *Sunday Times,* through an irrational decision made by one of that newspaper's editors. His admirers were greatly disappointed. Hirschfeld simply bided his time, and soon was back in favor. But he is realistic enough to realize that he is in "a lemming profession."

Operating in two fields, art and theater, that seem to subsist on neuroses, he is a figure of apparent contentment. "This is enough for me," he says of his career. "It's a whole life of hard work." He corrects himself: "Hard fun." He is well aware that humorists, and caricaturists in particular, have often led tragic lives: Barton committed suicide, Covarrubias was self-destructive, others have been alcoholics. At the very least they are pessimists, like S. J. Perelman, or they are, as Hirschfeld describes George S. Kaufman, "Dour, dyspeptic, antisocial, misanthrophic."

Looking for troublesome traits, one can find only the minor one of absentmindedness—something Hirschfeld vocif-erously denies. It is almost as if he has forgotten that he is absentminded. One story, a favorite among his friends, illustrates this. He and Dolly were in Fort Lauderdale and rented a car to visit friends in Palm Beach. As usual, Dolly sat in the back seat while Al drove. "We hadn't gone very far when Dolly said, 'You better check the gas gauge,'" he recalled. "It was practically empty. We went into a station and filled it up. And off we go. Driving along, I said to Dolly, 'We've got to look for Route Nine. If you miss it in this insane traffic, you have to go through all these little villages. We finally get to the turn. Then I'm up on the highway and I said, 'It's easy sailing.' I looked into the mirror and I didn't see Dolly. I thought she had fallen asleep. Then I looked in back and there was nobody there. It was absolutely traumatic." He turned off the highway, thinking he had lost her, probably in the gas station. "I headed back to Fort Lauderdale, but all the gas stations looked alike. So I thought I better go all the way back and start afresh. At about the third or fourth station, there's Dolly. She had gotten out of the car to get an ice-cream cone. When she saw me take off, she screamed, but I had the window up and the air-conditioning on." When Dolly saw him drive away, she told the gas station attendant that her husband had left her. He responded, "That's what they all say, lady."

"That's not absentmindedness," Hirschfeld said. "That was just one of those accidental things. I didn't know she got out of the car." The clincher to this discussion came one day when we were in his studio. He took out the drawer next to his drawing table to look for a booklet describing the history of that table, and out fell two checks. One was for $10.90 from the *Herald Tribune,* dated 1937, the other from the Margo Feiden Gallery for $12,038.50, dated February 1, 1981. Both checks were uncashed.

Hirschfeld's life has had its share of apparent contradictions, beginning with the fact that this quintessential cosmopolite spent his childhood in a provincial setting. Albert Hirschfeld was born in St. Louis June 21, 1903, the year that the Wright Brothers made their first flight at Kitty Hawk and the year before the World's Fair that turned Hirschfeld's home town into a festive center of nostalgia. His father, Isaac Hirschfeld, was from Albany, N.Y. (where Al's grandfather had emigrated from Germany) and traveled to Texas as a salesman. Heading home by way of St. Louis, he stopped for a few days at a boarding house. There he met Rebecca Rothberg, an immigrant recently arrived from Ukraine. She spoke only Russian and Yiddish; he spoke only English. But they managed to communicate. After they were married, they decided to remain in St. Louis, where Mrs. Hirschfeld ran a candy store.

Describing his childhood, Hirschfeld makes it sound idyllic but rustic. The Hirschfeld house had no electricity, gas, or running water. It was heated by a coal stove, and Al and his two older brothers were in charge of cleaning the kerosene lamps. Their mother was "a real pioneer lady who adjusted

to this country very quickly." As an artist, Al was a prodigy. By the age of five, he was drawing portraits of his schoolteachers. Posted on the school bulletin board, they attracted compliments. Hirschfeld's conclusion: "Very early encouragement is important. If someone says you're a clown, you believe it." And if someone says you have a talent for drawing, you become an artist. When he was nine, he found a mentor, a local artist named Charles Marx, who gave him his first art instruction and also took him to art galleries.

Marx felt that, given Al's precocious talent, he would be stultified if he remained in St. Louis. He recommended to Mrs. Hirschfeld that she take him to New York. With a determination that marked all her life, she packed up the family and moved across the continent. She was unconcerned about the immediate effects of the dislocation on her husband or on their other children (one of Al's brothers, talented at the piano, never pursued his prospective musical career; the other died in an influenza epidemic at the age of 18). The fact is that Isaac Hirschfeld was known as an amiable, lethargic person, someone who was not eager to exert himself with work and was willing to take a back seat to his enterprising wife. One of Al's most vivid memories of his father is of him spending long, diligent days with the daily newspaper, penciling in the circles of letters. He did it with a purposefulness as if it were an actual occupation instead of simply a time filler. His father, Al said, was "a double for George Burns," while his mother was the role model for Mildred Dunnock when she played Linda Loman in *Death of a Salesman*. Friends indicate that Hirschfeld inherited his humor from his father, his openness and his drive from his mother.

In 1915, with only five dollars in the household account, the Hirschfelds arrived in New York City. Rebecca led the family onto a streetcar and rode north to the end of the line. They alit at 191st Street and St. Nicholas Avenue, which at the time was a bucolic park filled with apple trees. Suitcases in hand, they headed south until they saw a "To Let" sign on a small wooden frame house on 183rd Street. Mrs. Hirschfeld rented the top floor for four dollars a month. She immediately got a job as a salesgirl at Wertheimer's department store while her husband continued his preoccupational pursuits, which increasingly were of a sportsman's nature. He acted as a starter for trotting races on what later became the East River Drive, and he umpired baseball games. Late in life, he made a contribution to the English language; he is said to have coined the expression "senior citizen."

Extremely upset at moving from St. Louis, Al cried for days, bemoaning the fact that he had left all his friends behind. Because of his Missouri accent, he was ridiculed by other boys in Washington Heights; they regarded him as an outlander. One day, he said, they roped him and tied him to a tree as if he were a wild animal. While trying to adjust to the vagaries of New York life, he corresponded with his schoolmates in St. Louis, sending them drawings of city street scenes. When he had his appendix taken out, he drew a picture of the operation and sent that back to St. Louis.

As a young man, Al was interested in baseball (he was a catcher on a semi-professional team) and in theater. With his mother, he began seeing plays, beginning with *High Jinks* at the Julian Eltinge Theater on West 39th Street. By the time he was a teenager, he was, in his words, "a vaudeville bum." With his friend Howard Simon, he became a stage-door Johnny, meeting chorus girls and, in a bold maneuver, taking them for ice cream sodas. Dorshka Raphaelson, the widow of the screenwriter Samson Raphaelson, has known Hirschfeld since he was 12. "He had the most enchanting sense of humor, even as a boy," she recalled. "He was wild and funny and very dear." During this period, he attended a vocational high school, and studied at night at the National Academy; later, he learned lithography at the Art Students League. He could also tap dance and play the ukulele, and, in exchange for the free rental of a studio, he plugged a song for a music publisher, singing and playing it in on a boat sailing up the Hudson River to Albany. Telling the story of his song-plugging days, he said, "I remember the song, 'Scandinavia.'" And in a light reedy voice, with a vaudeville Swedish accent, he sang, "Oh, Scandinavia, ey love you. I tink you bin fine Swedish gal. . . ."

Eventually, Hirschfeld was hired by the Samuel Goldwyn Studios, which were then in New York. He was paid four dollars a week. Working in the art department under the direction of the advertising manager, Howard Dietz (later famous as a Broadway composer), he ran errands and cleaned brushes for the artists. On his own, he drew all the time. Noticing his talent, Dietz asked him if he would like to do a drawing for an advertisement. The first Hirschfeld was of the actress Louise Fazenda. Dietz approved it and gave more assignments. But after Hirschfeld returned from a visit to relatives in St. Louis he found that another young man was doing his work at Goldwyn. Dietz offered to fire the newcomer. Instead Hirschfeld changed firms and went to work for Lewis J. Selznick, the father of David O. and Myron Selznick. By the age of 18, he was the art director of Selznick Pictures.

At Selznick's suggestion, he opened his own studio of artists and contracted to do all the movie work on a freelance basis. But when the producer went bankrupt, Hirschfeld found himself with a high overhead and heavily in debt. He decided to pay the salaries of his employees and cut his own expenses by moving back in with his parents. Eventually, he got a job with Warner Brothers and siphoned his salary back to the artists who worked for him. By the end of the year, he had paid his entire debt. Learning from the experience, he vowed never to work as a salaried employee and never to be an employer of others—and he did not break that vow. His uncle Harry, in St. Louis, was so proud of him for fulfilling the financial obligation that he volunteered to finance a trip to Europe for him. He gave him a boat ticket and $500—a considerable amount in 1924. At the

age of 21, Hirschfeld sailed to Paris to pursue the life of an artist.

On his first night in Paris, he met up with his old friend Howard Simon, who was also an artist. Simon introduced him to two young British artists—Roger Furse, who later became Laurence Olivier's designer and art director, and Robert Musgrave. The four stayed up all night drinking and talking, and by morning Hirschfeld and the two Englishmen had decided to share a studio. They found a small five-room house for $100 a year and took an eight-year lease.

Hirschfeld brought over his trunk, which was filled with a wardrobe supplied by his father, including a cutaway tailcoat and striped trousers, the elder Hirschfeld's idea of proper dress in Paris in the 1920s. The trunk was quickly turned into a table and the cutaway remained unused as the young American assumed the costume of the artist of his time—a red lumberjack shirt, corduroy pants and wooden shoes. In a photograph of the artists in their studio, the scene looks Bohemian: Hirschfeld is lying down, seemingly exhausted after a hard day at the easel. Because the studio had no hot water, the artists all stopped shaving. Hirschfeld has had a beard ever since.

About his Parisian days, he recalls, "Everybody was painting the great picture or writing the great novel." In cafés, he would see Picasso, Hemingway, Gertrude Stein, and others, though his own friends were beginning painters and sculptors. To earn money, he and Furse entertained in Zelli's, a popular nightclub on the Right Bank. In their act, Furse played the ukulele and Hirschfeld tap danced. When asked if that might have led to a career as a performer, he says, "I had no ambition in that direction. It was just excess energy."

Bothered by the cold Paris winter, he decided to head south, which he did with two friends.They went to Spain, crossed to Morocco, and found themselves in the middle of a Riffian war. To Hirschfeld's amusement, the war would stop every Friday night, take a break for weekend socializing, and then begin again on Monday. While traveling, he painted, and the drawings and watercolors he made during the six-month trip became the basis for an exhibition of his work in Paris in 1926. The paintings were subsequently shown in New York, Chicago, and St. Louis—a heralded homecoming and the auspicious beginning of what appeared to be a career as a painter. But later that same year his art took an unpremeditated turn.

Back in New York, he went to a performance on Broadway of *Deburau,* starring Sacha Guitry. While watching the play with Richard Maney, the show's publicist, Hirschfeld drew a quick sketch of Guitry on his program. "It was almost a doodle, but Dick was tremendously impressed," Hirschfeld said. "He said if I would put it on a clean piece of paper, he could place it in a newspaper." The following Sunday, the Hirschfeld drawing was on the first page of the theater section of the *Herald Tribune.* Seemingly in the most casual manner, the artist had embarked on a career that was to carry him through the century.

Several weeks later, Sam Zolotow, the theatrical reporter on the *Times,* sent him a telegram asking if he could do a drawing of Harry Lauder. Hirschfeld obliged, and the sketch appeared in the *Times* on January 29, 1928. Soon his work was being published in the *Brooklyn Eagle,* the *Morning Telegraph,* and the *World* as well as the *Tribune* and the *Times.* The *Times* was the only paper that paid him directly. When he worked for other papers, the producers of the shows paid for the drawings. "Suddenly I found that I was being paid for the things I thought nobody wanted," Hirschfeld says. "That reassures your ego. You suddenly believe—you're Hirschfeld!"

He kept working for the *Times* but more than a year went by before he met Zolotow. A friend introduced them during the intermission of a show. Because Hirschfeld had been leaving his drawings with a doorman, he'd never been in the *Times* offices. Zolotow said the next time he made a delivery, he should come up and meet the men in the drama department, George S. Kaufman, the drama editor, and Brooks Atkinson, the drama critic. Hirschfeld did and soon he and Atkinson were close friends and frequent companions on opening nights. Although he has continued to draw for the *Times* through the rest of the century, for more than sixty years it was on a freelance basis. Not until 1990 did he have a contract with the newspaper.

By the time he was 24, he had married an actress.

Sacha Guitry

Florence Ruth Hobby, who had been in the chorus of "Earl Carroll's Vanities" (and also performed a vaudeville act with Portland Hoffa, later Mrs. Fred Allen) and he had talked the *Tribune* into accrediting him as a theatrical correspondent in Moscow. With his bride, he flew to Paris and from there to Russia, at night, as the only passengers in an open-cockpit plane. In Moscow, Hirschfeld went to a hotel that had been recommended by the artist William Gropper. He had not been allowed to bring any rubles into the country, and discovered, to his dismay, that the hotel had no restaurant and would not cash checks. In the morning, he learned that it was a bank holiday. Having no money, and not speaking Russian, the couple went without food for the entire day. When the banks were still closed the

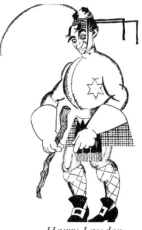

Harry Lauder

next day, Hirschfeld became frantic.

"I remembered hearing in Paris of a Dr. Hammer who had a pencil factory in Moscow and would take in foreigners who were stranded," he said. He found his name in the telephone book and called him. Hammer said, "Come over. We're having a party and you probably know some of the people." A car was sent, bringing Hirschfeld to the home of Armand Hammer, then chairman of the board of Occidental Petroleum. Among the guests were the writers Walter Duranty and Eugene Lyons and a Russian opera singer who helped Hirschfeld find an apartment in Moscow. He and his wife stayed for a year. During that time, he met Stanislavsky, Meyerhold, Pudovkin, Eisenstein, and others, watching them at work and making detailed sketches, some of which were printed in Izvestia. Periodically, he sent drawings and articles to the *Tribune.*

At one point, Hirschfeld took a side trip to Kharkov to look up an aged aunt. For many years, his mother had been sending money and food to a stepsister who had stayed behind in Ukraine when Rebecca came to the U.S. Other members of the family had wondered if the woman really existed. With the help of an interpreter, Hirschfeld tracked her down in Kharkov, knocked on the door, and discovered a tiny woman "who looked like a baked potato and seemed to be about a hundred years old," he said. "She threw her arms around me and pulled me into a room, which was filled with my drawings and photographs of me as a baby. I couldn't believe it." When Hirschfeld left, she showered him with gifts, including silver goblets and candelabras. A week later, she died. As Hirschfeld said, it was as if she had extended her life until she could meet him.

Returning to New York after his Russian adventure, he gathered his drawings and his journal and brought them to Albert Boni, of Boni and Livright, to see about publishing a book. After several weeks of silence, he called the publisher, who said he had no recollection of ever meeting Hirschfeld. The artist marched down to his office, and Boni then said he remembered him but not the drawings or the manuscript. The work was never found, and there was no duplicate. Looking back on this unfortunate episode, Hirschfeld is philosophical: "The world's got along very well without that book." The response is typical. He refuses to be overwhelmed by setbacks, but simply moves on to the next step.

Inspired by his Russian experiences, he began to contribute political cartoons to *New Masses.* There was a George Grosz-like mockery in these drawings, in contrast to his theatrical work. But he soon ended his career as a political cartoonist because of what he felt was a lack of freedom of expression. He had submitted a drawing of the notorious Father Coughlin to *New Masses.* With hatred for the priest's fascism, he had drawn him with swastikas on his glasses and with a mouse coming out from under his clerical collar. The editors rejected it because they felt that the picture would offend Catholic trade unionists. Hirschfeld responded that offensiveness was the whole point of the drawing.

Unsure about settling down in New York, he decided to seek an earthly paradise. He and his wife headed for Tahiti, and found that it was overwhelmed with tourists. "It was a depressing place," he said. "The food was European, the music was from 46th Street, and most of the cloth came from England or 14th Street." While Hirschfeld was suffering in Tahiti, his friend Covarrubias was luxuriating in Bali. He encouraged the Hirschfelds to visit, so they packed and left. By the time they arrived, Covarrubias had been gone for a month, but he left everything in his house, his bicycle as well as kitchen equipment.

Hirschfeld fell in love with Bali—with the people, the landscape, and the island's natural theatricality. "From morning to night, they had kite-flying, beetle-fighting, dancing of all kinds, puppet shows, silhouetted things with oil lamps and shadows thrown onto a screen. The whole place was a giant theater." It was on Bali, not Broadway, that he discovered what was to become the essence of his art. He began to "see in lines," and shifted to black and white. The elimination of color did not happen consciously. Looking back, he says, "I don't know when the peculiar alchemy took place." Partly, he credits Bali's climate. He has an elaborate theory that artists in Europe painted from a brightly colored palette as a reaction against their natural environment. "It's so gray there. It's always foggy and raining, and that enhances color." On the other hand, he says, the great graphic artists came from the Far East, where the sun is blazingly bright. "There's something about the sun that takes out all the color and leaves shadows. There's very little color left on the beach. It's all black and white, and you begin to think in terms of line. I think that has a profound influence on the artists of these countries." Being in Bali brought him closer to the Japanese artists he most admires, Hokusai, Utamaru, and Harunobu. The attraction, first of all, was to the precision of the line.

Despite his affinity for Bali, he decided to return home after a year, but by that time he was short of money. An extra-Balinese event made his departure possible. One day, Charlie Chaplin arrived with his brother Sidney, embarked on a trip around the world. Hirschfeld had met Chaplin several years before, when he did a drawing of him for a movie poster, and he invited the brothers to his house for dinner. Movies had not yet come to Bali. "It was the only place in the world Chaplin was not known," Hirschfeld said. After dinner, the entertainment began. There was a gamelan orchestra, and all the workers in Hirschfeld's compound danced. Then Chaplin got up and imitated what he had just seen. "They screamed with laughter," Hirschfeld said. "He played it like a drunk. He put on a pith helmet and flipped the helmet up in the air." The clowning instantly communicated itself to the audience. Hirschfeld was known in Bali as "the bearded man." Chaplin became "the funny man." Proving that his comedy could transcend all barriers, Chaplin was ecstatic. He was so appreciative of Hirschfeld (and

admiring of his talent) that he bought four of his watercolors. That purchase allowed Hirschfeld to pay for his transportation back to the U.S. "He saved my life," he said. "If he hadn't come by, I would probably still be on Bali."

Although one might have thought the experience in Bali would have made him a confirmed lover of the natural landscape, the opposite turned out to be true. In New York in the 1930s, he easily returned to his role as urban sophisticate. Almost every night, he was at the theater. In contrast to many of his journalistic colleagues, he was drawn into close friendships with the people he covered. Sharing an interest in jazz and swing, he and Eugene O'Neill would visit clubs on West 52nd Street. Errol Garner was a particular favorite of the playwright. Hirschfeld took George and Ira Gershwin to hear a young pianist named Oscar Levant play their music in a small club atop a delicatessen in Greenwich Village. Writers and composers were among his closest friends: S. J. Perelman, Edward Chodorov, Paul Osborn, William Saroyan.

When Hirschfeld was in Paris in the 1920s, Dolly Haas was growing up in Hamburg, the daughter of a German mother and an English father. At an early age, she took ballet lessons and soon became a child actress. When she was 15, she was discovered by the comic Max Pallenberg and his wife, Fritzi Massary, then the reigning queen of musical comedy and operetta in Germany. Before she was 20, Miss Haas was one of the three little maids in a Berlin production of *The Mikado,* and had a promising career in cabaret and musical revues.

In 1929, she made her first movie, playing a department store doll that comes to life in *One Summer of Happiness,* directed by William Dieterle. Personifying innocence in this and other films (written by people like Billy Wilder and Kurt Siodmak), she quickly became a favorite on the German screen. Because she was not Jewish, her film career was not jeopardized by Hitler, but she was horrified by his rise to power, and when she was called to England in 1934 to make a film, she began thinking about leaving Germany. Two years later, with her third English film, she made a complete break. The movie was the sound version of D. W. Griffith's *Broken Blossoms,* and her role was that of a Cockney flower girl, created in silent films by Lillian Gish. The director was Hans Brahm (later Anglicized to John Brahm), an exiled German who became Miss Haas's first husband. The success of *Broken Blossoms* brought

the actress to Hollywood, where, in characteristic fashion, producers wanted to change her name (to that perennial, Lilli Marlowe) and to glamorize her appearance. Despite Harry Cohn's momentary interest in her work, her career never took off. Samson Raphaelson wrote *The Shop Around the Corner* with her in mind, but the role went to Margaret Sullivan. Tired of languishing in Los Angeles, she left for New York and immersed herself in theater.

Seeing her playing an Oriental woman in Erwin Piscator's *Circle of Chalk,* Hirschfeld was instantly enamored. (By that time, he was separated from his wife.) When he heard that Dolly was working with the Jitney Players, a summer-stock company in Eaglesmere, Pennsylvania, he convinced Brooks Atkinson to let him do a drawing of the troupe for the *Sunday Times.* The sketch was of the company unloading scenery and props for its production of a play called *Her Cardboard Lover.* In the center is Hirschfeld's first portrait of Dolly, as a lady with a floor lamp. Sometime later, he was in Hollywood on an assignment. At dinner with Samson and Dorshka Raphaelson, he asked them if they happened to know Dolly Haas. Raphaelson said, "Ask this fellow," indicating another dinner guest. "He's her husband." It was, of course, John Brahm, now separated from his wife and continuing to pursue his own career as a director in America. Back in New York, Hirschfeld called her, and they began going out. Within months, they decided to get married.

In a taxi headed toward City Hall, Hirschfeld suddenly said he was not sure he had ever divorced his first wife. Dolly said he had better make sure. So he stopped the cab and telephoned Flo, sheepishly asking her if they were ever divorced. To his chagrin, he learned that they were still married. It was an extreme example of his absentmindedness. The wedding was postponed, the divorce was amicable, and then he and Dolly were married. They went to Nantucket for their honeymoon. After a half hour baking on the beach in

their bathing suits, Hirschfeld was restless and asked his bride if she would mind leaving that place. She said, "No, but where do you want to go?" He said, "Well there's a rehearsal of *One Touch of Venus* in Boston," and S. J. Perelman and Ogden Nash were there. With Dolly's assent, they immediately left Nantucket. He recalled, "We went to Boston and sat in that theater on a hot summer's day with the air conditioning on. It was delightful."

In 1945, their daughter Nina was born—an event the artist chose to commemorate in his drawing for the musical, *Are You With It?* In the background is a poster billing "Nina the Wonder Child." What began, in Hirschfeld's words, as an "innocent prank," soon became a national craze, as he concealed the name "NINA" in all his subsequent drawings. At one point, to Hirschfeld's surprise, the Pentagon initiated a $60,000 study to see if hidden NINAs could be used as a scientific tool to measure the visual aptitude of Air Force pilots. The NINAs became so attached to his work that years later, when he was commissioned to draw a series of portraits of comedians for postage stamps, special dispensation was made so that Nina's name would appear on the stamps, although, obeying government policy, the artist omitted his own name.

While the recognition gave the real Nina a certain cachet, it was also an encumbrance, especially in her younger days, when she was trying to pursue a career as a pianist and actress. The close identification with her father's work led to a loss of identity. On the other hand, she says that she loved growing up in an atmosphere where she was surrounded by the celebrated. For one thing, the Hirschfeld New Year's Eve parties were festive affairs, rivaled only by the New Year's Eve parties given by Lee Strasberg. As a young girl, Nina danced with Gene Kelly, sat in Laurence Olivier's lap, and had "the real" Peter Pan, Mary Martin, as a guest in her home. As she said, "Leaving my parents' house was the hardest thing I ever had to to do in my life." Married twice, with two children, Nina lives in Austin, Texas, while others across America continue to count their NINAs.

Next to Dolly, S. J. Perelman was Hirschfeld's closest friend. They shared a devastating wit and a delight in the intricacies of the English language. To this day, Hirschfeld often speaks with a Perelmanesque formality: he does not serve drinks, he offers libations. Perelman traced their first meeting back to 1929, when both were in Paris and happened to be seated at the same table in a Javanese restaurant. "In no time at all—five minutes, to be exact—we were laughing and chatting away as though we had known each other five minutes," Perelman wrote. When they ran into each other in New York, Perelman said, "we shared a stoup of kumiss together, and renewed our friendship." That single stoup led to many flagons, tankards, and steins as they became cronies and fellow boulevardiers.

One of the roots of their kinship was the fact that Perelman had begun his creative life as a cartoonist (his captions became longer; that made him a writer) and Hirschfeld has always been a writer manqué. Through Perelman, he came to know many of the humorist's fellow writers and artists at *The New Yorker*. Considering that close association, it's curious that for so many years he did not contribute to the magazine. For that he blames Harold Ross. In a series of collages that he did for *Life,* Hirschfeld drew a mustache on a picture of Ross in order to make him look like Joseph Stalin. He thinks that Ross never forgave him.

Despite their affinity for each other, Hirschfeld and Perelman had opposite temperaments. Where Perelman could be withdrawn, Hirschfeld has a natural buoyancy, and he has never lost his Old World courtliness. On several occasions they were collaborators. Having succeeded on Broadway in 1943 as the co-author of *One Touch of Venus,* Perelman maintained an often unrequited love affair with the theater. In the late 1940s, he suggested to Hirschfeld that they write a musical together, a show that was eventually entitled *Sweet Bye and Bye.* Vernon Duke wrote the music, Ogden Nash the lyrics, and the book was by Perelman and Hirschfeld. It was intended as a futurist musical under the title *Futurosy,* which definitely would have been a misnomer.

From the beginning, Hirschfeld was skeptical, partly because he'd never written a show before. Perelman insisted that they would be good collaborators. "We met every day for about a year to work this foolish thing out, and we thought we had a very funny script," Hirschfeld said. "The show might have made a comedy, but it could never make a musical, because it's impossible to outguess the music of the future. Duke's solution was to put a lot of harpists in the orchestra." During the tryout, everyone blamed everyone else for the musical's woes. One day, Perelman overheard Nash and Duke telling someone on the phone that they were rewriting the Perelman-Hirschfeld book. In reciprocity, Perelman made sure the composers overheard him in an imaginary phone conversation saying that since Hirschfeld could play the piano he

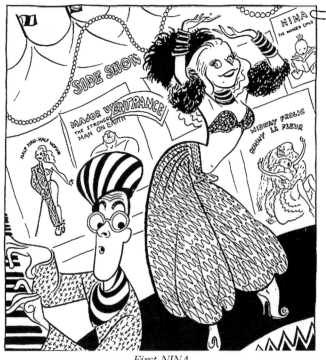

First NINA

was rewriting the Nash-Duke score.

Difficulties were deepened by the casting. The leading lady had a nervous breakdown and was replaced by Dolores Gray. Both authors had enjoyed the performances of a vaudeville comedian named Gene Sheldon, and he had been signed for the leading male role, despite the fact that he had no acting experience and was known largely for a comedy routine in which he pretended to sew his fingers together. "Well, we opened in New Haven," said Hirschfeld, "and the leading man comes on, meets the girl, and starts sewing his fingers together. He gets his finger caught in a buttonhole." As he realized, Sheldon was doing his own material. By the time the scene was finished, the authors had rushed backstage to accost the star. Perelman grabbed him and said, "What the hell were you doing out there?" Sheldon replied, "You heard them laughing. They weren't laughing at your stuff, they were laughing at my material."

"It suddenly dawned on us that this fellow had developed twelve minutes of material across a lifetime," Hirschfeld said. "He had never been on television, never been in the theater. Vaudeville—that was it." A furious Perelman threw Sheldon against the wall. "This was at the beginning of the performance. The stage manager went on for him for the balance of the show, and we let Sheldon go that day. Now we were without a leading man, and we opened the following week in Philadelphia. We had to cancel everything. Actors flew in from all over the world. Finally, we hired a guy because his agent sold us on the idea that he was a quick learner. At the end of two weeks, he didn't know one song." The reviews were damning, and the producers were frantic. Perelman later wrote that the show "closed in Philadelphia like a ten-cent mousetrap." Hirschfeld said, "I was taught my lesson. Pencil, pen, and a nib—that's it." He never tried to write another play, while Perelman never stopped trying.

As Perelman and Hirschfeld commiserated about the pre-Broadway failure, they were visited by an angel in the guise of Ted Patrick, the editor of *Holiday* magazine. He suggested that Perelman take a trip around the world and write about it for *Holiday*. The writer, momentarily bereft of creative ideas, accepted, and proposed that Hirschfeld, who had done "the Giant Swing" around the world before, should accompany him and illustrate the journey. Besides, Perelman said, he needed a bodyguard. Later, Perelman listed Hirschfeld's qualifications for the assignment: "a pair of liquid brown eyes, delicately rimmed in red, of an innocence to charm the heart of the fiercest aborigine, and a beard which could engulf everything from a tsetse fly to a Sumatra tiger. In short, a remarkable combination of Walt Whitman, Lawrence of Arabia, and Moe, my favorite waiter at Lindy's."

The idea was for the two of them to travel from Shanghai

S. J. Perelman

to Singapore and to send back monthly reports with pictures to the magazine. With strong hearts and stout stomachs and vowing a bond of untrammelled amity, the travelers embarked. The nine-month journey was chronicled in Perelman's book *Westward Ha!* As was the author's wont, his writing enlarged the experiences for comic purposes, but the true account of the expedition is even more exotic than the elaborated one that evolved in Perelman's typewriter. For that, one must look to Hirschfeld's memories and to the film he shot of the voyage.

Booked out of San Francisco on the *Marine Flier*, they headed across the Pacific to China. "Sid had never traveled much up until that time," Hirschfeld said. "He had been to Paris, and that was about it. When we left America, I tried to help him decide what to bring, but he was listening to all those fellows in Hollywood." At their suggestion, he brought along jewelry, silk stockings, and other trinkets he was planning to trade to the natives. "I dreaded coming into a port, because I had a movie camera and a lot of film, things that were taxable. But I never declared them. Sid kept saying, 'They're going to throw you in jail.' He brought along a little bottle of whiskey and he would declare it every place we went. They would confiscate it and put it in bond, along with the stockings, cigarettes, and jewelry. I'd go right through customs, but Sid was always stopped."

Between ports, each often traveled separately. Because of an ear infection, Hirschfeld had been forced to give up plane travel. This meant that Perelman would fly ahead and Hirschfeld would follow by ship, sometimes arriving as much as five days later, by which time his companion would be bored with the place and would be eager to leave. Hirschfeld was more flexible, willing to adapt himself to local exigencies, while Perelman was more often concerned with moving along, even if it meant missing an adventure.

A perfectionist, Perelman would labor over each article and then send it back through the nearest American Embassy. After the packet was sealed, he would invariably have second or third thoughts, questioning himself on the use of specific words. Hirschfeld would warn, "Don't open that envelope!" But Perelman would rip it open, take the manuscript back to the hotel, and retype pages. Wherever they went, they were aided by officials of the State Department and other government agencies. It was only two years after the end of the Second World War; some countries were still in a state of unrest and were unaccustomed to the return of tourism. It was up to Hirschfeld as the more seasoned traveler to smooth over problems. In their journey, Perelman and Hirschfeld were less Lewis and Clark than Hope and Crosby.

Watching Hirschfeld's home movie a half century later is a fascinating experience. So much has happened since then,

beginning with political and economic changes in the countries they visited (and, of course, the death of Perelman). With the movie loosely edited and transferred from 16 millimeter film to videotape, Hirschfeld put it on his VCR. As it played, he offered a running commentary to the silent documentary. One might say that Hirschfeld's eye for revealing detail was so acute as to encourage him, if he had so desired, to have a career as a documentary filmmaker. (He also has a talent as a still photographer. In his files are his Steiglitz-like pictures of New York in the 1920s and 30s.) Omitting shipboard scenes, the film showed the travelers arriving in Chinwangtao and then sailing back to Shanghai. "Here comes Sid," announced Hirschfeld and, wearing a raincoat and looking like a fugitive from a Humphrey Bogart movie, there was Perelman, jaunty in Shanghai. From Hong Kong, they went to Malay where they visited the regent of Jahore. On screen, there was a glimpse of the regent and monkeys from his private zoo.

Then Perelman flew to Bangkok, and Hirschfeld followed by ship. As the ship sailed in, we could see Perelman, in short sleeves, sitting on the pier. As he later recalled in his book, Perelman was so charmed by Bangkok that he found it difficult to be funny about it. The plan was to travel by rail from Bangkok to Chiang Mai. The mode of transportation was not, as one might have expected, an automobile or a train, but a stripped-down Chevrolet chassis with railway wheels on it, left by the Japanese after the occupation. The vehicle, which looked like a Toonerville trolley or a crate on wheels, was driven on the tracks and, when a train approached, it would slip onto a side rail. Overcome by qualms about the danger of the journey, Perelman decided to forego the trip north. For Hirschfeld, it proved to be one of the most memorable excursions.

As narrator, Hirschfeld pointed out the sights—the klongs (or canals), rivers and forests. There was a quick cut from a cremation ceremony to a Siamese dancer being elaborately made up and sewn into an ornate costume. Her dance, he said, was based on the movement of an elephant. "This is the first time that this had ever been photographed," he said, adding, "I showed it to Rodgers and Hammerstein before they did *The King and I*." Considering the fact that neither the composer nor the lyricist had ever been in Siam, one could assume that Hirschfeld's home movie was a primary source of their research.

Back on the railway car, there was a picture of Hirschfeld in black beard and yellow shirt, looking almost piratical. After pass-

ing floating villages and poppy fields, they arrived at a river where elephants were dragging teak logs, which would float down to Bangkok. "This is where I was bitten by a moth," he said. "You couldn't get anything more romantic than that. It should have at least been a cobra." It was, nevertheless, a serious infection, and the fact that he was treated immediately in a nearby leper hospital saved his eye. For the rest of the trip, he wore a white eye patch, which gave him an even more threatening mien. As the railroad car appeared again, he said, "The King of Siam was a ferrophile," then explained the Perelmanesque portmanteau: "He was a nut on railroads."

After a vista of the Taj Mahal, the scene shifted to a country road and there was Mahatma Gandhi, swathed in a dhoti and walking along with his two granddaughters. This turned out to be rare footage. The following day, Gandhi was assassinated. Hirschfeld's movie was probably the last record on film of the Indian leader. Inexplicably, Perelman omitted the entire incident from his book; perhaps there was simply no way to incorporate such a powerful event in his lighthearted account.

At the end of Perelman's book, the author describes a gathering of friends in New York, brought together to watch the Hirschfeld travelogue. Perelman makes fun of both the film and the audience, which, as rendered in an accompanying Hirschfeld drawing, seems catatonic except for one woman who is contemplating her highly polished fingernails. The film deserved a far better fate than being consigned to a footnote. In *Westward Ha!*, the well-traveled companions agree never to take such a trip again, even for a million dollars—a promise that Perelman himself soon broke. This was in fact the beginning of a new direction in his career. After *Westward Ha!*, he became famous as a traveler, journeying by himself and with his wife and two children (for *Swiss Family Perelman*). Later he retraced the steps of Phineas Fogg in his Oscar-winning screenplay for the Mike Todd film, *Around the World in 80 Days*. Hirschfeld illustrated several of Perelman's travel books while remaining safely at home in New York.

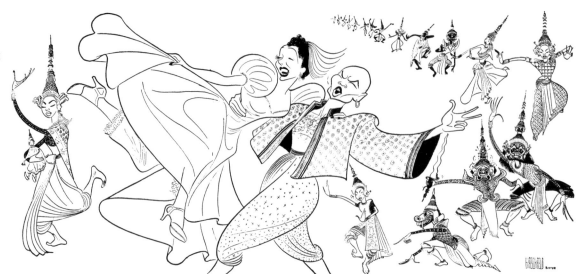

For many people, Hirschfeld is a friend of first and last resort, someone to turn to for advice and in time of illness or trouble. His circle includes not only artists and celebrities but also eccentrics and conmen, such as, in the midcentury, the notorious freeloader George "the Real" McCoy, who parlayed a gift of gab into a career as a radio commentator and journalist. Hirschfeld has a penchant, he says, for "attracting lunatics—my whole life has been peppered with these fellows." One of his most outrageous friends was Alexander King. He was, said Hirschfeld, "a swindler, thief, and hopelessly addicted dope fiend," as well as author, artist, and self-styled genius. Because King was such a marvelous raconteur, Hirschfeld and Perelman encouraged him to write a book. They brought him to Simon and Schuster and even volunteered to pay his advance covertly if the publisher would sign him up. King finished the book but it came out during a newspaper strike. As the book was about to disappear from the shelves, Hirschfeld suggested that King promote it on television. When King appeared on the *Jack Paar Show,* Hirschfeld listened with horror to his friend's tasteless conversation. But Paar loved King and so did the audience. He became an overnight celebrity and within three weeks his book was on the best-seller list, as were his next three books. Then with King owing his publisher another work, Hirschfeld extracted a discarded manuscript from King's trash basket. It was published and also became a best seller.

Because of his critical acumen and his experience, Hirschfeld has built up a reservoir of credibility as a theater expert. Though he has never served as a play doctor, his advice has been informally solicited by producers and directors when a show is out of town. That is not to suggest that he is infallible. Once, in New Haven for the opening of a new musical in the early 1940s, he was asked to meet with the producer at the Taft Hotel after the performance. Also invited were Mike Todd and Billy Rose. Each was asked for his opinion of the show. Todd was dismissive of it, suggesting that the producer close it in New Haven. With only slightly more enthusiasm, Rose admitted that there were several good tunes. Hirschfeld was the most favorable, barely; he said that he liked the dancing. The others jumped on him, saying that the choreography was similar to something that had been done the previous year on the dance stage.

When Hirschfeld returned to New York, he told Atkinson that the musical might never arrive on Broadway. Because of that doubt, he was hesitant about devoting his space in the *Times* on Sunday to the show. Scheduled to open the same week was an edition of the *Ziegfeld Follies,* starring Milton Berle. Therefore it was a rival candidate for a Hirschfeld drawing. Hedging his bets, he went to Boston to see the *Follies,* and while he was there a press agent convinced him to stay an extra night and have another look at the show he had seen in New Haven. To his surprise, it had improved so much that Hirschfeld decided to split his Sunday space between the two musicals. When he and Dolly went to the

New York opening, they were overwhelmed by the transformation, and in particular by the first number, "Oh, What a Beautiful Morning." The show that had been entitled *Away We Go!* in New Haven was now, of course, *Oklahoma!* Hirschfeld attributed the success to "the Kaufman law," named after George S. Kaufman, who said that "if you get the audience in the first two or three minutes, you have them for the whole of the first act."

With *My Fair Lady,* Hirschfeld remembers staying up until four in the morning trying to talk Moss Hart out of directing the show. "I had all the logic on my side," he recalled. "I said, 'Moss, you've got to realize *Pygmalion* is a marvelous play, and the movie with Wendy Hiller is great. How are you going to improve on this by having people sing and dance?' He said, 'I'm sure you're right, but I'm committed to it, and I'm going to do it.'" When Hirschfeld went to the opening, naturally he changed his mind. It is, he concludes, impossible to predict what will succeed on Broadway, which is one reason he would never invest in theater.

Then he mentioned a show that he loved in Philadelphia and turned out to be one of the biggest failures in Broadway history. The show was *Flahooley,* with a book by E. Y. Harburg and Fred Saidy and a score by Sammy Fain. It was a musical about the invention of a laughing doll. "I came back to New York and said, 'This is an absolute smash.' Then we went to the opening, and in the first scene people are sitting around a conference table with little toys in front of them. The toys are supposed to be sight gags. One doll is supposed to spring up, another to jump around. The first actor winds a doll up, puts it down and nothing happens. The audience waits. Another doll is wound up. Nothing happens. Three times, and the audience becomes restless. Kaufman's

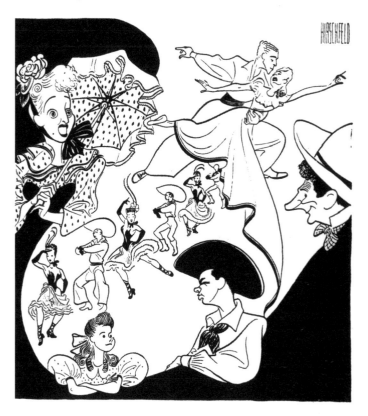

"Oklahoma!"

law: nobody cared what happened after that."

From the vantage point of more than seventy years of theatergoing, he is critical of what happened to Broadway, the fact that it became a high-powered industry. "Producing a play today is like organizing U.S. Steel. When you're dealing with that kind of money, there are so many backers and each has an opinion. Entrepreneurs like Sam Harris and Max Gordon used their own money. Some of them were men of taste. There was room in the theater for kitsch, mysteries, boulevard comedies, but there

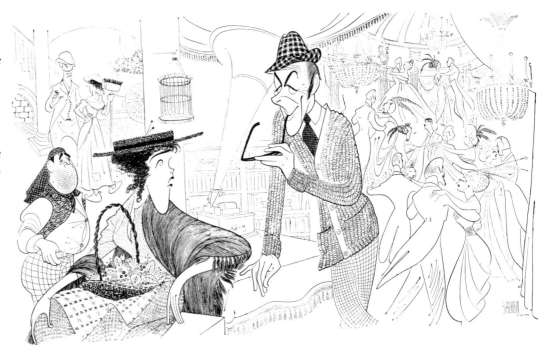

was also a potpourri of good plays to balance them off. Now it's all aimed at the bottom line: will it make money, will it sell to Hollywood? Is it any good for TV? The theater used to be a personal thing. Except for Stephen Sondheim, the musical today, from my point of view, is not music at all. You could take the songs out of *Les Misérables* and put them in *Cats,* or into *Phantom of the Opera,* or *Miss Saigon.* I don't think it would make any difference. It all sounds like the same piece of music. There's nothing in these million-dollar productions outside of steam and laser beams." Hirschfeld has broadly eclectic taste, which has led him to see plays Off Broadway and Off Off Broadway. Several years ago, he resigned as a nominator for the Tony awards because the Tonys continued to ignore the existence of Off Broadway.

He enjoys going to the theater and, equally, he enjoys chronicling his theatrical experiences. His method continues to be one of trial and error until, he hopes, "some kind of magic takes place." In making his drawings, he has certain favorite devices—two Picasso-like faces on one head when he is drawing twins; a playwright or a director acting as puppeteer and pulling the strings of characters or actors. But each time he draws someone it is as if for the first time. If it is an actor he has drawn before, he does not take out previous caricatures of the subject, but simply sits before his drawing board, with pen, memories, and perhaps a photograph, and offers a fresh look at a familiar figure. When he was having difficulty drawing Keith Carradine twirling a lasso in *The Will Rogers Follies,* he remembered his original drawings of Will Rogers.

About thirty years ago, Margo Feiden entered his life, and helped to turn his art into a profitable business. Having had minimal success with other dealers up to that point, he agreed to go along with her, and she pitched into his career like a producer bringing a musical to Broadway. She became his agent, promoter, archivist, and ardent admirer. Most important for him, she sold his work and sought commissions for portraits and advertisements. The gallery, he said,

"has allowed me to live beyond my means all these years." Rare for an art dealer, Ms. Feiden handles only one artist, Al Hirschfeld, and she is dedicated to the popularization of his work.

Despite his great success, Hirschfeld lives a modest rather than a lavish life. One of his few indulgences is his car, a sleek blue Cadillac. Hirschfeld is an automobilephile. In years past, when he would cover a show out of town he would always drive there. To this day, he drives to the theater for openings. Oblivious to the possible dangers, he generally parks his car on the street, and then walks briskly to the nearby theater, in his tenth decade retaining his anticipation and his zest for performance.

In his 90s, he continues his daily routine, working a full day in his studio, breaking only for lunch and having tea at his worktable (with a supply of caramels for snacks). Except for the telephone, he remains isolated and seldom breaks his regimen to go out to eat or to a museum. Evenings are reserved for theatergoing and socializing. When he is not at the theater, he is usually having dinner at home with friends. After the theater, if he does not go to an opening night party, he is home in time to watch the news and *Nightline* on television. Then he reads from midnight to two, favoring philosophical works, often rereading Thoreau or Bertrand Russell.

For fifty years he was happily married to Dolly Hass. In 1994, Dolly died after a long illness, and two years later, he married Louise Kerz, a theater archivist and a longtime family friend (and the widow of Leo Kerz, the producer and scenic designer). And as was true with Al and Dolly, Al and Louise are familiar figures on the aisle at Broadway openings and they are also hosts of most convivial dinners in their home.

More and more, Hirschfeld has been the subject of museum and gallery exhibitions. In 1998 his work was at the Smithsonian's National Portrait Gallery, the Katonah (N.Y.) Museum of Art, Harvard University, and the Norman Rockwell Museum in Stockbridge, Mass. Among the artists

who freely credit Hirschfeld's influence are those who draw animated cartoons for the Disney studio—most notably Eric Goldman, whose creation of the Genie in the movie *Aladdin* was clearly inspired by Hirschfeld's style. Beginning in 1993, his work started to appear in *The New Yorker.* Susan Dryfoos's *The Line King,* a film about Hirschfeld, was released in 1996 and was nominated for an Academy Award in the documentary feature category. With each year, he gathers new honors, insuring his role, as—in the Japanese manner—a living national treasure.

For all his sense of theatrical history, he is not eager to look back on his past work, preferring to look forward to the next show, the next drawing. But one day in his studio, he reached across his table and said, "Here's a drawing I rather like," and took out his portrait of Ben Turpin, one of a series he did on great clowns (a series that includes the Marx Brothers, Laurel and Hardy, and Chaplin). In the drawing, a dizzy, cross-eyed Turpin is being chased by a horde of Keystone Kops.

Trying to explain why he thought the drawing was successful, he said, "Accidents happen, and I took advantage of them right away. I didn't labor on it, and it doesn't look labored, which is very rare. I couldn't have done that years ago. I wouldn't have had the" He searched for the correct word, "The authority." Studying the picture, he said, "There's something so crazy about those Sennett cops. They're all

jumping up in one bunch." They are so close together that from a distance they look like a large ink blot surmounted by heads in policemen's hats. "And Turpin is reduced to a simple line. Moving along, he defies gravity." The clown seems to fly across the page, inches ahead of his hat, which is sprung loose on a coil like a Slinky toy.

"It's a kind of distillation," he said. "You squeeze all the inessential things out." I said that for one thing he had squeezed out all sense that Turpin had real legs. He agreed and added, "To my knowledge, that hasn't been done before. He's almost like a musical instrument, a violin or cello. And still it's him. That's my own thumbprint."

Reflecting on his life in the theater, he said, "Every now and then, a drawing that existed over seven or eight decades will survive, regardless of whether it's of the Lunts or of actors who are unknown today." Long after the event and long after the actors have disappeared, the Hirschfeld drawing continues to create a life and atmosphere of its own, a living record of the excitement of artists in performance.

[Portions of this piece appeared in different form in *The New Yorker* and *Graphis.*]

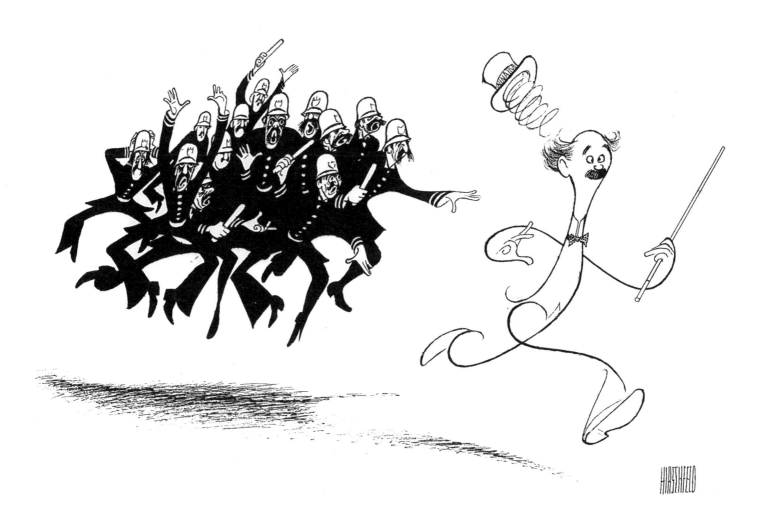

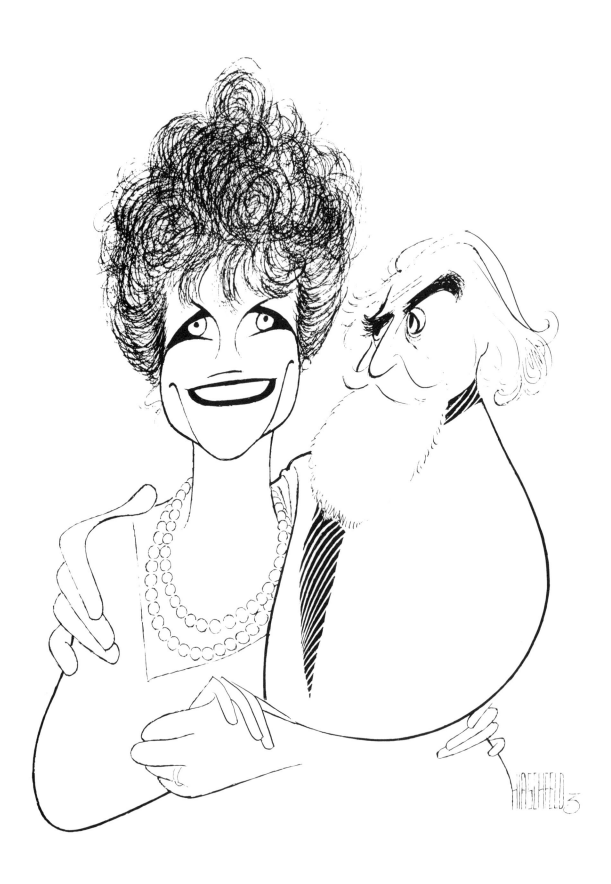

Looking Over His Shoulder
by Louise Kerz Hirschfeld

It was a high-powered opening night at a landmark theatre in New York. The curtain hadn't gone up and yet already there was real drama underway—out in the crowded theatre lobby. I remember how anxious I was standing there with the opening night audience, all of us waiting for the same person. But he was late. Suddenly, he appeared and the crowd parted. Someone excitedly shouted "Hirschfeld is here!" Then another ecstatic voice rang out: "Now the curtain can go up!"

I began to accompany my husband Al Hirschfeld to the theatre on a regular basis in 1995. Ever since, I've been assured of a good show put on by a consummate professional—occasionally onstage but always in the seat next to me and performed by Al Hirschfeld. In fact, during the stage performance, I become terribly interested in his reactions. I glance over and see a face completely entranced with the actors. There's a slight smile, but absolute attention is being paid to the stage. It's something akin to a state of reverence —Al's love affair with the theatre.

Since our marriage, I have had the unique experience of seeing a Hirschfeld drawing before it hits the newsstands, of being present during The Process, at the drawing board, and before the NINAs are hidden.

Before our marriage, however, I had already been a keen as well as a professional observer of the art of Al Hirschfeld —albeit without the luxury of proximity. I was a theatre historian, and Al Hirschfeld is an essential, at times a definitive, original resource in the History of the American Stage. Long before videocameras, it was Al doing the accurate recording of our greatest shows.

The first drawing of his I *really* studied was one commissioned by my first husband, Leo Kerz, for his Broadway production of Eugene Ionesco's *Rhinoceros* in 1961. That's the one where Zero Mostel transformed into the title character— a snorting, pawing, giant wild pachyderm. He did it right on stage without benefit of special makeup or special effects and terrorized his poor, shaking co-star Eli Wallach night after night, literally tossing him about the

Eli Wallach and Zero Mostel in "Rhinoceros"

stage. But it was Al Hirschfeld's equally remarkable theatrical art that, fortunately, captured the moment—in all its ferocity and power and originality—for posterity.

The scene was naturally the highlight of the play and, since I worked on the production, I got to witness it at many performances. Knowing the original as well as I did, I couldn't help marveling at the way Hirschfeld had encapsulated it in a line drawing, like some kind of visual shorthand, catching not only the look but the high drama of the moment. Hirschfeld's accuracy of theatrical detail is by now legendary, but he also seems to have some mysterious knowledge of the playwright's intentions. Like a clairvoyant with a pen instead of a crystal ball.

After that dramatic start I always returned to Hirschfeld's work to assist me in my research for museum exhibitions and television programs. Because of his incredible attention to visual detail and near photographic eye, Hirschfeld's drawings provide a wealth of visual history not only of the theatre but of American cultural life. Since his art runs like connective tissue through the last eight decades, his drawings are sociologically as well as aesthetically indispensable. In fact, a

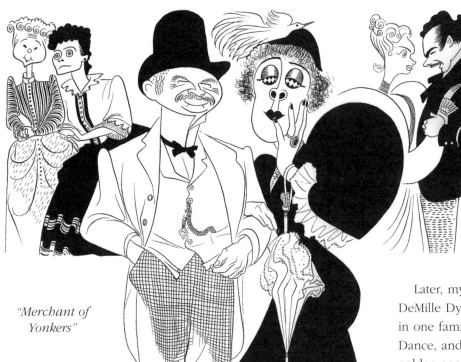

"Merchant of Yonkers"

Hirschfeld is often more revealing than a camera, because of the drawing's flair and fluidity of movement, an added dimension over mere photography or videography.

In 1974 I began my career as Theatrical Curator with an exhibition entitled "The Theatre of Max Reinhardt," honoring the brilliant Austrian stage director. The show, critics agreed, was filled with intriguing memorabilia, including a chain-mail costume the actress Elizabeth Bergner sent me and which she'd worn for her role of Joan of Arc. There was also a red curtain tassel from The Deutches Theatre in Berlin that brought tears

of remembrance to the eyes of European émigrés. But even here Hirschfeld was indispensable, because the great Reinhardt spent his diminished final years in America, never to attain the stature of theatre royalty he possessed in Europe. To research his Broadway productions of Thornton Wilder's *The Merchant of Yonkers* (which became *Hello, Dolly* in 1964) and Irwin Shaw's *Sons and Soldiers*, I again consulted the incomparable Mr. Hirschfeld. Stella Adler even lent me the Hirschfeld rendering of herself and Gregory Peck—fresh-faced in his first Broadway role!—in *Sons and Soldiers*.

Later, my exhibition at New York's Lincoln Center, "The DeMille Dynasty," celebrated one hundred years of creativity in one family. Agnes de Mille was a major force in American Dance, and championed ballet on Broadway. During the golden age of American musicals, she choreographed *Oklahoma!*, *One Touch of Venus*, *Carousel*, and *Brigadoon*, among many equally-celebrated others. But who can a poor theatre historian turn to when she needs to see how a stage show was choreographed? Who notices such things on a stage during the high drama? Who else but Al Hirschfeld. His ability to capture movement in accurate detail is as great as his knack for catching personal likenesses. So I naturally turned to Hirschfeld drawings of those de Mille shows to see how he viewed her contribution to the musical form. In his drawing of *Oklahoma!*, for example, the chorus of dancers was prominently centered, and I inadvertently "discovered"

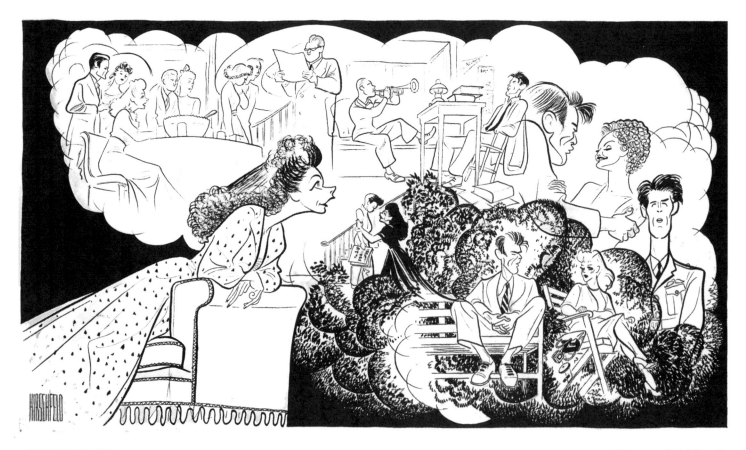

"Sons and Soldiers"

there the work of the distinguished costume designer Miles White. This was a true revelation to me. Looking at the Hirschfeld was like looking into a time machine. Every detail of the past came vibrantly alive again. You almost get the feeling that if you put the drawing under a microscope you could read the clothing labels.

Then, in my endeavors as research consultant for Smith-Hemion Productions, I constantly integrated Hirschfeld's images of the pioneers of television for The Television Academy Hall of Fame. People don't naturally think of Al Hirschfeld as a recorder of TV, but he was there with his sketch pad right from the first harsh, blanched-out flickers. For instance, his Edward R. Murrow is a man of action, whose intensity with just a telephone in hand expresses the ideals he brought to the new world of broadcast journalism. Murrow's the man who finally confronted Senator Joe McCarthy on the CBS show *See It Now*. And people did see it then. And thanks to Al Hirschfeld *we* can see Television in its formative years now!

A Night at the Theatre With Al

Both Al and I feel that going to the theatre is still a formal occasion. In fact, Al always wears custom-made shirts with an ascot designed by Turnbull & Asher in London, while I wear a festive long dress. At the appointed hour, I pick up Al's 1987 blue Cadillac and have it purring and ready for our departure downtown to the theatre district. We leave home early so that Al can locate a parking space near the theatre. This is an art in itself, one which Al has been performing for almost as long as his illustrating but with less public notoriety.

We both love to travel downtown via Central Park Drive because there is so much activity to observe. Runners, skaters, and bikers getting their exercise, children returning home, lovers strolling under the magnificent backdrop of the Manhattan skyline. No matter what the weather, it's a magical setting, and a good appetizer for the main course of drama to come. Once we pass Carnegie Hall, traffic gets heavy. I sit tight while Al maneuvers masterfully between honking buses, onrushing cabs, and unpredictable pedestrians. Al says that *driving relaxes him!*

Finally we reach the playhouse and Al always finds a parking space. Just as reliably, Hirschfeld fans are on hand requesting autographs. Al is a great favorite with the press as well. Photographers and videographers lined up outside the theatre always want to capture his image. They plead with him to smile and say a few words. "Hey, Al!" . . . This way please!" . . . "C'mon, not so fast!" Al's so shy, however, that he makes his way quickly into the lobby.

Ensconced in our aisle seats, we both transform into avid readers of *Playbill*. We usually devour the whole issue before the curtain goes up. During intermission, we remain in our seats, and directly after the final applause, we exit the theatre. Sometimes we attend the opening night party. Preferably, we go alone to a more private dinner at Sardi's,

The Algonquin, or a small French restaurant named Tous Va Bien on West 50th Street. "Tous va bien" means "All goes well" in French, but that hasn't always been the case in the theatre earlier. Over dinner, Al and I analyze the play we've just seen, venting our opinions about the writing, the directing, the acting, and the design.

Then it's back to the blue Caddy and back uptown.

While Al Is Sketching

While the first and second acts are underway, however, the sightseeing and socializing stops and Al becomes all business. This is true whether the show he's at is a simple "run-through" or a gala opening night. I observe him as unobtrusively as I can, hoping not to break his focus as he feverishly draws the actors or some aspect of the stage design and costumes—for the *entire* time there's action occurring onstage. If it's there he sees it. Very often he uses his "personal shorthand" to describe shapes and textures. We rarely converse during this crucial time, but my reward for my silence is a chance to look at the sketchbook when his work is completed. There, miraculously, are the leading characters and, invariably, the most dramatic moment and the musical highlight. Nothing gets past Al. This sketch work is, he says, "an evolving collage of the total experience," because he's constantly in touch with his silent partner—the author of the play. Remaining in his seat at intermission, Al appears to be relaxed, but he uses that time to look over his sketches from the first act.

Am I Surprised By Al's Take On a Show?

Sometimes I am surprised at a drawing. For instance, in the recent, marvelous Lincoln Center Theater production of *Twelfth Night,* directed by Nicholas Hytner. In his drawing, Al centered the three character actors, Philip Bosco, Max Wright, and Brian Murray, while the Oscar-winning "guest star" Helen Hunt was only featured. Obviously, this was Al's individual "take" on the production. In Hirschfeld's work, you're seeing how he saw it, not how the prevailing winds of the time would like audiences to see it. It's one of the things that makes Al's theatre drawings so valuable—their objectivity as well as their ingenuity. In this *Twelfth Night* drawing, for instance, Al also decided to capture the brilliant details of stage designer Bob Crowley's unusual watery environment. Twenty years from now, theatre historians are going to be much more fascinated and interested in that detail than that Helen Hunt won an Oscar. Al is not swayed by publicity.

Close Proximity to the Artist

In being so close to Al's work, I have more insight into the playwright's intentions, the actor's motivations, and the artist's process. Al really does notice everything on the stage—like that interesting Bob Crowley water. Al is a camera, and always zooms in on the most interesting thing to draw. He has those incredible powers of concentration and approaches his art with the same time-frame as a daily jour-

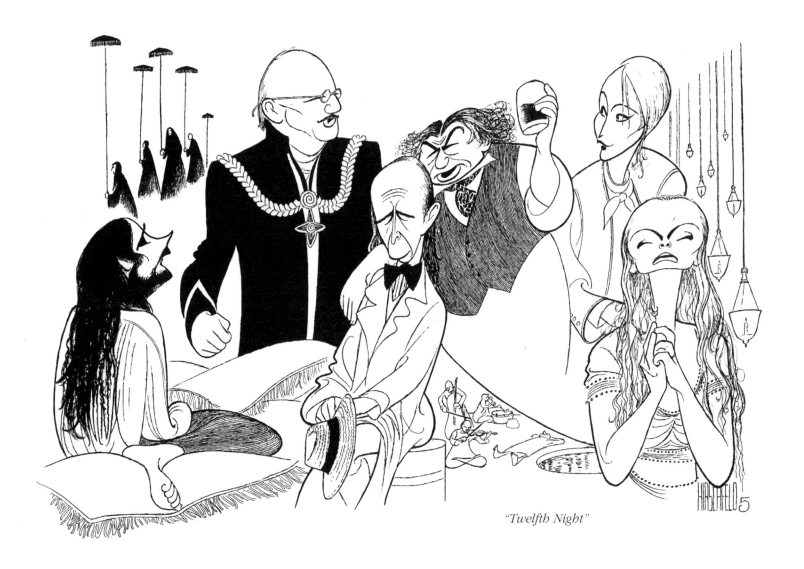

"Twelfth Night"

nalist trying to make the morning edition.

Miraculously, he can receive phone calls, carry on conversations with *The New York Times,* his daughter, or the Margo Feiden Gallery, have afternoon tea, and draw simultaneously. Let's see Woodward and Bernstein do that! Almost every drawing he does has a deadline, a rushed deadline, and Al will not leave his chair until a work is finished, like a captain on the bridge bringing his ship into port. Very often, when an assignment is difficult, he can't fall asleep until the artistic problem is solved, or he *dreams* about various ways of designing his drawing. Now that's what I call a hard worker! Even his subconscious doesn't give him any time off. The next morning, holding onto that dream, he rises at first light and races to his drawing board to jot down all those nocturnal notions. In his youth, he was called "the flash," which still describes not only his working habits, but how quickly he finds a parking space.

Now that I am a resident in Hirschfeld's landscape, certain misconceptions I had about his working methods have been eliminated. I never realized that he first creates a full pencil drawing, complete with every detail, including perspective lines. In fact, the *intent* of the drawing is fully realized in the pencil draft before being refined and simplified with pen and ink. The pencil lines are then erased, leaving the magic of black line.

Reaction of Subjects to Their Portraits

Looking at a Hirschfeld caricature of one's self is so intensely personal. Not only do the subjects want to recognize Themselves, they want to know how Hirschfeld sees them . . . as if he has a special awareness of their interior, and perhaps a secret clue to some area of their personality. Very often, he does. It's also a bit like taking a lie detector test then having the results printed in *The New York Times!* Fortunately, most subjects pass with flying colors— or, rather, flying black-and-white. I remember most vividly Carol Channing remarking that, in a drawing of her in *Hello, Dolly,* Al made her thinner, knowing that she wanted to lose a few pounds.

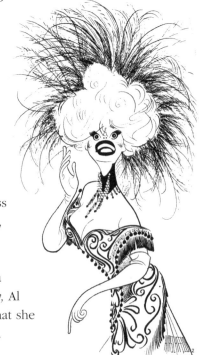

Hirschfeld's Artistic Sustenance

Al draws his artistic sustenance from Life, and absorbs what he sees. It is a constant learning process. During a visit to Florence, I climbed to the steeple of The Duomo while Al, in front of the Palace de Vecchio, under a statue of Michelangelo, was content to sit in the square observing an international array of visitors. Their costumes, gestures, movements . . . all fascinated him. And maybe that statue of Michelangelo was whispering comments in his ear by means of that mystical non-verbal communication great artists share.

Al, of course, is on familiar terms with most of the old masters, having studied them hard and long in his years in a Paris garret. It was there too that he became aware of the "modern movement" in art of the early Twenties. That style has left a lasting impression on him.

Even now, despite his hectic work schedule, Al has his eye open to "high art." Usually, he saves his energy for evening activities and it is up to me, virulent museum-goer that I am, to bring back full reports of current exhibitions around town. However, when we are out of town, and away from the barber's chair, he will accompany me to the museum. Recently, we've visited exhibitions at the Getty Museum, the British Museum, and Musée D'Orsay. I'll never forget the exhilarated expression on Al's face when he came upon Tiepolo's *Paradise* at the Doges Palace. The Early Picasso at the National Gallery and Renoir at the Art Institute of Chicago were also of special interest to him. At the Renoir show, Al studied the hoof of a majestic horse for quite some time. We also regularly attend friends' exhibits. Al feels they're as important as theatre openings—too bad Al can't whip up sketches of them for the morning paper! Arbit Blatas, Paul Jenkins, Jack Levine, David Levine, George Segal,

Ed Sorel, Bill Jacklin, Gloria Vanderbilt, David Rankin, and photographers Arnold Newman, Peter Basch, Roddy MacDowell, and Gordon Parks. Al Hirschfeld is never analytical or critical of fellow artists. He is supportive and enjoys seeing new as well as retrospective works.

Finishing Touches

I've learned one thing peering over that busy shoulder—Al Hirschfeld gives the same attention to every assignment. He is most democratic in that respect and makes no artistic compromises. He also always looks forward to the next challenge in pen and ink. Today, when he summons me up to his studio to peruse his current work, and comment on some aspect of the drawing, I am completely honest. The knowledge that 36 years of admiration for that work is a solid enough foundation for me to say, "Darling, the chin, or that brow . . ."

I gave the following poem to Al on his 92nd birthday. Every word is true and describes him vividly today:

Conclusion at Walden

There was an artist . . . who was disposed to strive for perfection . . . his singleness of purpose and resolution, and his elevated piety endowed him, without his knowledge, with perennial Youth. As he made no compromise with time, Time kept out of his way, and sighed at a distance, because it could not overcome him.

HENRY DAVID THOREAU

My Al Hirschfeld

by Whoopi Goldberg

As a younger person growing up in New York, I had a lot of advantages—access to wonderful museums, planetariums, great movie houses like Radio City, and the theatre. But one of the best advantages of growing up in New York was opening *The New York Times* and seeing a Hirschfeld, and quickly looking to the bottom of it to find out how many NINAs I was going to have to find.

Now, this was not a contest, mind you, where there was some big prize being offered. But it was the closest thing to a treasure hunt—and it wasn't as if it was real easy. You really had to pay attention. Talk about developing skills. I think it's one of the reasons I love Hirschfeld. Because you can't just glance. It isn't a throw-away. It isn't easy. Perhaps it was the original interactive. Sure, no bells and whistles went off—it was the joy of finding that final NINA, tucked in the crook of an arm, or hidden in a curl.

Well, I got a little older—okay, a lot older—and I got to meet Al. I like that I can say that, "Al." The first time I saw him, I think I went into a fantasy world because I didn't know who it was and yet I was grinning like a kid. Perhaps it's because he bears an unusual resemblance to a Mr. Santa Claus. And he was with his late wife, Dolly, who bore an uncanny resemblance to Mrs. Claus. I remember saying to someone, "That man looks just like Santa Claus. Who is that?" They said, "That's Al Hirschfeld." I said, "Get out of here!" They said, "No, really, it's him." Now, being the poised, sophisticated woman that I am, I let out a really loud sound that resembled "Hi," along with a run-on sentence that would have slayed any English teacher who got in its way: "OhmyGodIcan'tbelieveitIloveyourworkIfoundall theNINAsIcan'tbelieveitohmyGodwhatareyou-doinghereIcan't believeit!" Happily, he understood the sound of an over-enthusiastic fan when he heard it. Once I calmed down, we talked.

Well, I didn't think anything else of it because it couldn't get any better. Until one Sunday morning I opened *The New York Times* and—there I was, in the guise of many of my characters. Low and behold, there were NINAs, and plenty of them, 40! This was unprecedented! It's the kind of thing you just want to brag about—so I am.

Al Hirschfeld is one of the most extraordinary people I've ever met. He's able to capture the essence in a few short strokes of the pen. He's unassuming in that you don't know he's there drawing you, seeing you. He's able to see what's in a character and put it right on the page so other people see it too. And this is before the show even opens.

Now, I am kind of older and I have my Hirschfelds and others that he has done of Fats Waller to Louis Armstrong to Frank Langella and there are NINAs that I still haven't been able to find. I always think that the object of a Hirschfeld is to force people to use their powers of observation—to sit at the table with the newspaper open, searching for no other reward but for the sheer joy of finding. There is no better way to spend a Sunday morning with a friend. But, if you get the paper on a Saturday evening, you may find yourself late to the gathering you're going to—looking for those NINAs, honey, looking for those NINAs.

Al Hirschfeld, the Maker of Icons

by Kurt Vonnegut

The front of the human head, approximately oval, and starting from the top, goes like this: hair (except for baldies), eyebrows (almost always), eyes, nose, nostrils, mouth, chin—and then ears sticking out like jug handles on either side (except in the exceptional case of Vincent van Gogh). And, oh sure, sometimes a moustache or beard.

So few features, displayed in such a predictable sequence on a surface the size of a dinner plate, should make our visages as indistinguishable, one from another, as servings of fried eggs and hashbrowns and bacon and toast. And yet, we are in fact so keenly appreciative of and responsive to the most minimal variations in facial topography that we can identify with a certainty an old friend or enemy or lover, maybe from far away and years ago, among hundreds of approaching faces as we hasten on an errand, let us say, down New York City's teeming, polyglot Fifth Avenue.

Yes, and Al Hirschfeld exploits our emotional attunement to human faces as delightfully as Wolfgang Amadeus Mozart did with our alertness to noise. Nor have I hesitated for a heartbeat before putting Hirschfeld and the greatest musician of all time in the same sentence. Both came into this world with artistic gifts rare enough to make them stars in a freak show.

And talk about luck? Mozart lived at a time when there were instrumentalists and singers capable of performing music, no matter how intricate and profound. There were audiences then, most strikingly of aristocrats, sufficiently sophisticated to experience near ecstasy when hearing noises juxtaposed by a genius.. And Al Hirschfeld lives at a time when actors and actresses and dancers and singers are widely regarded simply as themselves as being adorable works of art. Such is Hirschfeld's own genius that he can show us with pen and ink what it is about our icons' faces which triggers our love.

His pictures, aside from their wit and excellent draughtsmanship, might not amount to much more than celebrity worship, if it weren't for this (and God only knows how Hirschfeld makes them do it): they revel in the glorious baloney of theatricality in all its forms, in all places, throughout all time.

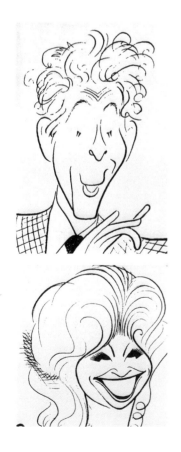
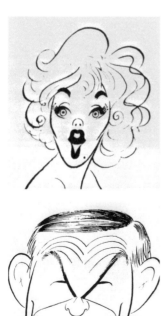
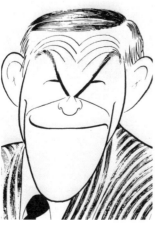
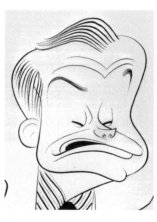
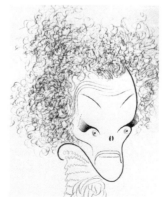
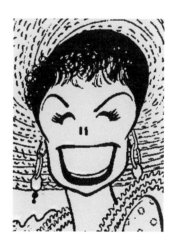
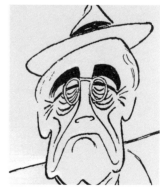

High Style and Hirschfeld

by Grace Mirabella

Describing "clothes by Hirschfeld" is a daunting task. for his drawings reflect the infinite variety of costumes worn by so many actors and actresses, all in the countless shows he's recorded. I can assure you this much—he gives us a remarkable as well as a true impression of the costumes of the actors. In fact, a collection of Hirschfeld's work from 1925 through 1998 gives us arguably the clearest impression of how the people on stage looked. Effects do count.

As costumes must reflect the time, the place, and the people, indeed each person, Hirschfeld with his magic pen and gigantic talent conveys a solid, sound impression of the play and its characters. The expressions of the faces and the seemingly definitive look of the costumes. No, the reader won't see each seam. Hirschfeld is neither designing costumes nor is he doing detailed copies. Remember, he is a master impressionist.

Gertrude Lawrence dances with Yul Brynner in *The King and I*, a swirling long skirt, a décolletage, a tiny waist, a fling of Gertie's leg as she dances. All swirling lines, an impression and a very telling one. Just when you think Hirschfeld has captured the very look of a costume, you're wrong. It's the impression that is so strong, the "sort of" outline is there.

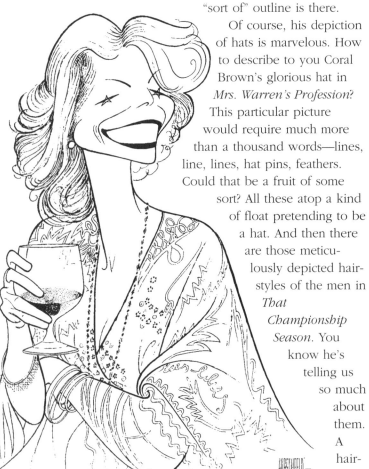

Of course, his depiction of hats is marvelous. How to describe to you Coral Brown's glorious hat in *Mrs. Warren's Profession*? This particular picture would require much more than a thousand words—lines, line, lines, hat pins, feathers. Could that be a fruit of some sort? All these atop a kind of float pretending to be a hat. And then there are those meticulously depicted hairstyles of the men in *That Championship Season*. You know he's telling us so much about them. A haircut

that gives the cut of the man.

One cannot but marvel how Hirschfeld "uses" the performer's clothes to capture the subject's personality. Judy Garland's cocky fedora, firmly placed over one eye, her skintight pants giving her yet extra verve; Carol Channing's gown in *Hello, Dolly* all sequinned and beaded, and Channing's sunburst of a head almost filling the stage; yet another of Gertrude Lawrence's dresses for her role in *The King and I*; Cecil Beaton's costumes in *My Fair Lady*. The style is Hirschfeld, just as the style of Charles Dana Gibson (he of the famous, or infamous, "Gibson girl") was Gibson's, and an era's. Hirschfeld, not surprisingly, admired Gibson, an artist whose drawings are so readily recognizable.

Indeed, by following Hirschfeld's pen we realize that Al Hirschfeld is not an "eye, ear, nose, and throat man." From him we sense the play even though we don't yet go out humming the songs. So far, no specific fashion points but style is Al's game for sure.

Has Hirschfeld influenced fashion? Maybe ever so slightly with the tilt of a hat, the smallness of a waist. Does Broadway influence fashion? Seventh Avenue was loaded with clothes in black-and-white after the opening of *My Fair Lady*. But let's put Hirschfeld in the proper place in his artist's world. It's not costumes but expressions he wants to capture; the clothes, I am the first to admit, are secondary. The costume adds an extra dimension to Hirschfeld's caricatures, to be sure. When the costume "counts," he'll add it and the lines will do more than swirl. Otherwise the "Line King" dispenses his lines with economy. If he were a fashion designer, ruffles would not be his signature.

But wait. Although Al Hirschfeld isn't about fashion, wouldn't you like to see what he would do with the finale of a French haute couture show? Especially now when fashion is really show business.

This theatre buff, this "stage-struck genius" somehow convinces us, always, that gaiety and glamour do exist—this man who spent eight months traveling the world with S. J. Perelman, all the time willing to "trade it all for a pastrami sandwich." How, I ask you, has he moved through the years without falling into the trap of trends, without heeding "the buzz" from the pretenders, without reinventing himself each decade? Brooks Atkinson described Hirschfeld's lines as being ever "nimbler and more mischievous."

In the Nineties, when fashion photography sometimes works hard to make fashion secondary, Hirschfeld's drawings tell us, with lines flowing and communicative, about the guts of the play. The impression is there. Like any great illusionist, he makes you think you're seeing everything. But what he is telling us is that theatre lives! And that personal style does count. Certainly his does.

Al Hirschfeld's Secret

by Arthur Miller

Al Hirschfeld knows the secret of all theater, whatever its stylistic mode, its message or absence of same, its opulence or bareness, its poetic use of language or its pedestrian throttling of it, the theater of aspiration and the theater of the smug and self-satisfied, the bourgeois boulevard theater and the academic cult theater, the theater-for-laughs and the tragic theater, the charismatic illusionist theater and the stark theater of self-revealing method, the romantic and classical — the theater in any of its disguises, bar none, here or in any other country. I have long been convinced that he grew his monstrous big beard in order to conceal his reactions and the better to keep his secret from being surmised.

For he has always known that once his secret is out, once it is taken to heart by producers and directors and playwrights and actors and actresses, as well as scenic designers, his own canvas will be narrowed down, his vast galleries of characters will be thinned to a very few, and his art might finally be extinguished altogether. At any cost, Al Hirschfeld has not allowed even the merest hint of what he knows to become public knowledge.

Thus, he will attack the problem of drawing an actor or actress or playwright involved in a production that he knows perfectly well may not last until his ink has dried, and with precisely the same ardor and attention to the absurdities of other human face as he will bring to the faces of those who have created a great success that will run for years. Never is there a hint, not only of favoritism, but of his judgment upon the work at hand. People in a Hirschfeld drawing all share the one quality of energetic joy in life that they all wish they had in reality. Looking at a Hirschfeld drawing of yourself is the best thing for tired blood. The sheer tactical vibrance of the lines and their magical relationships to each other make you feel that all is not lost, that you still have a way to go before bed, that life can be wonderful, that he has found a wit in your miserable features that may yet lend you a style and a dash you were never aware of in yourself. And he accomplishes these miracles because he serves his secret. In service he makes us all seem like a purposeful, even merry band of vagabonds whose worst features he has redeemed. The homely actress is not made beautiful, the rapacious producer is not made a prince of charity, the half mad director is not given a philosophical insight, the male star exuding vanity is not a caring parent under Hirschfeld's touch — no, each in fact is sunk a little deeper into his horrible traits.

The main gift he has laid upon them is all so simple, so directly born of his secret, that in all these decades nobody has recognized it but me. He makes all these people look interesting. Because they probably are to him. Because his secret is that whatever else it is or is not, whatever it tries to do or eschews.

Theater mustn't bore the people. Everybody, including critics, has forgotten this from time to time, but never Hirschfeld. Something like joy is in every one of his drawings, quite as though he really loved being able to draw a subject who in turn was happy to be a creative person. Obviously, therefore, taken in bulk his drawings are better than the theater mirrored over these many decades, wiser, more celebrative, and far less cynical. At the same time they are drawings that never cease to remind us that theater is all an act and is not real life, that its deaths are not real deaths and its laughter does have to subside into silence, that God in the theater is only an actor, after all, however convincing, and that the devil in private life might even be a nicer fellow. And so if there is a single tone under all his work, perhaps a melody or even a statement, it has something to do with the recognition by this quiet and marvelous artist of the universality of our helpless pretensions, our putting on of personas because in response to others' demands we are helpless not to.

Inevitably, there is something funny about this, something preposterous, in fact, and at the same time something deadly serious. That is Hirschfeld's combination, and it never ceases to surprise and maybe even disturb us.

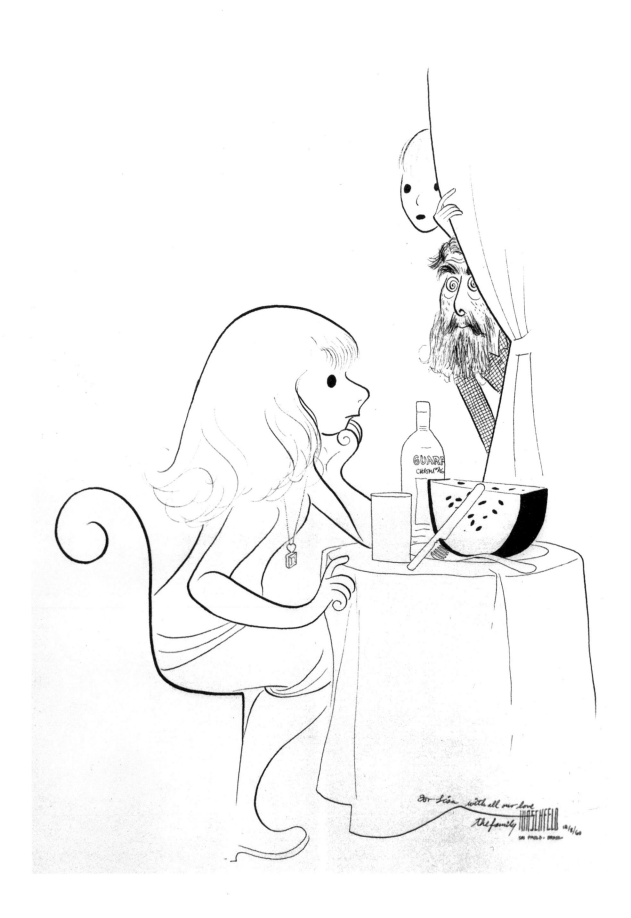

Growing Up in (My Father's) Pictures

by Nina Hirschfeld

The first time I realized my father had put my name into one of his drawings, I must have been eight or nine. I was sitting at the dining room table and my mother pointed out the "NINA." It made me feel special. But my parents always did that. I also remember when my school friends found out about the NINAs. One day a whole bunch of my friends gathered around me to ask me about it. I must admit, what was more important to me at the time was knowing that my father was always home—there to help me with my homework. But I never had any idea, as a child, that *millions* of people knew who "Nina" was. My friends and I had no interest in the theatre then.

I didn't really learn how "big" a name I had in the theatre world until I grew a little and tried to be an actress myself. I attended the American Musical and Dramatic Academy (where Dad still was a big help with my homework), and studied with Lee Strasberg and Herbert Berghof. Frankly, I think I gave up on that dream too quickly, and still wonder what my life would be like if I hadn't gotten married, had children and moved away from New York. In a sense, my way of getting away from being "Nina" was by going to Texas.

My father never encouraged me to take up drawing—largely because he knew full well I had zero interest in it. What I loved was playing the piano, and for many years I wanted to be a pianist. Music and acting drew me! I even studied piano with the famous instructor Nadia Boulanger at Fountainbleu in France. My father, while very successful at his job, led a pretty isolated professional life as an artist, and I was too social for that.

So, actually, is he. I think that's why, after being by himself in his studio all day, he's always loved having friends over in the evening and getting out to the theatre whenever he can.

One of my father's first drawings of me—that is, all of me and not just my name—was when I was seventeen, done for a magazine called *Gentlemen's Quarterly*. I believe the occasion was for my birthday. I do distinctly remember liking the way he made me look. I do not, however, possess any special radar that helps me find the NINAs in my father's drawings any faster. I too have spent many Sundays looking for my name. Then my friends would call me up when they got stumped, expecting me to have the answer. Most of the time I had to disappoint them. My cousin still seems to think I should know a lot more about art because I was surrounded by it all my early life.

My parents gave the best dinner parties in the world. And the older I got the more interesting those occasions got. The most interesting people I've ever met used to come to my house without me ever having to go out looking for entertainment. My mother and father would spend hours getting the table ready, preparing the meals. A lot of the time, my parents and their guests would play the piano and the bongo drums until midnight. Not everybody had bongo drums in their living room.

I didn't go to the theatre as much with my father as I did with my mother. My mother and I went to see Mary Martin in *Peter Pan* at least twenty times. I also vividly recall my first musical, *The Music Man*. One thing I don't remember is ever buying theatre tickets, as my father always got complimentary seats. I still go to

the theatre every time I get the chance. My Lone Star State children are so far removed from my parents and the theatre world that they rarely ask me questions about either. My children will grow up with their own special memories, I suppose, of where they grew up. But the older I get the more I appreciate and cherish the memories of growing up in New York.

Nowadays, I miss my father and Louise and my old friend, Theatre very much. But there are so many people that come to mind. I also miss the whole pace of the city, the shops, the zoo, the Broadway shows, the taxis, the parties, the museums, and even the buses. I hope to live in New York again one day. I love everything about it. The great revelation of my adulthood is that I'm a New Yorker! When you grow up with the city's most fabulous tour guides, my mother and father, how could you be anything else?

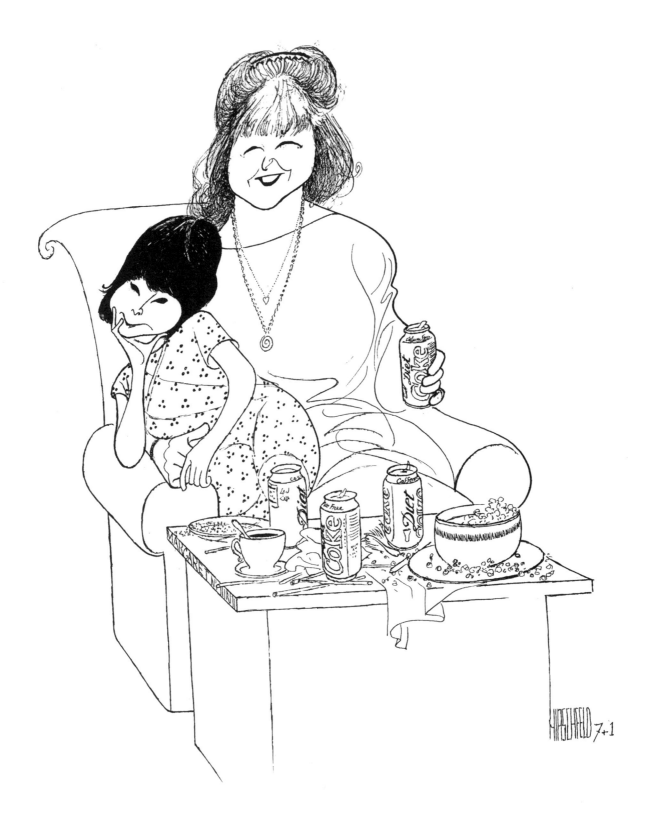

Nina and daughter Margaret

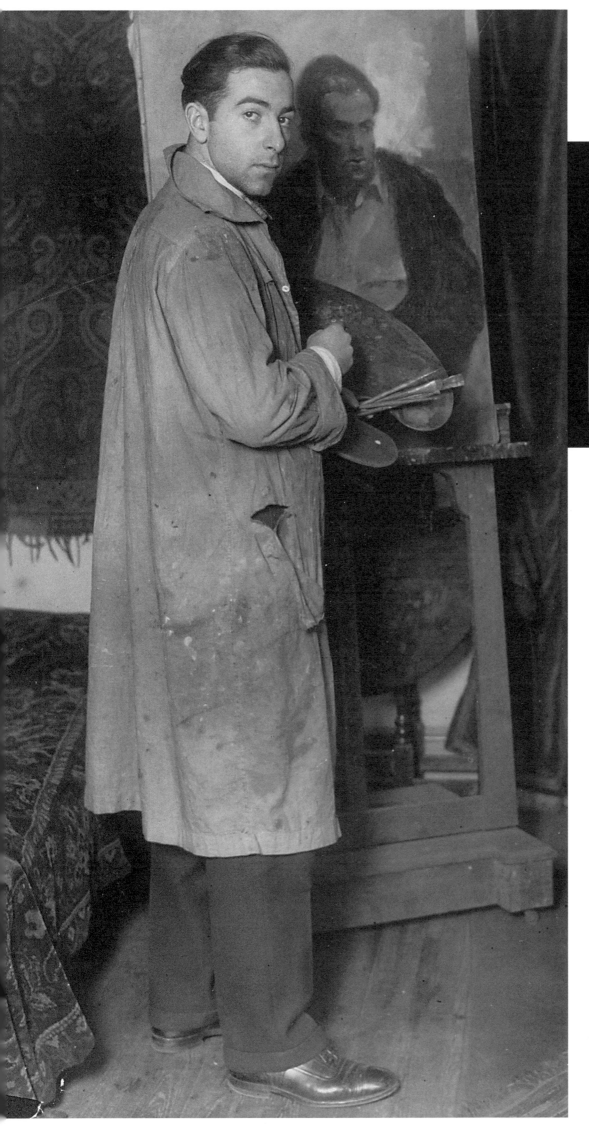

YOUTH
& YOUNG
MANHOOD

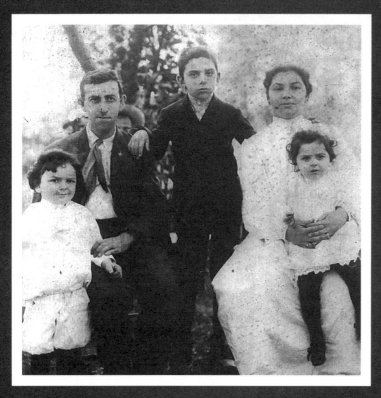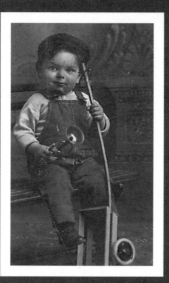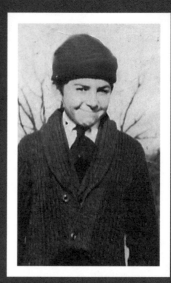

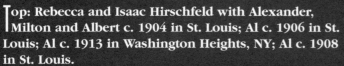

Top: Rebecca and Isaac Hirschfeld with Alexander, Milton and Albert c. 1904 in St. Louis; Al c. 1906 in St. Louis; Al c. 1913 in Washington Heights, NY; Al c. 1908 in St. Louis.

Bottom: Hirschfeld's parents celebrate their 67th wedding anniversary in New York c. 1940; Al with first wife Flo Allen at Coney Island c. 1924.

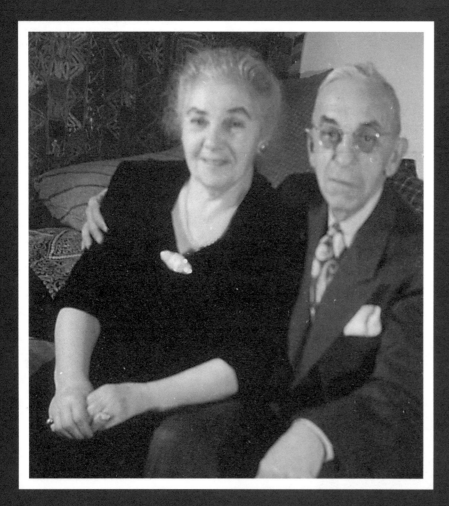

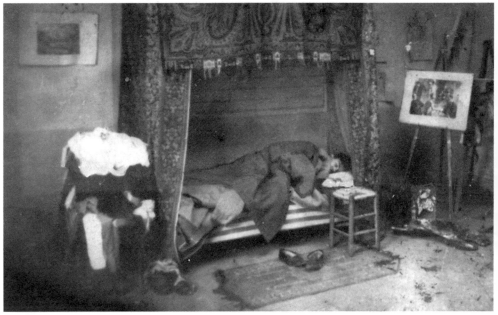

Top: Arrival in Paris; in Paris studio, 1925. Center: art director at MGM c. 1923 in New York. Bottom: With parents and pals L. Sonny Aronberg, front left; Alex King, far right; and Marge Champion, in back with bow; right: back to work c. 1925 in Greenwich Village.

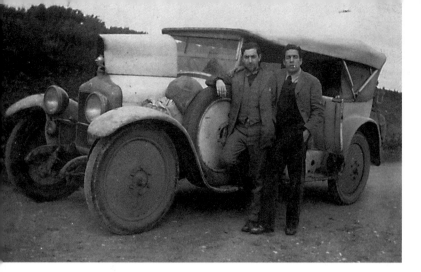

Top: In North Africa with Vic Thall, 1926; visiting museums in Florence, Italy c. 1925.

Bottom: No heat in Paris studio results in flannel shirts and a beard c. 1926; haircut in Bali c. 1932.

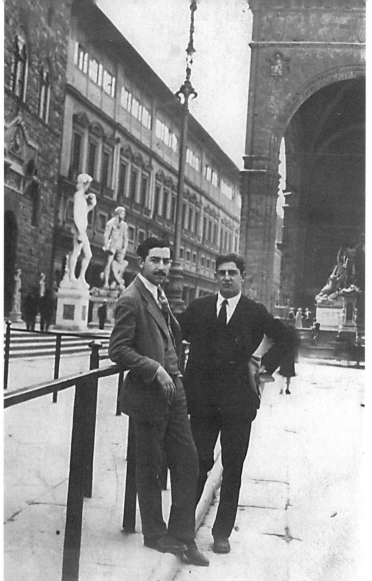

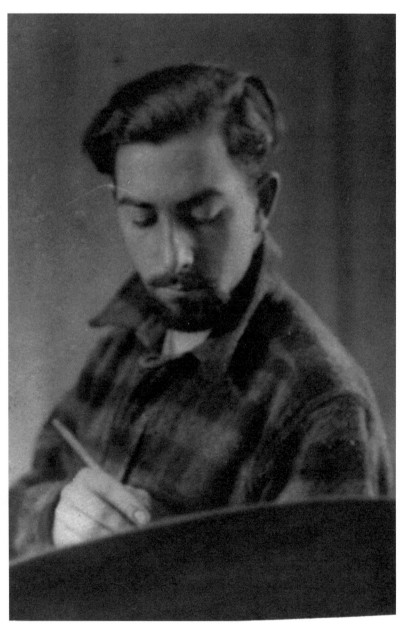

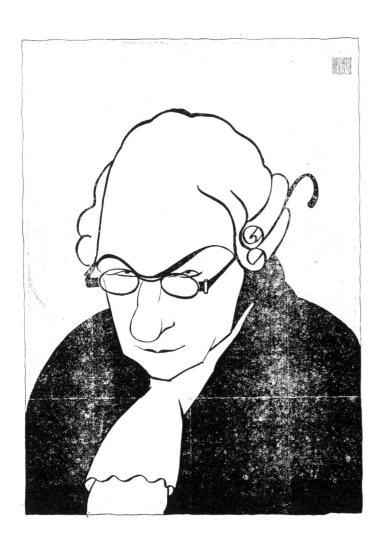

Sacha Guitry, 1926

On December 26, 1926, with this little drawing of Sacha Guitry, I began my New York theatre career. Guitry was a big French star of the time, and was co-starring, I remember, with Yvonne Printemps. I'd gone to the theatre with Dick Maney, the press agent, and just scribbled a drawing of Guitry on the *Playbill*. Dick looked it over and thought it rather good. He said if I'd put it on a clean piece of paper he'd take it along and see if he could place it in a newspaper. So I did. I put it onto a decent sheet of paper. The following Sunday it appeared in *The New York Herald Tribune*. Encouraged by Arthur Folwell, George Goldsmith, and Mark Goodrich, who comprised the editorial staff of the *Herald Tribune* drama department, I made a weekly contribution to the Sunday edition of that paper for the next twenty years. I see I was already signing my name with those condensed, elongated letters, but I can't remember when I started that.

Harry Lauder, 1927

This one of Harry Lauder is the first drawing I did for *The New York Times*. I received a telegram one day from Sam Zolotow who was, he claimed, in the Drama Department at the *Times*. He asked me if I would do a drawing of Harry for them. Lauder was a Scotch comic who at that time was in one of his interminable farewell-performance runs. Somewhat like those stores that are forever going out of business. So I did the drawing and took it down to the *Times*, leaving it with the doorman. A couple of weeks later I received another telegram—this obviously was in the days when the telegram was a going concern. It was again from the *Times*, asking me to do another drawing for them. This went on—telegram, drawing—for a couple of years. I never met or saw anybody at the *Times*, other than, of course, that doorman. And then one evening—quite by accident again—in the Belasco lobby during an intermission, I was at long last introduced to Sam Zolotow. He told me I should drop down to the paper and meet the fellows in the drama department. The following day I did drop down, and I met George S. Kaufman, the drama editor, and Brooks Atkinson, the drama critic. Brooks and I became friends for a lifetime. George eventually got out of the newspaper business and made a name for himself.

Bill Robinson, 1928

The original Mr. Bojangles. I've drawn him here doing his famous tap dance on the steps in *Blackbirds of 1928*. (Hollywood preserved him doing a version of it with Shirley Temple.) It seems a familiar routine now, him tapping up and down the steps, but it was stunning at the time. He's the one who made it a classic. *Blackbirds* was a musical revue, with such songs as "I Want to Be Happy, Too." And the "black" in blackbirds was a direct reference to the African-American performers, back in those pre-Civil Rights days. It would be difficult to overstate, though, the charm Robinson exuded on stage.

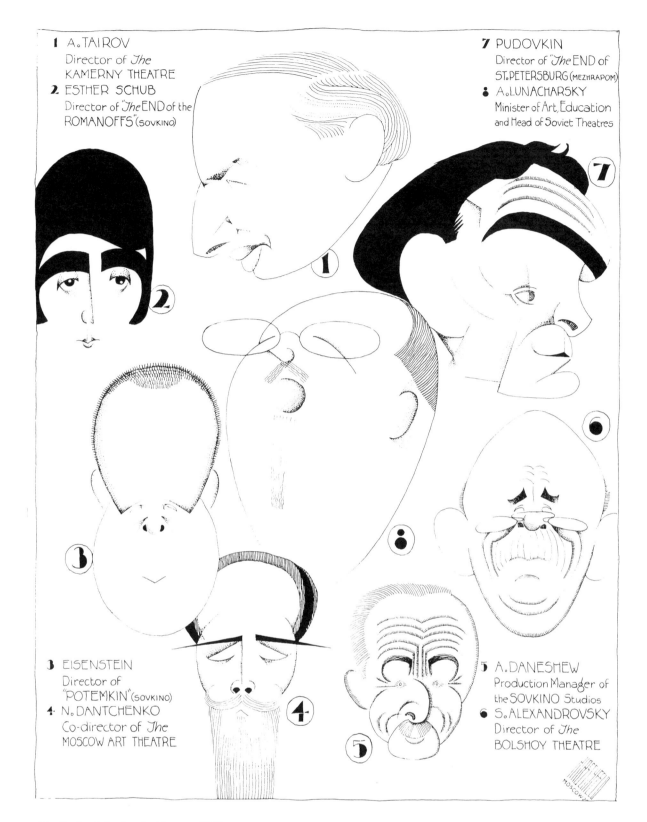

1 A. TAIROV
Director of *The*
KAMERNY THEATRE

2 ESTHER SCHUB
Director of *The* END of the
ROMANOFFS (SOVKINO)

3 EISENSTEIN
Director of
"POTEMKIN" (SOVKINO)

4 N. DANTCHENKO
Co-director of *The*
MOSCOW ART THEATRE

5 A. DANESHEW
Production Manager of
the SOVKINO Studios

6 S. ALEXANDROVSKY
Director of *The*
BOLSHOY THEATRE

7 PUDOVKIN
Director of "*The* END of
ST. PETERSBURG (MEZHRAPOM)

8 A. LUNACHARSKY
Minister of Art, Education
and Head of Soviet Theatres

The Heads of the Russian Theatre, 1927

I went over to Russia for a year on assignment for the *Tribune*. They were having a revolution in everything over there during this time, the stage and cinema notwithstanding. Stanislavski, of course, was still the biggest name in the theatre, and Sergei Eisenstein was making as big a noise in silent films. I had hoped to publish a book of my drawings and observations, but the manuscript, including the illustrations, was lost by the publisher, Boni of Boni and Liveright. In fact, no fragment of either text or drawings has ever appeared. This drawing, "The Heads of the Russian Theatre," is a pun on "heads," of course—heads only of the head figures. Later on I persuaded Brooks Atkinson in 1936 to come with me to the Soviet Union specifically to cover the theatre at that time. We both were disenchanted.

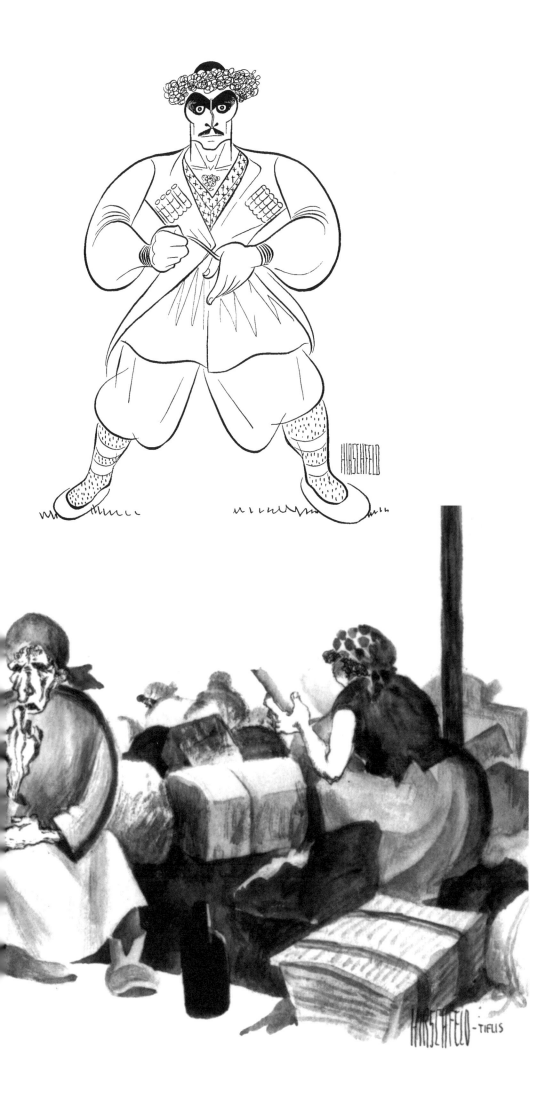

The Russian People, 1927

I suppose these drawings may be of some historical significance now. They show the Russian people in the first decade of Communism. Today, a decade after the end of the regime, the Russians seem dedicated to becoming regular money-mad capitalists. Back then, though times were equally tough and the economy in trouble, they were still dedicated to Communism, and to vodka.

The reason for the sparse collection of drawings from this early period is that these are the only ones I could reasonably lay my hands on. Moral for younger artists: Keep a filing cabinet handy. For the first thirty years of my illustrious illustrative career, my drawings appeared in the drama sections of *The New York Times,* the *Herald Tribune,* the *Brooklyn Eagle,* and the *World*. I produced thousands of drawings, which became scattered in living rooms, museums, and men's rooms across the country. Had I known, in 1920, that one day there would be concerted pressure from my family and friends to publish a book in order to pay a few bills I, of course, would have meticulously filed each original drawing under the day, month, and year of its inception. But, alas, such was not the case. The truth is that I distributed my drawings around as promiscuously as Dr. Wharton signs (forty years ago Dr. Wharton signs were very promiscuous, trust me).

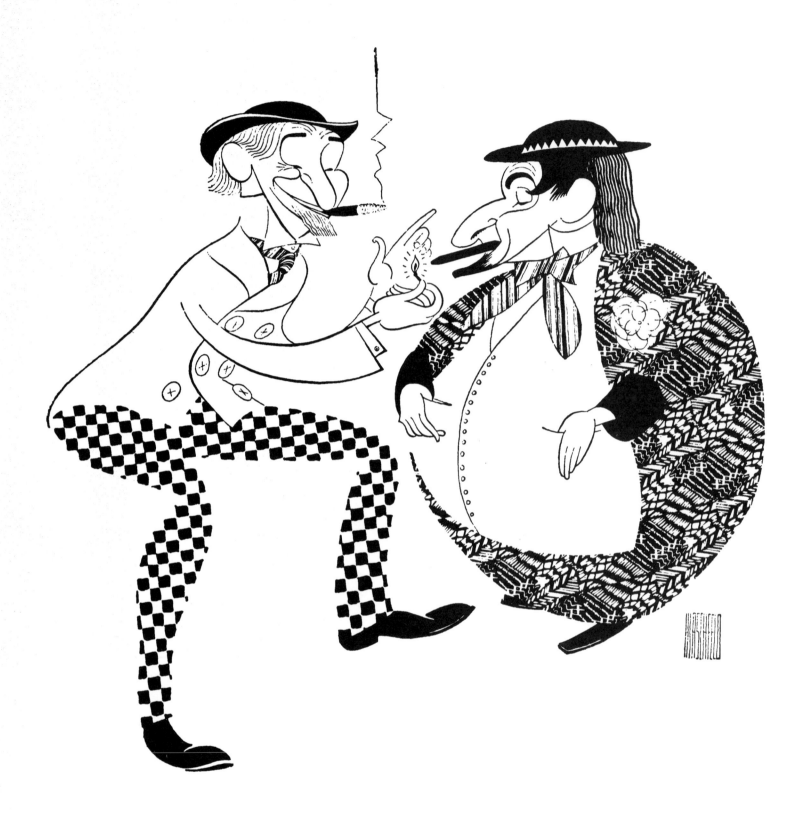

Joe Webber and Lew Fields

Webber and Fields were German burlesque comics who were popular over here during the late Twenties. It was a more inno-cent period, when Germany and comedy didn't sound like an odd combination. The team was already legendary when I came into the theatre. The bizarre costumes they're wearing here in their show *The Lambs' Gambol*, by the way, are not much of an exaggeration. To approximate them, I used pieces of wallpaper I'd found here and there and pasted them directly onto the drawing. Their respective weights are fairly well represented in the drawing, too. One was skinny and the other as round as a barrel. I guess you could say they were the Laurel and Hardy of German comics.

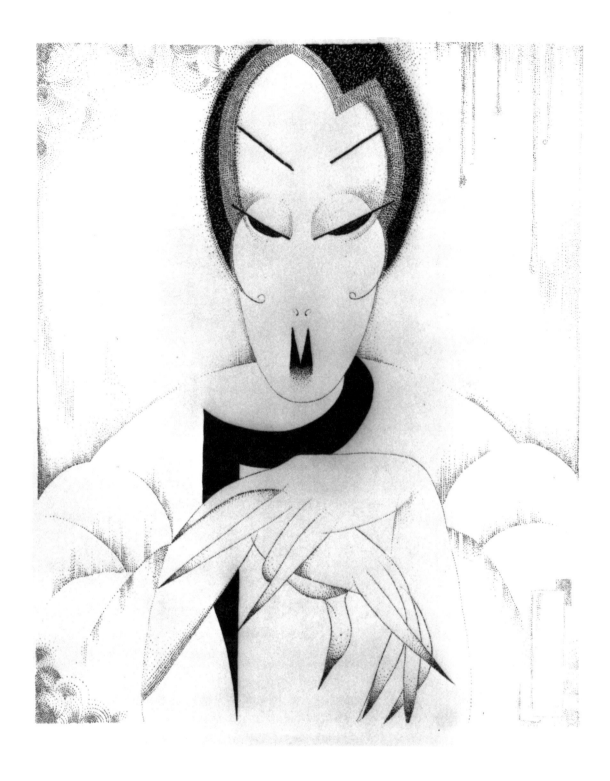

Florence Reed, 1926

(as Mother Goddam in *Shanghai Gesture*)

Florence Reed looking dangerous in a less than sunny role. There is something interesting in the technique of this drawing, a flirtation with pointillism. It's different from the style of pure line I developed later on for newsprint. At the time I was experimenting with various techniques—I was obliged to, in fact, because the newspapers were being printed on something that can only be described as toilet paper. Very difficult to get a good, sharp image. All an artist could do then was to experiment and then see if the publisher accepted or refused it. The most daring technique I recall trying was lithographic crayon and dry brush.

Basil Rathbone, 1928

(right, in *The Command to Love;*
below, as Sherlock Holmes [1989])

Here again you can see the development of the line.
I was treading carefully back then, trying to find out
what I was doing and experimenting with the look
of my line. Nowadays I would do it differently, as
you can see below in a drawing from 1989, but it
pretty much captures the personality of Basil at that
time. He is equally well remembered, now, for play-
ing Sherlock Holmes and villains. Many other dash-
ing English leading men of the time had to be one
or the other in Hollywood to survive. At least Basil
got to be both.

Whenever I am asked, "What is a caricature?" I
am reduced to blubbering reasonable nonsense. So I
don't refer to my drawings as caricatures. The fun of
recognition on the part of the public is very impor-
tant in its way, but the drawing itself has to commu-
nicate something about the personality that exists in
that human being. To capture personality in graphic
terms is the problem I try to solve in every drawing,
and every drawing dictates its own solutions. I have
spent all these years trying to find out what it is that
makes individuals look the way they do in order to
communicate it to someone else. Some kind of
alchemy takes place, but I am unable to explain it. I
know, without question, when I have distilled a like-
ness in my drawing, but I still do not know how, or
why, the likeness got there.

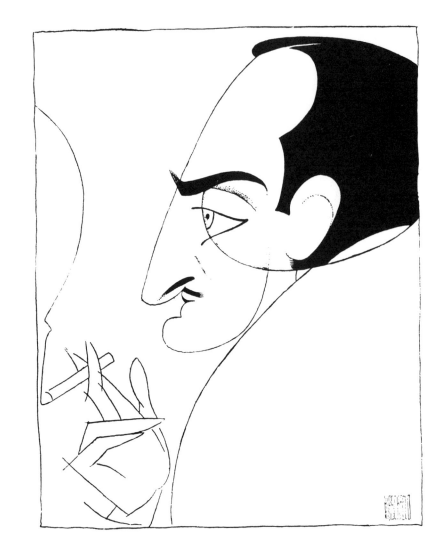

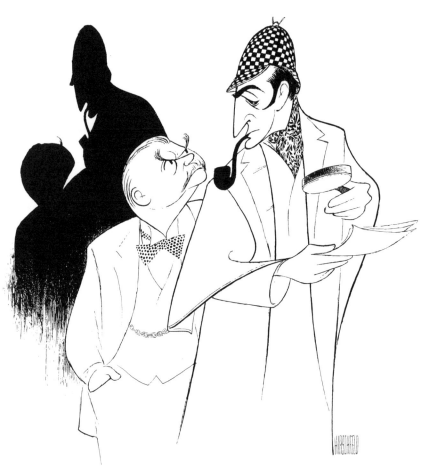

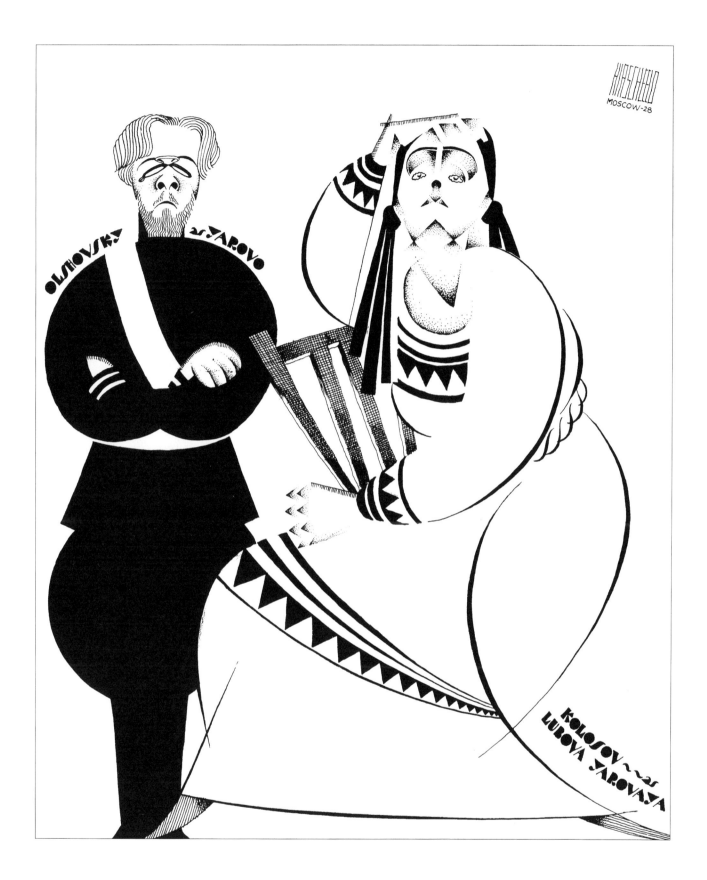

The Molly Theatre in Moscow, 1928

Here is yet another experiment in line from the Twenties—both my own and history's. What makes it a little different from even the other drawings of this time was the Russian influence. The graphics in the Soviet Union of the era had a tremendous influence on me. Within my limitations, I pushed that Russian-ness a little bit to achieve this development. There was little or no artistic repression in Moscow at this time and it was an international scene. The Molly Theatre was still playing *The Inspector General*. In fact, it played before, during, and after the Russian Revolution. Of course, it's such a Russian classic that it's still playing today.

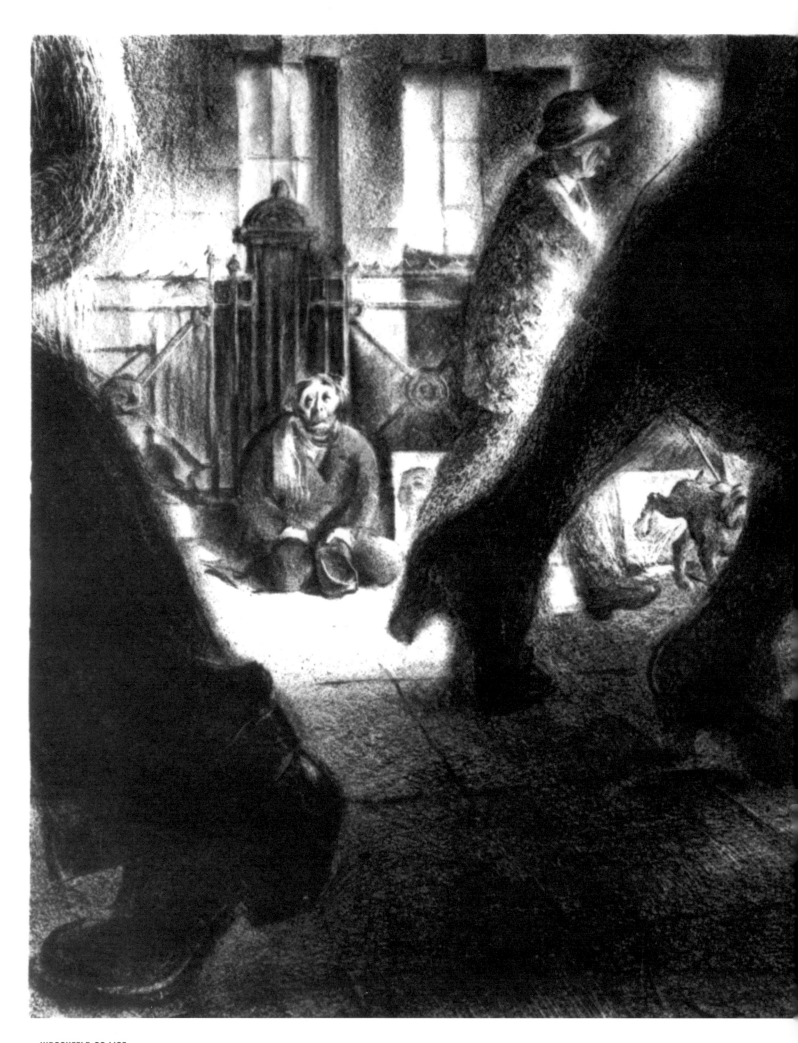

Art and Industry, 1931

A social protest lithograph of an artist and his dog on the sidewalk outside the British Museum. It was not drawn for publication in a book or newspaper, but rather as part of a series of signed and numbered lithographs.

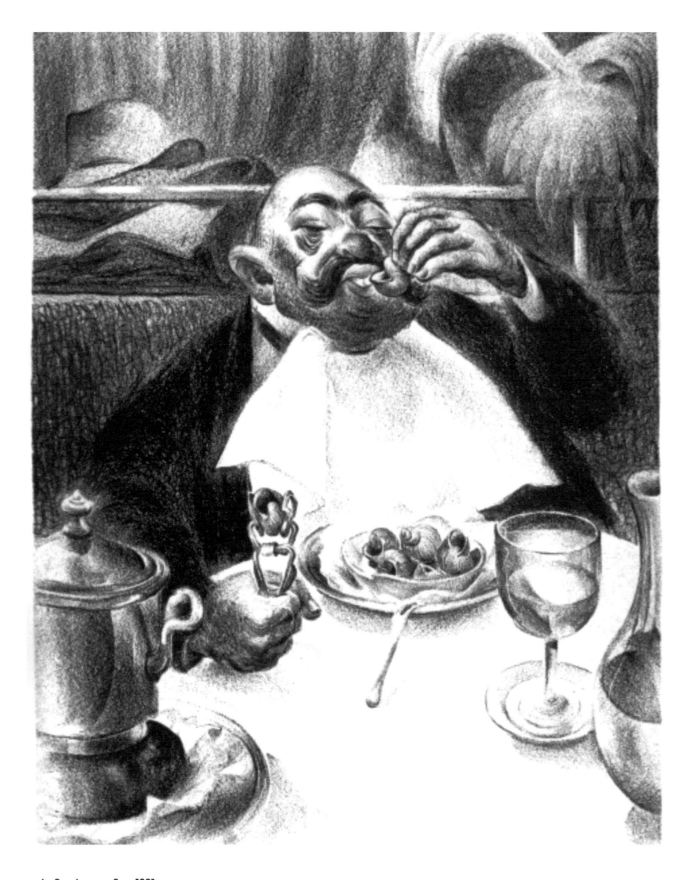

La Serviette au Cou, 1931

Here's a drawing of a snail-eating gourmand. This is a lithograph, drawn on stone, during an early stay in Paris. I lived and painted in Paris during most of the Twenties, occasionally returning to New York to "look around" and add to my collection of contemporary money. In Paris, I shared a bungalow in the Rue Vavin with two other artists. We took it on an eight-year lease for 2,500 francs a year, which at the time worked out to about $33 apiece. (Coffee was one cent!) That's also when I grew a beard; there was no way to shave—our tap was always frozen. By the time I left France, for Bali by way of Tahiti, I'd lost my early infatuations with painting, with sculpture, even with so-called fine arts. My real satisfaction had become the image of pure line.

INFLATION POLITICO-EROTICA

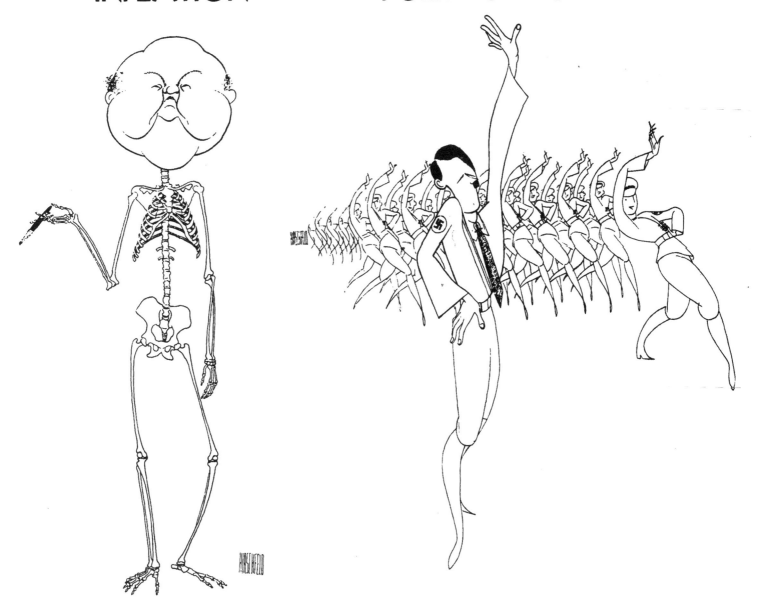

Inflation, 1932, and Politico-Erotica, 1933

Americana, the satirical magazine I did these two drawings for, was co-published at this time by Alexander King and myself. We were the first to publish posed satirical photographs made to imitate documentaries. For instance: A pregnant woman looking at a stork in the Bronx Zoo, or an Afro-American shining shoes at the base of Lincoln's statue to celebrate the national holiday. The magazine was eventually taken over by the old *Vanity Fair,* and then both publications went into bankruptcy. "Inflation" was a general political comment on the times, showing a bloated plutocrat. "Politico-Erotica" is an early attack on Hitler, obviously.

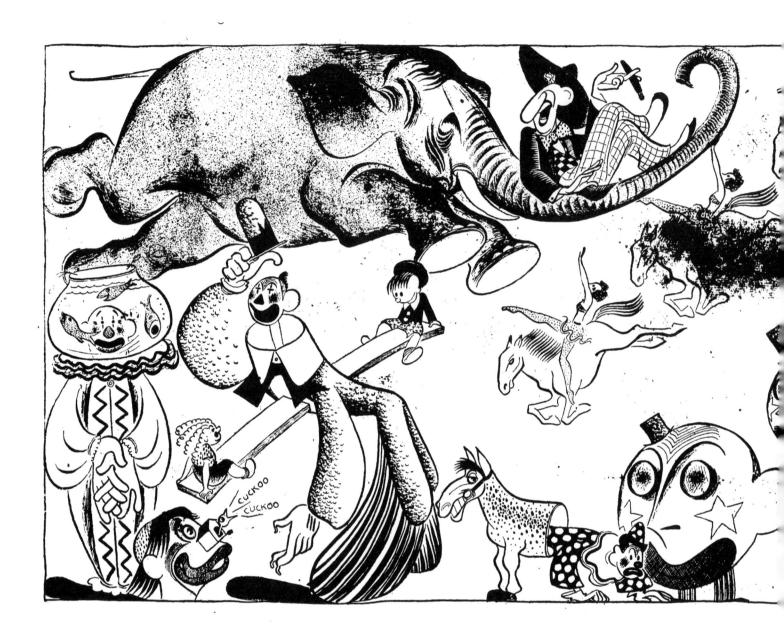

Jumbo, 1935

Jumbo is another Rodgers and Hart show, a genuinely elephantine production starring Jimmy Durante (here borne on a trunk), and produced by Billy Rose. Billy and I were very close. He may be best known now from *Funny Lady,* in which he was played by James Caan, and which covered his marriage to Ziegfeld star Fanny Bryce. But back then I used to go to the *Jumbo* rehearsals, and they were marvelous. You'd suddenly see two fellows on stage. One two-feet tall, and the other a towering nine feet. Billy always brought my attention to things like that. He had a great eye for the theatrical. I remember I once brought along my friend and co-publisher Alex King. He thought he had the greatest idea for the production. He suggested to Billy that they have a lion and a lamb lie down together. Billy looks at him and says, "No kidding? Have you got the lion and the lamb?" On the extreme right is Paul Whiteman, who along with his orchestra provided the music. He's the guy who coaxed George Gershwin into writing "Rhapsody in Blue."

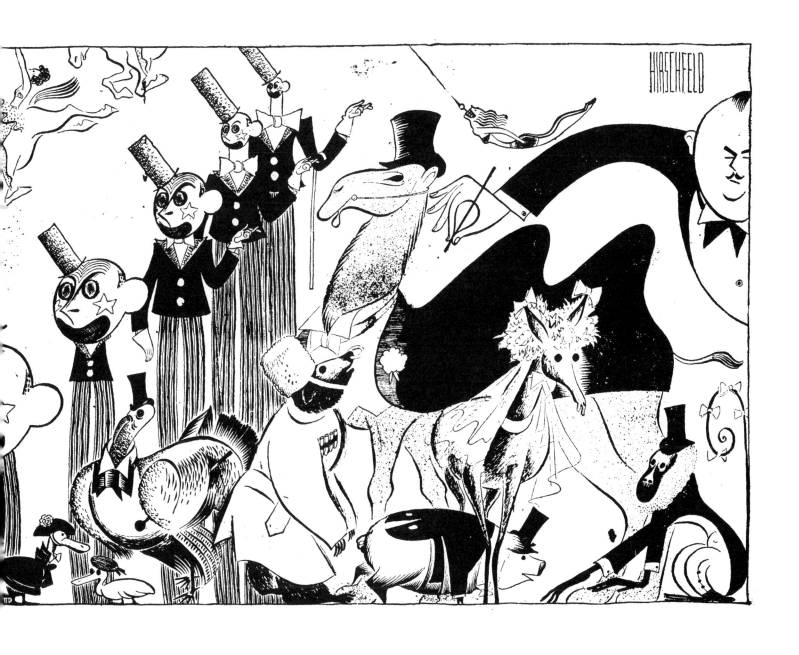

Albert Carroll and Mei Lan Fang, 1930

(in *Garrick Gaieties*)

Garrick Gaieties was the first of the Rodgers and Hart musicals. It played down in Greenwich Village and starred Albert Carroll, a female impersonator. Impersonators were then extremely popular, many of them achieving real fame. One of the greatest, Julian Eltinge, had a theatre named after him—The Eltinge Theatre. Albert Carroll was equally famous when I did this drawing of him, except that here he's playing it straight (and looking like King George, or Tsar Nicholas II, take your pick). Mei Lan Fang is the one in the dress. Obviously there appears to be some sort of rapprochement between the Union Jack of Britain and the Rising Sun of Japan, which doesn't at all sound like a show called *Garrick Gaieties*. Not that it much mattered then. Once the Depression took hold, of course, this sort of skylarking died down.

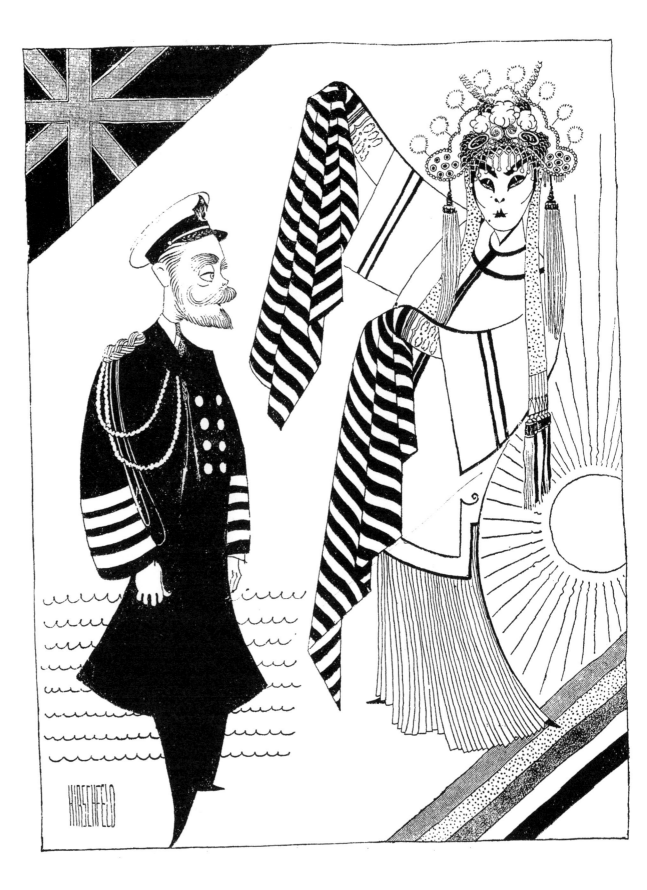

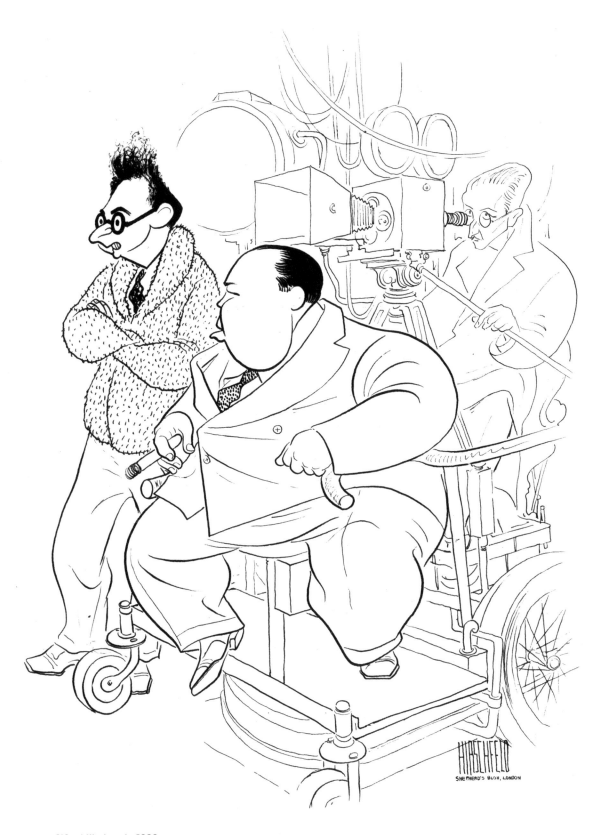

Alfred Hitchcock, 1936

(on London set of *Sabotage*)

I was in England at this time and happened to go up to Shepherd's Bush, the film studio outside of London. Hitchcock was there making *Sabotage,* which was retitled *The Woman Alone* when it got to the States. I was very impressed with what he was doing and made this drawing. Later, of course, I got to know Hitchcock much better. My late wife, Dolly Haas, had a part in his film *I Confess,* and through that connection we became friends. Whenever Hitchcock would come to New York he'd visit with us. The other fellow in the drawing is Hitchcock's partner at that time, Ivor Montague. You'll notice the anonymous cameraman is looking at you (or me) as though glancing at a person taking his photograph, a filmic touch I couldn't resist.

Orson Welles and Paula Laurence, 1937

(in *Dr. Faustus*)

I was trying to represent two different things here. On the right is a show called *Power,* on the left is *Dr. Faustus.* Paula Laurence is the woman in the middle looking sharply pointy herself as Welles tries to press his point. Faustus was one of those roles, like Falstaff, that Orson was born to play. The somber fellow in the chair is Norman Lloyd. *Power* was produced by the Living Newspaper Unit of the Federal Theatre Project—a name that has Depression Thirties written all over it. Candle power on the left gives way to steam power on the right. The two shows really have nothing in common, but I decided I might as well mesh them together thematically since I was putting them both in the paper that week. The choice of what to cover is a judgment call, based usually on the track record of the people involved in each show—playwright, actors, producers, set designers, etc. The *Times* editors and I had a good working relationship in setting the agenda for the week.

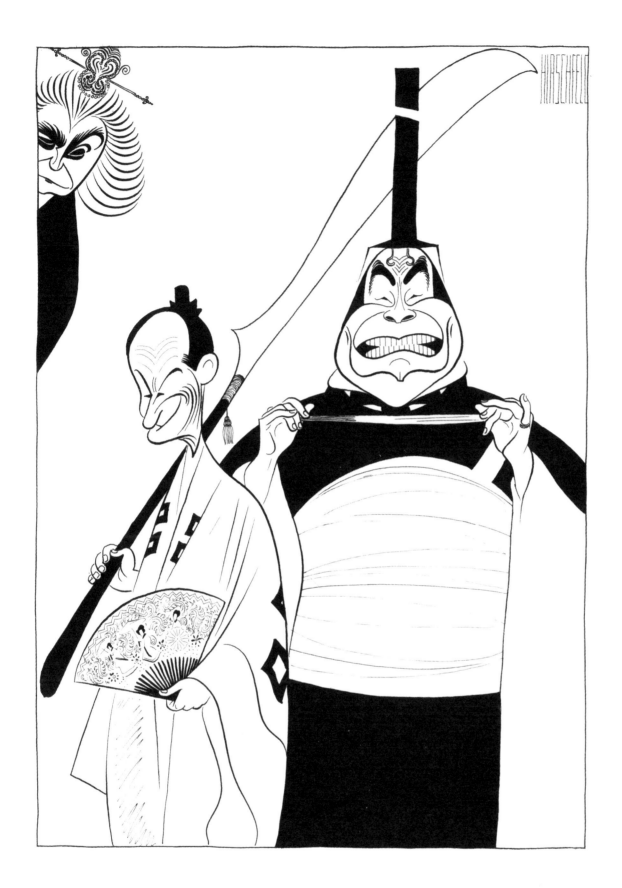

The Mikado, 1936

The subject of *The Mikado,* produced by the D'Oyly Carte Repertory, allowed me to indulge my Oriental influences, from my travels in Bali and elsewhere in the East, as well as the effect that Japanese graphic artists have had on me: black and white composition, a deliberately two-dimensional flat look. Left to right, the actors are Vera Ross, Frank Moulan, and William Danforth. That corset does seem to be giving Mr. Danforth some difficulty. I was not consciously studying other artistic styles at this time, but reacting to what I was seeing around me. One of the limitations of drawing in the theatre as well as for it, however, is darkness. The only way I overcame this handicap was to learn to draw in the dark. I practiced with a pencil stub, sitting in the dark, using a small notepad and sometimes a flashlight. I eventually learned to draw in my pocket. My system is a kind of shorthand I alone can decipher. Written words and hieroglyphic signs help me defeat the darkness. Since then my routine hasn't changed. Seated out front on the aisle with a vacant seat next to me, I start sketching at the rise of the curtain. Later, back in my studio, I correlate words and pictures into a designed composition for the finished drawing.

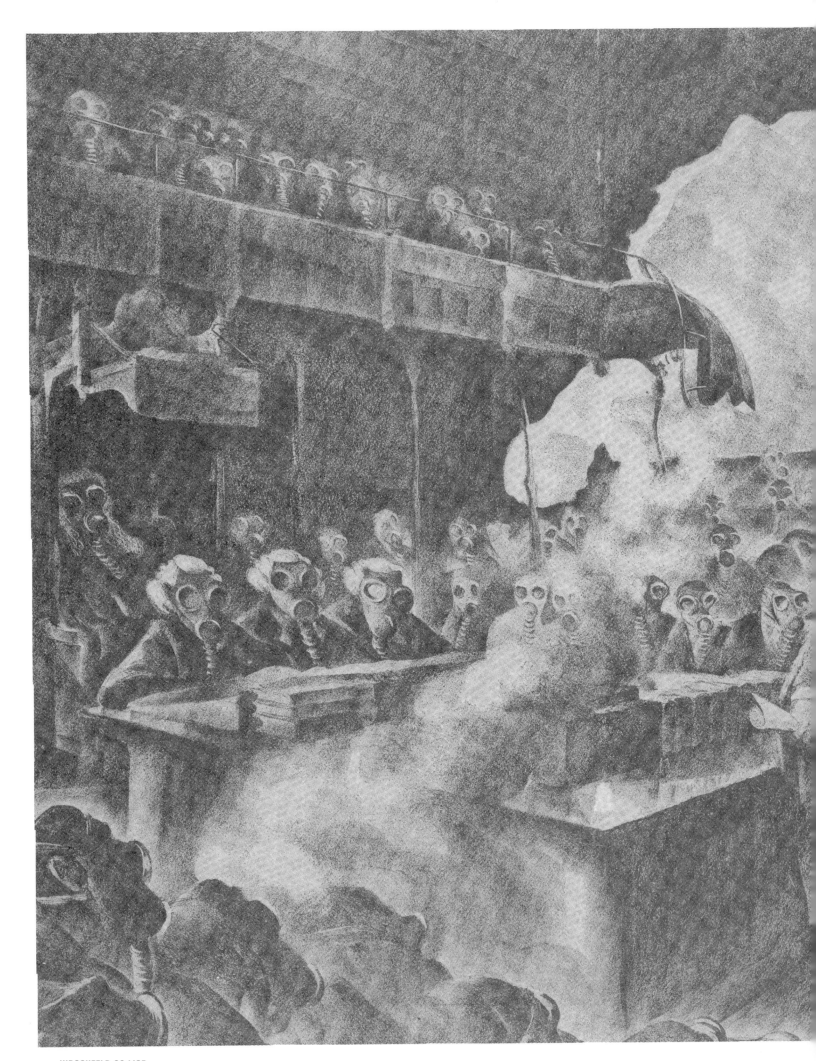

Peace in Our Time (Neville Chamberlain), 1939

I made this lithograph, of Parliament undergoing a gas attack and all the members wearing gas masks, as another political commentary, but didn't do anything with it. I thought it was a very powerful image, but I knew better than to try to market it. Then one day I picked up the paper and read that Parliament had been bombed. Suddenly my political drawing was actual news. So I ran it down to the *Times* thinking it had some current events value and the editor said, "No, it's a Communist drawing—because it's a lithograph."

The Communist Party never made many inroads into America, but the one thing they did take over, apparently, was lithography. Which was just my luck, since I've always liked making lithographs. The editor suggested I take it to the *New Masses*. I did and they used it as a double spread. And that's how I got hooked up with that publication. After the drawing's publication, a Mr. Markel, the editor of the *Times* Sunday edition, told me, "You see? It *is* a Communist drawing!" Sometime later, the British used this lithograph on the cover of a benefit at Radio City for British–Soviet Front United. I rushed to confront Markel with this accolade of the British Empire. His comment: "England's going Communist!"

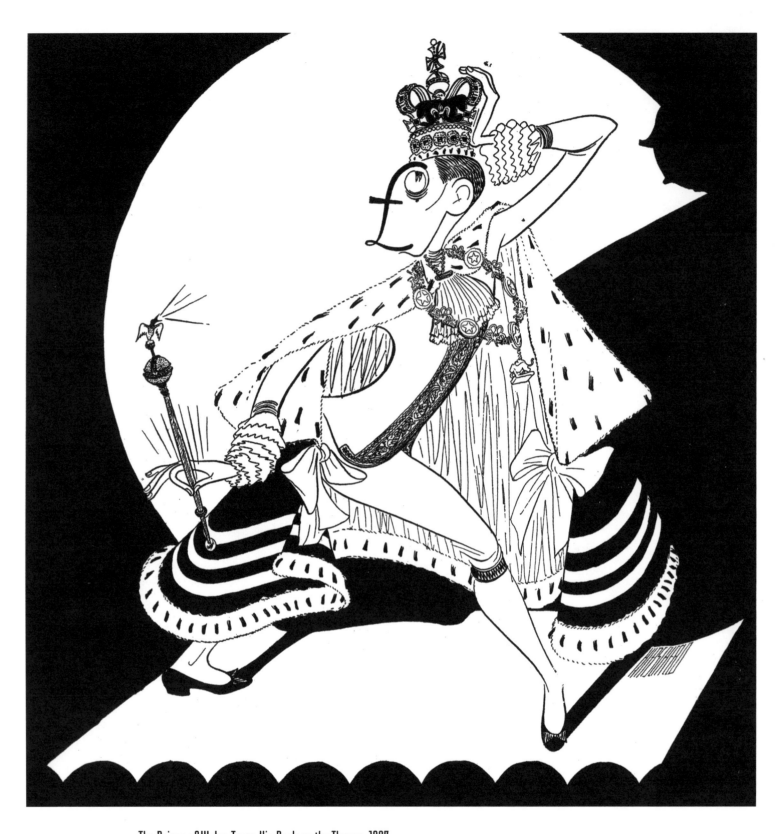

The Prince of Wales Turns His Back on the Throne, 1937

This was a cover I did for the *New Masses,* which at this time was an outlet for my political drawings or anything too hot to be handled by the mainstream New York papers. I was fairly far Left back then. The idea I had here was nothing too shocking, as the Prince of Wales turned himself into the Duke of Windsor under an intense spotlight on a grand world stage. The most obvious touch is that the English pound character "£" lent itself to his highness's likeness. Also, the bird atop the scepter is uttering its own protest. I never had it in me to be a real go-for-the-throat political cartoonist, but I did care passionately about politics.

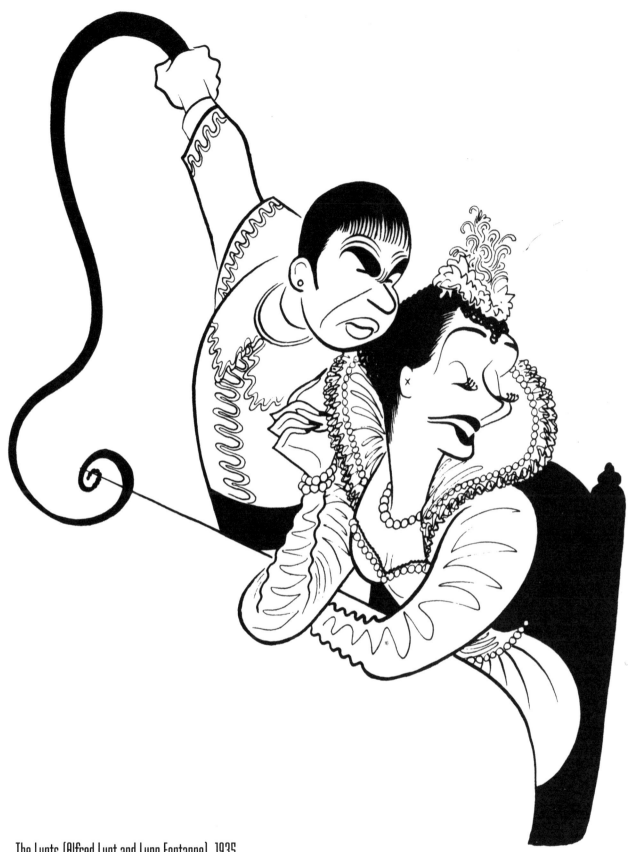

The Lunts (Alfred Lunt and Lynn Fontanne), 1935

(in *The Taming of the Shrew*)

The Lunts, like some mythical creatures, are now legendary for being legendary. Yes, they really were the reigning couple of Broadway, along with Katherine Cornell and Helen Hayes in the superstar category. They got their start in the original Theater Guild company. To me, though, what's most interesting here is that she has a very long, beautiful neck. Along with the other great stage actors of their era, the Lunts trained to project voice and image. On a screen, the camera does this automatically for the actor. An eye blinking on a movie screen measuring twenty feet in diameter requires a completely different acting performance than communicating a wink from stage to the second balcony. The Lunts were masters of this art.

HISTORY OF THE AMERICAN COMMUNIST PARTY

History of the American Communist Party, 1939

I spent quite a lot of time on this drawing for *Life* magazine, largely because the research was endless. It's a history of our very own red-white-and-blue Communist Party, up to that time, starting in the upper left hand corner with the Palmer investigation of 1919. The party went underground in 1920, then came out as the People's Party. Trotsky tried to derail it in 1921. It runs around until the train gets a shiny new 20th-century top over its aging locomotive. It continues chugging along until Hitler and Stalin, represented by the two opposing trains, shake hands. All the passengers are thrown overboard and end up in the little stream. Or up a creek. The final act is the whole contraption transforming into a kind of roller coaster being run by the two ladies who financed *The Daily Worker* newspaper. It makes me wonder now if *The Daily Worker* would have taken any of my drawings. Chances are they didn't pay as well as *Life*.

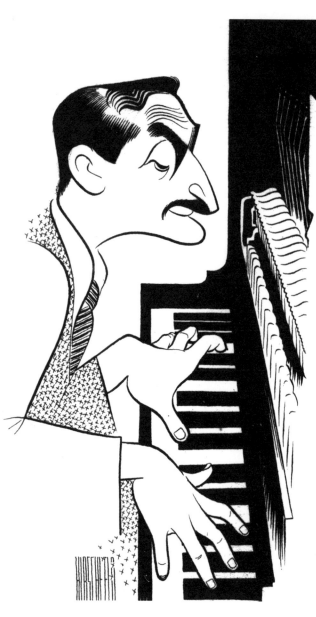

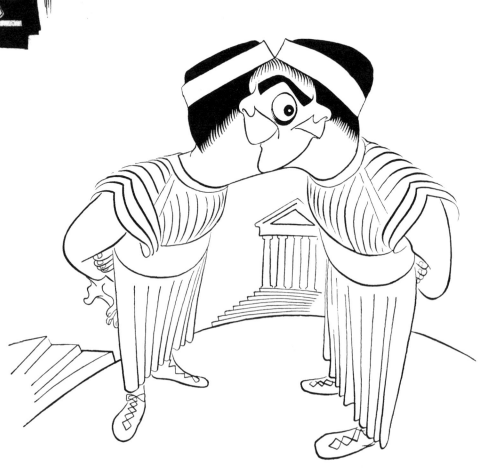

Marc Blitzstein, 1937

(*The Cradle Will Rock*)

Marc Blitzstein had composed an opera called *The Cradle Will Rock* for the WPA, directed by Orson Welles. However, for political reasons, the Federal government padlocked the theatre on opening night. The assembled first-nighters, myself included, were entertained in front of the darkened theatre by Marc Blitzstein (pictured) playing at a mini piano on an improvised open truck, while Orson scurried around town in a frantic search for another available theatre. Eventually he found one. And it proved a memorable night in the theatre.

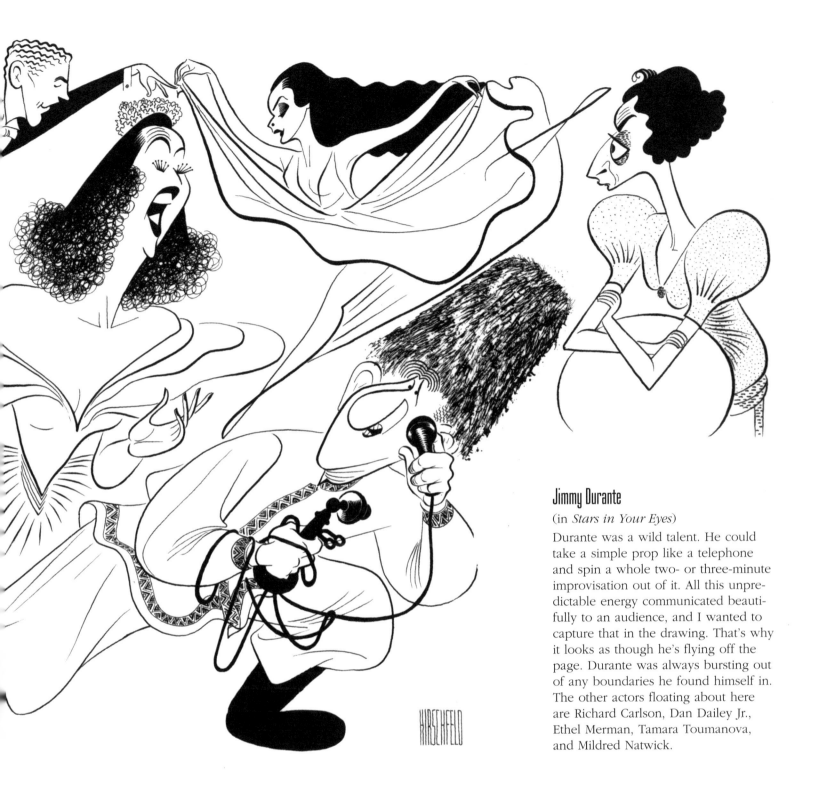

Jimmy Durante

(in *Stars in Your Eyes*)

Durante was a wild talent. He could take a simple prop like a telephone and spin a whole two- or three-minute improvisation out of it. All this unpredictable energy communicated beautifully to an audience, and I wanted to capture that in the drawing. That's why it looks as though he's flying off the page. Durante was always bursting out of any boundaries he found himself in. The other actors floating about here are Richard Carlson, Dan Dailey Jr., Ethel Merman, Tamara Toumanova, and Mildred Natwick.

◄ The Boys from Syracuse, 1938

(Teddy Hart and Jimmy Savo)

I indulged in a little visual trickery in this drawing, combining the two heads. If you press your hand over the right one, you see Teddy Hart. If you press your hand over the left one, you see Jimmy Savo. The story of this Rodgers and Hart musical, based on Shakespeare's *A Comedy of Errors,* involved mistaken identity, as the heads graphically describe. A case of one head literally being better than two.

Waiting for Lefty, 1936 (drawing, 1973)

(Clifford Odets, Elia Kazan)

Very few people today are aware that Elia Kazan was an actor. This was the first time he appeared as one. The whole event was an historical affair of a sort. There was a taxi cab strike on in New York at the time and the Players company had this meeting of everyone. Lee Strasberg got up and asked if anybody could write a short play about the strike. And Cliff Odets said, "I'll try my hand at it." And he did. He wrote *Waiting for Lefty*. Kazan played the taxi driver. So world theatre has ornery New York City cab drivers to thank for one of its greatest plays. Remember that the next time you're trying to make a curtain time and your taxi's stuck in traffic somewhere over by the river.

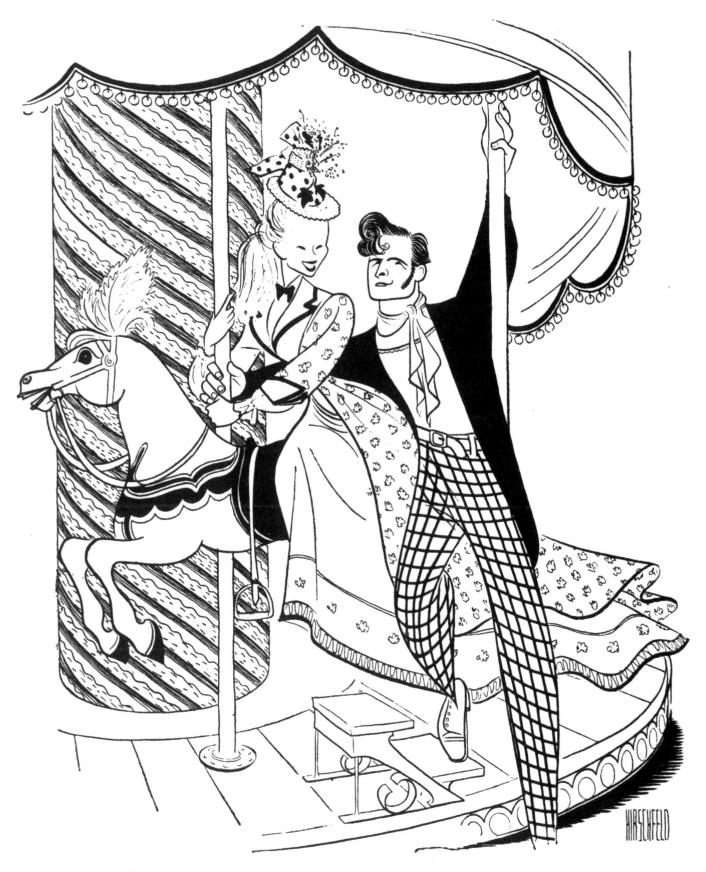

Carousel, 1945

(Jan Clayton, John Raitt)

Larry Hart had gone his own way and Richard Rodgers was teaming up with Oscar Hammerstein now. Mr. Rodgers could have teamed up with anyone and it still probably would have been a great show. The little patterns and other details are what make this drawing interesting. The costumes and the carousel— a rich, interesting interplay of patterns and shapes. Stage effects can often be seductive to me as an artist, especially lighting. The setting here was by Jo Mielzener, the costumes by Miles White.

Café Crown, 1942

(Yiddish Theatre)

The café in the play *Café Crown* was based on a hangout for Yiddish theatre actors that existed on Ninth Street and Second Avenue. Trotsky used to hang out in it, too, and it was called The Café Royal. Later it became famous as the place where the Group Theatre members hung out. The players hanging out in this drawing are George Petrie, Eduard Franz, Morris Carnovsky, Sam Jaffe, Mary Mason, Paula Miller, Mitzi Hajos, and Daniel Ocko. Essentially, the Group Theatre turned their own café life at the Café Royal into the production *Café Crown*.

The Skin of Our Teeth, 1942

Teeth was a play produced by Mike Meyerberg. It was his first show and he assembled a cast that no other Broadway producer would even dream of casting. On the other hand, Thornton Wilder's play was not your standard Broadway drama. Part of it takes place in the Ice Age, for instance. Florence Eldridge (in the large-brimmed hat) was in it, with Freddy March (in the fez), Montgomery Clift (in the knickers), Tallulah Bankhead (in the bathing suit), Frances Heflin (under the feathers), and Florence Reed (in the Gypsy getup). This is what would later be called a star-studded cast. Mike opened in Philadelphia, where I saw it and datelined it. I persuaded Brooks Atkinson to trek down to Philadelphia to see it. Generally, Brooks' feelings about Philadelphia were in accord with W.C. Fields'.

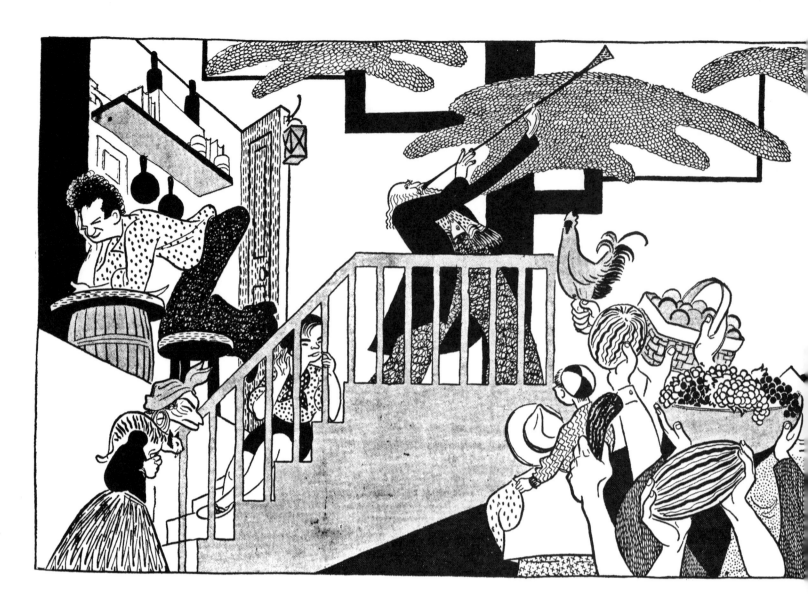

My Heart's in the Highlands, 1939

(Sidney Lumet)

Highlands was William Saroyan's first play on
Broadway. It was also future film director
Sidney Lumet's acting debut—he's that kid
on the stairs. The others pictured are Philip
Loeb, Hester Sondergaard and Art Smith.

Odets Plays, 1939

(Sandford Meisner, Luther
Adler, Clifford Odets)

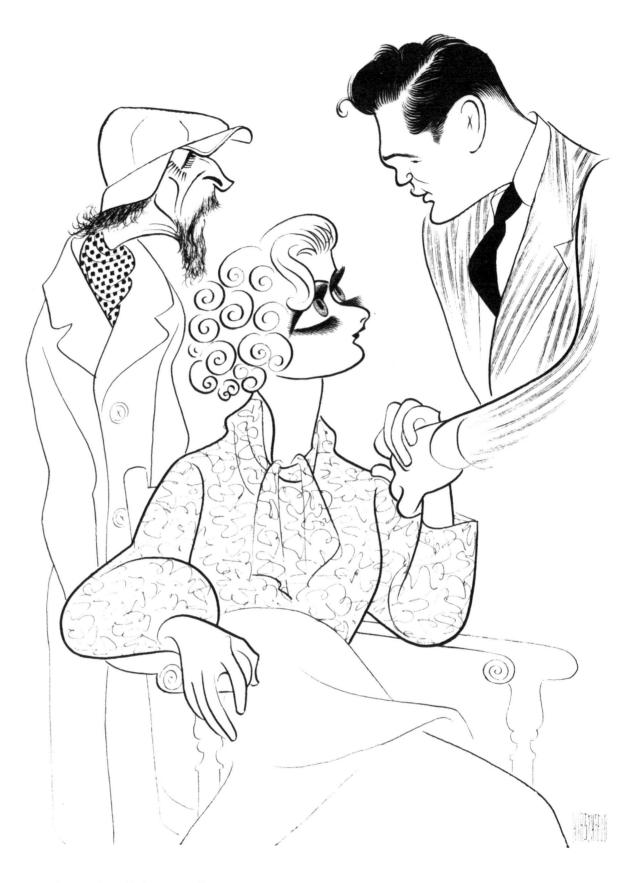

Awake and Sing, 1935 (drawing, 1973)

(Stella Adler, John Garfield)

Stella Adler, pictured here in the middle, was about as famous as any actress the Group Theater ever had. Largely because they never bothered to develop actresses. They concentrated on the men. Perhaps this is why Stella never really made it as an actress and had to go into teaching. Of course, the Group Theatre didn't have the reputation in the Thirties that it has had subsequently. This drawing is, however, representative of the Group Theater productions in general, in another classic Odets play. The actors flanking Stella are Morris Carnovsky and John Garfield.

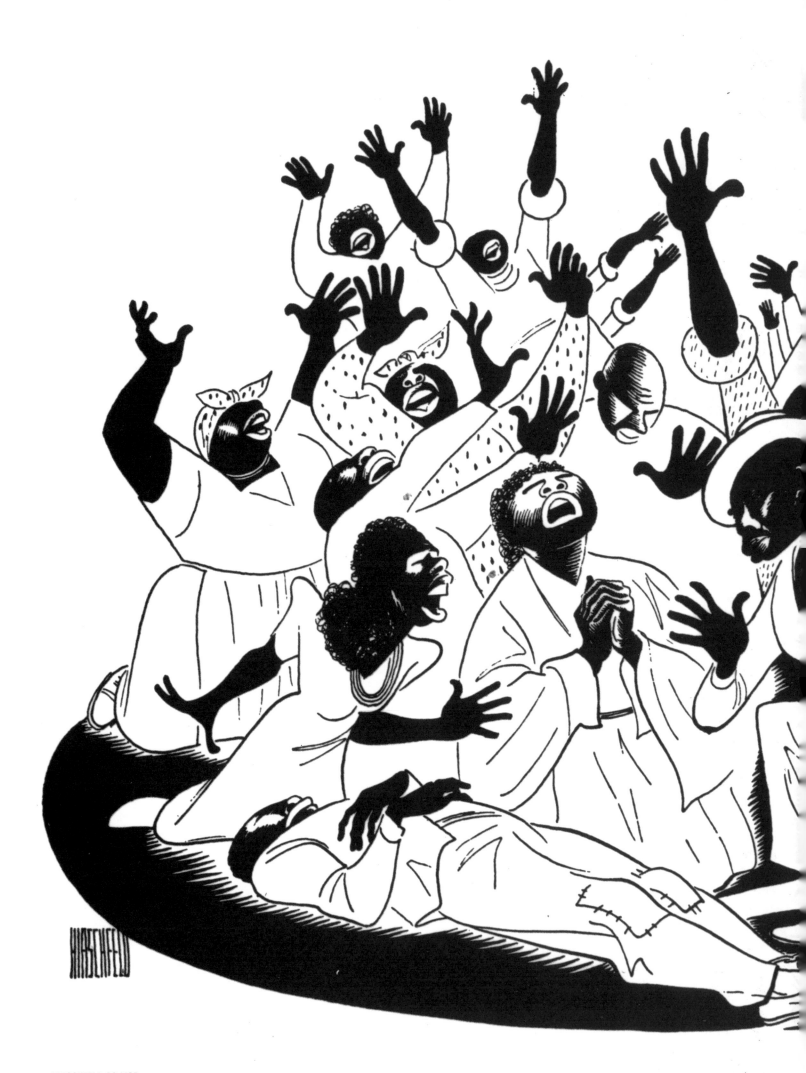

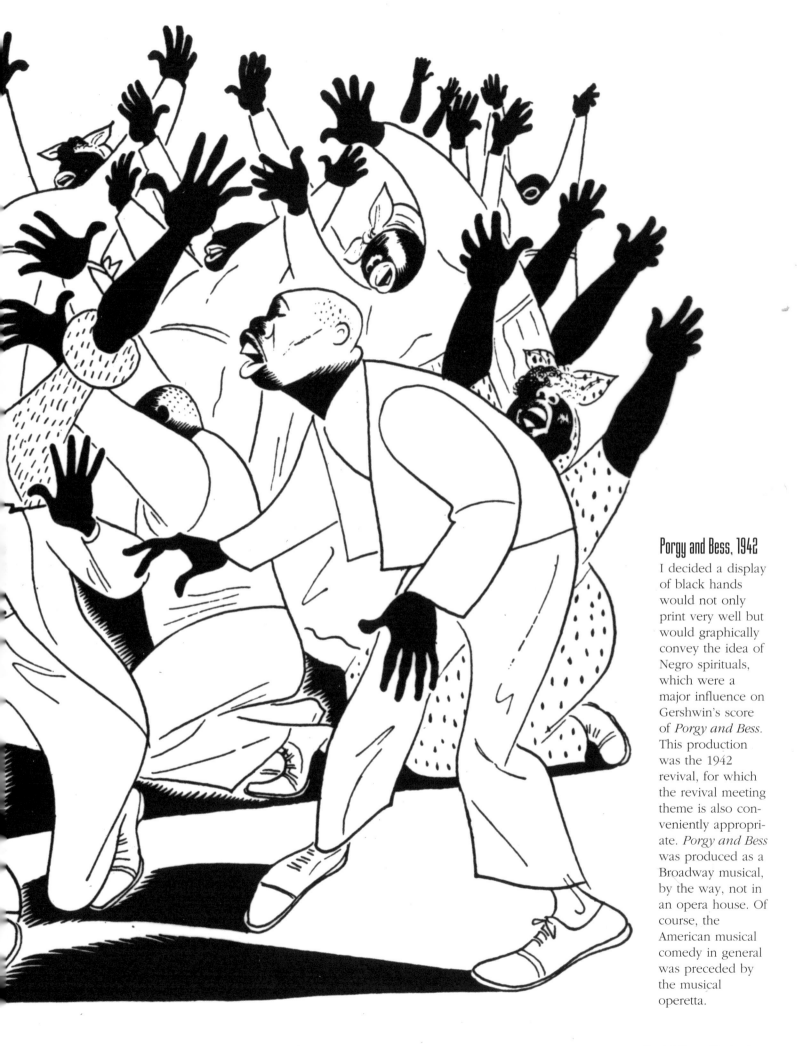

Porgy and Bess, 1942

I decided a display of black hands would not only print very well but would graphically convey the idea of Negro spirituals, which were a major influence on Gershwin's score of *Porgy and Bess*. This production was the 1942 revival, for which the revival meeting theme is also conveniently appropriate. *Porgy and Bess* was produced as a Broadway musical, by the way, not in an opera house. Of course, the American musical comedy in general was preceded by the musical operetta.

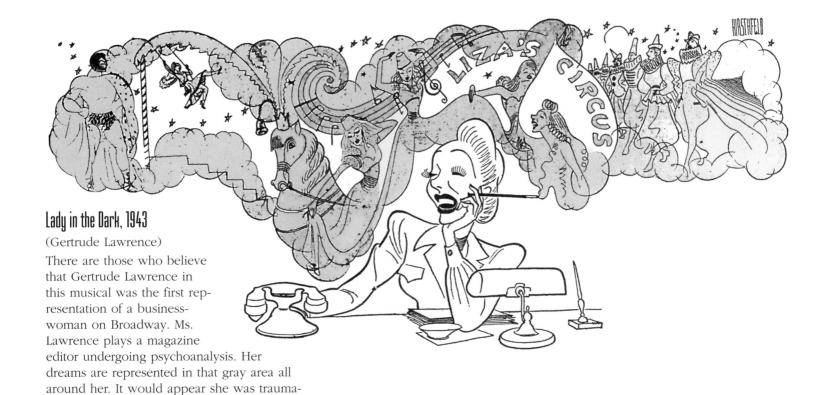

Lady in the Dark, 1943

(Gertrude Lawrence)

There are those who believe that Gertrude Lawrence in this musical was the first representation of a businesswoman on Broadway. Ms. Lawrence plays a magazine editor undergoing psychoanalysis. Her dreams are represented in that gray area all around her. It would appear she was traumatized by a circus at a young age. Nonetheless, she seems to be having too good a time in these dreams to be neurotic. The book was by Moss Hart and the songs by Kurt Weill and Ira Gershwin, which is remarkable enough in its own right. One side note: Danny Kaye sang a tongue-twister song, with lyrics written by his wife Sylvia Fine. That one brief appearance made him a star. The royalties from the show also more than repaid Moss Hart's weekly contributions to psychoanalysts' fees across many years.

The Barretts of Wimpole Street

(Brian Aherne, Katharine Cornell)

and The Glass Menagerie, 1945

(Laurette Taylor, Julie Haydon)

Here, opening the same week, we have the old Broadway and the new. On the left, the grand dame of Broadway, Katharine Cornell, playing Elizabeth Barrett Browning. On the right, a new poet to give the Brownings a run for their artistic money, Tennessee Williams, with his first Broadway production, *The Glass Menagerie*. Laurette Taylor plays the Southern-belle-out-of-water and Julie Haydon is her bewildered, introverted daughter Laura. Even the sets tell the story—heavy 19th-century drapes on the left versus naturalistic tenement fire escapes on the right. It was a first-rate week of New York Theatre.

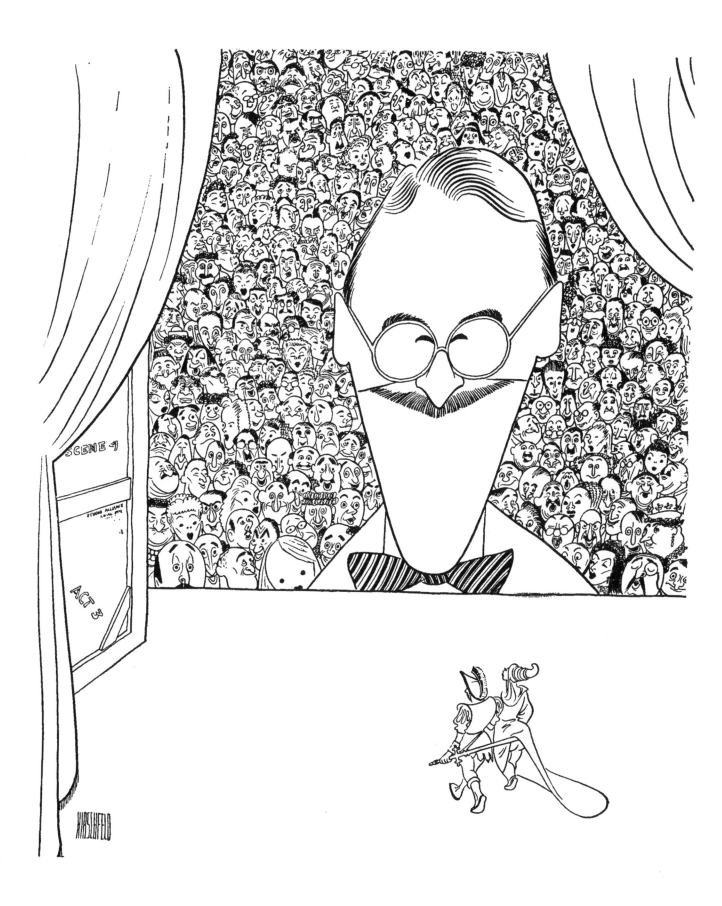

Brooks Atkinson, 1948

Brooks, as reviewer for the *Times*, really did loom this large, as *Times* critics have long tended to do. The sharp-eyed may also notice my wife Dolly Haas's head peeking over Brooks' right shoulder (your left). Also, the sword of the Conquistador appears to have gotten entangled in the wimple-hatted lady's train., leaving her in a state which many a fully-clothed actor has felt in Mr. Atkinson's professional presence. The *Times* back then earned a reputation for veracity in all its departments, which helped establish its theatre critics. Brooks himself had a wild talent for scratching at the truth through his choice of words, which had a profound influence on theatre criticism. Also, his negative opinions had the positive effect of egging the Broadway theatre into becoming a livelier art.

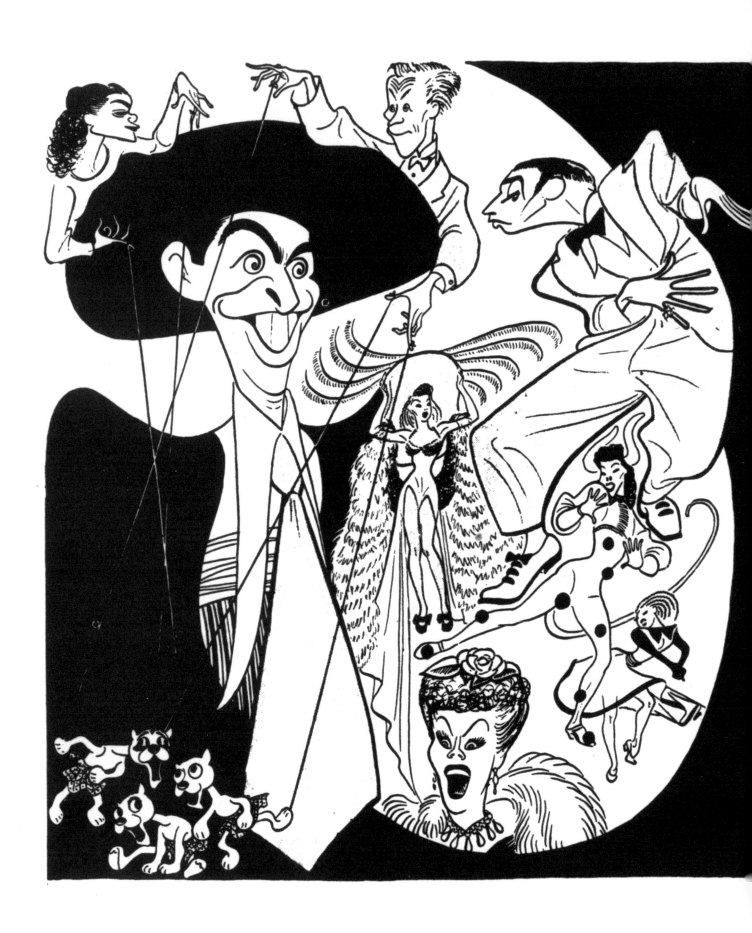

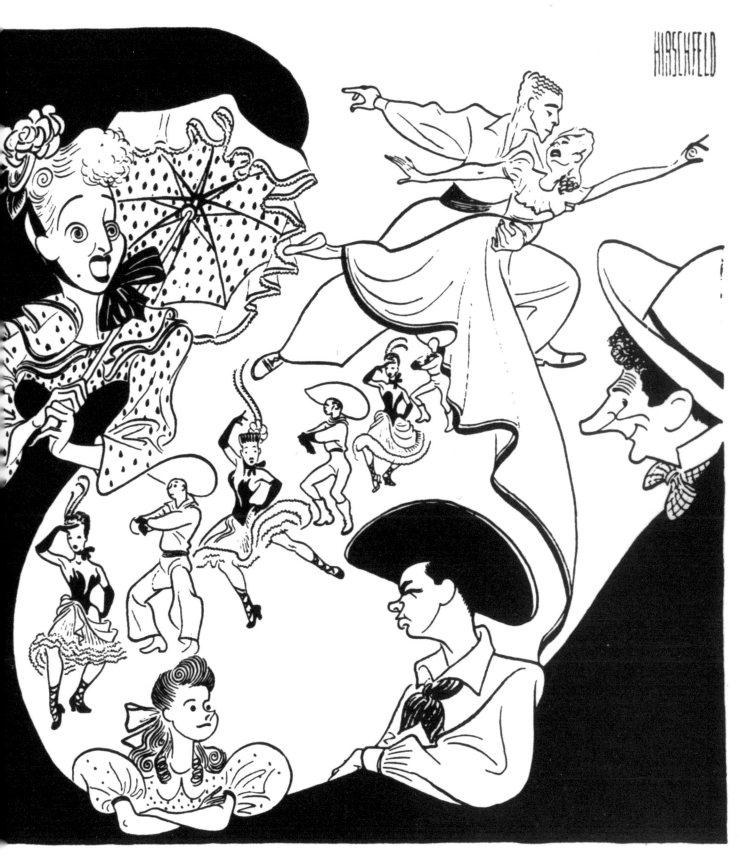

Oklahoma! and The Ziegfeld Follies, 1943

The cast of Rodgers and Hammerstein's ground-breaking *Oklahoma!* is pictured along with the Ziegfeld Follies (starring Milton Berle, with the Cora and Bill Baird Puppeteers, Jack Cole and Martha Raye) because I was hedging my opening-night bet that week in the *Times*. *Oklahoma!* had been named *Away We Go!* out of town, and it looked to almost everyone like it was gonna be a bomb. Howard Cullman, the celebrated angel, refused to invest in *Oklahoma!* after seeing it performed in New Haven. Billy Rose turned thumbs down on it, and Mike Todd said, "*Oklahoma!* is not commercial." Then they moved "Oh, What a Beautiful Morning" into the opening scene and Broadway history was made. The only thing they kept from the original title was the exclamation point. The players in *Oklahoma!* are Celeste Holm, Marc Platt and Katherine Sergava (dancing), Joan Roberts, Alfred Drake, Joseph Buloff and the Agnes DeMille Dancers; costumes by Miles White.

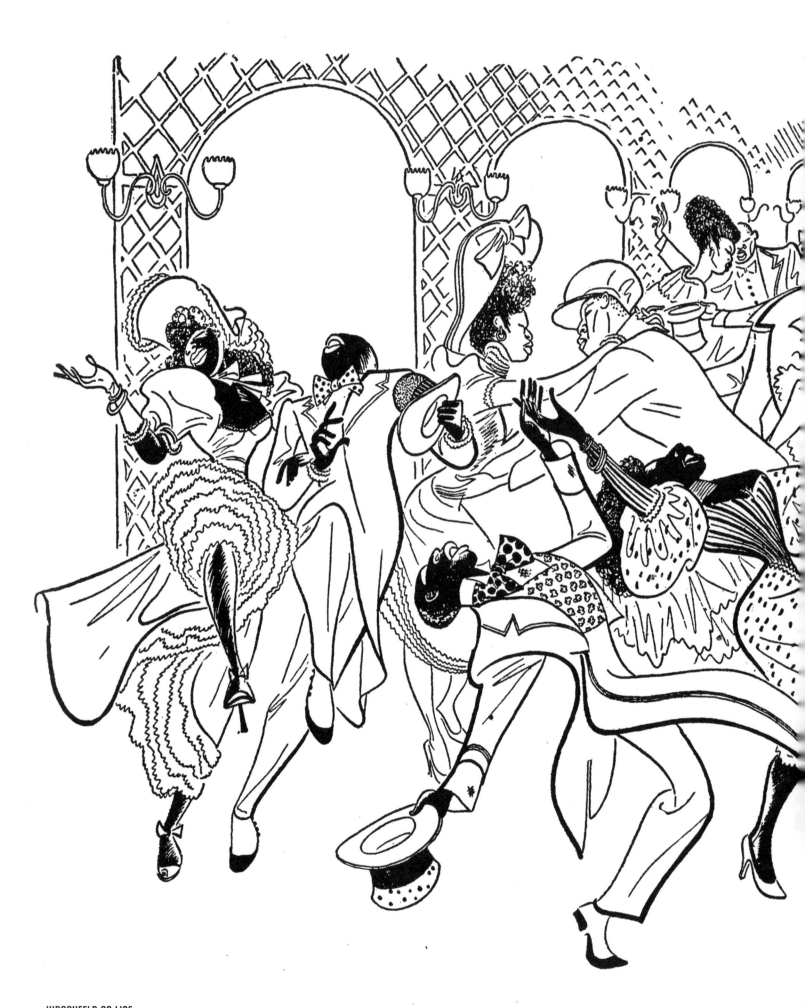

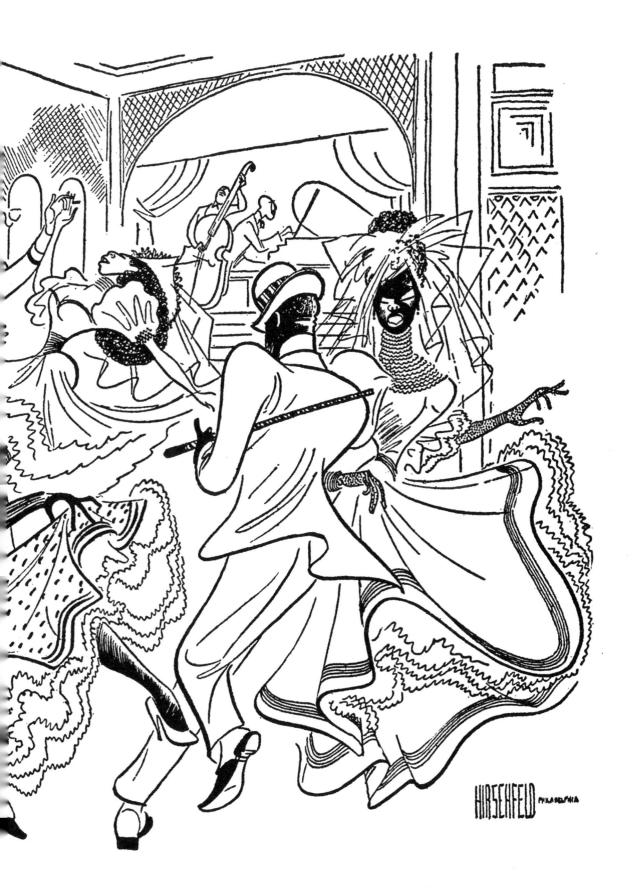

St. Louis Woman

(Pearl Bailey)
Now, here's the type of drawing I love to do. It's got some spirit to it. Some action and love and movement. It just jumps off the page and is full of life. Pearl Bailey also made her debut in this Harold Arlen-Johnny Mercer musical. This scene, again datelined from a tryout in Philadelphia, is of the cakewalk dance in the first-act finale, which combined energy and tradition. The show had an all African-American cast, which was not unusual for this era. Duke Ellington, Fats Waller, Sisel and Blake, and W. C. Handy are among the great African-American musical artists who got their shot on Broadway. *St. Louis Woman* was recently revived in a City Center concert version.

Crime and Punishment, 1947

(Lillian Gish, John Gielgud, Dolly Haas)

They put together a pretty good cast for this one, including my late wife Dolly Haas. She was a very helpful sounding-board and critic of my own work, but I never tried to give her any acting advice across our fifty-two years of blissful devotion. Dolly, just prior to this, during the war years, had transferred her genius for the stage into broadcasting nightly as America's "Axis Dolly" over the facilities of the OWI to her former colleagues in Germany.

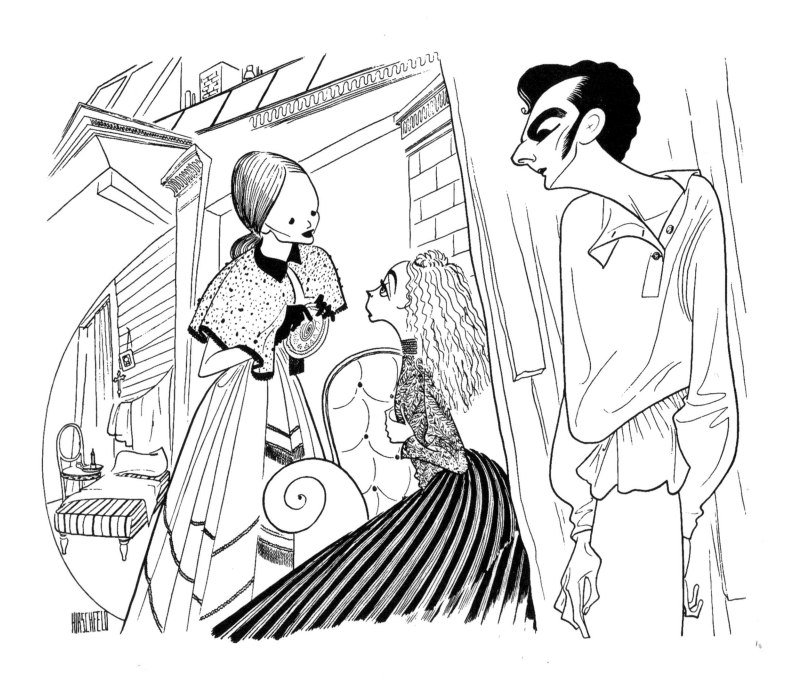

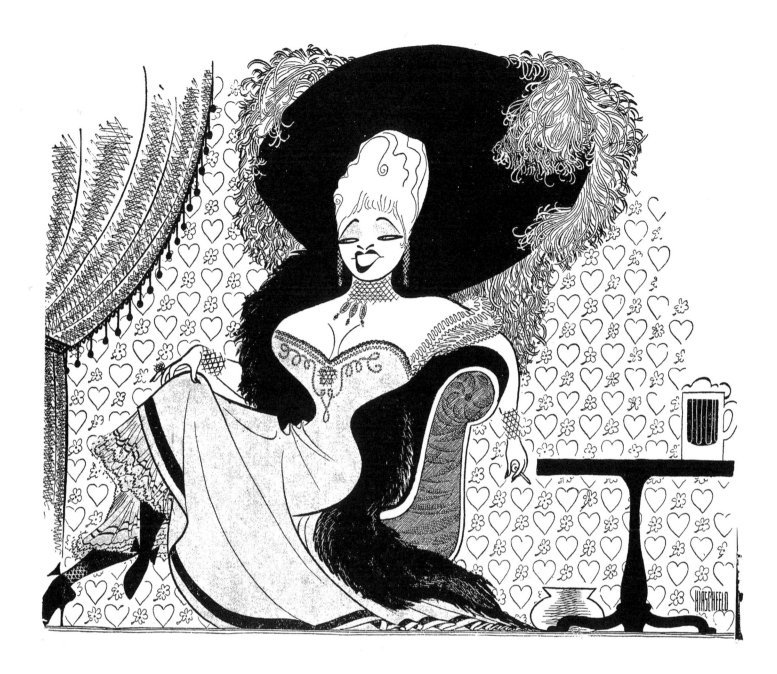

Mae West, 1949

(in *Diamond L'il*)

Here's some more of that John Held Jr. two-dimensional woodcut feel. No doubt it was heresy to portray in a two-dimensional drawing a woman so endowed that the military named its inflatable lifejacket after her, but the rest of the show's Gilded Age setting lent itself to that style. Again, the important thing here is patterns. They tell the story. You've got hearts and flowers on the wallpaper, and the feather boa fringe on the broad-brimmed hat, the embroidery on the dress, the border on the petticoat. They really liked patterns in those days and had no fears of mixing and matching. All of these patterns combined, of course, describe pictorially the bigger-than-life buoyancy of Mae (with or without the life-jacket). The use of blacks and lines is also well realized. It's a very successful drawing, I think. Particularly the hands.

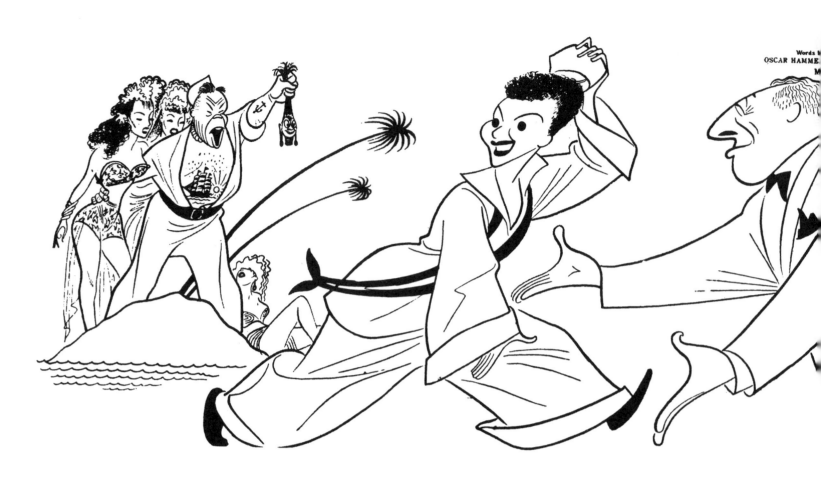

The Mack Sennett Ballet, 1947

(*High Button Shoes*)

Here's another one of those shows that today sounds like some All-Star Game of Broadway legends. *High Button Shoes* was a Jule Styne–Sammy Cahn musical directed by George Abbott and choreographed by Jerome Robbins. Those guys managed to pack into this number everything Mack Sennett was famous for—the Keystone Kops, Bathing Beauties, the Breakaway, double-takes, triple-takes, and a gorilla, which is not only stealing the scene but a satchel of cash as well. There's a bit of a John Held Jr. woodcut influence as well, especially in the rosy-cheeked bathing beauty. Held, who illustrated the Twenties the way Fitzgerald narrated it, was a big influence on me when I was young.

Bali Ha'i

Music by
RICHARD RODGERS

South Pacific, 1949

Here I used the first sheet of music from one of the songs as background for Ezio Pinza. His big number is "Some Enchanted Evening." And it was. The oversized outfit on Mary Martin describes her character in the show. The gentleman on the left with the shrunken head is Myron McCormick. The show, *South Pacific,* by Rodgers and Hammerstein, who seem as ubiquitous here as Rodgers and Hart did only a moment ago, was adapted from James Michener's huge post-WWII best-seller *Tales of the South Pacific.* The show was equally successful, as I recall. That lump of vanilla ice cream Mr. McCormick is standing on is the island of Bali Ha'i itself. This may be the first time in Broadway history where the actresses wore more clothes than the natives they were portraying.

Bobby Clark, 1948

(in *As the Girls Go*)

I usually go around saying this is the most important drawing I've ever done. Why, I'm not exactly sure anymore. I do know that Bobby Clark's playing of this role had a tremendous influence on comic performers after him—that walk, everyone copied that walk, including Groucho Marx. It was the one thing that jumped out of the show. Bobby Clark invented it, sort of hugging the ground on his knees. It was a very strange kind of anatomical disfiguration that captured his, and his character's, personality. And of course it's the kind of vibrant stage motion that always captures my eye and imagination.

The show was in 1948, but Bobby's obviously playing a Roaring Twenties college man, with the raccoon coat. Even the pennants were furry back then. Years ago in Boston, I witnessed the opening of *Walk a Little Faster,* a musical with Beatrice Lillie and Bobby Clark, sponsored by one of our better producers, Courtney Burr. The opening curtain was raised on that memorable occasion and halfway up it got stuck. The brainless electrical device used for raising curtains persisted in its inexorable course until the curtain was torn loose from its moorings and with a resounding crash fluttered down over the musicians like a giant blanket. The entrapped musicians, under the mistaken impression that they were aboard a sinking clipper ship, continued their fiddling until a rescue was effected.

This show, incidentally, was written by Kiss-of-Death Perelman, Yip Harburg, and Vernon Duke—and designed by Boris Aronson. It was the first time any of these now-famous theatre personalities had been employed theatrically.

Ed Wynn, 1940

(in *Boys and Girls Together*)

Here again I used some wallpaper (left over from doing my own bedroom) for his coat. The rest is all drawn, of course. But, graphically, it is a very successful drawing of both Wynn and the coat, as depicted by these patterns. To this day, of course, I keep expecting to hear from the wallpaper manufacturer about having plagiarized his work. The strangest materials I ever incorporated into a drawing, though, were paper doilies and swatches of cloth for men's clothing sewn together.

Are You With It?, 1945

(The First NINA)

This is the first time I hid my daughter Nina's name in a drawing. *Are You With It?* opened on the day that she was born and I facetiously put her name in the little poster in the background, as you can see in the upper right hand corner. This little folly was, over the decades, to turn into a monster. I am now incapable of discontinuing the process. In fact, when I did try leaving the Ninas out, crazed *Times* readers posted me desperate letters either demanding that I reinsert a few retroactively, or to confirm how they had alone, through some special power, discovered where I had so cleverly hidden the name, which never really existed, among the cross hatchings and swirls. I got the message and returned to including the NINAs, just to give my postman some rest. Nina herself, I suspect, dislikes this form of oblique celebrity. But she and I are both hopelessly caught in the gears now. On another occasion I made the equally unpardonable error of microscopically lettering in the name of Nina's best girl friend, Lisa, the daughter of the distinguished writer Louis Kronenberger. All hell broke loose on a different front. I received telegrams and flowers from forgotten acquaintances and complete strangers. One came all the way from Alaska, congratulating my wife and me on the new arrival. It was in 1960 that I instituted the custom of appending a numeral to my signature, signifying the number of Ninas to be found in that drawing. (Some time later, the Pentagon devised a system whereby pilots learn to target their bombs better by hunting down the Ninas in my drawings.) By the way, both my wife Dolly and I were suckers for the number "9"—and "Nine" became Nina.

Where's Charley?, 1949

(Ray Bolger)

That Ray Bolger was the whole show here this drawing capably documents. He was still as limber and funny as ever ten years after that strawman he played in *The Wizard of Oz*. Bolger once told me that he tried desperately to live up to my sinuous depictions of him. But all I did was translate the exaggerated character he'd made out of himself to the page through ink. Again, this is the kind of drawing I like to do. Bold characters leaping around—and occasionally off—the page. I was not handicapped, as he was, by gravity.

Her Cardboard Lover, 1940

(Dolly Haas)

It was at a summer theatre production in Hershey, Pennsylvania, where I first met Dolly Haas. I thought she was the greatest actress I'd ever seen, and I married her. This is a drawing not of the production, however, but of the company striking camp from the Chocolate City of Hershey, headed to home base in Eaglesmere, Pennsylvania.

My late wife Dolly appeared in a good string of productions in addition to this one: *Crime and Punishment, Circle of Chalk, Three Penny Opera, Anastasia, Winter Soldiers,* and *Lute Song.* From my point of view, they were all great performances. Dolly was equally enchanted with my delineations of her in line.

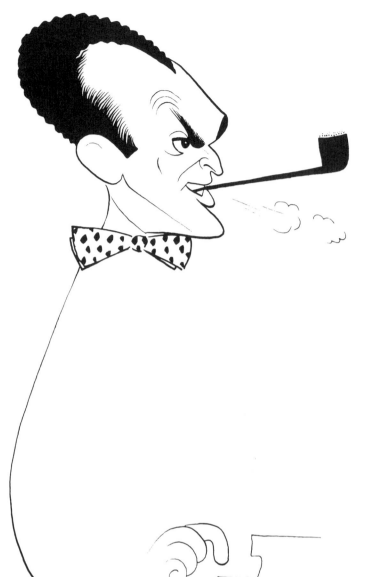

Moss Hart, 1943

(Author of *Winged Victory*)

Moss Hart again. I put him here at his typewriter, an instrument with which he was fairly proficient—a direct line from the high-browed head to the finger on the key. He was born in the Bronx and got his big break co-writing a show with George S. Kaufman. Years after this he wrote down his Bronx-to-Broadway story in his remarkable autobiography *Act One*. It's one of the great theater rags-to-riches tales of all time, the kind of story even Ripley's *Believe It or Not* would think twice about expecting people to swallow. Years later, I tried to dissuade Moss from embarking on the foolhardy project of turning Shaw's *Pygmalion* into a Broadway musical. I couldn't for the life of me imagine anyone adding songs and lyrics to Shaw's masterpiece. Besides, it's axiomatic in the theater that when you name something "My Fair Lady" the critics are going to lambaste you simply for the chance to play with your title in their headline—"My Fair-to-Poor Lady." "No Fair, Lady." "Fare-Thee-Well, Lady." And, of course, as usual, I was proven absolutely right: the show was an absolute disaster, as have been the dozens and dozens of revivals since.

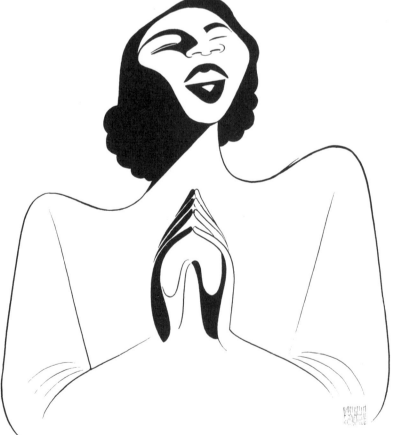

Marion Anderson, 1948

She looks a bit like an angel here—the shoulders like open wings. She certainly sang like one.

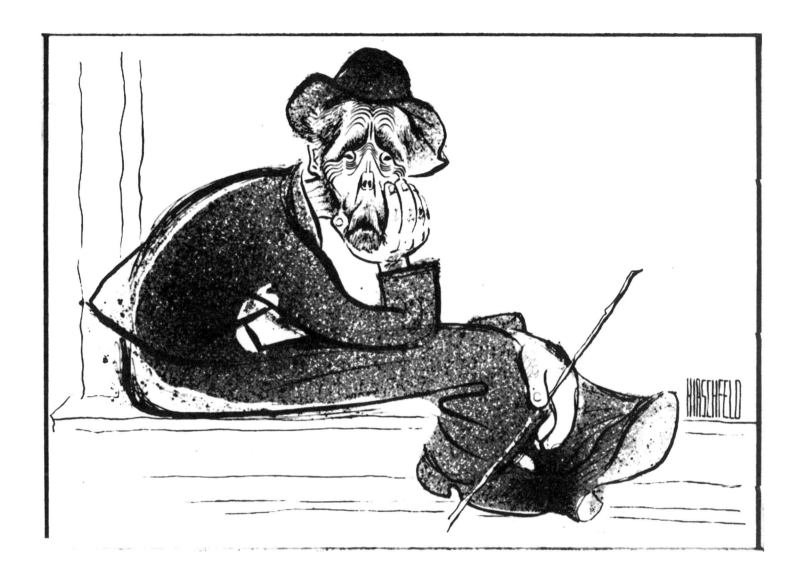

Tobacco Road, 1943

(Henry Hull)

Henry Hull was only one of the many Jeeter Lesters in the long, long run of this adaptation of an Erskine Caldwell novel. The show ran so long they eventually grew their own turnips on the stage of the 48th Street Theatre. One illustrative item of note in the drawing is the use of spatter. That's where you dab ink on the bristles of a toothbrush and "spatter" it onto the drawing. I employed it here in combination with very free lines and it seems, to me anyway, to work for this portrayal. Read: "Seedy." The lines in his face in particular describe the toll the Depression took on Jeeter and this country. Although, no doubt it detracts some from the Mystery of Art to confess that I use common household items to produce my effects. But these are the harsh, ignoble realities of my trade.

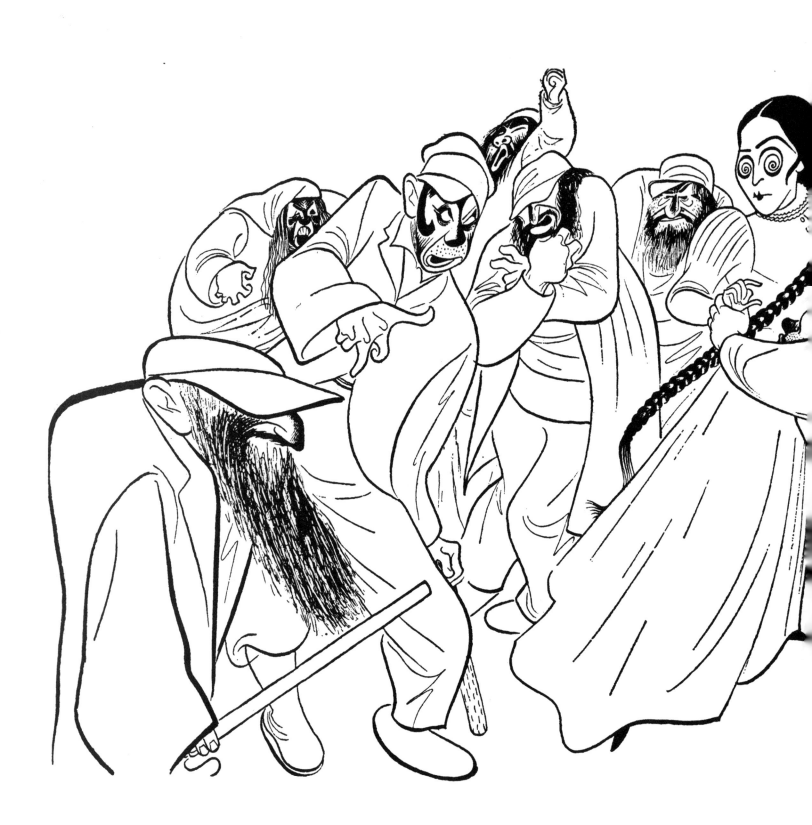

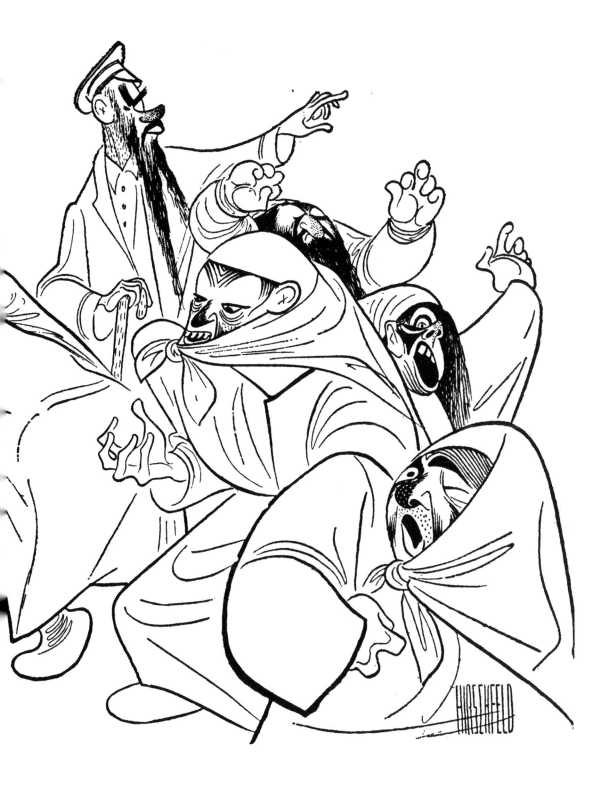

The Dybbuk, 1948

(Habima Theatre of Israel)

The Habima Theatre is depicted here in 1948 performing the "dance of the beggars" from *The Dybbuk.* This drawing represents to me the caricature of caricatures. These characters are all so overblown to begin with. The actress with the braid in the middle of the commotion, by the way, is Hanna Rovina. In 1998, fifty years after this limited engagement at the Broadway Theatre, as well as the fiftieth birthday of the state of Israel, the company came back here to celebrate both anniversaries.

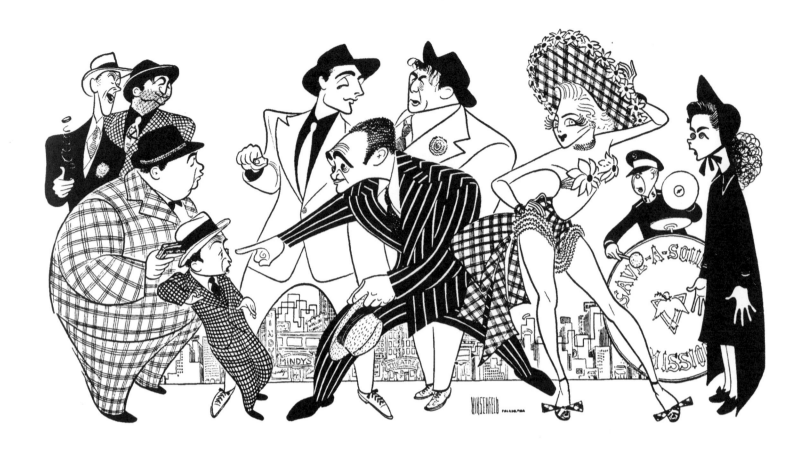

Sweet Bye and Bye, 1946

(creative team)

Philadelphia is where New York used to send its landfill before they discovered Staten Island. *Sweet Bye and Bye* is a case in point. It all began with a telephone call from S. J. Perelman in the early Forties. He suggested we collaborate in the writing of the book for a musical. We met for lunch at the old Lafayette Hotel café that same day. I don't remember what I ate, but fifteen years later the gas pains were still with me. Our collaboration eventually included lyricist Ogden Nash and composer Vernon Duke. The four of us labored a couple of years on this foolproof, tightly knit extravaganza—and whelped the piece of idiocy titled *Sweet Bye and Bye.*

You might think a show written by S. J. Perelman, lyricist Ogden Nash, composer Vernon Duke, and yours truly might have a chance of making it to Broadway. Let this drawing be a lesson to all with such delusions. This scene of our hotel room in Philly aptly represents the insanity of anyone writing a musical. We were in trouble, the four of us, rewriting and trying to save what we'd been working on for those couple of years. But a couple of years of hotel food will twist anyone's mind, and ours were pretty corkscrewed. The show was in even worse shape. It died in Philadelphia and the four of us had to leave the country for a while.

S. J. Perelman was another great friend of mine. The friendship survived the production. In fact, we left the country together, in a professional capacity. The week before the $400,000 mishmash of *Sweet Bye and Bye* folded in Philadelphia, Perelman and I had lunch with Ted Patrick, the editor of *Holiday* magazine, at the Warwick Hotel. Patrick, throwing reason to the wind, boldly made the proposition that both Perelman and myself be dispatched to Hollywood to write and draw something about the colorful natives there for *Holiday.* Thus it was that, after some additional martinis and insane conversation, Mr. Patrick ultimately commissioned us to go around the world. Before the week was out we managed to suck in both Simon *and* Schuster for a fat fee in advance of royalties on a book which turned out to be the best-seller *Westward Ha!* The accumulated loot from *Holiday* and *Westward Ha!* enabled me to move out of my reconverted storage space on the roof of an apartment building on West 57th Street and buy the townhouse that I still inhabit.

◄ Guys and Dolls, 1950

Here's another case where the costumes were exciting, incredible, and larger than life—despite the fact that the production got much of its clothing from the Salvation Army. The wild outfits also, fortunately for me, lent themselves to line drawing. I mean, they were marvelous against a background of a New York skyline and a cast of lunatic characters. The players were as dizzy as the clothing, and they are all rather accurately portrayed here. There was not much room left for me to exaggerate in the drawing. Frank Loesser did an incredible job of adapting Damon Runyon's stories into these guys and dolls. Who are, by the way, Douglas Deane, Tom Pedi, Stubby Kaye, Johnny Silver, Robert Alda, Sam Levene, B.S. Pully, Vivian Blaine, Pat Rooney Sr., and Isabel Bigley.

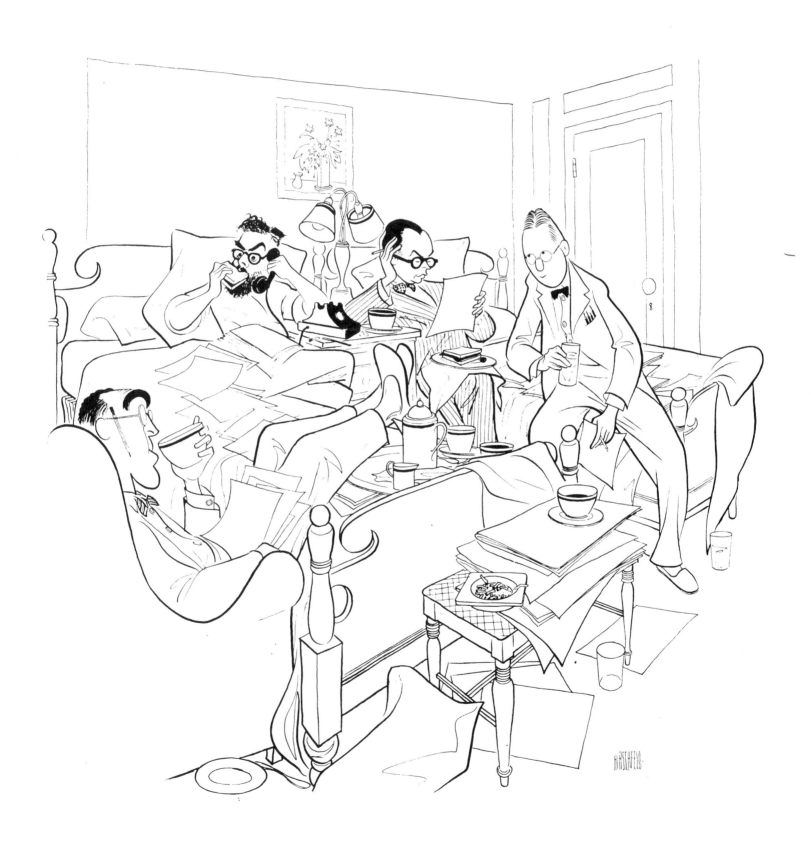

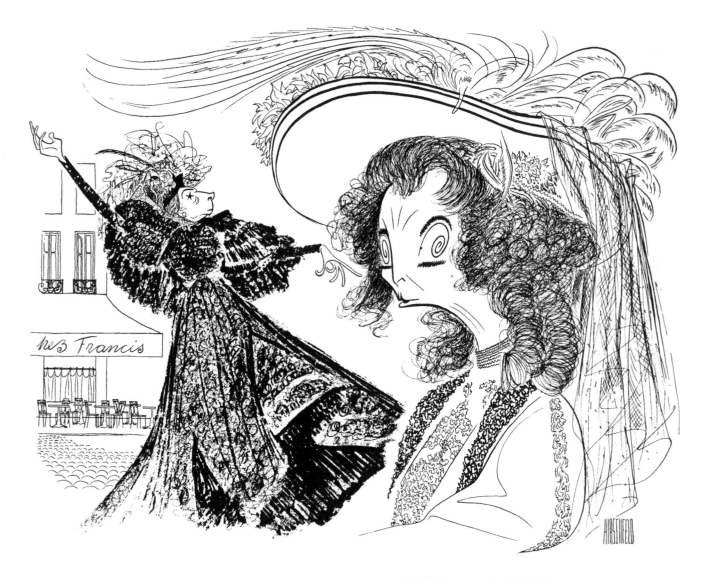

The Madwoman of Chaillot, 1948

Martita Hunt and Estelle Winwood, two extravagantly sane women, in the Jean Giradoux play. I experimented with different patterns here. It seems to work for this drawing, which lends itself to flourishes of every kind—including the little drawing of the café in the background, which still exists in Paris.

Eleanor Roosevelt, 1953

Years after this drawing was done, my Gallery used this image for an edition of lithographs to help raise funds for the Eleanor Roosevelt statue that now adorns a new plaza at the edge of Riverside Park, at 72nd Street and Riverside Drive in Manhattan.

PHOTOGRAPHS BY HIRSCHFELD

The Late Thirties

THE
MIDDLE
YEARS

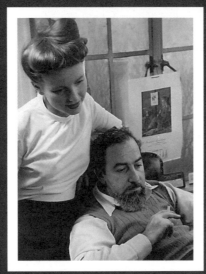

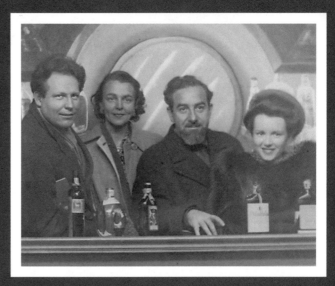

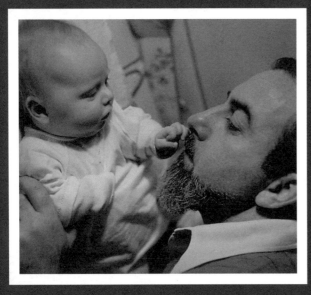

Top: Dolly Haas on the cover of *Film Woche*, 1934; Mr. and Mrs. Al Hirschfeld; Dolly Haas and Al with Lydia and Don Freeman at Coney Island, New York, c. 1940.

Center: Al and daughter Nina, 1945.

Bottom: Nina, the young actress, 1965; Dolly tours Israel and Nina accompanies her.

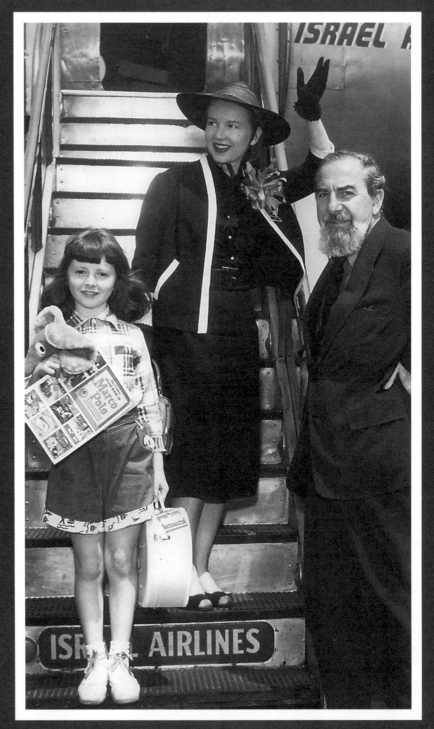

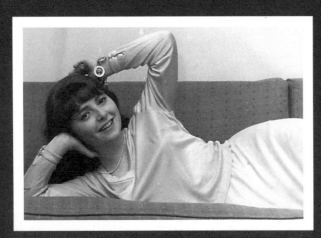

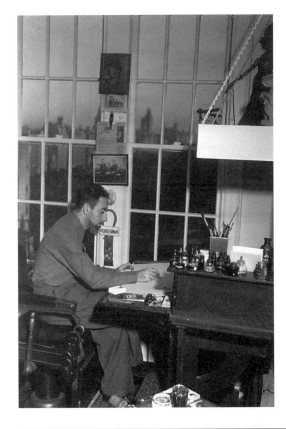

Top: First barber-chair studio on W. 57th Street c. 1940; outside backstage entrance c. 1940; in actor's dressing room with dresser c. 1940.

Middle: With young Jessica Tandy.

Bottom row: In Broadway Theatre with producer Gilbert Miller and theatre press agent Dick Maney c. 1940; in theatre c. 1940.

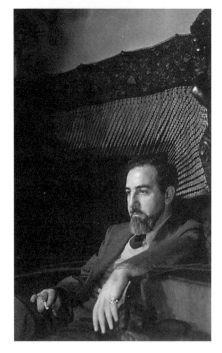

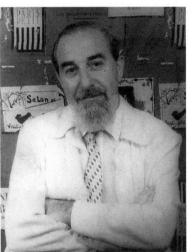

Top: Mural in Times Square Hotel; in 57th Street Studio with Bali art collection c. 1945; with friends Laura and S. J. Perelman and Boris Aronson.

Middle: In front of mockup Paris created by a photographer, early 1950s.

Bottom: Broadway leading ladies mural in Times Square hotel: Ethel Merman, Julie Harris, Lynn Fontanne, Helen Hayes, and Katherine Cornell.

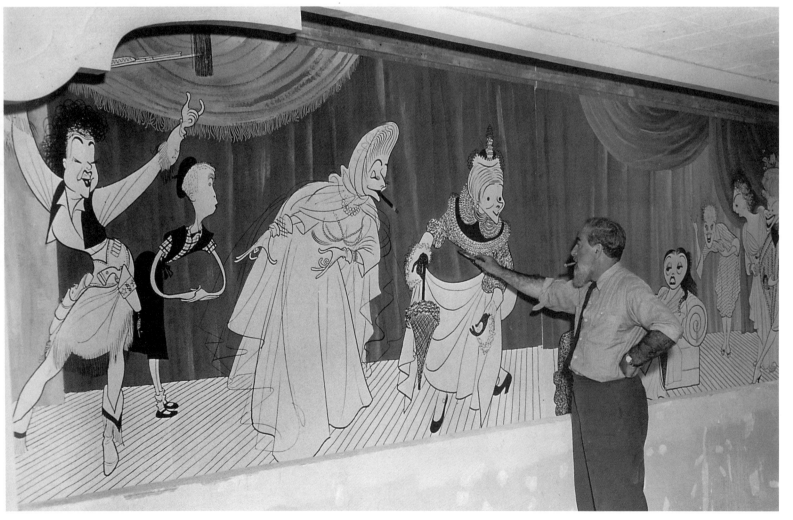

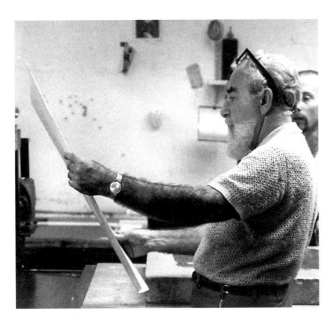

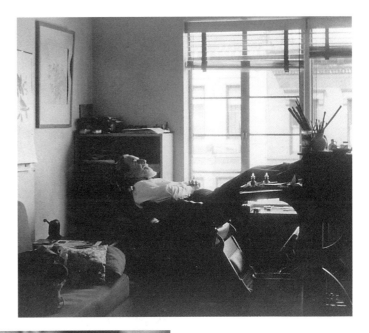
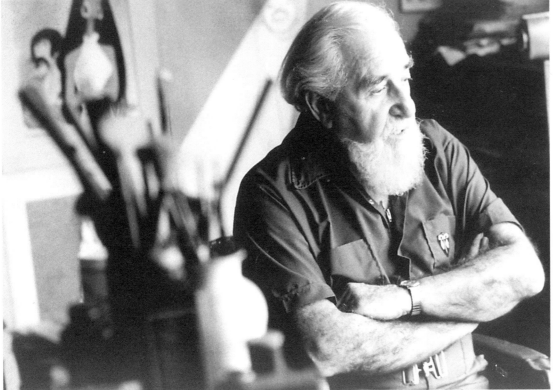

Top: Checking lithograph proof for *Rhythm* Series at the famed Bank St. Atelier, 1969; with *Sweet Bye & Bye* creative team: Ogden Nash, S.J. Perelman, and Vernon Duke.

Middle: With S. J. Perelman en route to Asia during writing of *Westward Ha!*; between drawings, 1950;

Bottom: Temporarily on hiatus from *The New York Times*, 1975.

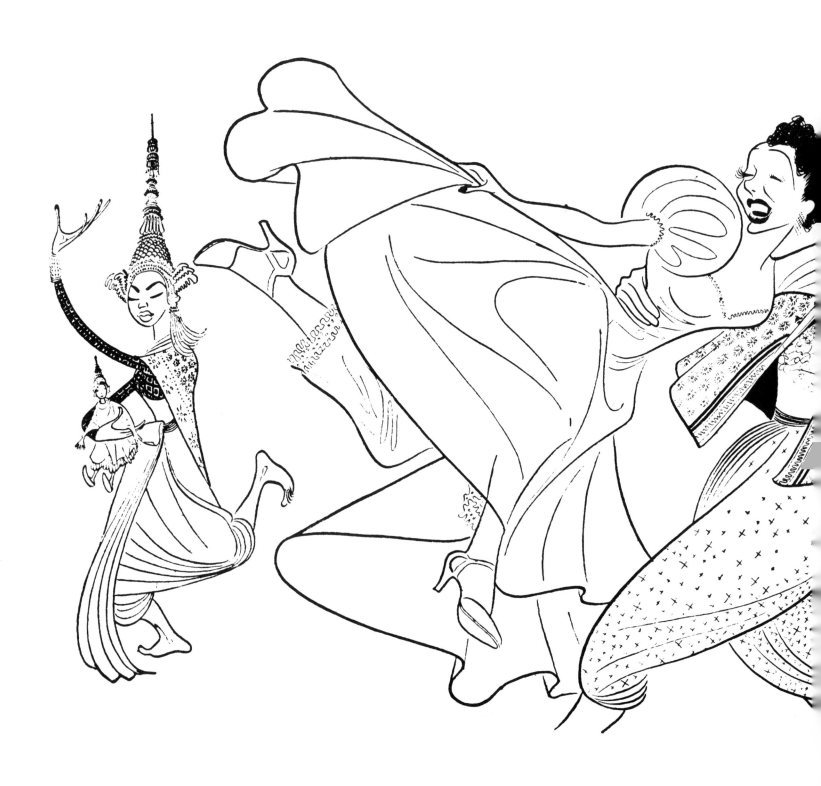

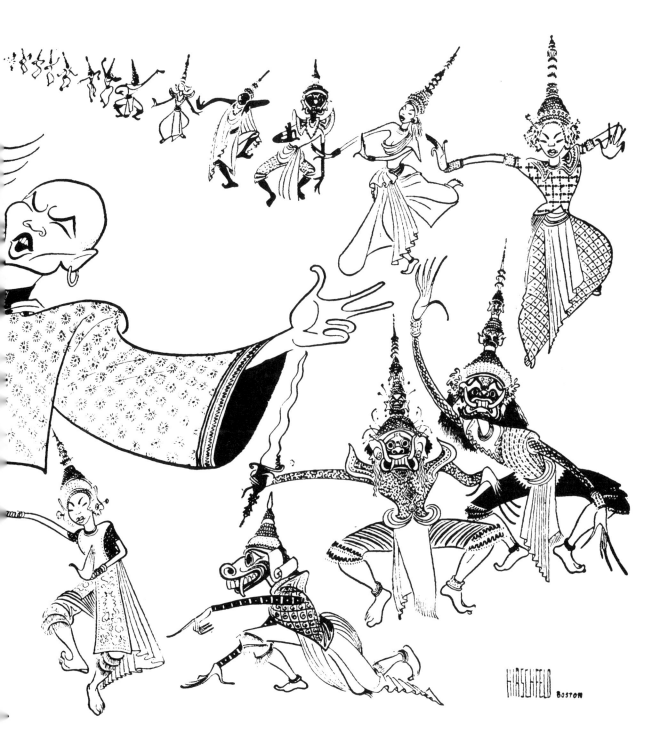

The King and I, 1951

Well, what do you know. Here's another wildly successful Rodgers and Hammerstein show. This one, however, I was personally more involved in than most. I had made home movies of Siamese ceremonial dancers being sewn into their costumes when I was there. It was the first time anyone was allowed to photograph it. I showed Rodgers and Hammerstein the footage when they were doing research for their adaptation of Margaret Landon's novel *Anna and the King of Siam*. They were very grateful and used some of the ideas in the elaborate costumes of the production. In any event, I was able to use my own knowledge to good effect in this drawing. That's Gertrude Lawrence kicking up her heels with Yul Brynner, in his career role.

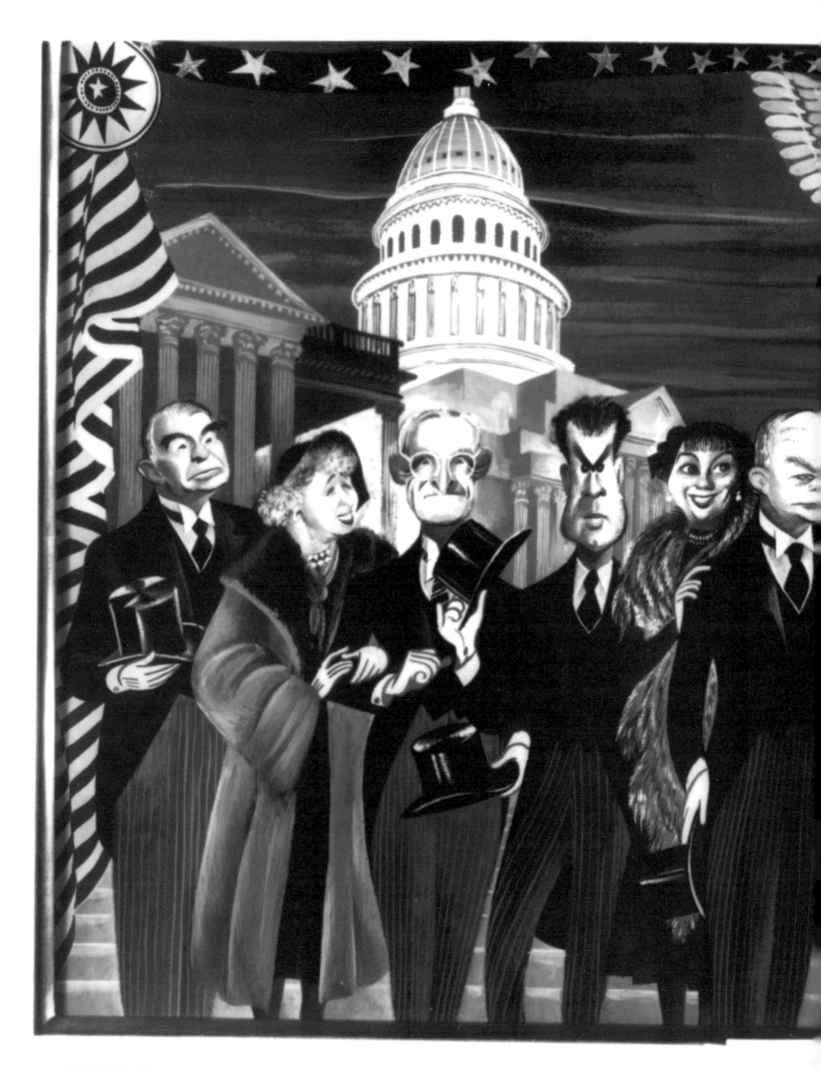

The Eisenhower Inauguration, 1953

Ike's swearing in to his first term of office was an elaborate show that never made it out of Washington to Broadway, but nevertheless was a good-sized hit. I did this drawing for *Vanity Fair*—that's the new *Vanity Fair,* a tribute to Miguel Covarrubias's original conception that appeared in the old *Vanity Fair* of FDR's inauguration. As with my stage work, I tried to capture the character of each person, starting with Truman and his wife Bess, and Nixon and his wife Pat, and Eisenhower, of course, and the Chief Justice. I think I pretty much did them all justice. That look of ominous foreboding on Nixon's face wasn't so much prescience on my part as a case of character being destiny. The medium of the drawing, by the way, is something called gouache. The only other inauguration I covered was Johnson's gala, staged by Richard Adler in 1964. However, I vividly recall the Kennedy inauguration as one of the notable theatrical events of the Sixties. Robert Frost read his poem and the rostrum caught fire. FBI security agents rushed to the rescue and in full view of what was up to then the largest assembled TV audience in world history, put out the fire by pouring ginger ale on it. Those really were more innocent times. Left to right: Vice President Alvin Barkley, Bess and Harry Truman, Richard Nixon, Mamie and Dwight D. Eisenhower, and the Chief Justice, swearing.

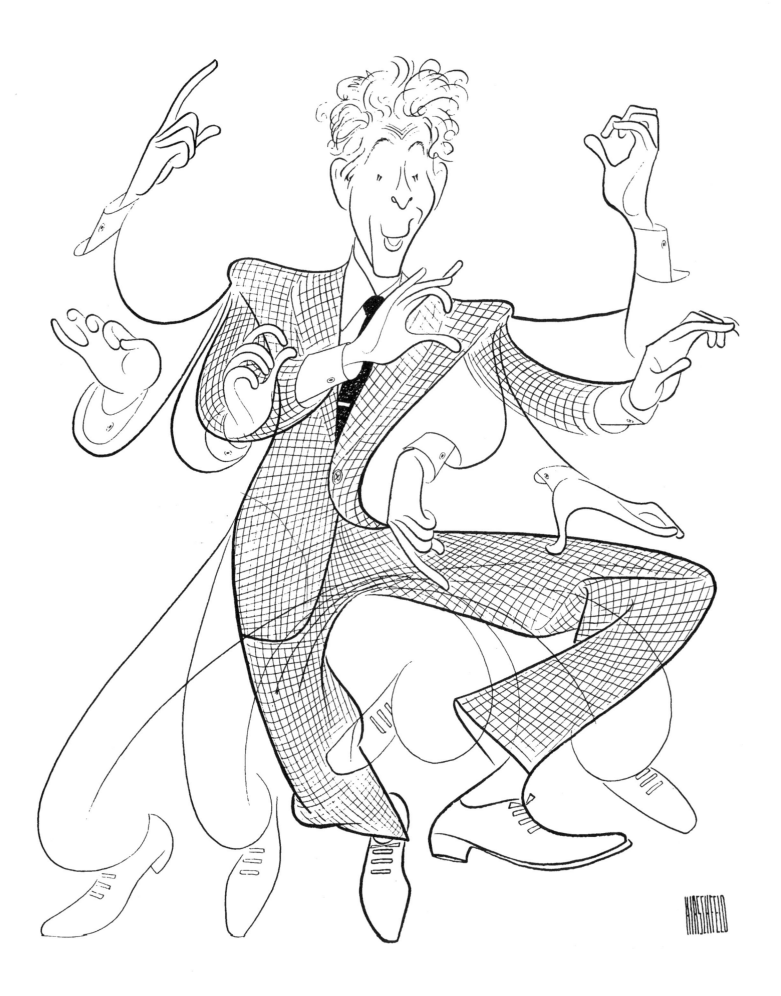

Danny Kaye, 1953

Obviously, I used the many hands and legs to communicate action. Danny Kaye, as we all know, was a bundle of it. This is in a way using animation technique in a single-panel drawing, like watching a few seconds of Mickey Mouse. Kaye was a live-action cartoon, an actor and special effects man all in one, similar to what they say of Jim Carrey nowadays.

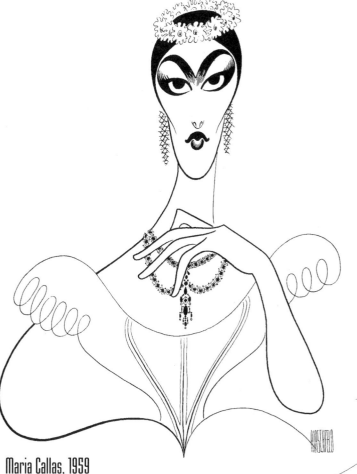

Maria Callas, 1959

I deliberately tried to keep the lines here down to a minimum, in an effort to catch the classical quality of her singing and of her character. Each line is important in telling the story.

Ethel Waters, 1953

A very simple yet emotional drawing. The hands, again, express everything about her. It's true I lean toward those characters who leap off the stage and the page, but every now and then a quiet drawing like this can be equally powerful. A mere "hello" from Ethel's emotional voice would make me feel cozy.

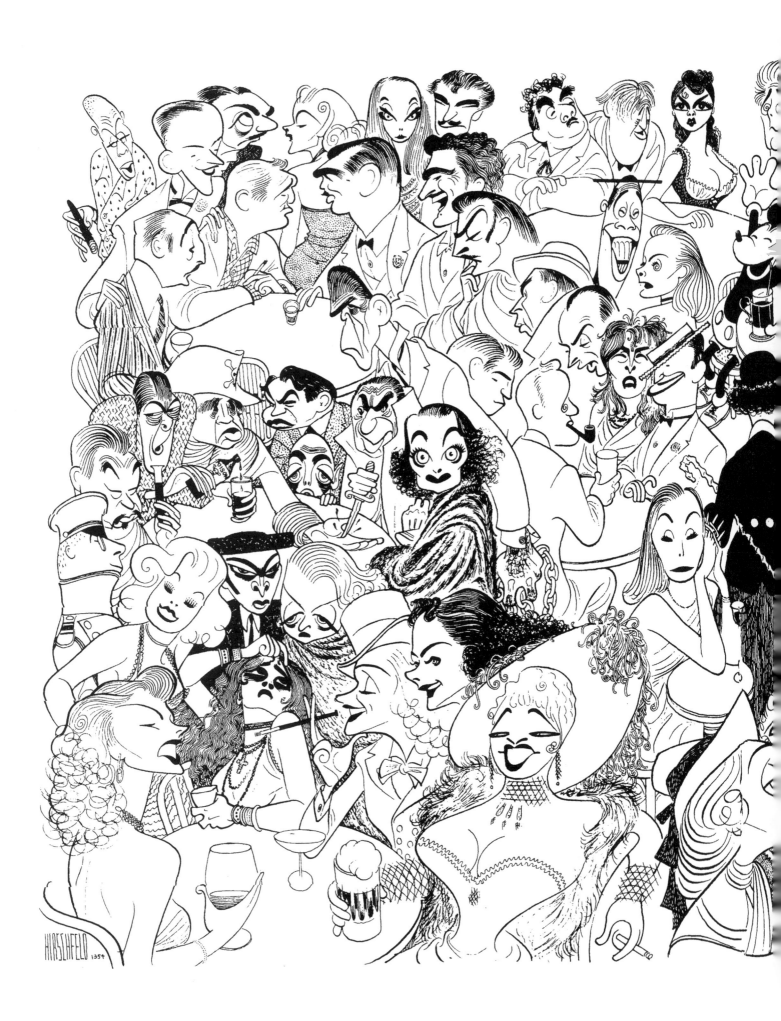

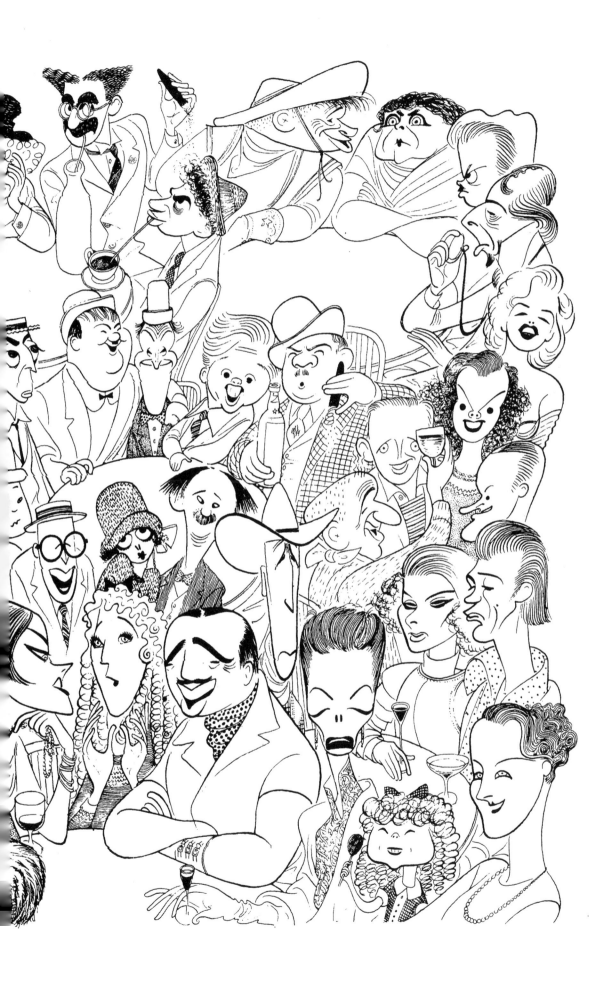

History of the Movies, 1954

Patience is what is required for a complicated drawing like this. It's the research and the correlating of all the material that's the hard work. Doing the drawing itself wasn't difficult, but figuring out how to get everybody on there was an interesting project. It's actually a mural, of American movie stars, that I did for Fifth Avenue Cinema. (My drawing was enlarged photographically to twenty feet wide for the entrance to the cinema.) You start in the lower left with the screen sirens, the vamps, and above them are the screen villains, all trying to knock each other off. And, well, you just have to follow it around all the way to the legendary aristocracy of Hollywood at lower right. I think everyone pretty much knows who everyone is by now. If not, a full listing of the names is available from me for a slight service charge . . . (Rumor has it that my Gallery has the legend.)

TV Personalities of 1954

And this mural historically depicts the state of television up to this time. I think I got all the big TV stars in, including the refrigerator. That was the great thing about television. It made celebrities out of our appliances. Joe McCarthy is there too, although his show got canceled. And Bishop Sheen, and Edward R. Murrow and roller derby. And wrestling, of course, which looks so much more believable on television, thanks to the camera angles.

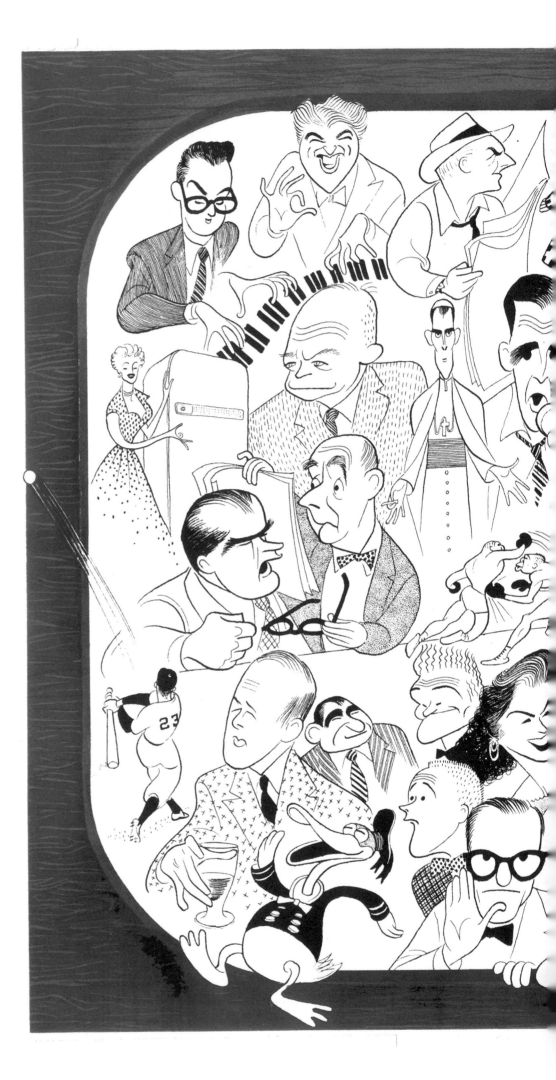

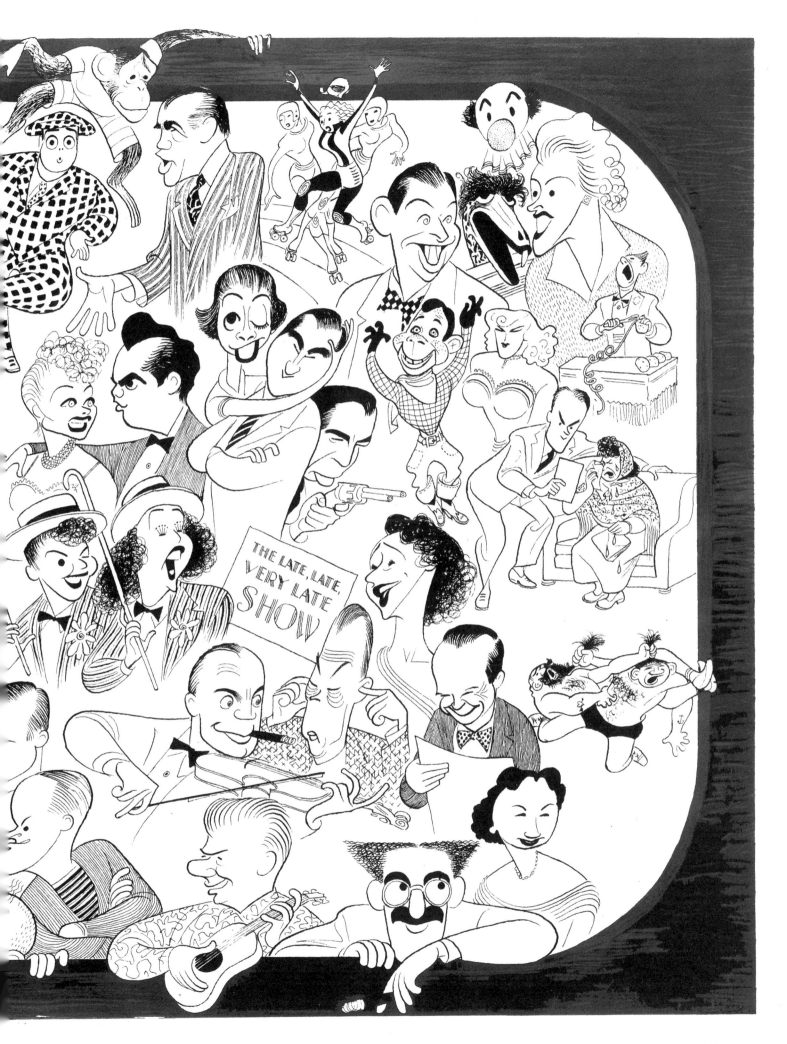

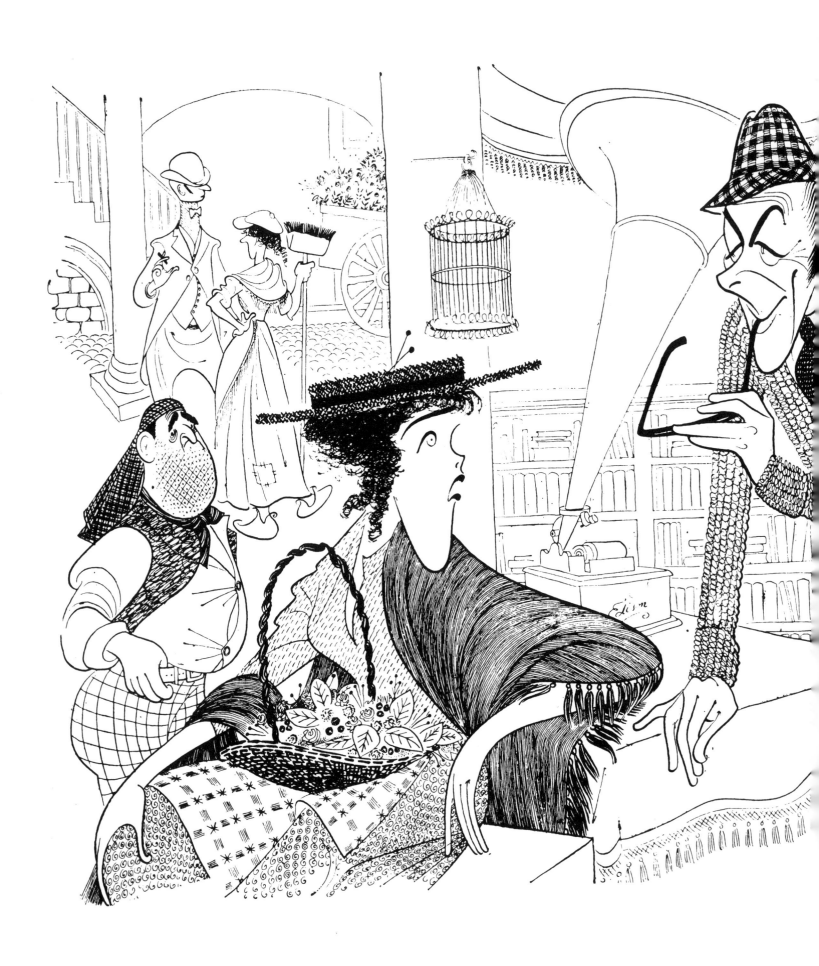

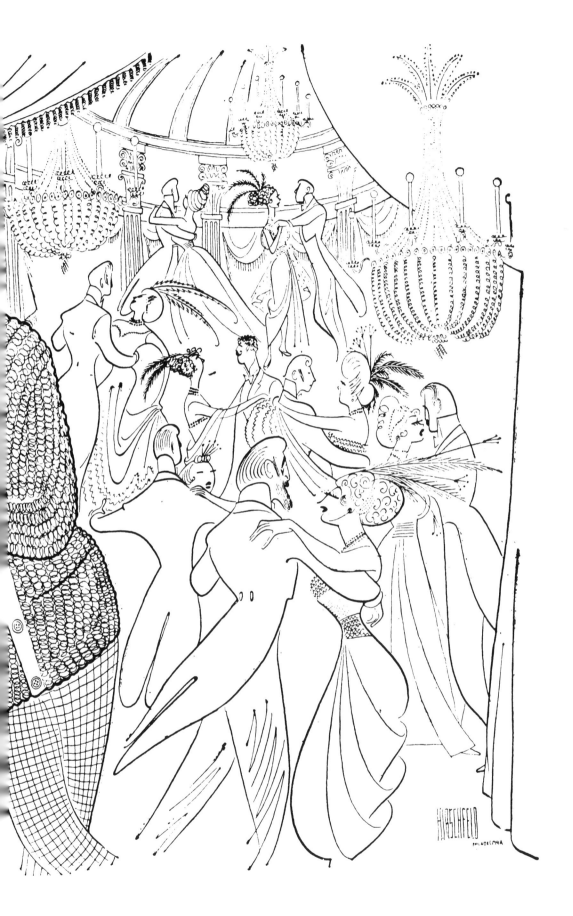

My Fair Lady, 1956

In Lerner and Loewe's classic, Eliza moves from the world of Covent Garden ragamuffins on the left through the megaphone of Henry Higgins' speech lessons to the glamour of the high society ball on the right. That's Stanley Holloway with the stubble on the left, Julie Andrews as Eliza, and Rex Harrison as Higgins. All but Ms. Andrews made it to the screen version, one of the greater artistic injustices of our time. Ms. Andrews is on the cast album, however, as is another well-known drawing of mine showing Shaw operating Higgins like a puppet, who in turn is pulling Eliza's strings.

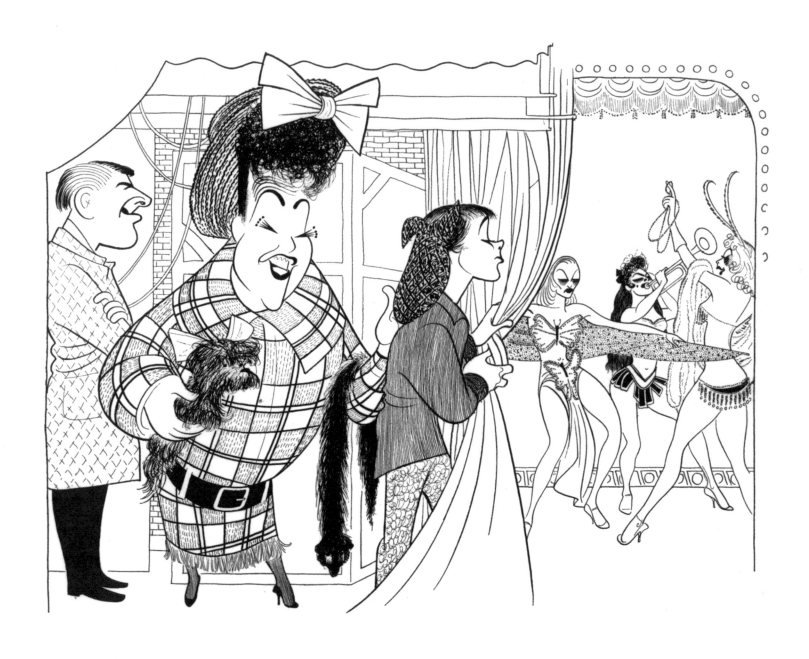

I Am a Camera, 1951

I Am a Camera was based on
Christopher Isherwood's stories of
Berlin. Those tales have inspired a con-
glomeration of plays and musicals, not
the least of which is *Cabaret,* now
back on Broadway in the late Nineties.
That's Julie Harris as Sally Bowles and
William Prince as the hero and
Isherwood stand-in.

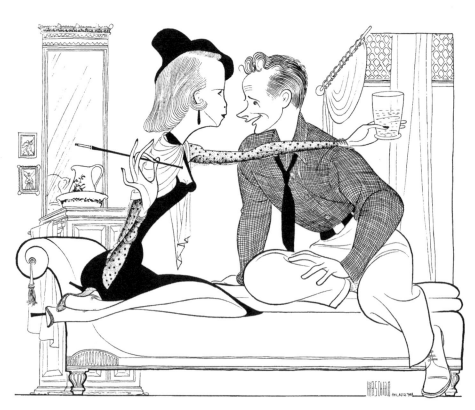

◀ Gypsy, 1959

Gypsy was another of those story ideas that failed to immediately strike one as a sound idea for a Broadway musical. But it worked, and worked beautifully. I didn't even think about it as a musical, really, so well integrated were the songs into the story. It was also a case of the transformation of a huge musical comedy star, Ethel Merman, into a dramatic character role. That's Jack Klugman (making another odd couple with Ethel) on the left, and Sandra Church (peculiar name for a stripper!) as Gypsy Rose Lee. And the three "specialty acts" in the background.

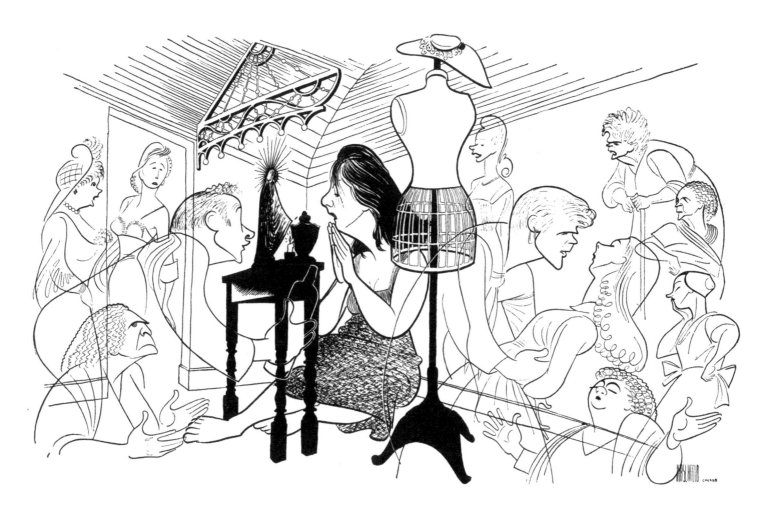

The Rose Tattoo, 1951

I used two symbols to try to convey the sense of this story —the religious symbols and the mannequin. They portray the flip sides of Maureen Stapleton's character in this Tennessee Williams play, the saint and the whore. In fact, I sometimes think about becoming a tattoo artist myself. The production also starred Eli Wallach (holding bottle).

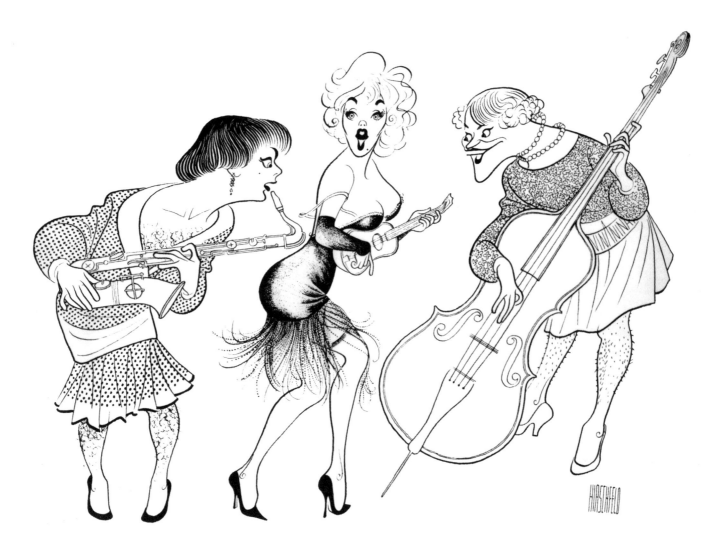

Some Like It Hot, 1959

Here's another specialty-act trio, performing almost as shamelessly as *Gypsy*'s stripteasers. And ogling is what this drawing and this movie is all about, or so it seemed to gaga-eyed me. Tony Curtis and Jack Lemmon in drag ogling Marilyn Monroe. And director Billy Wilder ogling Marilyn Monroe. And us in the audience ogling Marilyn Monroe. What the heck, ogling Marilyn was practically a national pastime in 1959, at the peak of her fame. Incidentally, I did my first drawing from a film in 1921. My method is identical to working in a theatre, sitting on the aisle with a sketch pad. The only difference is I occasionally work from movie stills when I need help with the details of sets and costumes.

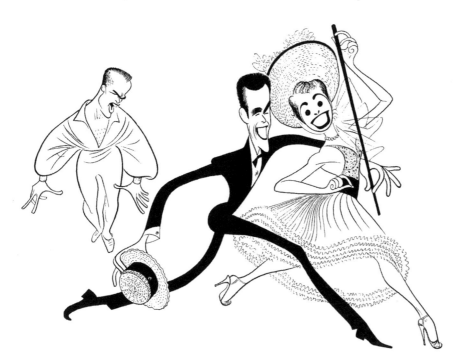

Three For Tonight, 1955

(Harry Belafonte, Marge and Gower Champion)

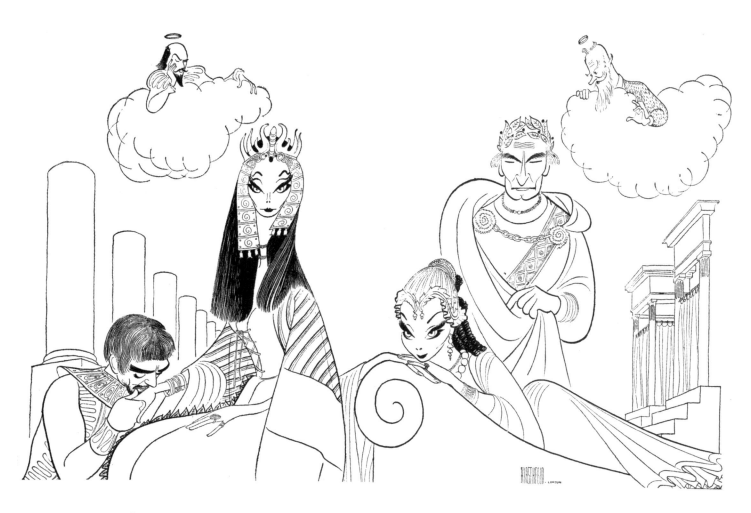

Caesar and Cleopatra / Antony and Cleopatra, 1951

Laurence Olivier and Vivien Leigh on the left, and Laurence Olivier and Vivien Leigh on the right. The two productions played alternate nights, with Olivier as Antony and Caesar, and Vivien as both Cleopatras. That's Shakespeare and Shaw keeping an eye on the competition from the clouds.

The Great Sebastians, 1956

(The Lunts)
Master illusionists ply their trade in this one.

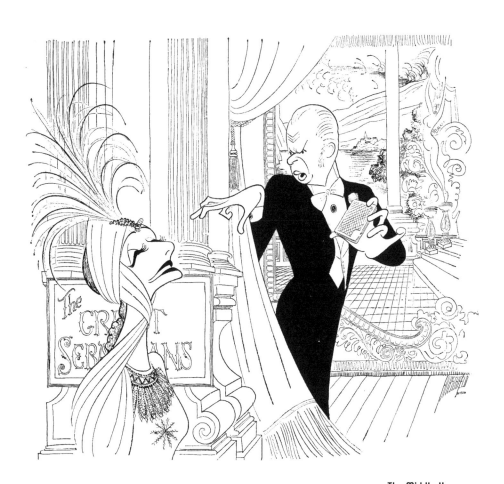

The Visit, 1958

(The Lunts)

Alfred Lunt and Lynn Fontanne were at the end of their illustrious dual career at this point but this production remains in my memory as one of their finest. For those who don't know, they were the most famous Broadway acting couple ever. I'm surprised their name didn't go into the dictionary as a verb—to lunt: to star with your wife on stage. The Dürrenmatt play also is a modern classic and this was a very stylish production. All the eyes in the background is my way of suggesting the anxiety of being under intense social scrutiny.

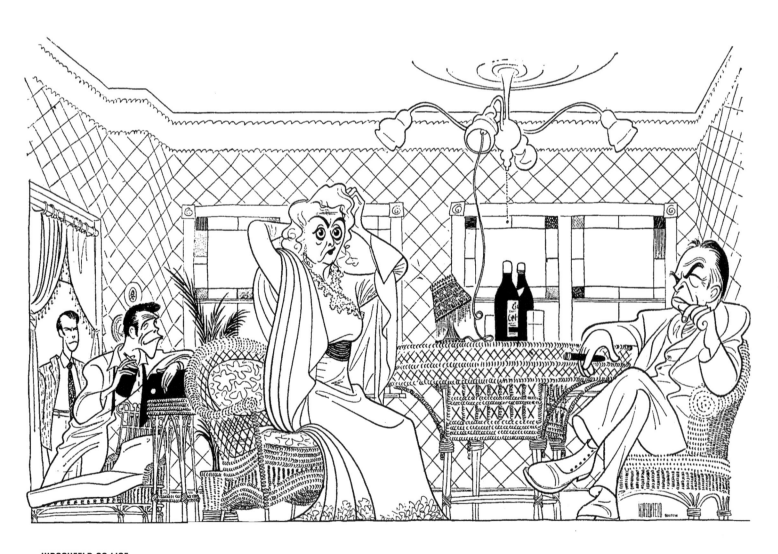

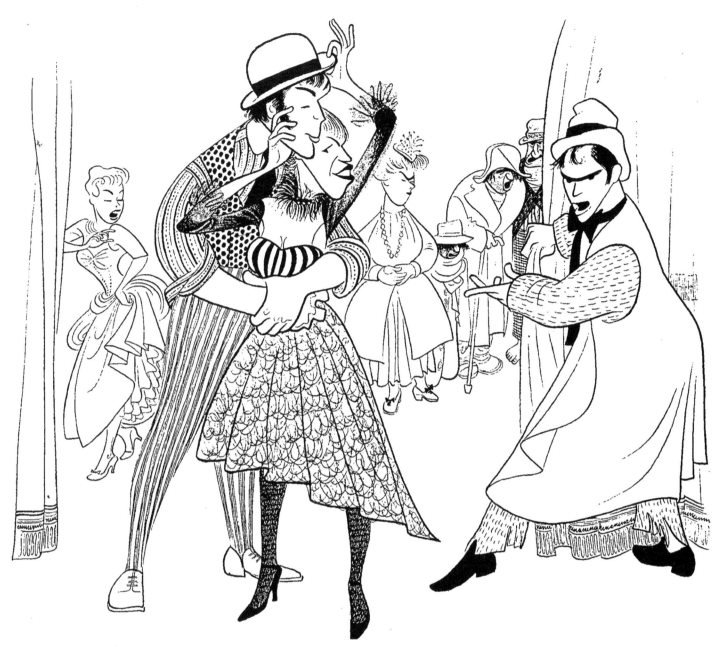

Three Penny Opera, 1955

Turning John Gay's classic 18th century satire, *The Beggar's Opera,* into a musical wasn't that much of a stretch, since it already was one. Gay used popular tunes of his day in his play to mock that new attraction in town, Italian opera. A couple of hundred years later, along came Kurt Weill and Bertolt Brecht, who managed to make the material even darker than it already was. My wife Dolly Haas was in the cast as well in a later version, replacing Lotte Lenya, who is shown here embraced by Scott Merrill. Most people today, oddly, know it from Louis Armstrong's, or Bobby Darin's, rendition of "Mack the Knife." I knew both Brecht and Weill. Kurt was serious with a built-in harmonic scale. Bertolt was facetious with a demonic sense of humor.

◄ Long Day's Journey Into Night, 1956

Florence Eldridge is looking wraith-like here in a diaphanous blouse, as the troubled wife in O'Neill's great tragedy. Freddie March plays the father and that's Jason Robards as his son. Jason later replaced Freddie in a revival of this same play.

Ulysses in Nighttown

Zero Mostel as James Joyce's troubled hero Leopold Bloom. Zero was an absolute original who defied analysis. I don't think he ever imitated anyone.

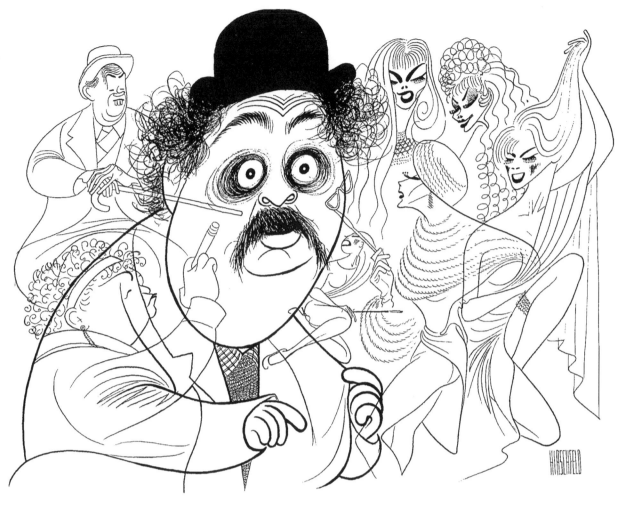

West Side Story, 1957

I'm glad no one came to ask me if I thought *Romeo and Juliet* would make a good musical. *West Side Story* was so full of action that it also lent itself to a vigorous graphic drawing. There was romance, and energetic dancing, plus Leonard Bernstein's score, with an unknown lyricist named Stephen Sondheim. *West Side Story* boasted another Broadway first—the first time a dancer and choreographer, Jerome Robbins, became the director. Sort of a feet first. In the cast: Larry Kert, Carol Lawrence, Chita Rivera, Ken LeRoy, and Mickey Calin.

Marcel Marceau, 1956

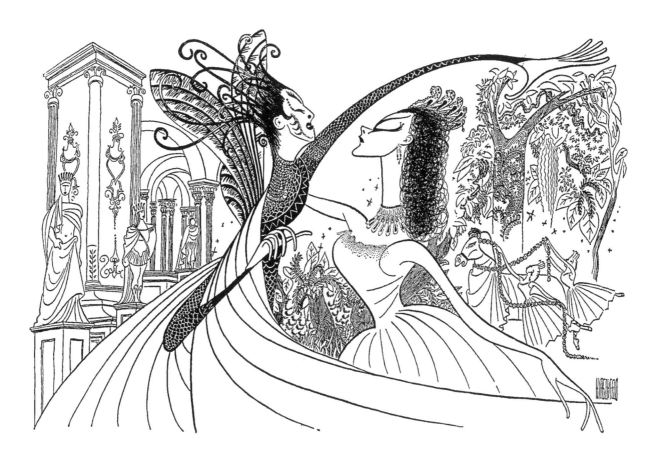

A Midsummer Night's Dream, 1954

Here I came to be very much influenced by the English illustrator Aubrey Beardsley. He made great use of a fine line, and especially of black against white. (Pictured are Robert Helpmann and Moira Shearer.)

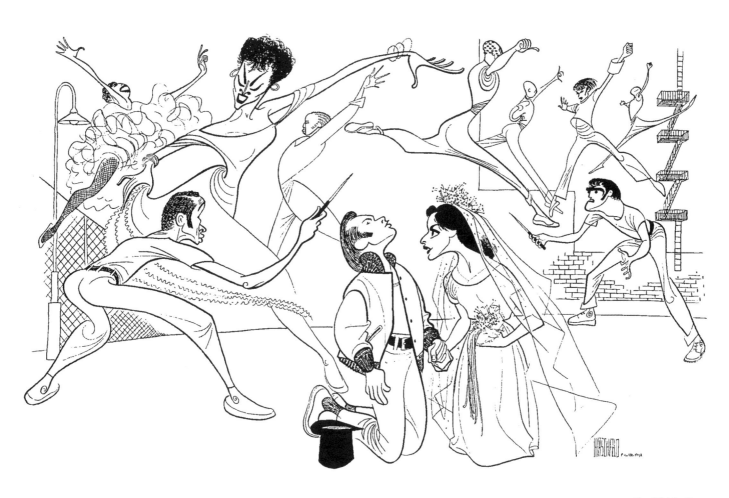

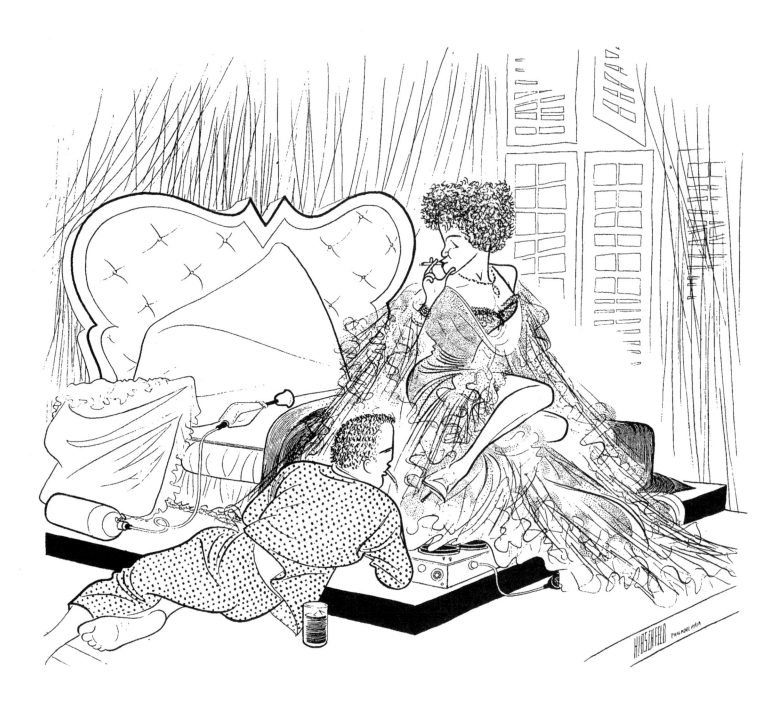

Sweet Bird of Youth, 1959

The props as well as the drawings of the two characters (Paul Newman perched at the feet of Geraldine Page) tell the story, playing off one another. The decadence of Tennessee Williams' play in this drawing spills over with all the physical props, the cigarettes, etc. Williams was a great poet as well as playwright. Poetic images such as his are, for me, the permanent material of great art, defying time and current opinion.

Waiting for Godot, 1956

Everybody claims that comedy is very close to tragedy, but nobody ever proved it as well as Samuel Beckett in *Waiting for Godot*. ("I can't take anymore." "That's what you think.") Here we are with Bert Lahr, the Cowardly Lion himself, a great comedian, but also a tragic figure. He's wearing a kind of clownish uniform that also expresses all the tragedy within him. His fellow tragi-comedians are Kurt Kaszner, Alvin Epstein, and E.G. Marshall. The drawing is also surrealist in its interpretation, in keeping, I hoped, with the tone of the play.

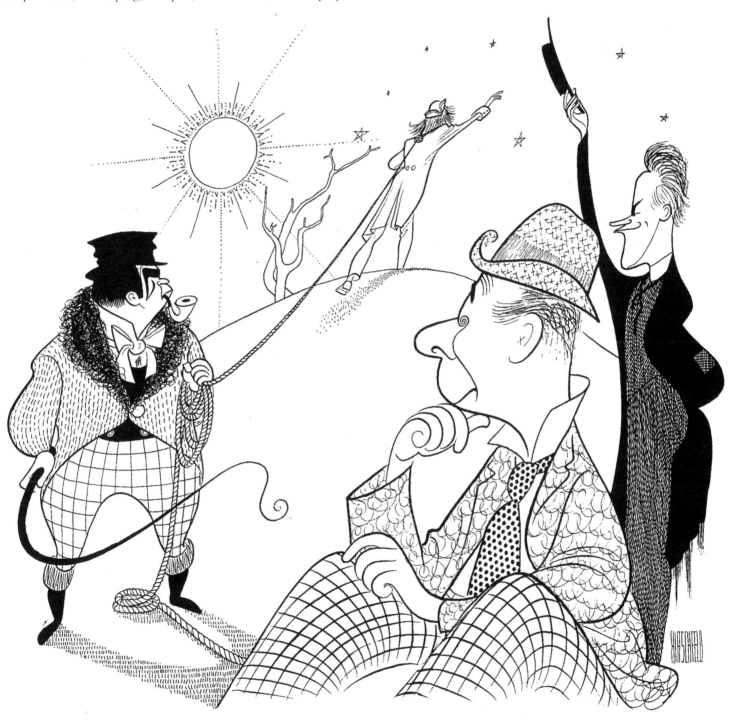

Fanny, 1954

William Tabbert, Walter Slezak, Florence Henderson, and Ezio Pinza add music to Marcel Pagnol's classic Cesar trilogy. Music and lyrics by Harold Rome. Reviewing this drawing, I am overwhelmed at having captured Slezak so accurately.

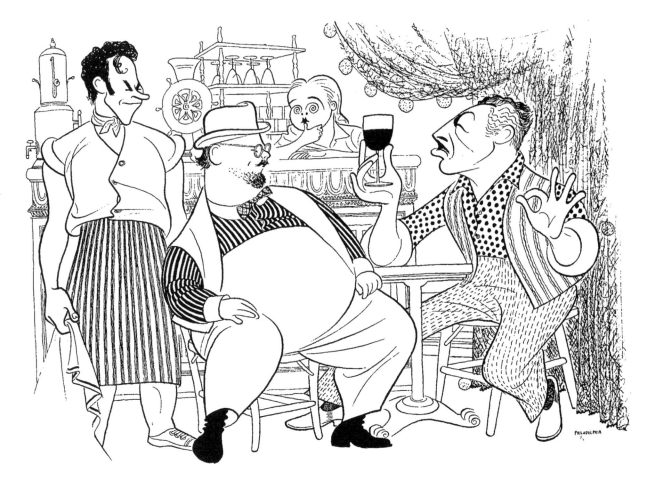

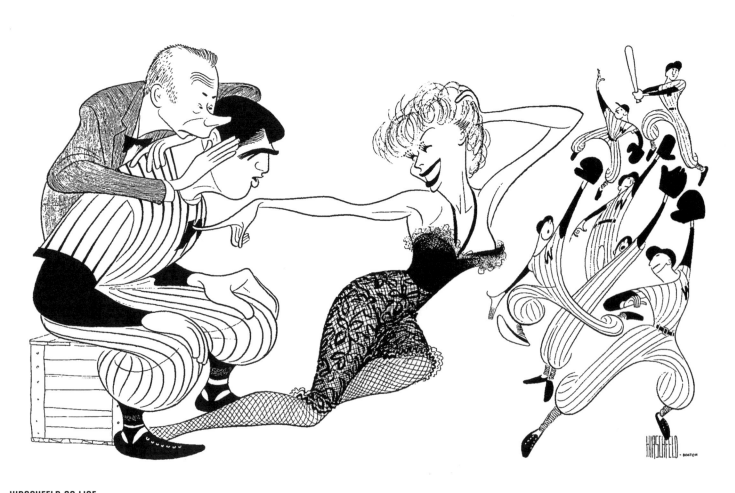

Jamaica, 1957

(Lena Horne)

That hat—it frames her face so beautifully. But it's the figures in the background which tell the whole story of *Jamaica*.

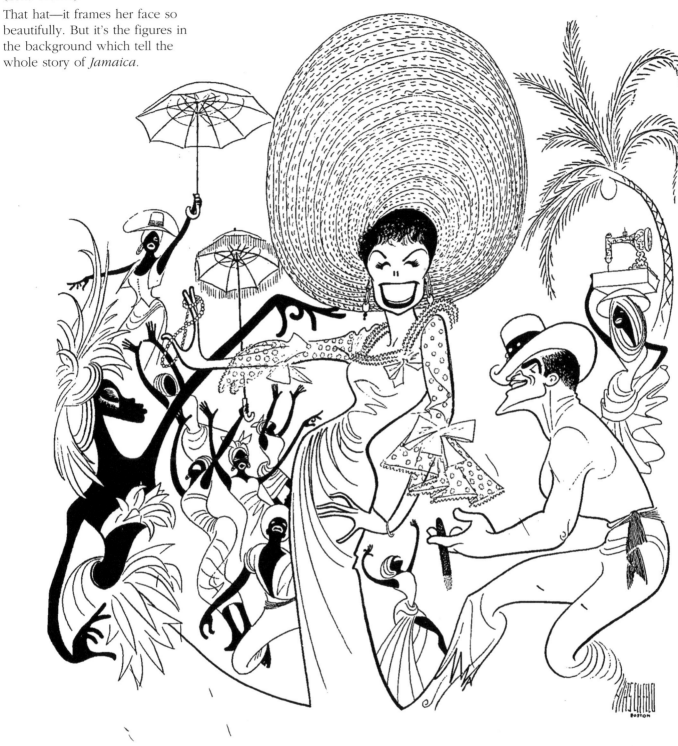

◄ Damn Yankees, 1955

(Gwen Verdon)

Gwen was established on Broadway with this role. And that fishnet-stocking outfit she was wearing was very seductive. If I remember correctly, they had some trouble keeping her in it on the advertising poster. Or rather, on the poster with her in it. The only way to describe her performance is enchanting. Here, the story is told through the satanic character (Ray Walston) whispering, to the Washington Senators player (Stephen Douglass) on the left, to make a Faustian deal, along with the team on the right (the Bob Fosse Players/Dancers), to beat the then perennially unbeatable Yankees. Play ball with me, Satan's saying, and the World (Series) will be yours! For the record, I'm not particularly a Yankee fan, so it was okay with me.

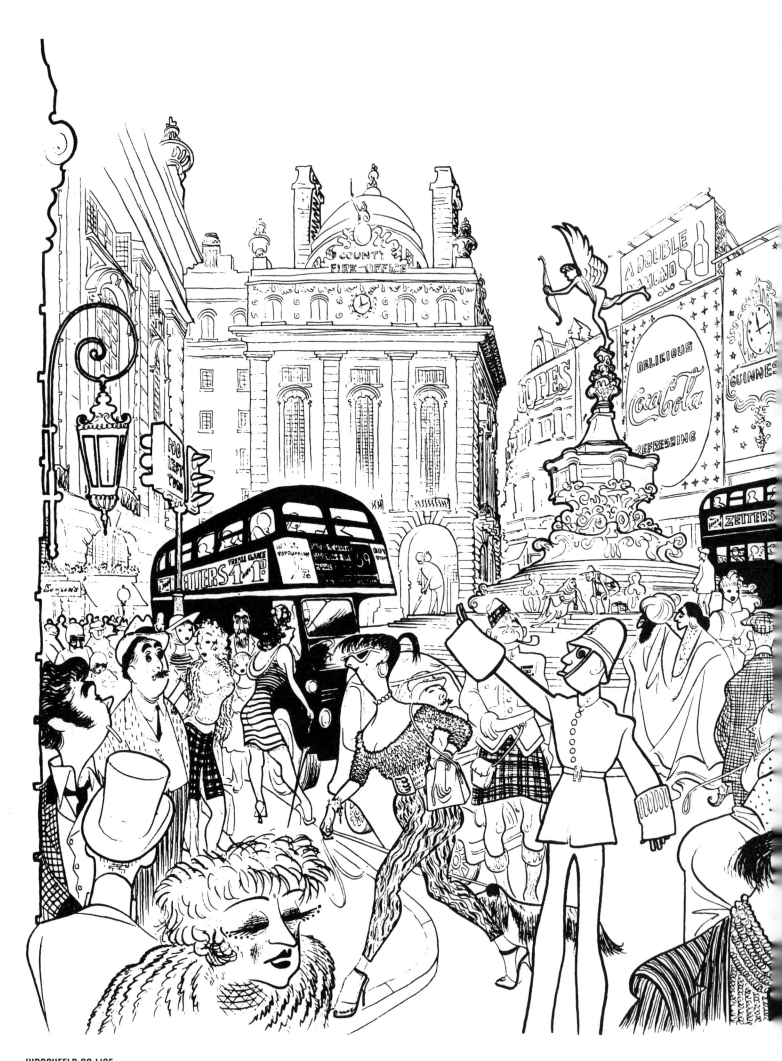

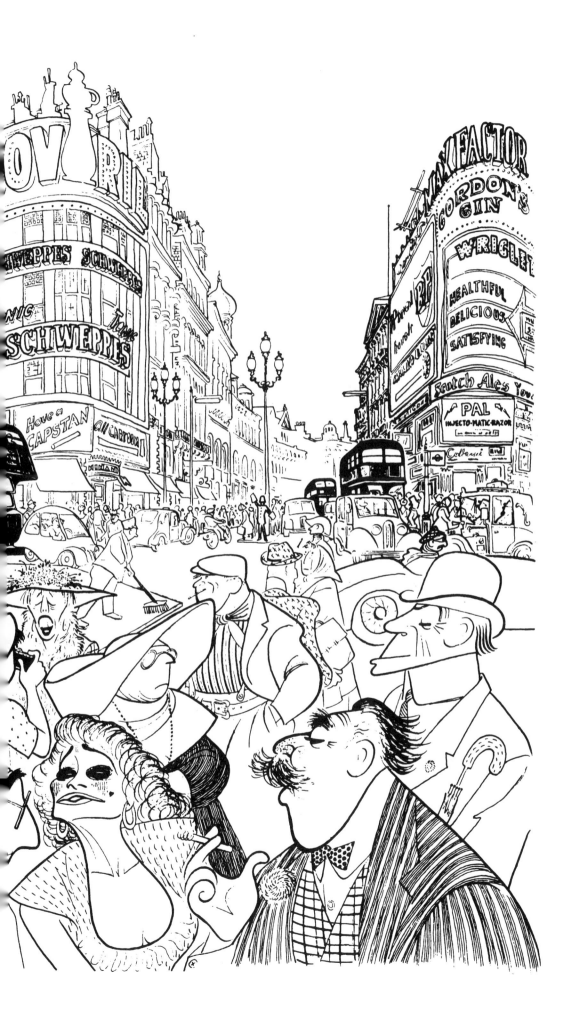

Drop of a Hat, 1959

The big deal about this one is that the producer Alexander H. Cohen hired me to design this curtain, depicting Picadilly Circus in London. It was my only stab at stage designing, largely because it did not require joining the Stage Designers Union. To be a designer in the New York theatre at that time you had to be able to recognize the difference between a great braguette and a G-string; also between a Tuscan pillar, an Ionic column, and a Brass Rail. And you had to have five hundred dollars in cash. Equipped with these essentials, plus an ability to make a drawing in perspective, you were eligible to join the Scenic Artists' Union, Local 829, an affiliate of the Paper Hangers' Union. If you happened to pass the mental and financial tests and were accepted as a full-fledged Local 829 member, the logical consequence of your folly would be that you'd actually be given an assignment to design the sets for a new play. The probability of this extravagant assumption ever happening was about as remote as the growth of a small hand behind your ear.

Off Broadway Audience, 1956

I facetiously put in all the names of all the fellows in the drama department at *The New York Times*. Sam Zolotow, Arthur Gelb, Louis Calta, etc. Brooks Atkinson scans the coming attractions. The guy in the perplexed beard to the right is me. My wife Dolly is down front (with cigarette) draped in a mink stole. They're all in here if you look carefully, in all those signs in the background. If you have the patience. And 20/20 vision.

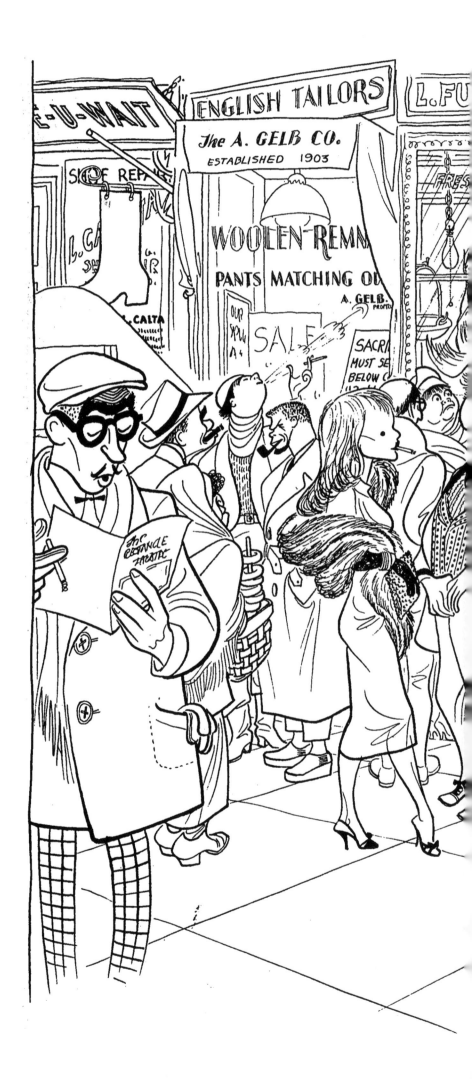

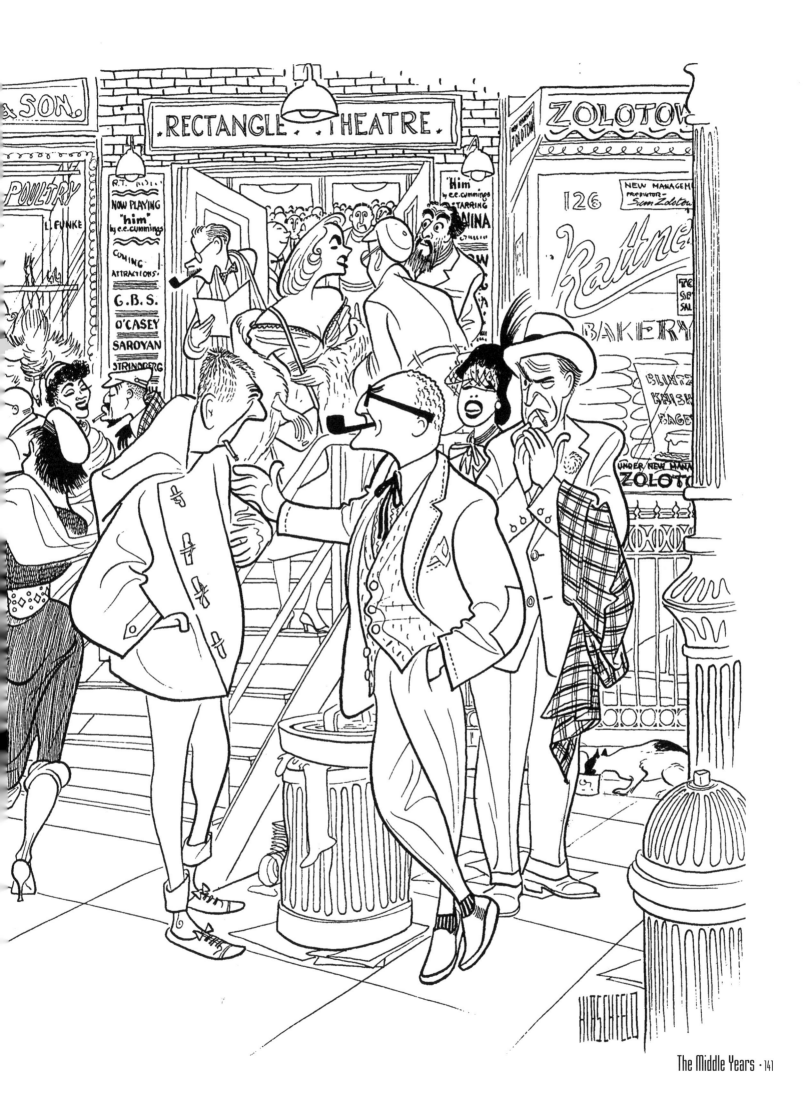

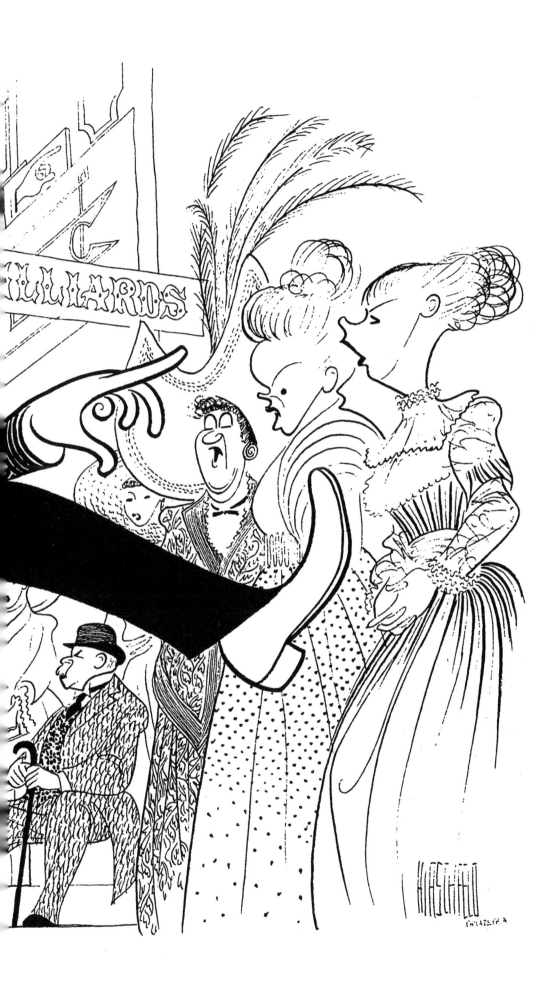

The Music Man, 1957

Bob Preston as melodious conman Harold Hill here stretches like a colossus across the eight (it's six now) columns of *The New York Times,* and for good reason. He was The Music Man, no question about it. In the background are all the other characters from the original production, including Barbara Cook as Marion Paroo, the pretty town librarian who cons Harold into giving up his scams and marrying her. Also in the cast: David Burns, Helen Raymond, and Pert Kelton.

The Entertainer, 1958

(Laurence Olivier)

The chief character of this John Osborne play is, like *Waiting for Godot's* clowns, both a comic and a tragic figure. Larry Olivier was equally adept at portraying both. He had so much fun playing this decadent character falling absolutely apart, at the bitter end of his career in a backwater town. Supposedly the play is about the collapse of Great Britain after World War II, but you'd have to ask Mr. Osborne about that. I enjoyed it too much. Olivier was a master of makeup. I like it too. It helps me delineate character.

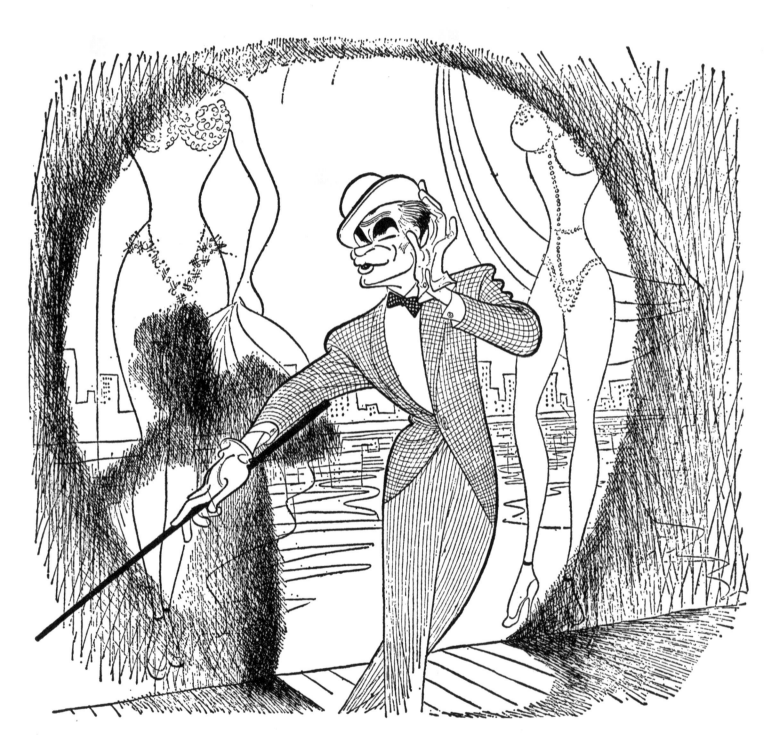

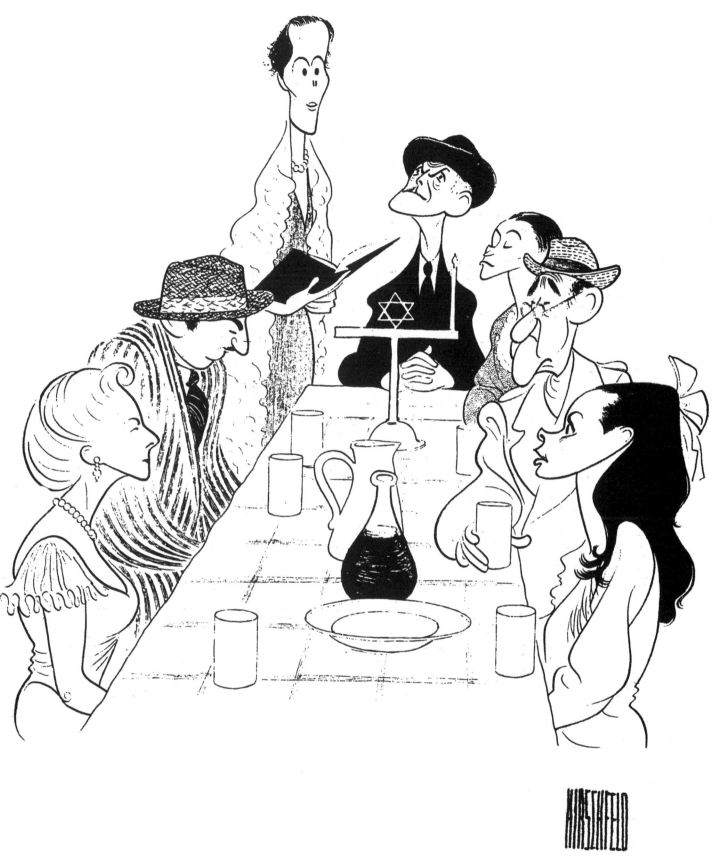

The Diary of Anne Frank, 1955

(Joseph Schildkraut and Susan Strasberg; written by Frances and Albert Hackett)

Here's the opposite of Olivier in *The Entertainer*. Susan Strasberg, lower right, was the daughter of Lee Strasberg, the famed acting teacher, but also a young girl who'd never had a part in a play before. And she did spectacularly well. In fact, it was my wife Dolly who suggested to the producers that they use Susan in the lead. They had, Dolly insisted, to get a girl nobody had ever seen before, because you can't take an actress who's known from last week's drawing-room comedy and put her in as Anne Frank. Dolly knew Susan had come from a theatre background and thought she had talent. And, as usual, Dolly was right. At the table with Susan are Joseph Schildkraut (as Otto Frank), Lou Jacobi, Gusti Huber, Eve Rubinstein, and Jack Gilford.

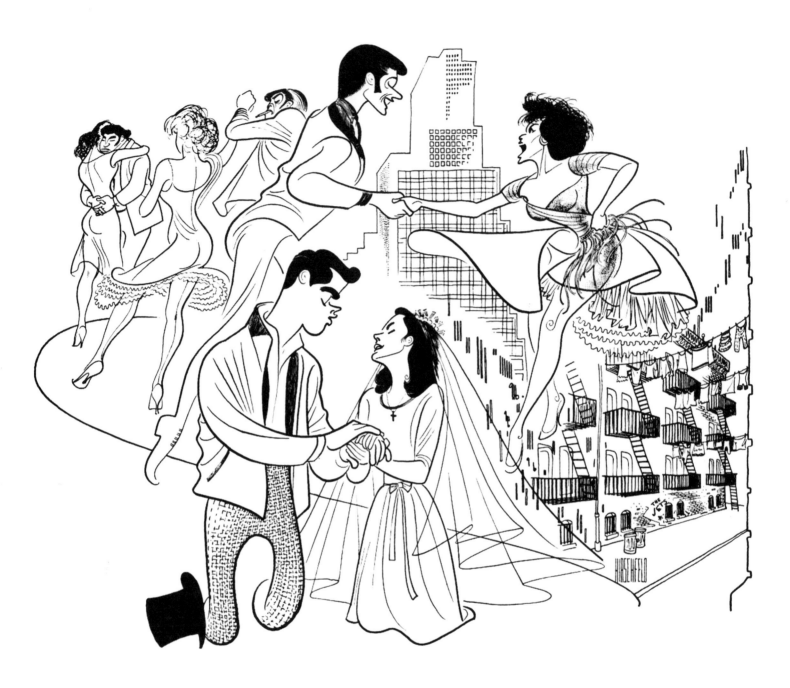

West Side Story, 1961

The film version, directed by Robert Wise, was just as successful and groundbreaking as the stage production, with George Chakiris, leader of the Sharks, dancing to a Latin beat with Rita Moreno on top, and Richard Beyer, reluctant leader of the Jets, getting soulful with Natalie Wood below. The New York City streets and tenements were an equally dramatic, and starkly poetic, element.

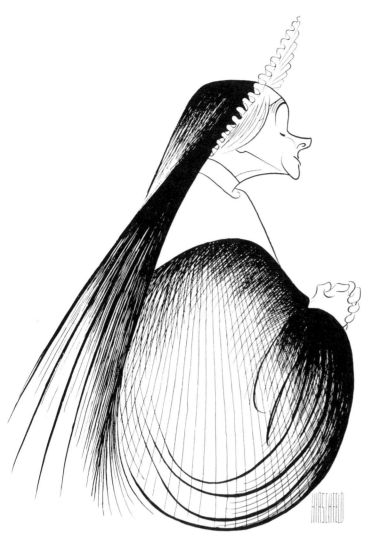

Helen Hayes, 1960

(in *The Velvet Glove*)

Abe Burrows, 1988

I first met Abe when he was entertaining at parties. I met him at the home of the Hacketts (Albert and Frances, authors of *The Diary of Anne Frank* and many screen credits for M-G-M) in California, where he introduced lyrics of his own making, such as "Dolly with the three blue eyes" and other such insanities. He had some pretty big successes on stage, too. He co-wrote the libretto of *Guys and Dolls*. He also had hits with *Can-Can, Silk Stockings* and *How to Succeed in Business Without Really Trying*. He looks suitably relaxed and wry here, being the life of whatever party he's at, not pausing even long enough to knock the ash off his cigarette.

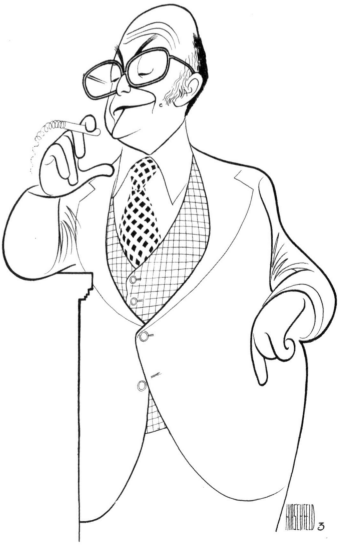

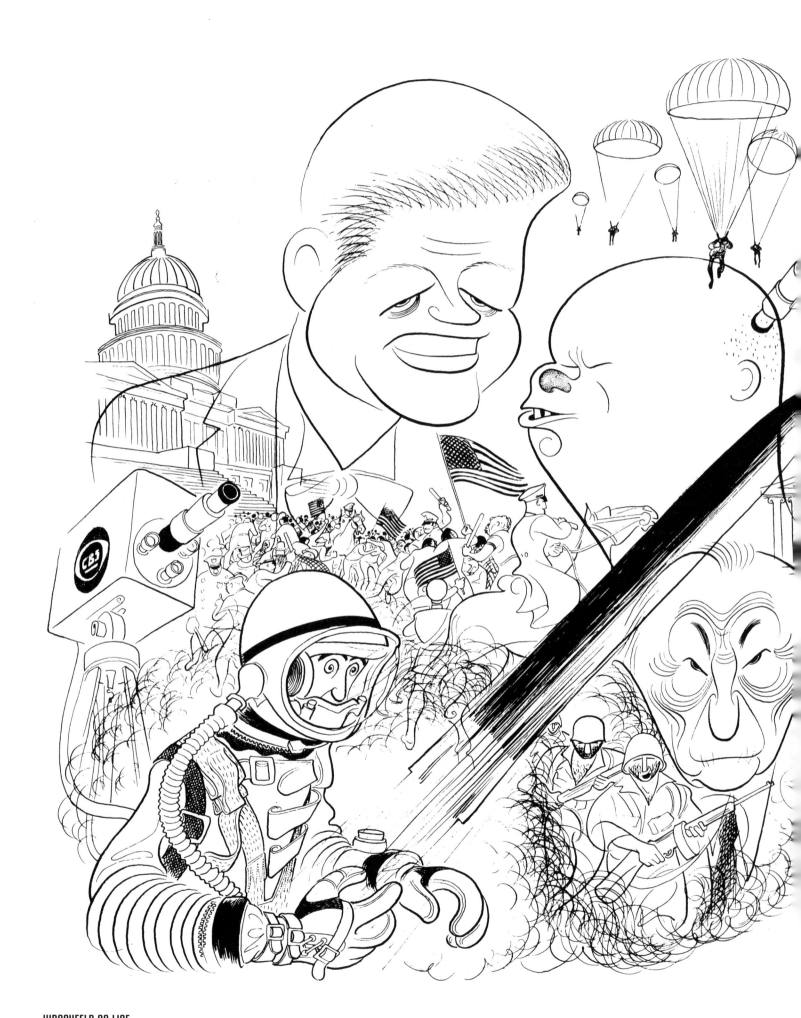

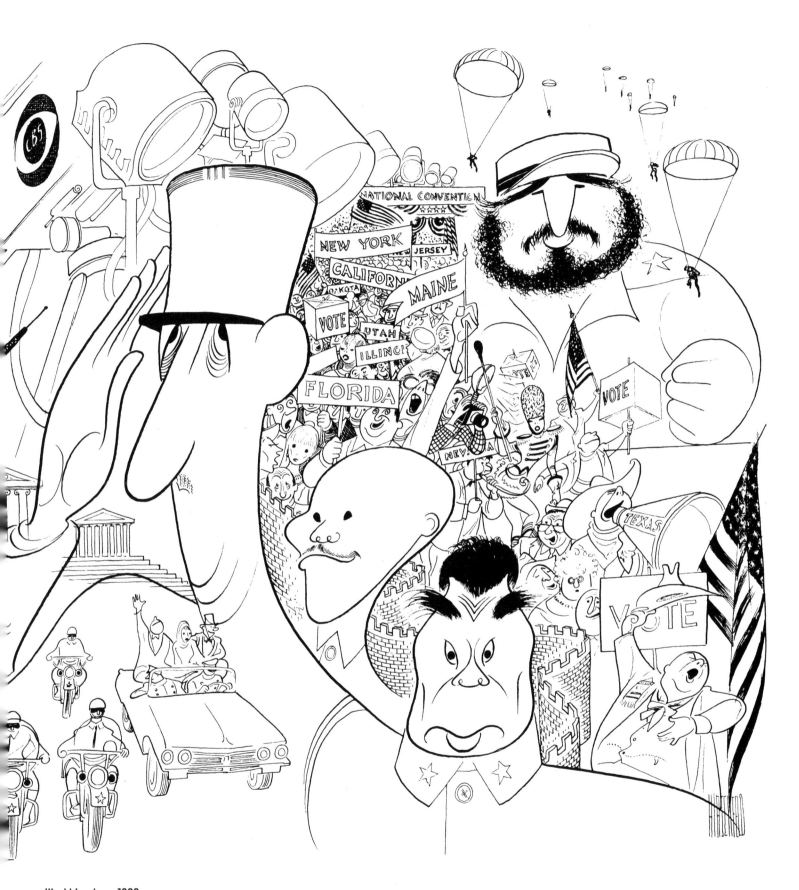

World Leaders, 1962

When you look at these leaders, these monumental figures, isn't it amazing that almost forty years later we don't have this kind of leadership in any of our countries today? John F. Kennedy, Nikita Krushchev, Konrad Adenauer, Charles de Gaulle, Chiang Kai-shek, Chou En-lai, and Fidel Castro. Even Castro is getting fatigued. CBS certainly seems to be getting good product placement here, reporting all the big stories of the day. Maybe it's television that has replaced great world leaders.

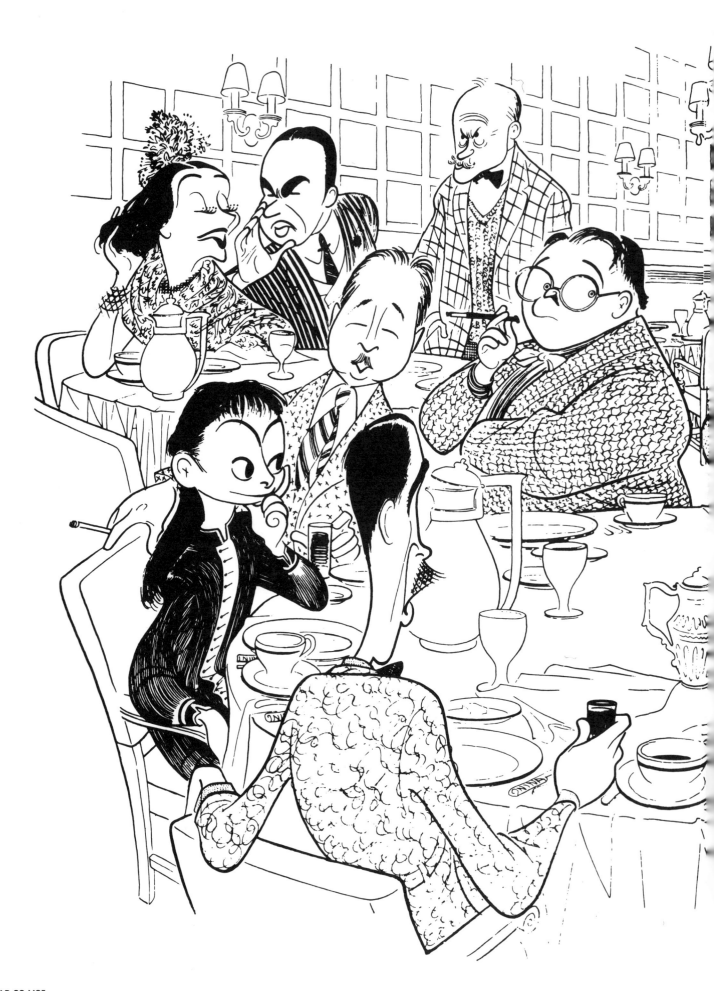

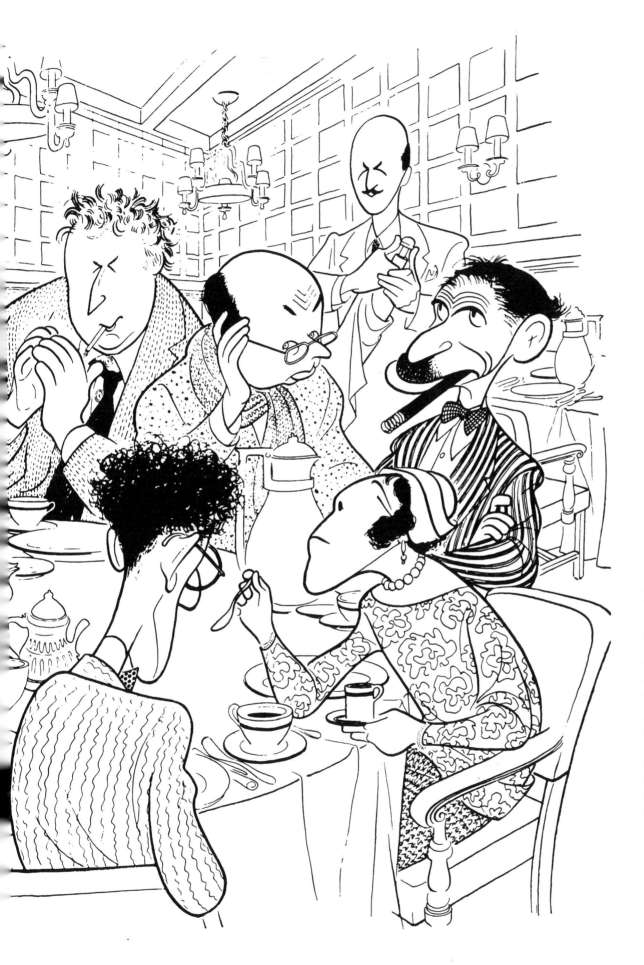

Algonquin Round Table, 1962

Not only have the wits of New York's Algonquin Round Table all disappeared, it sometimes seems as though wit itself has gone with them. This drawing recalls a time when it was wonderful to be a writer in New York City. Or an artist. I never attended the luncheons as a bona fide participant, but I happily went to many as a voyeur. Not that I ever ate much; I was sketching constantly. Here are the regulars, the everyday knights of the round table. Robert Sherwood, Dorothy Parker, Robert Benchley, Alexander Woollcott, Heywood Broun, Marc Connelly, Franklin P. Adams, Edna Ferber, and George S. Kaufman. In the outer ring, also looking on, are Alfred Lunt and Lynn Fontanne, Frank Crowningshield, and the Algonquin's host, Frank Case. As for the food at the round table, the apple pancake with boysenberries, eggs Benedict, and the steak sandwich were the staples.

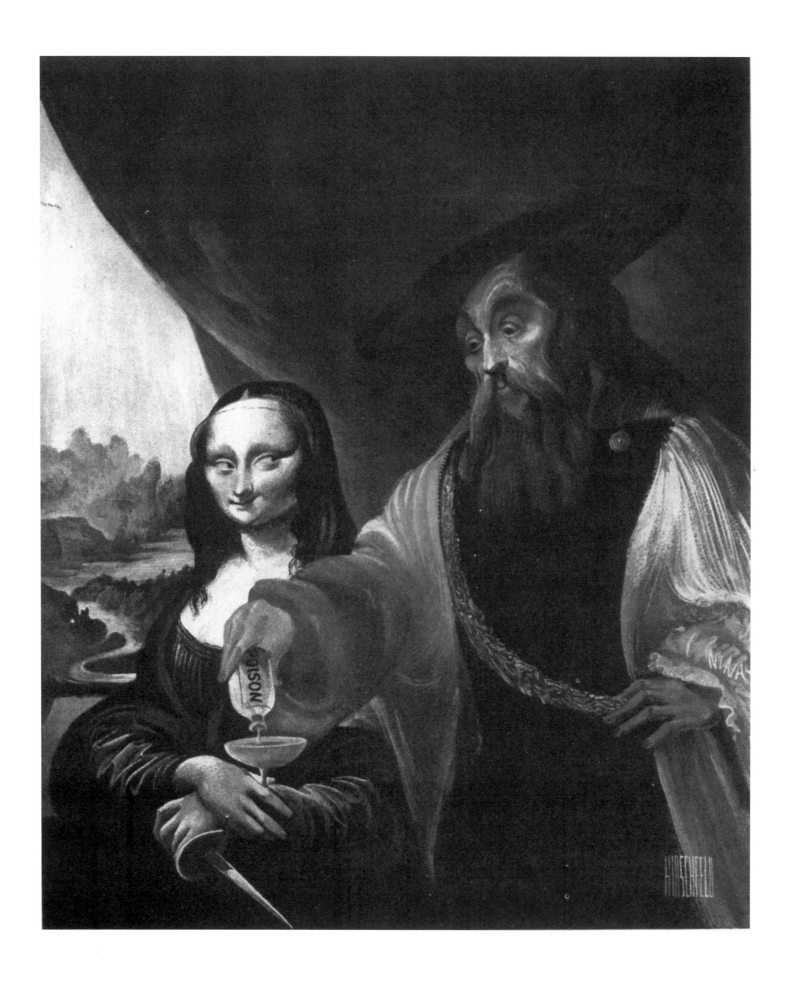

◄ Famous Feud at the Met, 1963

I did a series for the magazine *Show,* including this one, in gouache, on the famous feud between Leonardo da Vinci's *Mona Lisa,* on loan from the Louvre, and Rembrandt's *Aristotle Contemplating the Bust of Homer* at the Metropolitan Museum of Art in New York. Mona won hands down, as it were, pulling in over a million people in a line that stretched three blocks long, more than doubling the museum's usual monthly attendance. Rembrandt and Aristotle are taking out their revenge here, but it was Mona who had the last smile. Later, the Met bought my painting as part of their permanent collection. The lines to see it have reportedly diminished.

Hello, Dolly!, 1964

(Carol Channing)

Carol Channing claims I discovered her in the chorus of *Lend an Ear* and featured her in the drawing I did for the *Times.* I don't remember doing it. She remembers it with great clarity, and maybe that's enough. However, I think it also explains Carol's star power and success—her ability to create this fantasy version of her own legend. Carol is one of the few performers of that time who invented themselves, especially here in her most famous and most plumage-filled role of Dolly Levi. I merely copied her original design of herself.

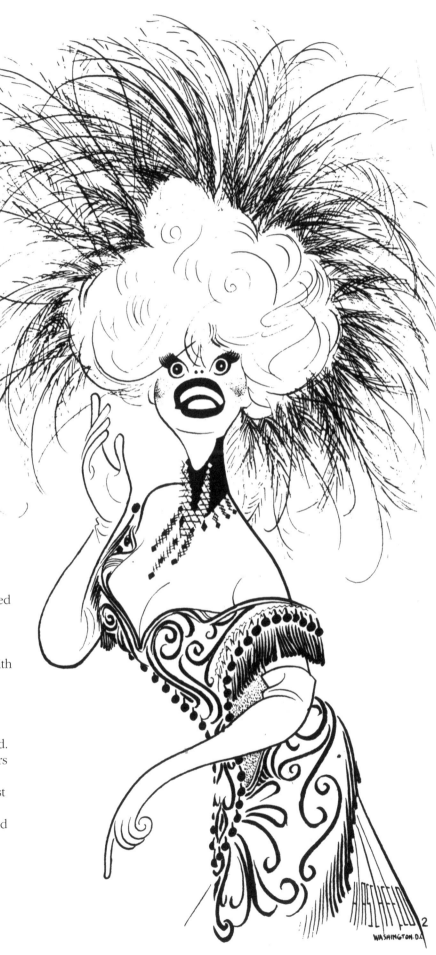

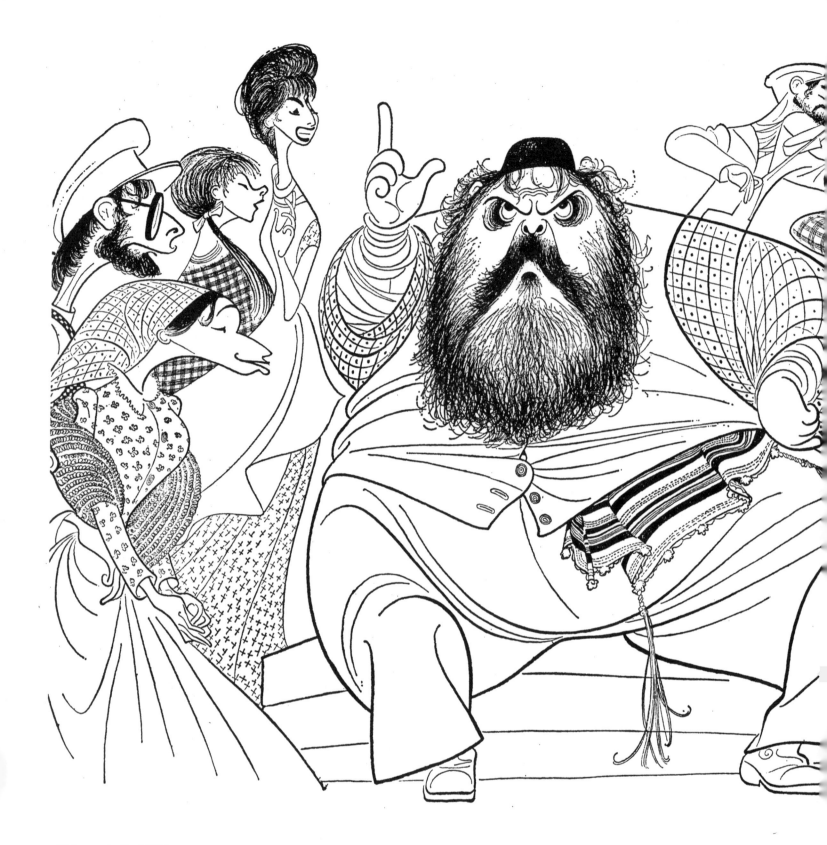

Fiddler on the Roof, 1964

(Zero Mostel)

You might think the vest on Zero Mostel buttons the wrong way. I did too. When I looked at my sketch sheets I thought, Well, I made an error when I did the original sketch in the theatre. I called up Boris Aronson, the designer of the show, and said, "Boris, in my drawing you probably notice that the vest buttons the wrong way." He said, "No, no. That buttons the right way. That's the way they buttoned the vest in those times." This proves that I always strive for historical accuracy in my drawings. You'll probably also notice that the fiddler here is not on a roof but coming out of the pattern of Tevye's shawl. I did that to keep him in the imaginary dimension he occupies in the play. He's the one who symbolically keeps everyone alive with his music. And the music was such an integral part of *Fiddler* that it was part of the very fabric. Surrounding Zero as Tevye are Julia Migenes, Austin Pendleton, Tanya Everett, Joanna Merlin, Gino Conforti (with the fiddle) and Maria Karnilova. The unsung heroes of this show for me, though, were Boris, a great designer fluent in the Yiddish of Sholem Aleichem, and Jerome Robbins, the choreographer.

Judy Garland, 1963

Judy Garland's performance at the Palace concert was sold out, with people hanging from the rafters. As for the drawing, it's a good combination of solid blacks and line. I liked the idea of the one eye and the nose and the other eye just disappearing into that black hat and glove. It captures how far Judy had come by this time from that yellow-brick road or that house on Kings Highway in *Meet Me in St. Louis.*

Burton & Taylor, 1960's

Eyes were big in the early Sixties—big eyelashes, big eyebrows, big eye shadow. And nobody's eyes were bigger and more beautiful than Liz's and Dick's. Their orbs communicate their personalities. Of course, they don't seem to have eyes for each other here. I think I took them from two different shows at this time, but in any case I was really only interested in drawing them. His cable-knit sweater and her headband sort of describe an era, don't they?

Rhinoceros, 1961

(Zero Mostel, Eli Wallach; produced and designed by Leo Kerz)

Zero Mostel was incredible in Eugene Ionesco's satire *Rhinoceros*. Mostel actually turned himself into a snorting, stomping rhinoceros before, as the saying goes, your very eyes—and without resort to additional makeup or stage props. Unbelievable, you say? I know, but the transformation was absolutely convincing. He became a rhinoceros. Much, I might add, to the playwright's dissatisfaction. Ionesco grew rather beastly himself, because Mostel refused to wear an animal mask over his head. The author returned to Europe without even attending the opening. But Zero quite rightly insisted upon his characterization, because it worked beautifully. Just ask Eli Wallach, who had to confront him on stage every night. It was one of those shows you really didn't want front row seats to, just in case Zero got too far into the act. The producer announced before opening that he would not quote any reviews from the critics to promote the production. He thought audiences should judge the play for themselves. Of course, the reviews were all raves and Zero never got his due. That's show business for you.

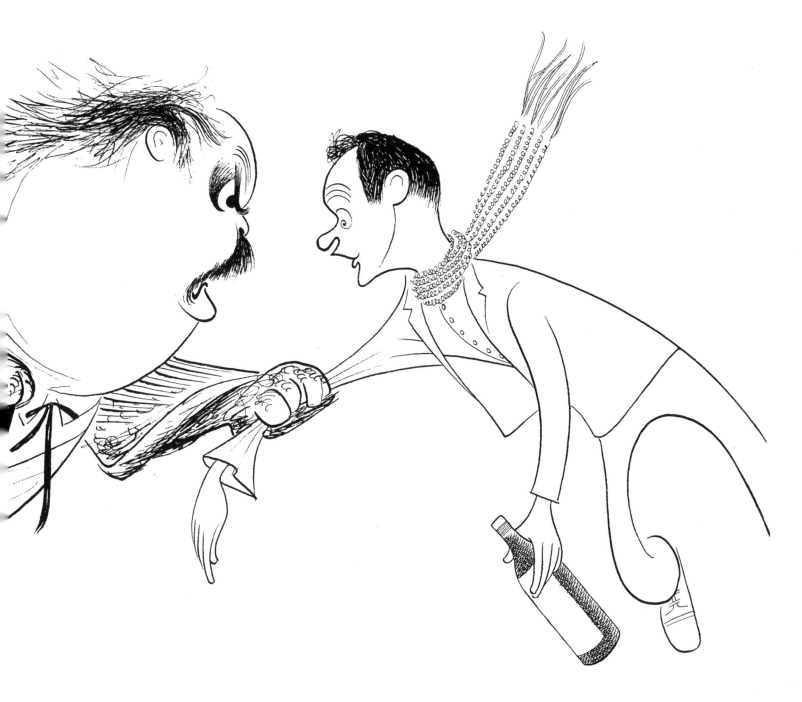

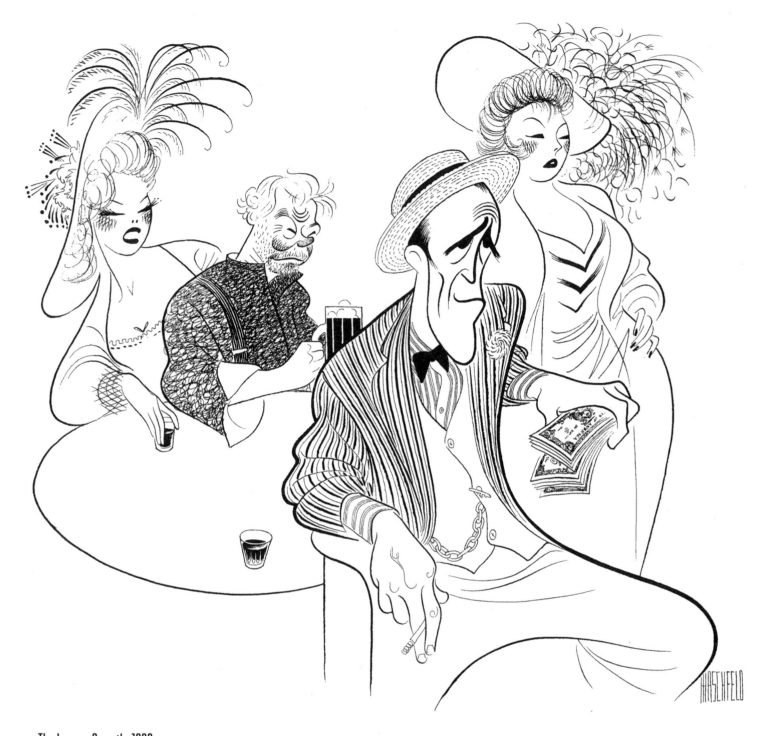

The Iceman Cometh, 1960

(Jason Robards, Myron McCormick/TV)

O'Neill's classic drama was the Play of the Week on television in 1960. This was one of ten drawings reproduced for inclusion in a Folio of *Play of the Week* productions. The Folio later became a collector's item.

Hair, 1968

(Jerome Ragni)

Hair was a revolt against organized society that really cleaned up at the box office. It was a revolutionary musical, both in subject matter and music. I tried to get its sense of abandon into this drawing—like the top character thumbing his nose at the audience, and the viewer. I remember people at the time expressing amazement that I could be "with it." I don't know why. It seems to me you have to be in step with your time in order to do anything in the theatre. And if anyone has a close association with lots of hair it should be me. For those who may be wondering if I've ever been shocked by a Broadway show, the answer is yes—*Oh, Calcutta!* Which then ran for sixteen years.

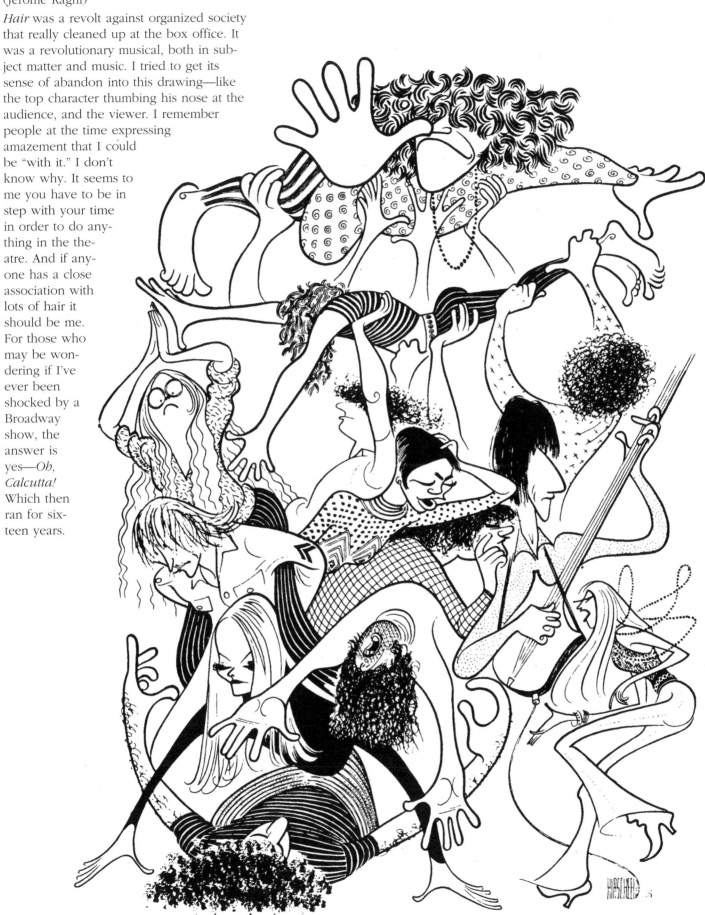

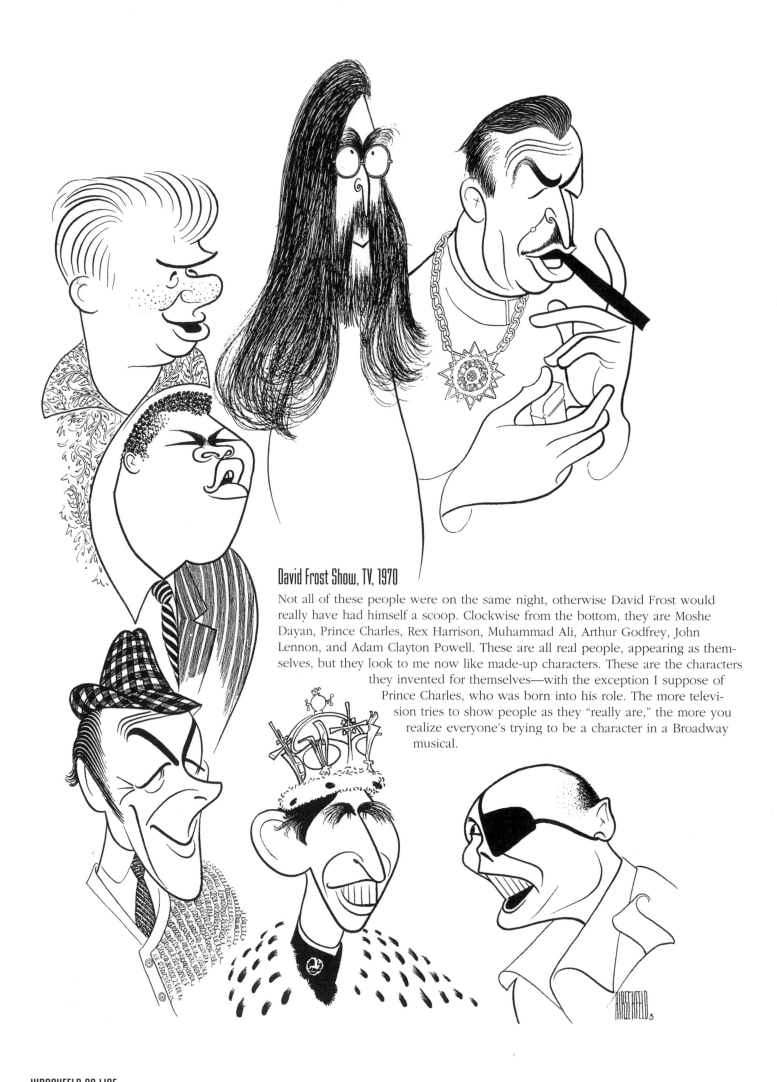

David Frost Show, TV, 1970

Not all of these people were on the same night, otherwise David Frost would really have had himself a scoop. Clockwise from the bottom, they are Moshe Dayan, Prince Charles, Rex Harrison, Muhammad Ali, Arthur Godfrey, John Lennon, and Adam Clayton Powell. These are all real people, appearing as themselves, but they look to me now like made-up characters. These are the characters they invented for themselves—with the exception I suppose of Prince Charles, who was born into his role. The more television tries to show people as they "really are," the more you realize everyone's trying to be a character in a Broadway musical.

Pablo Picasso, 1961

When I was living in Paris in the early Twenties Picasso used to come around to the Rotund, which is across the street from Le Dome. In this drawing I had fun portraying him as he might have drawn himself. Picasso, I find, is a marvelous caricaturist himself in his work.

Becket, 1960

(Laurence Olivier, Anthony Quinn)

Irreplaceable. Laurence Olivier plays the title role, with Anthony Quinn as his friend and opponent Henry II, on Broadway. However, Olivier—in his usual quixotic way—switched to Henry II on alternate nights.

Counter Culture: Zabar's, 1971

Zabar's was and is *the* delicatessen on Manhattan's Upper West Side, something like the Metropolitan Museum of Art for cold cuts. It's the place where everybody who was anybody in New York had to go. It's a very densely packed place, both with people and with salami, and I tried to get all of that detail, such as all the hams and cheeses hanging from the ceiling, in along with each personality. Who are, left to right, Sam the counterman, Dwight Macdonald, Joseph Heller, Ted Solotaroff, Norman Podhoretz, Irving Kristol, Murray Kempton, James Wechsler, Jack Gelbert, Jason Epstein, Eli Wallach and Anne Jackson, Meyer Levin, Irving Howe, Robert Silvers, Wilfrid Sheed, and Alfred Kazin. If you know who all those people are, you are either a social historian or you live in the neighborhood. I've been known to appear in Zabar's myself, but my favorite New York deli is the 2nd Avenue Deli.

The Great White Hope, 1970

James Earl Jones and Jane Alexander in *The Great White Hope.* Two wonderful actors who really made great names for themselves in the theatre. Jane Alexander later became the head of the National Endowment for the Arts, and is since retired and back in the theatre. Washington, D.C. is a tough place for unelected actors. Which leads to the question of my own opinion about public arts funding. With the arbitrary closing of the Federal Theatre (WPA sponsored) production of Marc Blitzstein's *The Cradle Will Rock,* I began to distrust the wisdom of making Washington politicians oracles of art. Nothing since this outrageous decision has persuaded me that they've acquired any new wisdom. Having said this, however, I am still all for the public funding of the arts. I don't believe in its capacity to produce anything except economic survival for the artist, but I'm all for that.

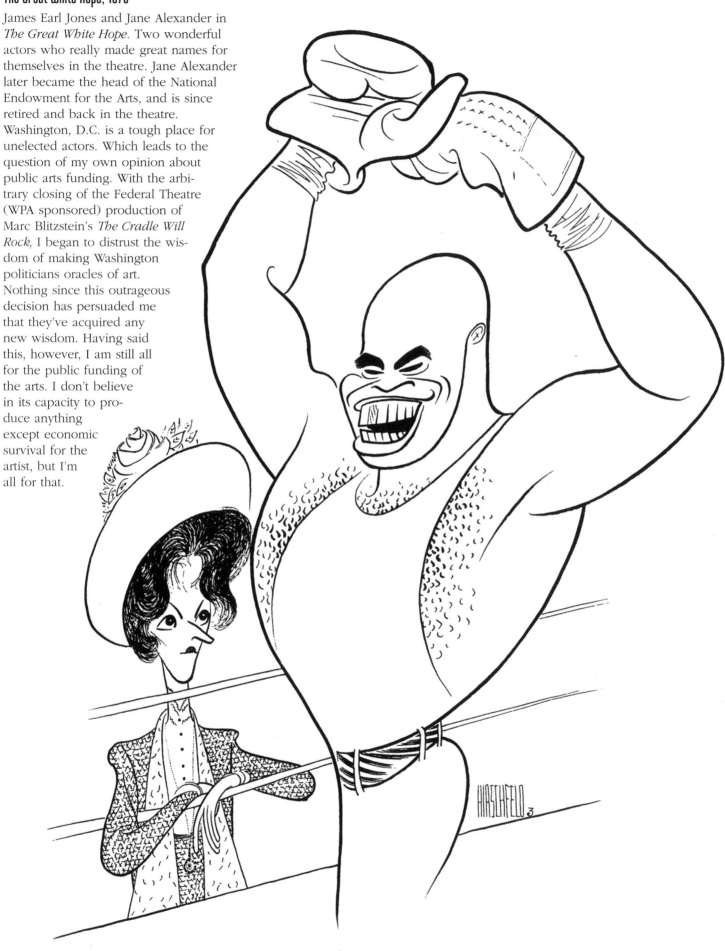

Noel Coward

I'd hoped to comment here on Noel's kind of humor and acerbic wit. He certainly looks disapproving enough here, of something. It probably doesn't matter much what. He was my favorite sophisticated, as opposed to purely comic, playwright.

Jack Paar

A dear friend with a short fuse and a great sense of humor, and probably the most unique entertainer TV has ever produced. Jack Paar, for those with short memories, was the man after Steve Allen and before Johnny Carson on the *Tonight Show*. He may not have had the zany humor of those other two, but he was a great raconteur. As his expressive hands and side-of-mouth delivery here indicate. I think he may be wearing the only cardigan sweater in this collection.

S. J. Perelman & Nathanael West

The satirist S. J. Perelman (below) was a great friend of mine, and Nathanael West (left) was his brother-in-law. Sid Perelman and I collaborated on many books together, went around the world together, and wrote "that" musical together. He probably had the most extensive and arcane vocabulary of any English-speaking person ever, and his casuals in *The New Yorker* were masterpieces of mind-bending linguistic tongue twisting, often involving some intrigue in an ice cream parlor. His personal creative tragedy was that this exquisite literary style didn't translate to the stage (as he and I discovered together in Philly). He once wrote of himself that his pastime was the raising of turkeys, which he occasionally exhibited on Broadway.

Nat started out as a Pinkerton agent, as well as the manager of The Sutton Hotel on 56th Street that was, thanks to Nat, wonderfully forgiving when it came to putting up starving artists, such as Dashiell Hammett (another Pinkerton man), Lillian Hellman and all of their acquaintances. Later, West went West to Hollywood, where he wrote *The Day of the Locust*. He died tragically young.

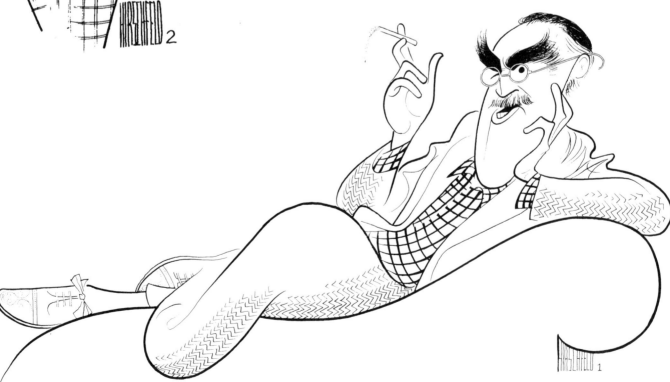

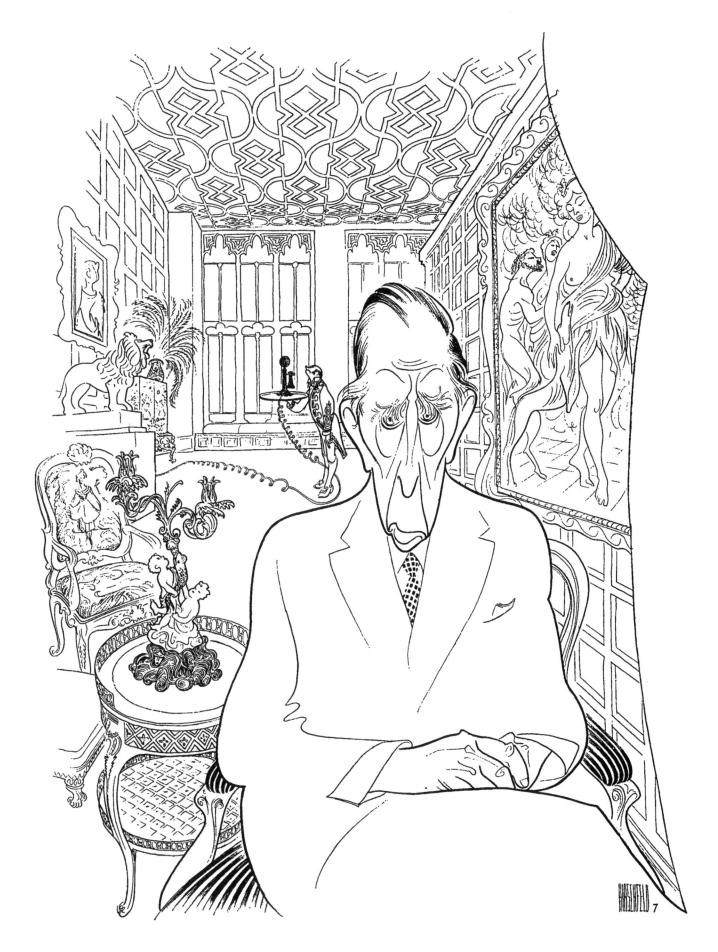

J. Paul Getty, 1974

Surrounded here by the baubles he accumulated during a lifetime, Getty doesn't look very happy. I don't imagine he was very happy. He's not having as wild a time as the people in the painting in any case. He collected great art, and great furniture, all fueled by his gas stations. Fill-'er-up and help J. Paul buy a Picasso. One gets the feeling he was trying to make up for some perceived personal cultural lag there.

To date, the Getty Museum has yet to acquire any of my own work.

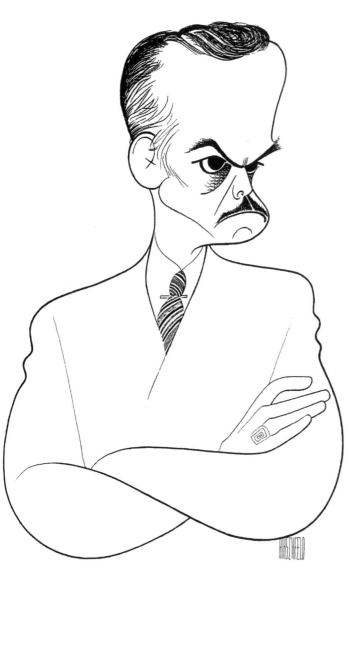

Arthur Miller & Eugene O'Neill, 1974

These are the two leading playwrights of our time, though these drawings were done for different publications. Miller (below) seems to be having the better time. The drawing of O'Neill (left) must be from after he got married. He and I used to go to 52nd Street two or three nights a week in the speakeasy days to listen to great jazz pianists. He was just enchanted with that kind of music. But after he got married he was difficult to get in touch with. I think his wife didn't want him hanging around with the boys. That's when he was writing his great plays, so maybe he was better off staying home and writing. Or, we're better off for it, anyway. He does look here like a little boy who's just been sent to his room to finish his homework.

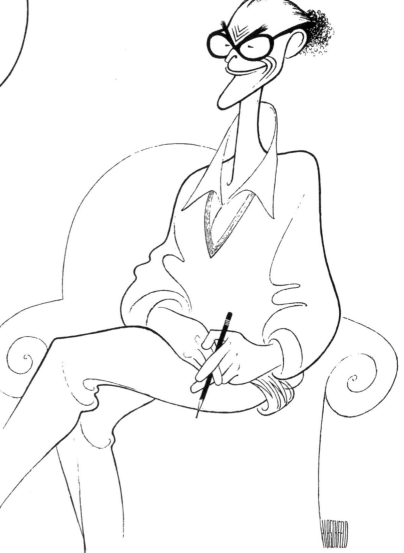

Paddy Chayefsky, 1973

There are those who say that Paddy had a contentious nature. I can only give you an example from my own acquaintance with him. One Sunday evening I was driving him downtown in New York in an open convertible. It was a lovely summer's evening and he was saying, "My gosh, this is the only way to see New York. It's just beautiful." Then we were driving along Mulberry Street and a bag of water came out of a window and hit Paddy. He turned around angrily on me and said, "How can you drive in an open car? You're a lunatic!" Also, I still can't decide whether his eyeglass frames or his hair was the thicker.

George Burns, 1974

George Burns was an original, no question about it. He somehow managed to be a perennial young man, all the way up to age 100. He was more than just a stand-up comic. He had a real profound sense of the time he was living in and of what made him tick. This drawing was done from a concert stage he shared with Carol Channing.

The Front Page

(film version: Billy Wilder, Jack Lemmon, Walter Matthau, and Carol Burnett)

This version of the oft-mounted Hecht-MacArthur play was done on film by Billy Wilder, with three of the greatest film comics ever. I managed to get in a small drawing of Nina along with her name on the back wall. The murderer in the play may or may not be inside that roll-top desk. I leave that up to the imagination of the viewer. I knew *The Front Page*'s former-newspapermen authors, Ben Hecht and Charles MacArthur, but I never knew any real Hildy Johnsons, male or female, on any of the papers I worked for. Maybe Stanley Walker. No, on second thought, cancel that.

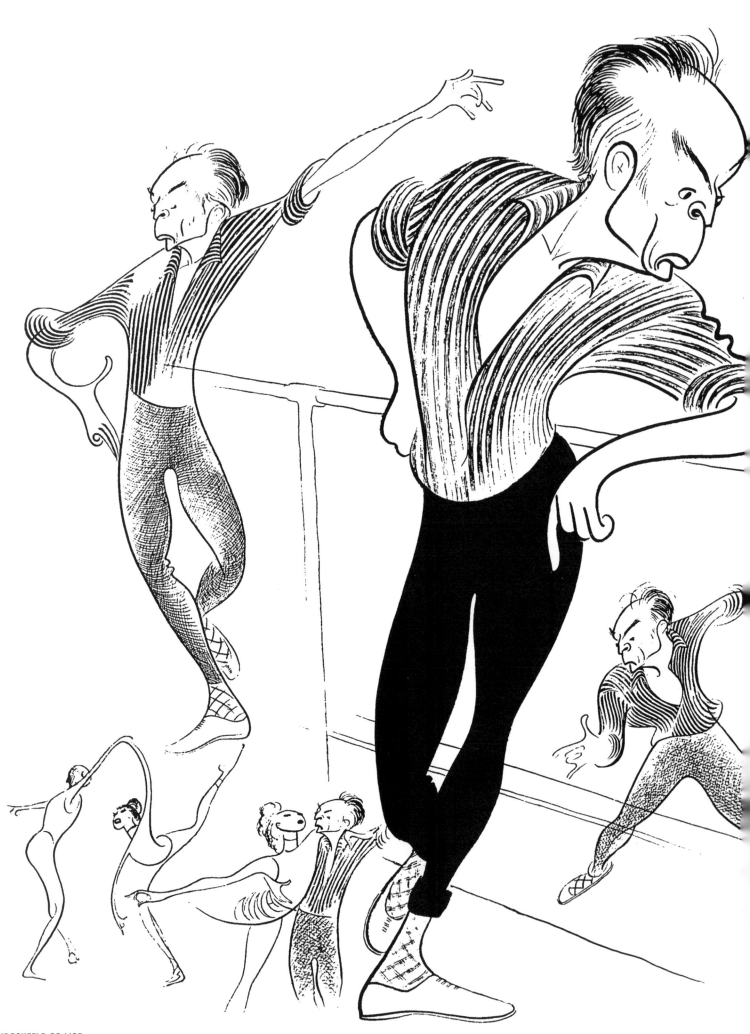

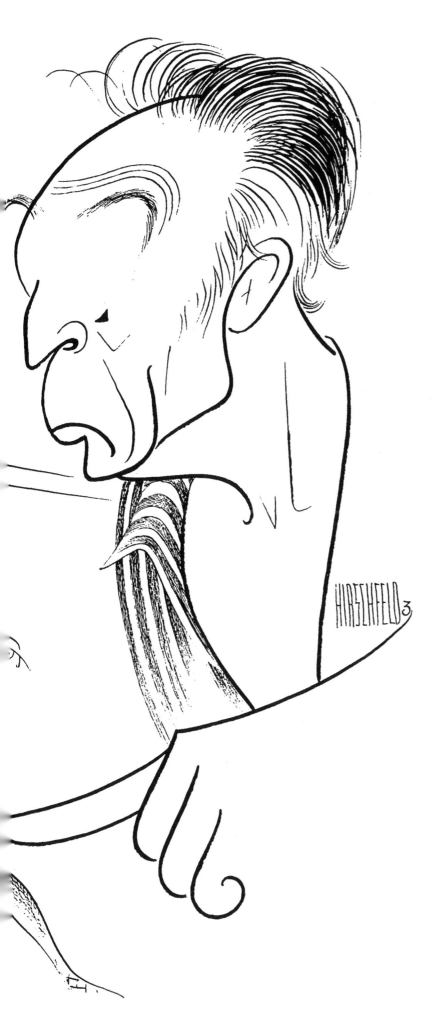

George Balanchine, 1974

I had gotten to know George Balanchine rather well. I used to go to his rehearsals and I'd made a lot of sketches and drawings of him that just never appeared anywhere. Then he called me one day and said, "How is it you've never done a drawing of me?" I said, "We'll have to change that." And so I did this drawing of him, which appeared in the *Times*. I suppose I tried to make up for the oversight a little here by putting him in the drawing five times. In general, I find ballet dancers a pure joy to draw.

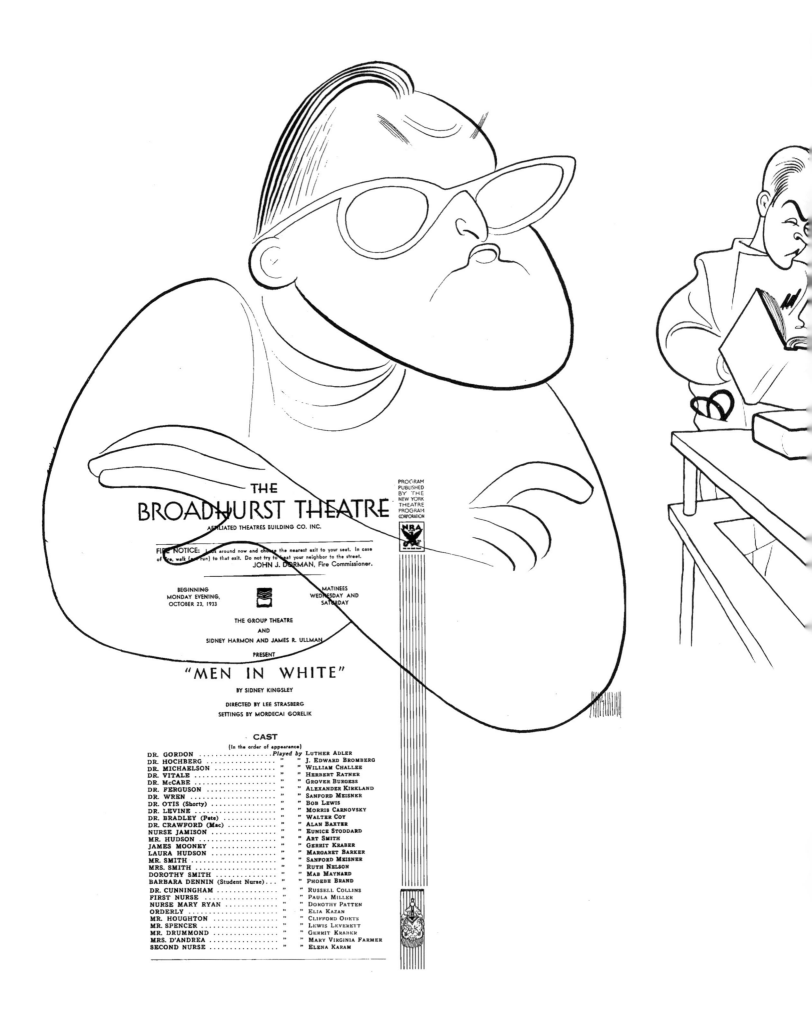

THE
BROADHURST THEATRE
AFFILIATED THEATRES BUILDING CO. INC.

PROGRAM
PUBLISHED
BY THE
NEW YORK
THEATRE
PROGRAM
CORPORATION

FIRE NOTICE: Look around now and choose the nearest exit to your seat. In case of fire, walk (do not run) to that exit. Do not try to beat your neighbor to the street.
JOHN J. DORMAN, Fire Commissioner.

BEGINNING
MONDAY EVENING,
OCTOBER 23, 1933

MATINEES
WEDNESDAY AND
SATURDAY

THE GROUP THEATRE
AND
SIDNEY HARMON AND JAMES R. ULLMAN
PRESENT

"MEN IN WHITE"

BY SIDNEY KINGSLEY

DIRECTED BY LEE STRASBERG
SETTINGS BY MORDECAI GORELIK

CAST
(In the order of appearance)

DR. GORDONPlayed by LUTHER ADLER
DR. HOCHBERG " J. EDWARD BROMBERG
DR. MICHAELSON " WILLIAM CHALLEE
DR. VITALE " HERBERT RATNER
DR. McCABE " GROVER BURGESS
DR. FERGUSON " ALEXANDER KIRKLAND
DR. WREN " SANFORD MEISNER
DR. OTIS (Shorty) " BOB LEWIS
DR. LEVINE " MORRIS CARNOVSKY
DR. BRADLEY (Pete) " WALTER COY
DR. CRAWFORD (Mac) " ALAN BAXTER
NURSE JAMISON " EUNICE STODDARD
MR. HUDSON " ART SMITH
JAMES MOONEY " GERRIT KRABER
LAURA HUDSON " MARGARET BARKER
MR. SMITH " SANFORD MEISNER
MRS. SMITH " RUTH NELSON
DOROTHY SMITH " MAB MAYNARD
BARBARA DENNIN (Student Nurse)... " PHOEBE BRAND
DR. CUNNINGHAM " RUSSELL COLLINS
FIRST NURSE " PAULA MILLER
NURSE MARY RYAN " DOROTHY PATTEN
ORDERLY " ELIA KAZAN
MR. HOUGHTON " CLIFFORD ODETS
MR. SPENCER " LEWIS LEVERETT
MR. DRUMMOND " GERRIT KRABER
MRS. D'ANDREA " MARY VIRGINIA FARMER
SECOND NURSE " ELENA KARAM

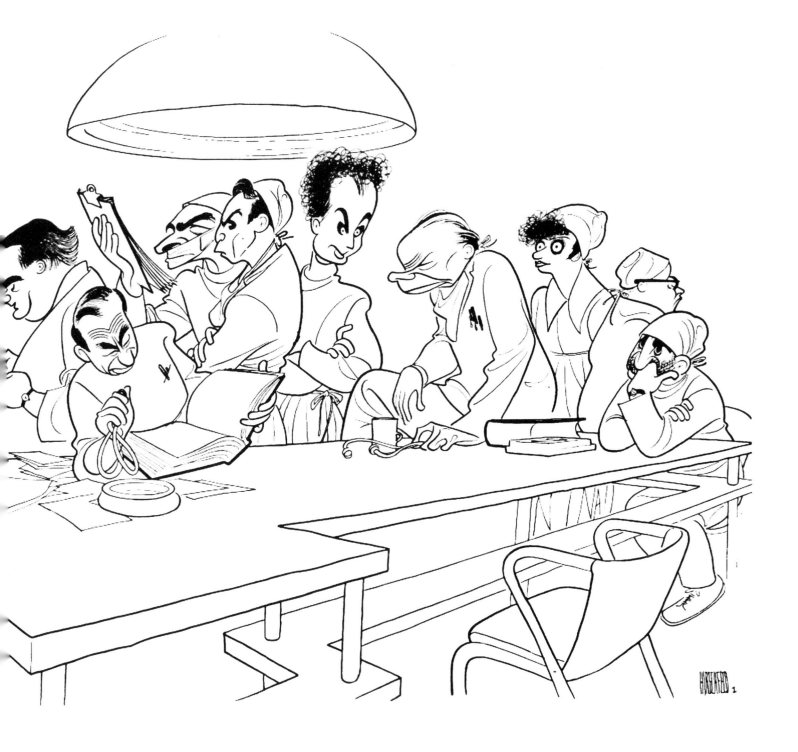

Men in White, 1934

(collage, Kingsley); 1975 Pulitzer Prize Series

Sidney Kingsley was an amazing playwright to whom, it seems to me, the television industry owes a bundle of money. He was the first to write about backstage in hospitals. He was the first one to write about gangsters in the theatre, and he was the first to write about detectives in *Detective Story*. Now, without detectives, nurses, and gangsters, you'd have very little on TV except cars crashing into each other. To the right of Sidney in the drawing is the assembled cast of the play: Alexander Kirkland, J. Edward Bromberg, Sanford Meisner, Morris Carnovsky, Luther Adler, Clifford Odets, Russell Collins, Paula Miller, Bobby Lewis, and Elia Kazan—most of them denizens of the Group Theatre.

Death of a Salesman, 1947

(collage, Miller); 1975 Pulitzer Prize Series

I used hands to great advantage here to describe the characters they're both playing (Lee J. Cobb as Willy Loman and Mildred Dunnook as his wife). She's using her hands to hang onto him for dear life, and there's a frenetic mix-up of fingers as they clutch each other's hands. Arthur Miller's play was about the American Dream of grabbing everything within grasp—only in this case it all slipped through their fingers into tragedy. One other item, the Tiffany lamp in the background was a visual technique I used to establish not only the time of the play, but the frustration it depicts. *Death* confronts the reality that everyone is a salesman of one sort or another no matter how desperately we deny it.

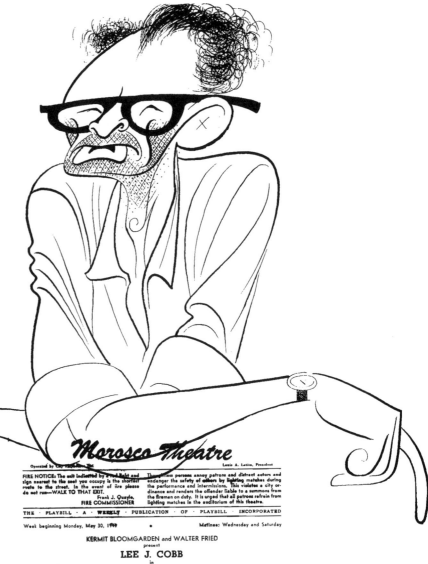

Morosco Theatre

Operated by City Playhouses, Inc. Louis A. Lotito, President

FIRE NOTICE: The exit indicated by a red light and sign nearest to the seat you occupy is the shortest route to the street. In the event of fire please do not run—WALK TO THAT EXIT.

Frank J. Quayle,
FIRE COMMISSIONER

Thoughtless persons annoy patrons and distract actors and endanger the safety of others by lighting matches during the performance and intermissions. This violates a city ordinance and renders the offender liable to a summons from the firemen on duty. It is urged that all patrons refrain from lighting matches in the auditorium of this theatre.

THE · PLAYBILL · A · WEEKLY · PUBLICATION · OF · PLAYBILL · INCORPORATED

Week beginning Monday, May 30, 1949 • Matinee: Wednesday and Saturday

KERMIT BLOOMGARDEN and WALTER FRIED
present

LEE J. COBB
in

ELIA KAZAN'S Production of

DEATH OF A SALESMAN

A New Play by ARTHUR MILLER
Directed by ELIA KAZAN
with

ARTHUR **KENNEDY**	MILDRED **DUNNOCK**
HOWARD **SMITH**	THOMAS **CHALMERS**
CAMERON **MITCHELL**	ALAN **HEWITT**

Setting and Lighting by JO MIELZINER
Music Composed by ALEX NORTH
Costumes by JULIA SZE

CAST
(In Order of Appearance)

WILLY LOMAN LEE J. COBB
LINDA MILDRED DUNNOCK
HAPPY CAMERON MITCHELL

BIFF ARTHUR KENNEDY

BERNARD DON KEEFER

THE WOMAN WINNIFRED CUSHING

CHARLEY HOWARD SMITH

UNCLE BEN THOMAS CHALMERS

HOWARD WAGNER ALAN HEWITT

JENNY ANN DRISCOLL

STANLEY TOM PEDI

MISS FORSYTHE CONSTANCE FORD

LETTA HOPE CAMERON

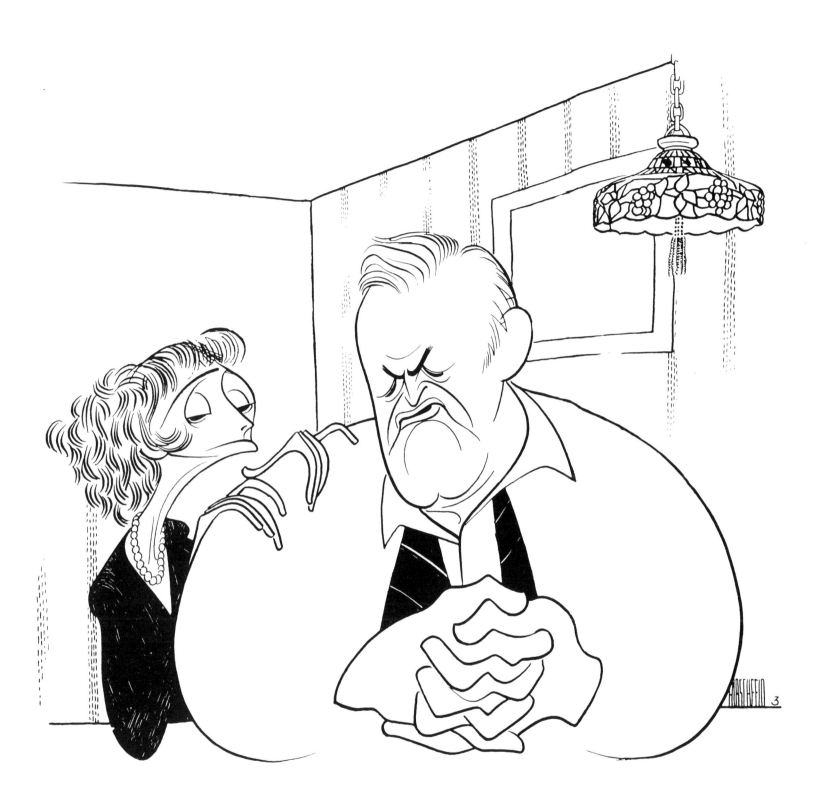

A Streetcar Named Desire, 1947

(collage, Williams); 1975 Pulitzer Prize Series

This was the first time I drew Marlon Brando. Jessica Tandy as Blanche Du Bois was equally spectacular. This drawing, like a lot of Williams' play, is all about light, and the casting of shadows. Blanche has put the Japanese lantern over the bare light bulb to hide her aging features, but the lamp throws their shadows on the window, so they can be seen together from the outside. It's a very crucial part of the play. And of the drawing. The show was produced by Irene Mayer Selznick. Stage design by Jo Mielziner. Costumes by Lucinda Ballard.

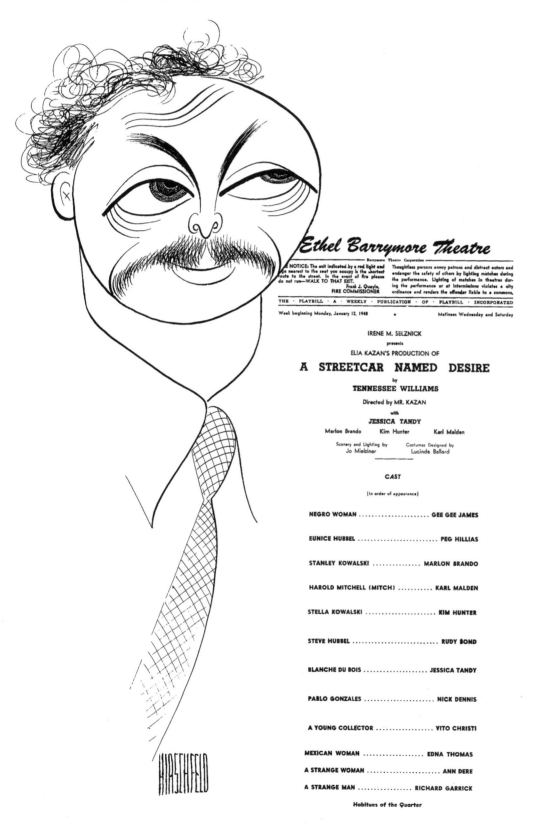

Ethel Barrymore Theatre

Barrymore Theatre Corporation

NOTICE: The exit indicated by a red light and sign nearest to the seat you occupy is the shortest route to the street. In the event of fire please do not run—WALK TO THAT EXIT.
Frank J. Quayle,
FIRE COMMISSIONER

Thoughtless persons annoy patrons and distract actors and endanger the safety of others by lighting matches during the performance. Lighting of matches in theatres during the performance or at intermissions violates a city ordinance and renders the offender liable to a summons.

THE · PLAYBILL · A · WEEKLY · PUBLICATION · OF · PLAYBILL · INCORPORATED

Week beginning Monday, January 12, 1948 • Matinees Wednesday and Saturday

IRENE M. SELZNICK
presents
ELIA KAZAN'S PRODUCTION OF

A STREETCAR NAMED DESIRE
by
TENNESSEE WILLIAMS

Directed by MR. KAZAN
with
JESSICA TANDY

Marlon Brando Kim Hunter Karl Malden

Scenery and Lighting by Costumes Designed by
Jo Mielziner Lucinda Ballard

CAST

(In order of appearance)

NEGRO WOMAN GEE GEE JAMES

EUNICE HUBBEL PEG HILLIAS

STANLEY KOWALSKI MARLON BRANDO

HAROLD MITCHELL (MITCH) KARL MALDEN

STELLA KOWALSKI KIM HUNTER

STEVE HUBBEL RUDY BOND

BLANCHE DU BOIS JESSICA TANDY

PABLO GONZALES NICK DENNIS

A YOUNG COLLECTOR VITO CHRISTI

MEXICAN WOMAN EDNA THOMAS

A STRANGE WOMAN ANN DERE

A STRANGE MAN RICHARD GARRICK

Habitues of the Quarter

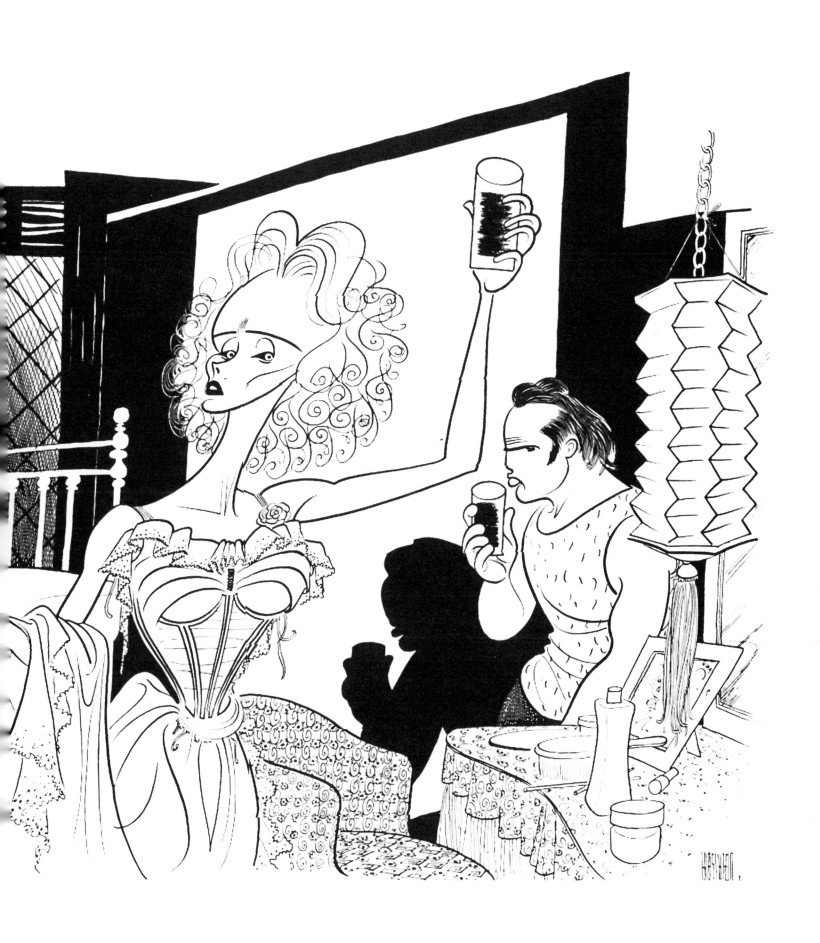

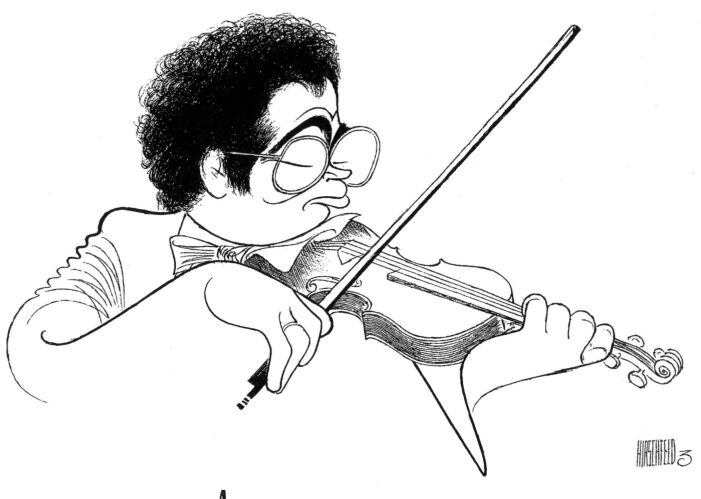

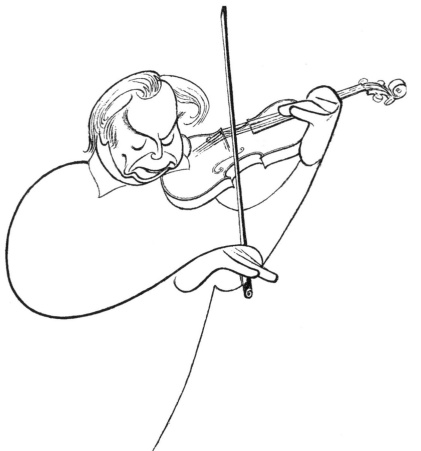

Itzak Perlman & Isaac Stern, 1988-1989

Two dedicated violinists (Perlman above; Stern left), in love with their violins. Solo musicians are at a decided disadvantage usually, compared to most theatre performers. There are no stage sets; no chorus girls. In fact, at a Broadway musical, the guys with the violins are hidden away, in the pit. But in concerts, they get their opportunity to perform, to shine for the audience, even ham it up. And I'm more than happy to try to give them their due graphically. Personally, I'm only a half-hearted classical music lover, though. Jazz is my favorite.

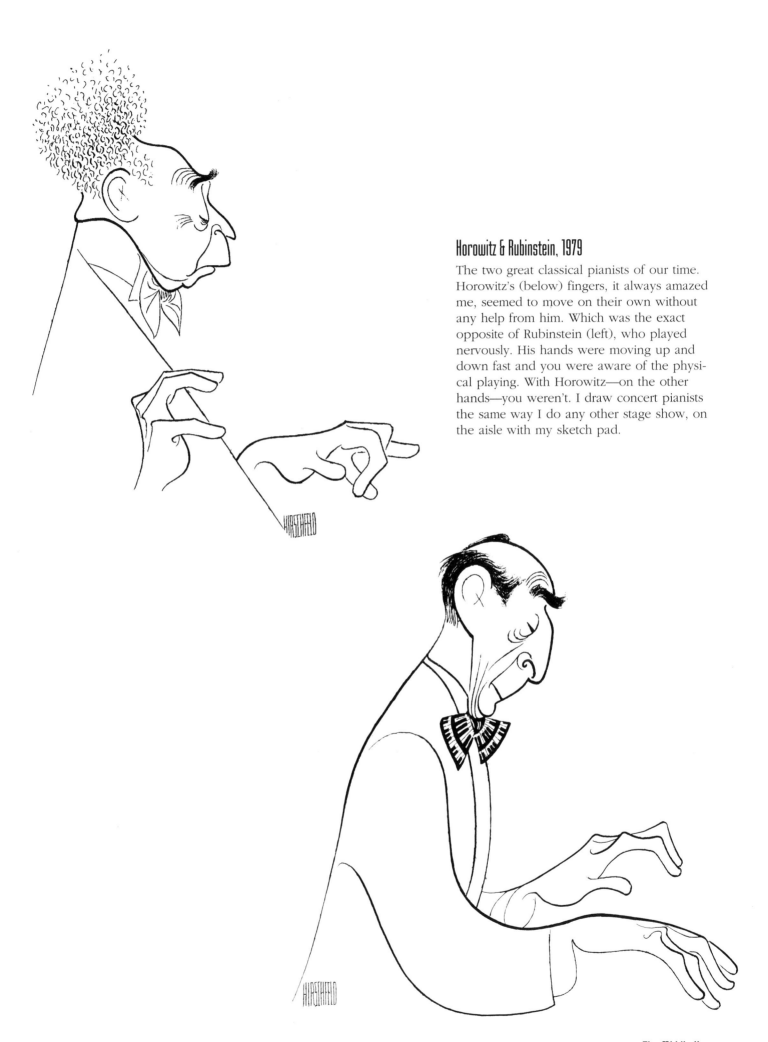

Horowitz & Rubinstein, 1979

The two great classical pianists of our time. Horowitz's (below) fingers, it always amazed me, seemed to move on their own without any help from him. Which was the exact opposite of Rubinstein (left), who played nervously. His hands were moving up and down fast and you were aware of the physical playing. With Horowitz—on the other hands—you weren't. I draw concert pianists the same way I do any other stage show, on the aisle with my sketch pad.

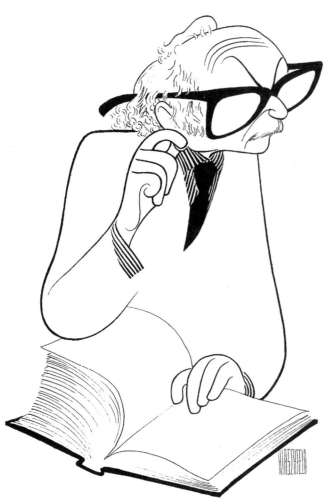

Lee Strasberg, 1978

I've pictured Lee holding his ear for some reason or other. I don't know whether he was hard of hearing or whether that was just an affectation. I do know he had a great influence on the American theatre. Whether that was ultimately a good or bad influence, I'm not sure. He certainly was very knowledgeable about theatre and produced some first-rate talents. One of my favorite anecdotes involving Lee takes place in the Forties. I was attending a run-through of a revival of *R.U.R.*, a play about the inherent evils of manufacturing neurotic robots (paging *2001: A Space Odyssey*). I don't know about the robots, but the play perfectly illustrated the dangers of producing a show on Broadway. Daniel Blank and David Silberman, the producers of *R.U.R.*, were seated out front in the empty auditorium, Blank with a Lily cup full of rye and Silberman holding the bottle. On stage was Lee Strasberg, at the top of his form then, showing a mob of extras how to walk like robots. Blank and Silberman sat there bug-eyed watching the drama taking place on stage, visibly moved by every nuance in the play. At the final curtain, they arose as one man and threw their arms around each other. Convinced they'd just seen a play that would run longer than the combined runs of *Abie's Irish Rose* and *Life With Father*, they assigned me to design a robot that could be used for paperweights, salt shakers, and automobile radiator caps. The plans were to make *R.U.R.* an American institution. The play opened the following week and was hammered by the critics. It closed after four performances. I wound up with a paperweight of a robot I had designed.

Marlene Dietrich

Pauly, Marlene's grandson, used to live a couple of doors down from me. She would visit him and take him to the park and, oddly enough, nobody recognized her. Afterward, she and Pauly would come over around 10:30 or so and have breakfast with me and my wife Dolly. The way she appears in this drawing is not how she dressed for the park, however. No doubt, more people would have recognized her if she had.

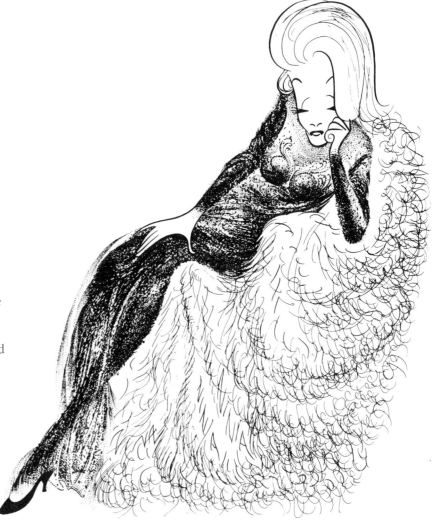

Buster Keaton, 1975

I started drawing silent film stars back in the Twenties, but this one is of more recent vintage. A retrospective of sorts. Buster is frozen here in one of his trademark comic dilemmas. He's pushing his boat with the oar unaware that he's about to fall in. He took quite a fall after sound hit the movies, as an actor and as a director. Probably the biggest pratfall of any of the great silent comedians. More than any of the others, his style depended on the fluidity of the camera. It's also why his silent work seems more modern to us now than that of his peers. He was a great film maker as well as a sad clown.

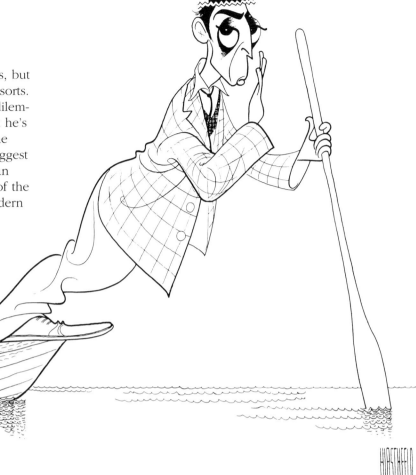

Jack Lemmon, 1979

I've drawn Jack a number of times, but this is my favorite. Jack's a very malleable actor, in life as on the stage. A great personality. And he has a genuine sophistication, which he really showed off here in *Tribute,* because that's what the play was all about. Of course, that was back when cocktails and a cigarette stood for sophistication. Jack also plays jazz piano.

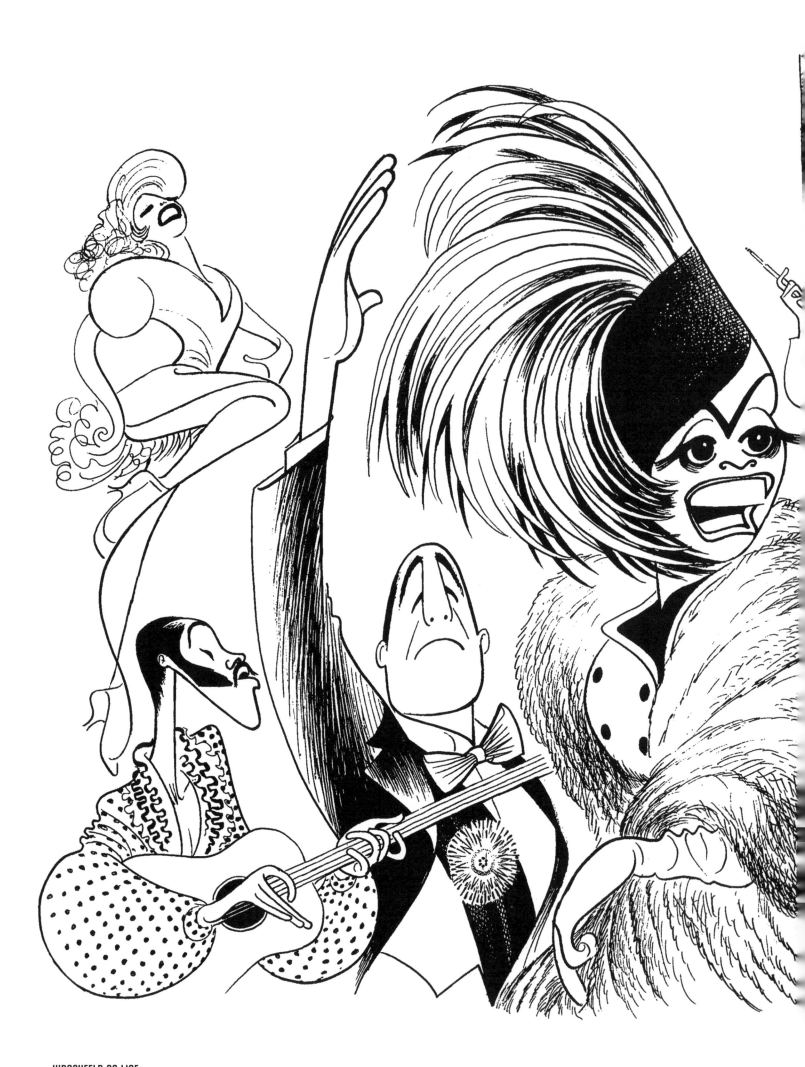

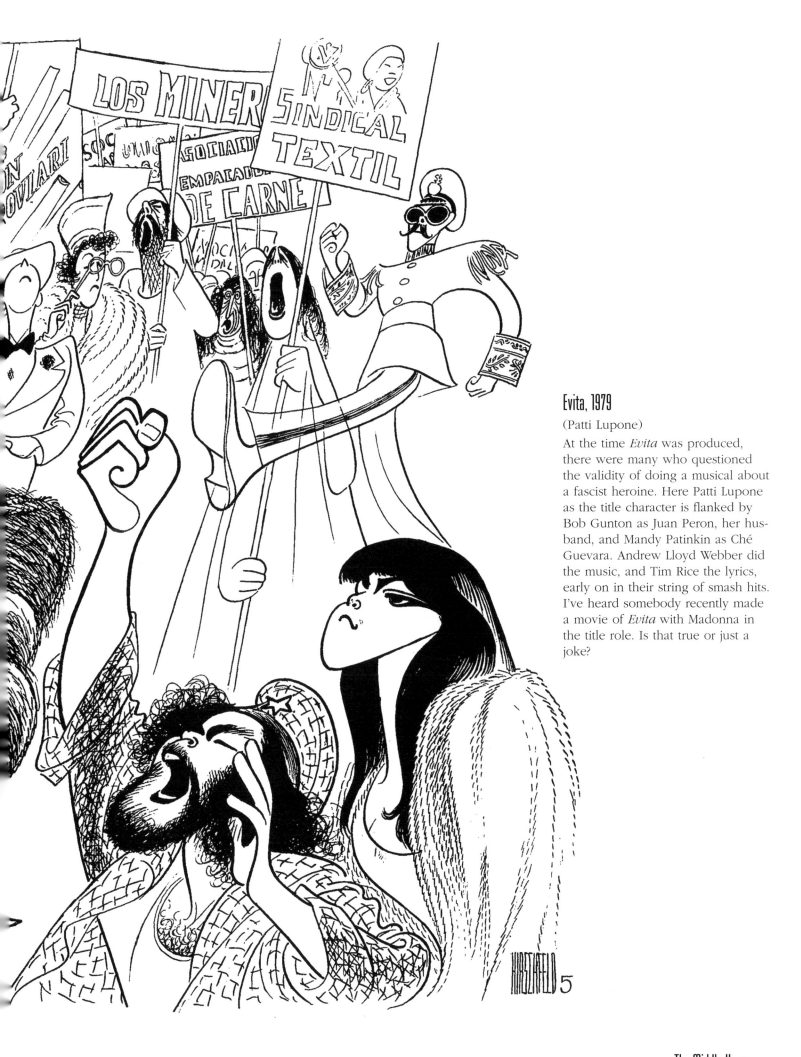

Evita, 1979

(Patti Lupone)

At the time *Evita* was produced, there were many who questioned the validity of doing a musical about a fascist heroine. Here Patti Lupone as the title character is flanked by Bob Gunton as Juan Peron, her husband, and Mandy Patinkin as Ché Guevara. Andrew Lloyd Webber did the music, and Tim Rice the lyrics, early on in their string of smash hits. I've heard somebody recently made a movie of *Evita* with Madonna in the title role. Is that true or just a joke?

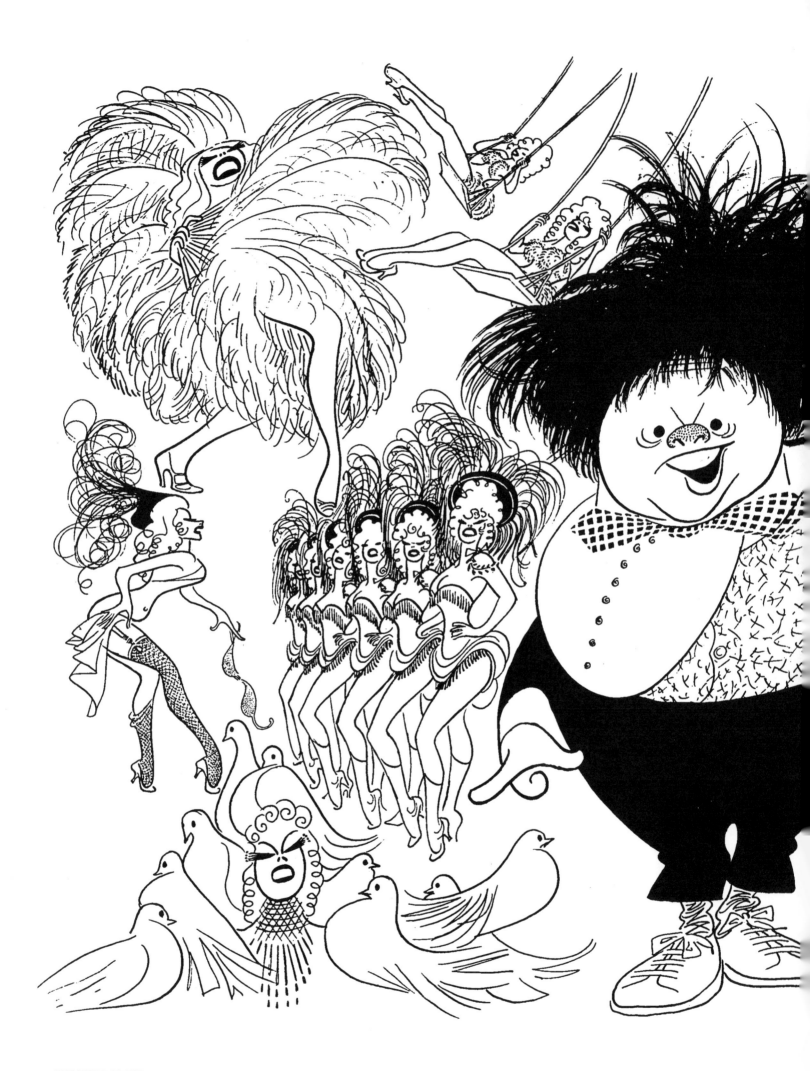

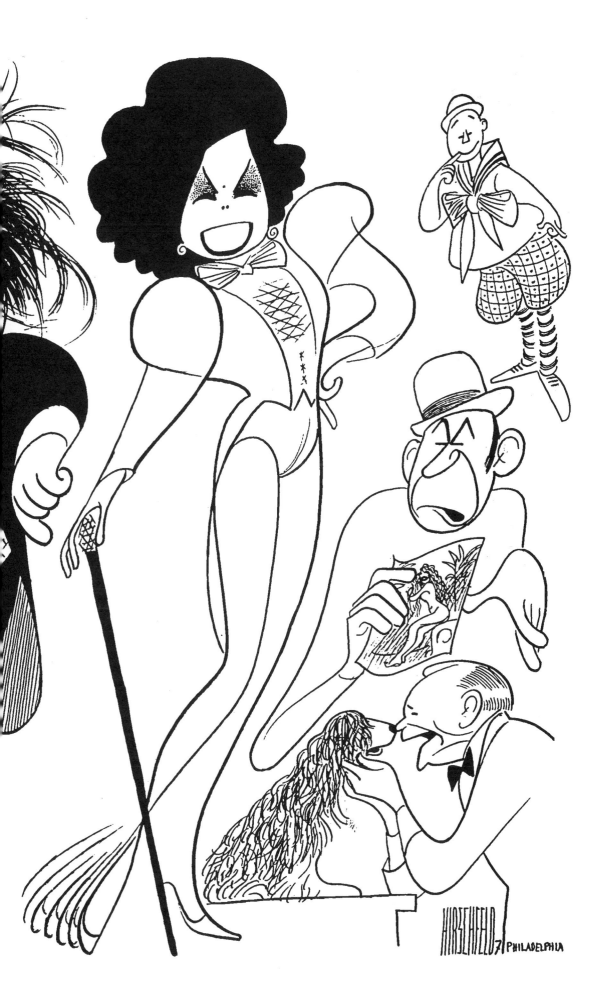

Sugar Babies, 1979

Mickey Rooney and Ann Miller on a stage. Like a couple of tigers on a rib roast. It doesn't, as they say, get any better than that. A couple of real troopers, and performers, from the old school. *Sugar Babies,* a collection of old burlesque routines reignited by Ralph Allen, was a wonderful production. I remember Mickey coming to Charlie Chaplin's house out on the west coast. Chaplin used to have those Sunday afternoons where he invited people and sat around and schmoozed for a couple of hours. Mickey Rooney was so big one day entertaining Chaplin's guests that when he left Chaplin said, "If he's going to be that good every time I invite him, I'll never invite him again."

I loved vaudeville when I was young, but was not as fond of burlesque. I did once go with e.e. cummings to Minsky's on 42nd Street. A Saturday Night Special round-up of all the strippers on Broadway. Each stripper was given a short time on stage to perform. Towards the end of the evening one of the strippers got rid of her costume in record time—facing the audience completely nude. The drunk sitting next to me cupped his hands to his face and yelled, "Fake!"

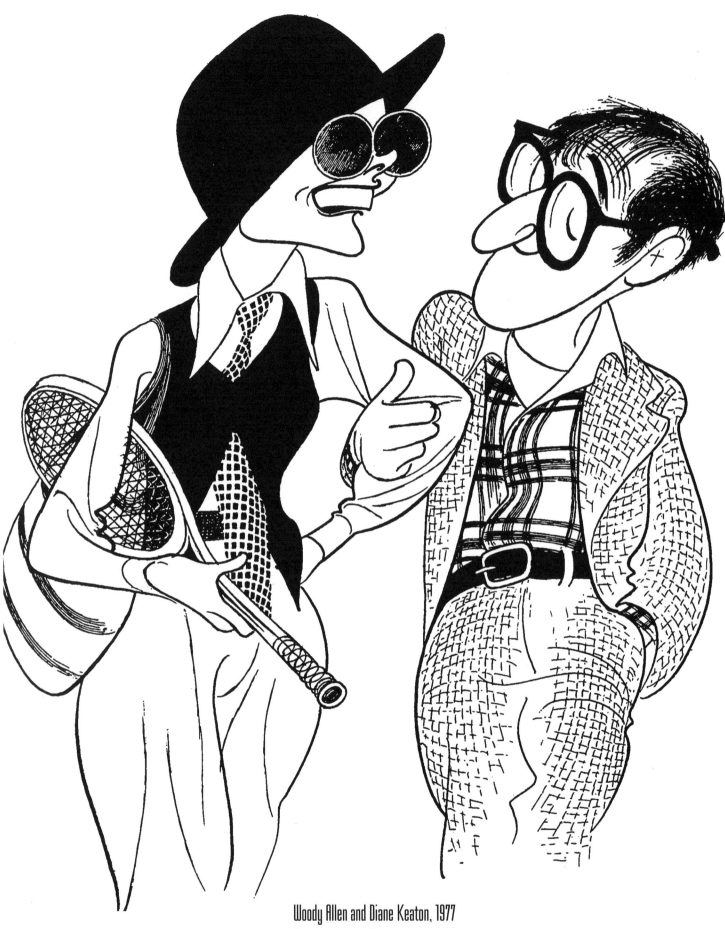

Woody Allen and Diane Keaton, 1977

(in *Annie Hall*)

Woody here has the homey quality of the jazz aficionado he is in real life. Her mix-and-match mannish outfits (designed by Ruth Morley) set off a fashion craze for some years. This was one of those movies that set a tone for a whole generation.

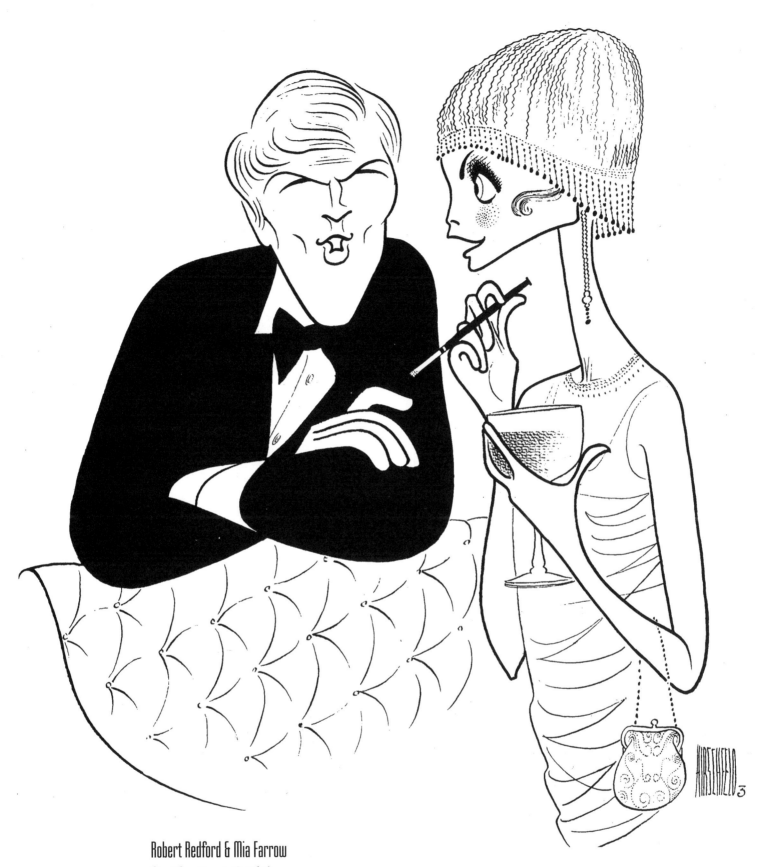

Robert Redford & Mia Farrow

(in *The Great Gatsby*)

This portrays the decadence and stupidity of *The Great Gatsby* and of its time, when women with no curves smoked a lot. It passed for sophistication anyway. The headdress Mia Farrow wears here is very typical. It looks like a Tiffany lampshade but is typical of the time, and helps recreate that period. Daisy was a bit of a dim bulb in the story. It seemed like the whole country was in a Marx Brothers movie in the Twenties. That tiny purse Mia's holding looks like something from the disco era, but is also accurate to the time. As for the movie of Fitzgerald's great novel, I remember S. J. Perelman saying that seeing Redford and Farrow acting in it was like watching two matzoh balls make love.

Joel Grey & Liza Minnelli

This drawing of the film version of *Cabaret* is one of my best known. It was also Liza's breakthrough role in the movies. I'd known her since she was a child, and even then she had tremendous energy. She was pretty awesome as Sally Bowles. And Joel Grey had tremendous appeal. His original stage performance made you think no one will ever be able to play it but him. *Cabaret* was one of those rare musicals that worked great on stage and on film. Like everyone else, I thought Director Bob Fosse was a brilliant choreographer. His anatomical gyrations were a lot of fun to draw.

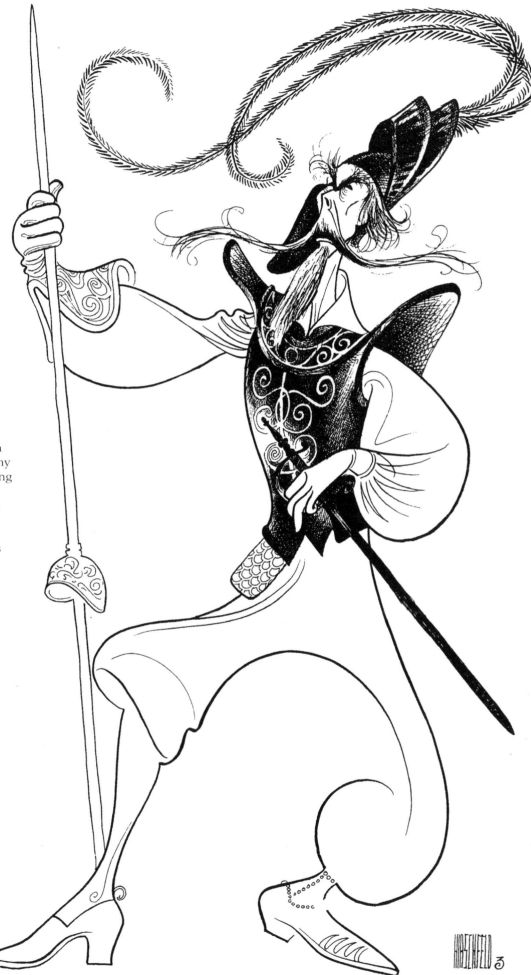

Man of La Mancha, 1977

(Richard Kiley)

Richard Kiley as Don Quixote, dreaming the impossible dream in *Man of La Mancha*. He's one of my favorite actors. Here he is, one long pantaloon and one short, at knee length. And the props he used — the lance, for tilting at windmills, and the saber, with which he dueled those imaginary characters who kept him from reaching his lifelong dreams.

Katharine Hepburn

(in *The Glass Menagerie*)

That simple line defining the outline of Katharine Hepburn's face and those little dots for eyes and mouth somehow capture the essence of this woman. I don't know why or how but from my point of view they're very easily recognizable. I'd recognize her anywhere and I think anybody else looking at the drawing would too. It's almost as though she's been turned into one of the glass animal figurines in the play.

Zero Mostel, 1973

(in *Ulysses in Nighttown*)

Zero was just as much of a joy to draw as to watch on stage. I notice from looking at this drawing again that it's very similar in design to the one of Judy Garland, with all the black and the one eye completely eclipsed by the hat. The huge neck and small hand are very typical of Zero. It has a force and a vitality of its own. The play was a staging of the famous section of Joyce's *Ulysses,* which is written in play form but has all sorts of strange things going on that could only take place in a novel—or brought to life by someone as creative and as wild as Zero. My favorite Zero role, though, is still *Rhinoceros.*

Boris Aronson

I met my friend Boris when he first came to this country in either the late Twenties or early Thirties. He was designing shows for the Yiddish Theatre and his first production here was *Bronx Express,* which had to do with the advertisements in the subway coming to life. The characters in the chewing gum and other ads were very well known to everyone. It sounds like a show full of television commercials, but it was fun. Boris progressed from there to working with the best of Broadway, eventually contributing an awful lot to *Cabaret* and *Company,* and all the hotshot productions of that time. Boris even helped in the rewriting of *Fiddler on the Roof,* helped practically rewrite it, actually. His knowledge of Yiddish and early readings of Sholem Aleichem, along with a retentive memory, made him an authority of this "Chagall-like" locale. I've placed him here on his set of *Pacific Overtures,* another Sondheim musical.

Cy Coleman & Steven Sondheim

These two composers represent the greatest piano virtuoso and lyricist of today. Perhaps one day they'll create a musical together.

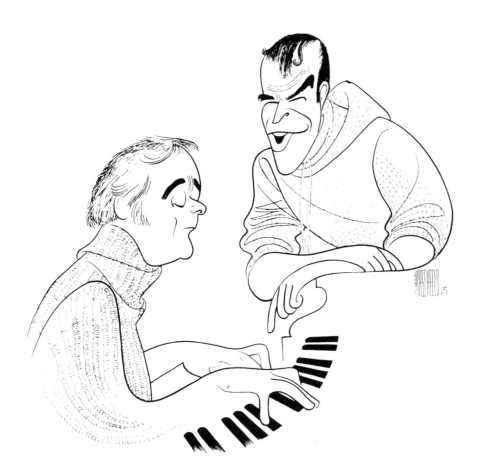

John Kander & Fred Ebb

Composer and lyricist of *Cabaret* (1966), *Zorba* (1968), *70, Girls, 70* (1971), *Chicago* (1975), and *Woman of the Year* (1981), they seemed to have a wild talent for the public's unpredictable acceptance.

Yip Harburg

Yip discovered the "Laughing Doll"! Historically, there have been "talking," "crying," "screaming," "peeing," and "mommy" and "daddy" dolls. But never a laughing one. Yip thought it a natural for a musical about a laughing doll. *Flahooley* opened in 1951 to smash reviews and sold out performances in Philadelphia, and bombed in New York. Figurez vous.

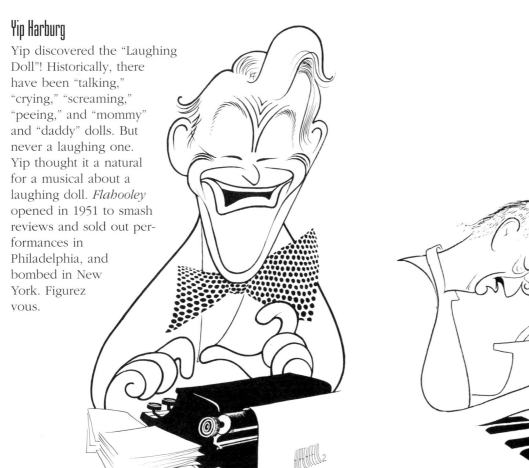

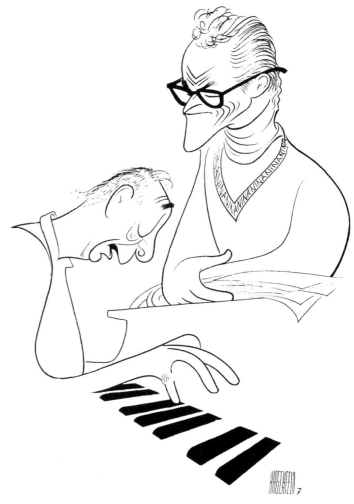

▼ The Gershwins

George and Ira were the two remarkable music masters of the time. Actually I became quite friendly with both of them. I'd visit their home on the Upper West Side and listen to George play. George was an incorrigible entertainer. If there was a piano around, you couldn't keep him away from it. Ira was the exact opposite of George, very much introverted, very shy. Ira authored, "I'm bidin' my time, that's the kinda guy I'm." He never boasted about his abilities as a lyricist. Of course, he didn't need to.

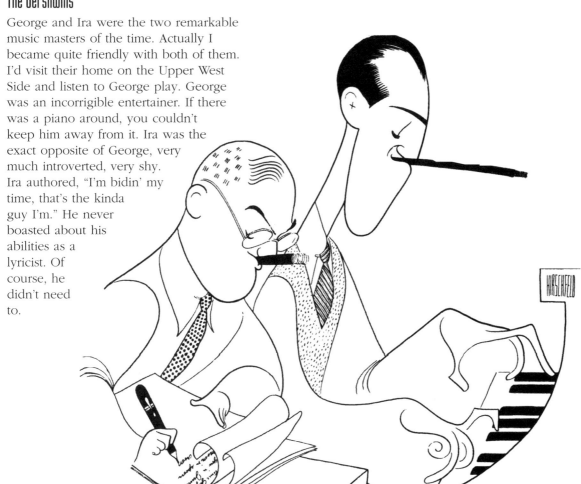

▲ Burton Lane & Alan Jay Lerner

Burton was the last of an era of composers whose songs one sang years after the show closed. I don't think Lerner was the ideal lyricist for him, though, when they teamed up after Lerner's great partner Frederick Loewe retired. Lane and Lerner did produce *On a Clear Day You Can See Forever* in 1965, and *Carmelina* in 1979.

Joseph Papp

A picture of Joseph Papp brooding. It would be interesting to find one of him doing anything else. At least all that thinking paid off with some great theatre. Besides, he had the eyebrows for brooding. It's difficult to look pensive with thin eyebrows. He was wonderfully skeptical, wouldn't take no for an answer. He had an idea and insisted upon doing it and pushed it about as far as he could go, which often was farther than anyone else could have imagined. What he created with the New York Shakespeare Festival, and the free Shakespeare in the park—it's as monumental an achievement, a contribution to New York, I think, as the people who built the Brooklyn Bridge. Joe had a great civic sense in addition to his theatrical brilliance. It was a great, possibly unique, combination. A sort of Brendan Gill of theatrical dedication.

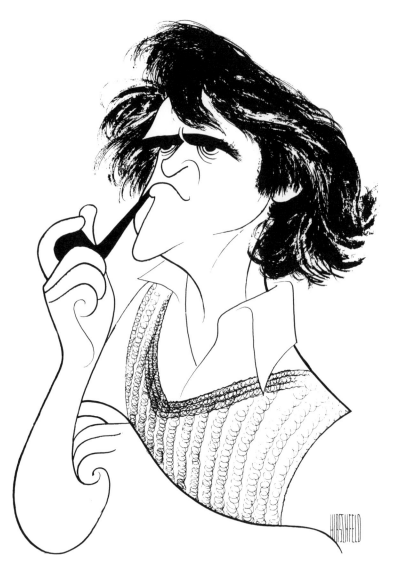

Mike Nichols

I first discovered Mike Nichols with Elaine May performing in a little café somewhere on Madison Avenue in the 30's—that's the streets, not the decade. They did their stand-up comic thing with improvisation long before improvisation comedy was popular. Performing on a stage is terrifying enough without having to write, direct and choreograph what you're doing at the same time. I like this drawing of Mike—it seems strange I know to say —because it's so much like Mike Nichols. And because it's so simple. I caught him with the economy he strives for.

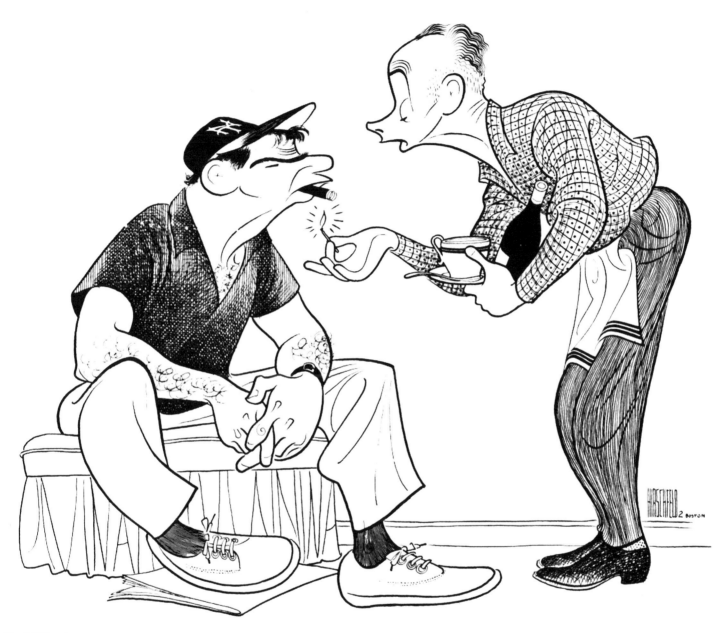

The Odd Couple

(Walter Matthau and Art Carney)

The original Odd Couple, Walter Matthau and Art Carney, Oscar and Felix, long before the duo was popularized on TV. It was a lovely combination of the two, in the play by Neil Simon. Neil, who once wrote for Sid Caesar, is neither a TV writer nor just another George S. Kaufman. He is, in my estimation, a first-rate playwright who happens to write comedies which inspire critics to explode with envy.

Beverly Sills

Beverly's so full of joy and has such a wonderful smile and is so open and easy in her performance, as in real life—characteristics which make someone a delight to draw. If a performer is electric on stage, chances are that electricity will translate into the drawing. Here she is making a grand entrance in the kind of dress you only get to wear on an opera stage or at state dinners these days. Which is probably a lot of the fun of being a diva.

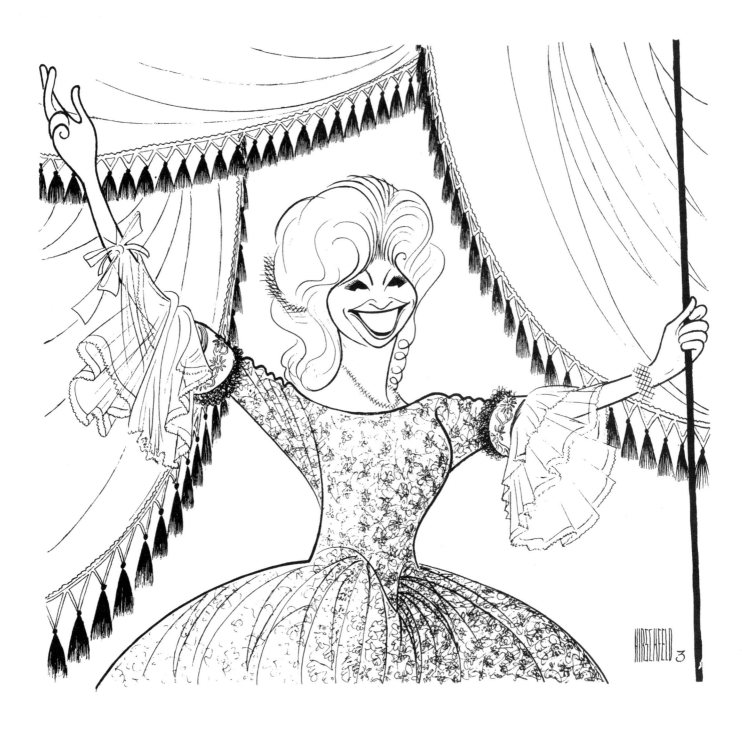

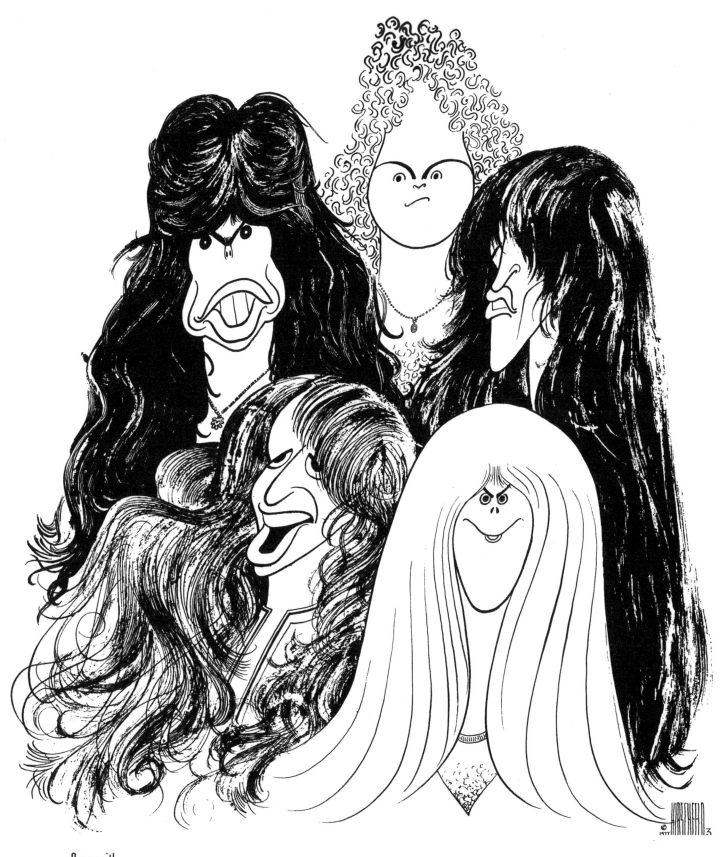

Aerosmith

I attended a rehearsal in a barn somewhere in upper New York State to draw this one. The hair and the eyes are crazy. I don't think I've ever crowded so much hair onto one page before. But it makes for an explosive drawing, like an erupting ventricle, and I think it also captures the lunatic spirit of the group. This represents the high water mark for long hair on men in this country. After Aerosmith, there was nowhere else to go. Without it getting hazardous. The Seventies was also a time when rock theatricality was bigger than Broadway theatricality. Those rolling light-and-sound shows were like out-of-town tryouts every night. The makeup was bigger, the stage sets were bigger—because rock groups could afford it. Broadway was being outbid.

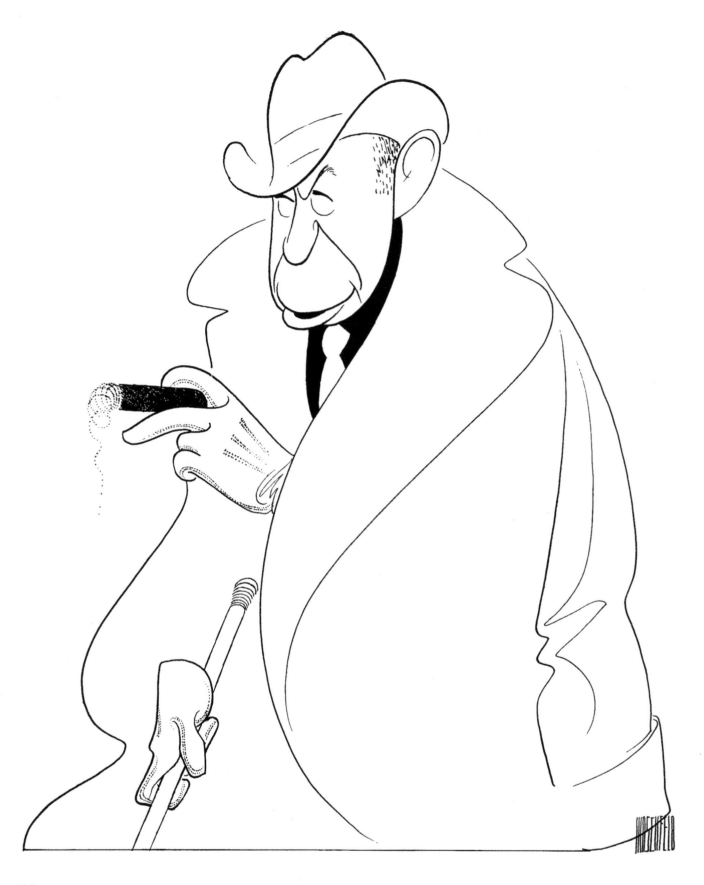

Harold Clurman

Harold Clurman was one of the greats of the American theatre, no question about it. He somehow managed to generate excitement and enthusiasm, from the early days when he talked the Group Theatre into existence through his years as a director, teacher and critic. He had a real profound sense of the time he was living in and of what made him tick. This drawing was done for the opening of his eponymous theatre on Theatre Row.

HIRSCHFELD

IN COLOR

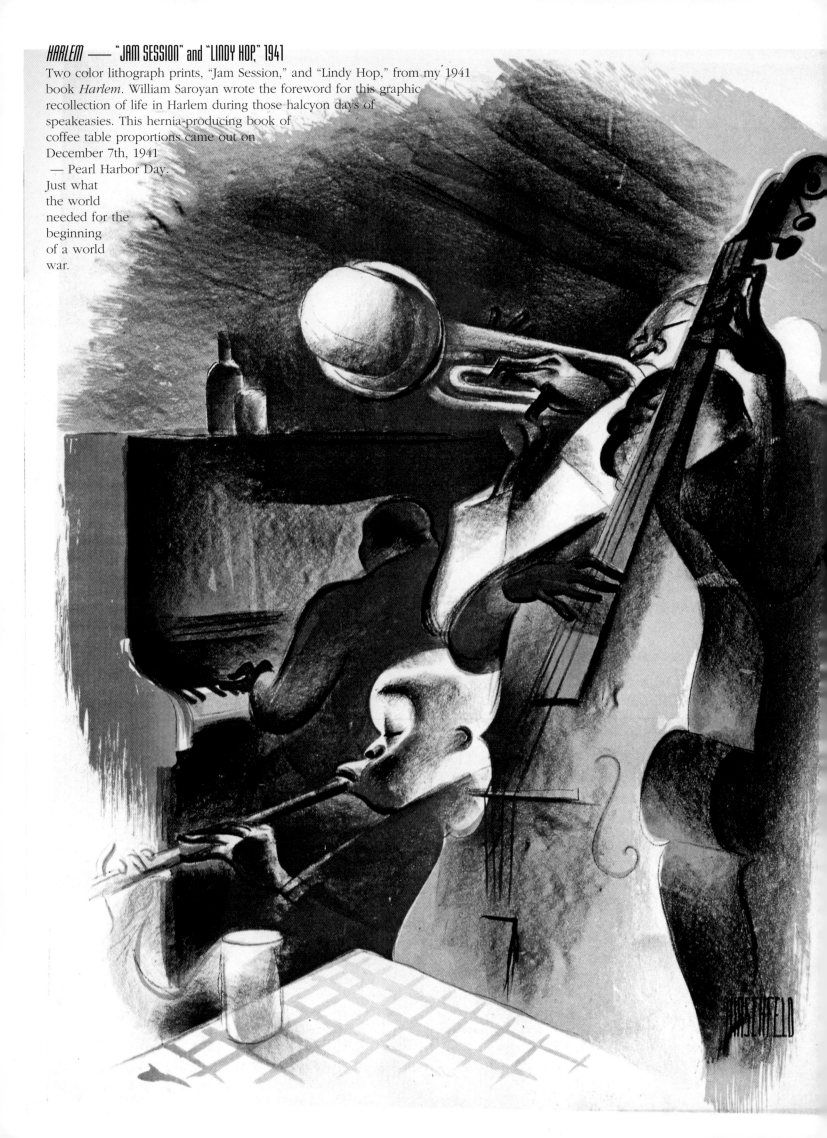

HARLEM — "JAM SESSION" and "LINDY HOP," 1941

Two color lithograph prints, "Jam Session," and "Lindy Hop," from my 1941 book *Harlem*. William Saroyan wrote the foreword for this graphic recollection of life in Harlem during those halcyon days of speakeasies. This hernia-producing book of coffee table proportions came out on December 7th, 1941 — Pearl Harbor Day. Just what the world needed for the beginning of a world war.

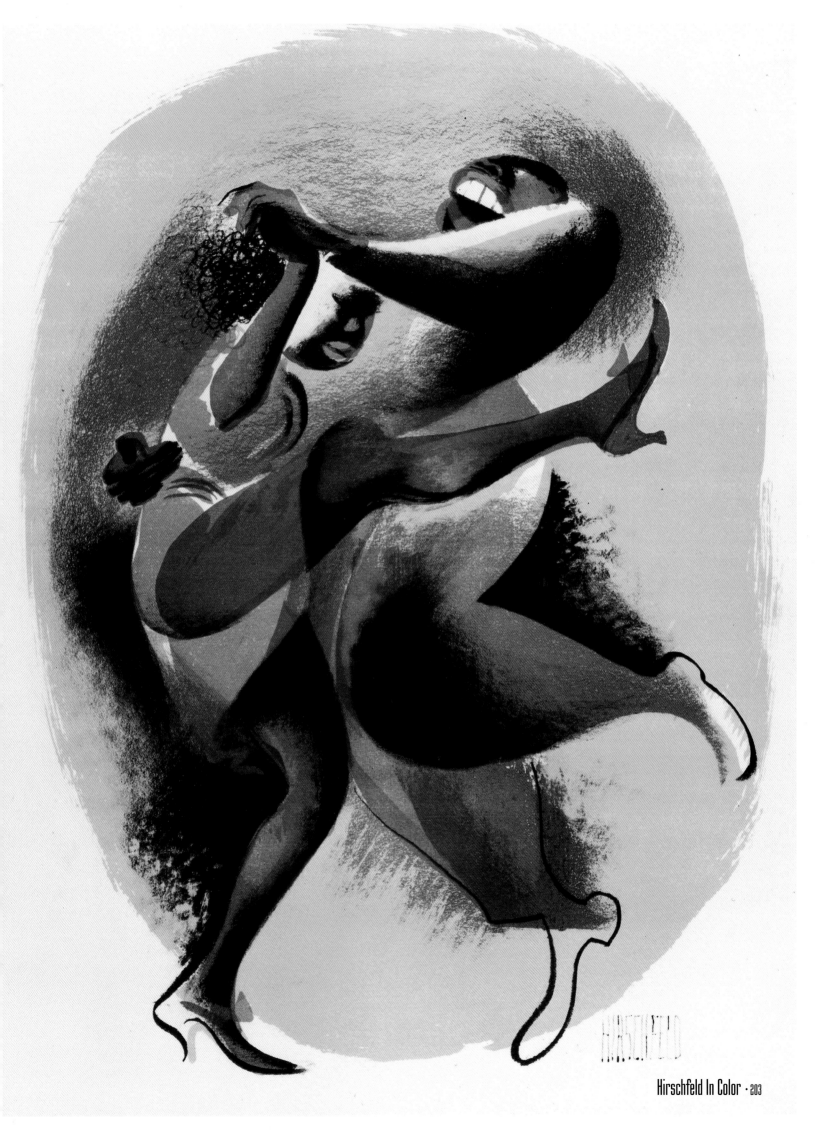

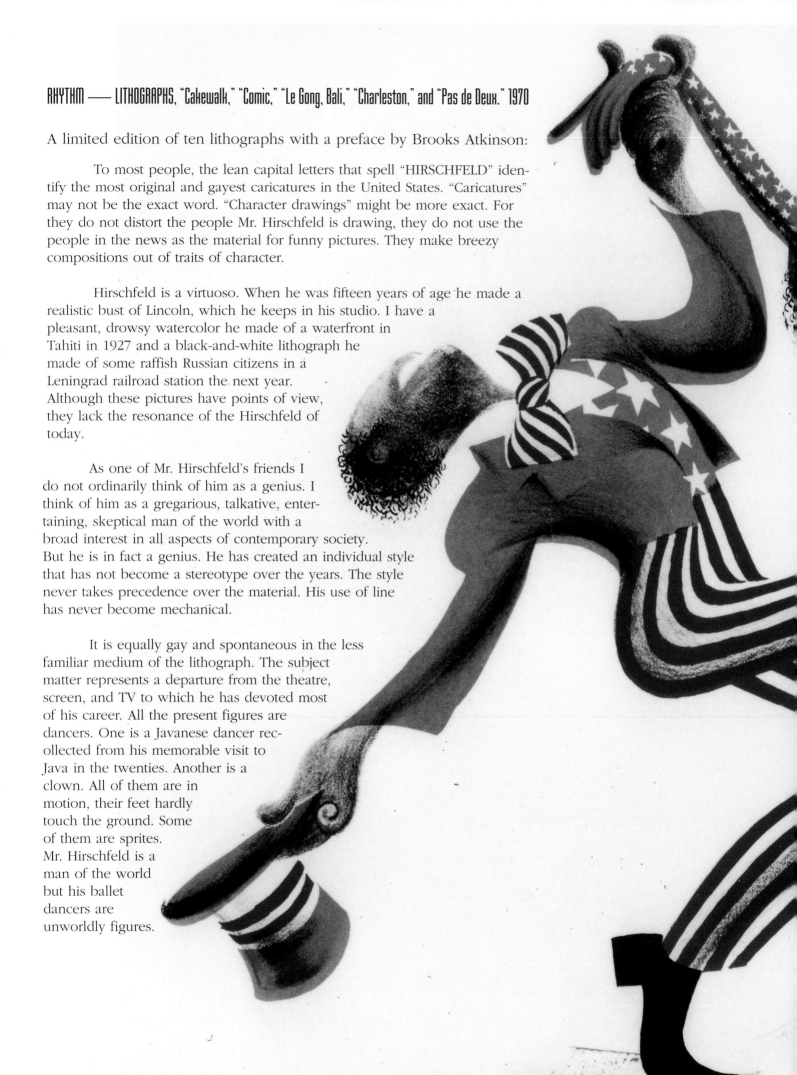

RHYTHM —— LITHOGRAPHS, "Cakewalk," "Comic," "Le Gong, Bali," "Charleston," and "Pas de Deux." 1970

A limited edition of ten lithographs with a preface by Brooks Atkinson:

To most people, the lean capital letters that spell "HIRSCHFELD" identify the most original and gayest caricatures in the United States. "Caricatures" may not be the exact word. "Character drawings" might be more exact. For they do not distort the people Mr. Hirschfeld is drawing, they do not use the people in the news as the material for funny pictures. They make breezy compositions out of traits of character.

Hirschfeld is a virtuoso. When he was fifteen years of age he made a realistic bust of Lincoln, which he keeps in his studio. I have a pleasant, drowsy watercolor he made of a waterfront in Tahiti in 1927 and a black-and-white lithograph he made of some raffish Russian citizens in a Leningrad railroad station the next year. Although these pictures have points of view, they lack the resonance of the Hirschfeld of today.

As one of Mr. Hirschfeld's friends I do not ordinarily think of him as a genius. I think of him as a gregarious, talkative, entertaining, skeptical man of the world with a broad interest in all aspects of contemporary society. But he is in fact a genius. He has created an individual style that has not become a stereotype over the years. The style never takes precedence over the material. His use of line has never become mechanical.

It is equally gay and spontaneous in the less familiar medium of the lithograph. The subject matter represents a departure from the theatre, screen, and TV to which he has devoted most of his career. All the present figures are dancers. One is a Javanese dancer recollected from his memorable visit to Java in the twenties. Another is a clown. All of them are in motion, their feet hardly touch the ground. Some of them are sprites. Mr. Hirschfeld is a man of the world but his ballet dancers are unworldly figures.

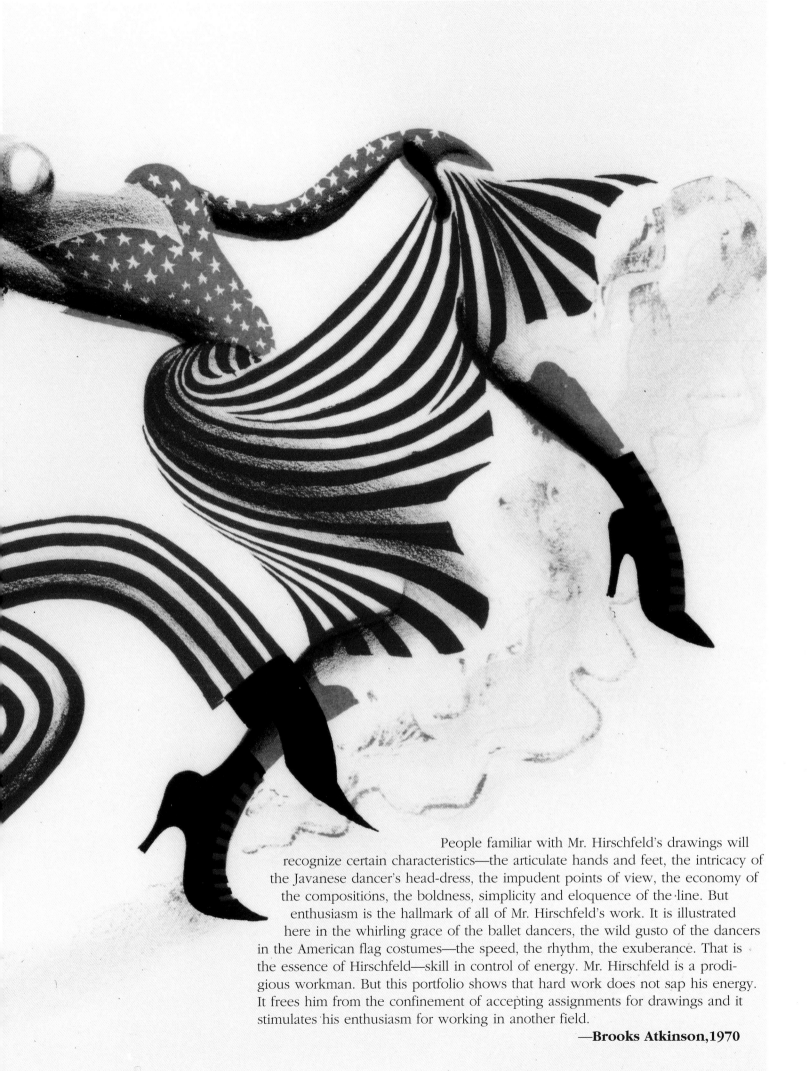

People familiar with Mr. Hirschfeld's drawings will recognize certain characteristics—the articulate hands and feet, the intricacy of the Javanese dancer's head-dress, the impudent points of view, the economy of the compositions, the boldness, simplicity and eloquence of the line. But enthusiasm is the hallmark of all of Mr. Hirschfeld's work. It is illustrated here in the whirling grace of the ballet dancers, the wild gusto of the dancers in the American flag costumes—the speed, the rhythm, the exuberance. That is the essence of Hirschfeld—skill in control of energy. Mr. Hirschfeld is a prodigious workman. But this portfolio shows that hard work does not sap his energy. It frees him from the confinement of accepting assignments for drawings and it stimulates his enthusiasm for working in another field.

—Brooks Atkinson, 1970

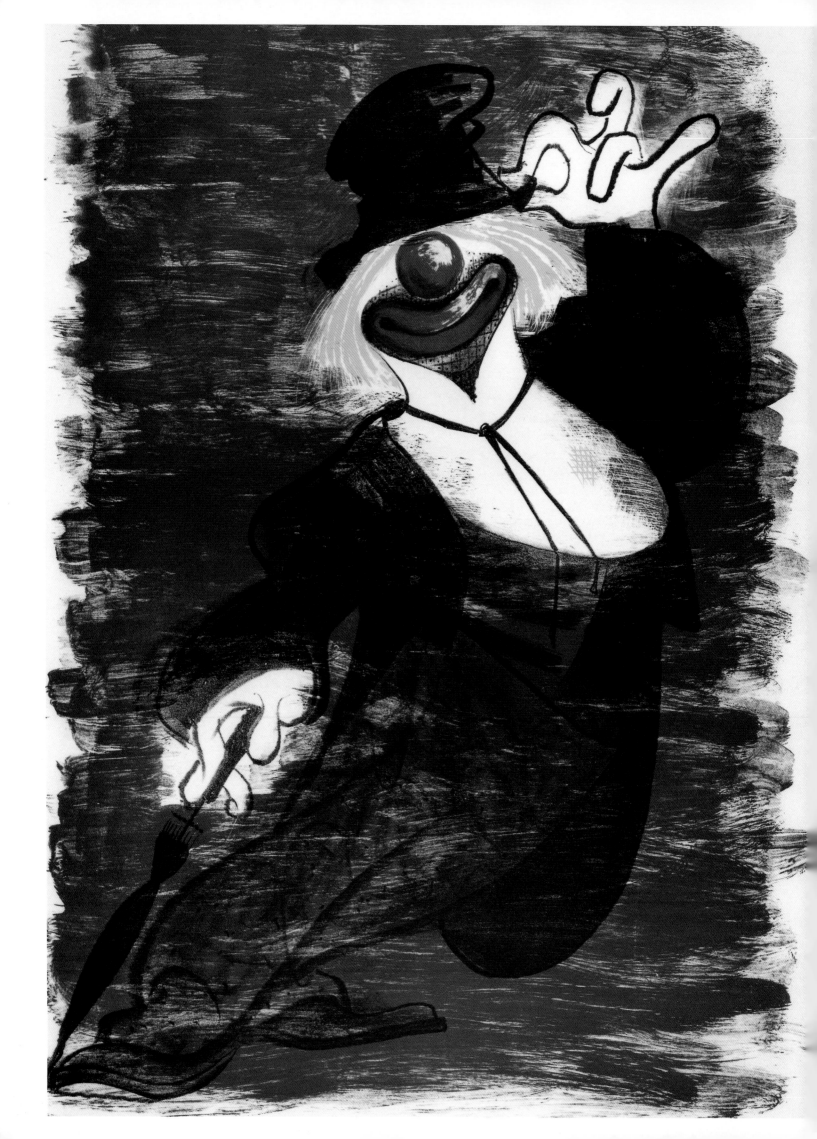

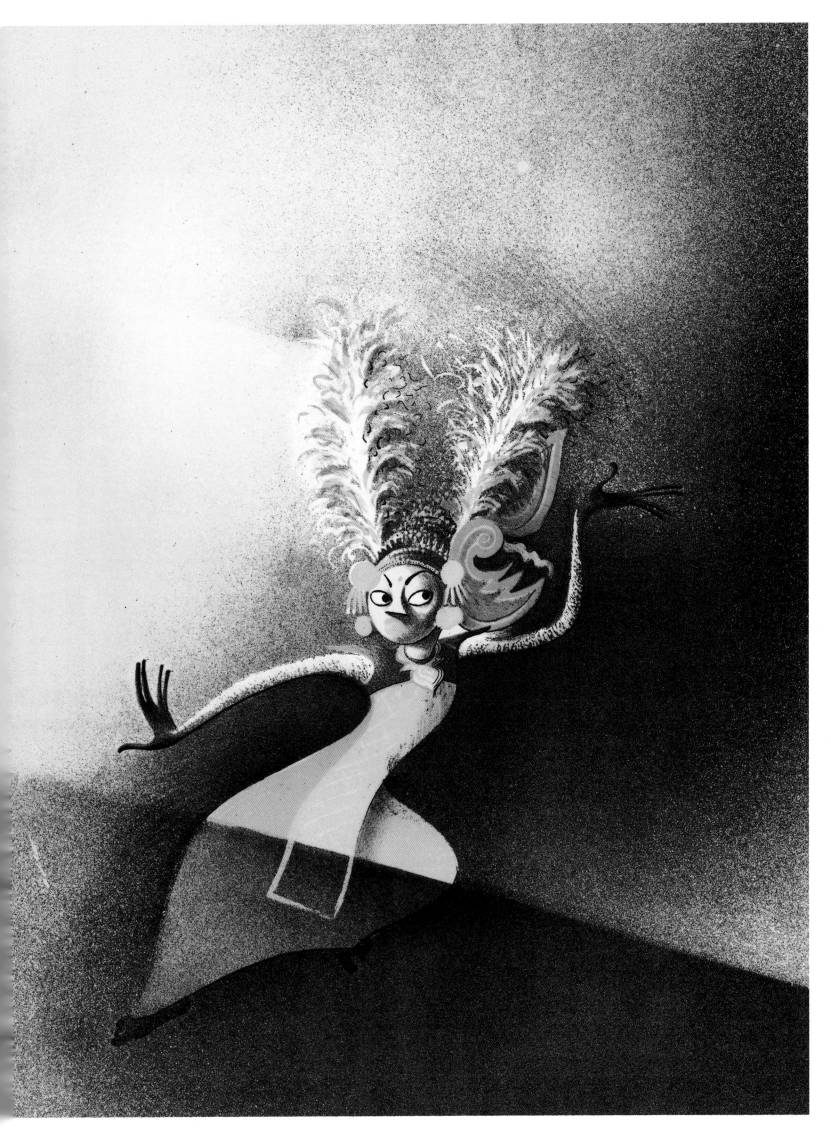

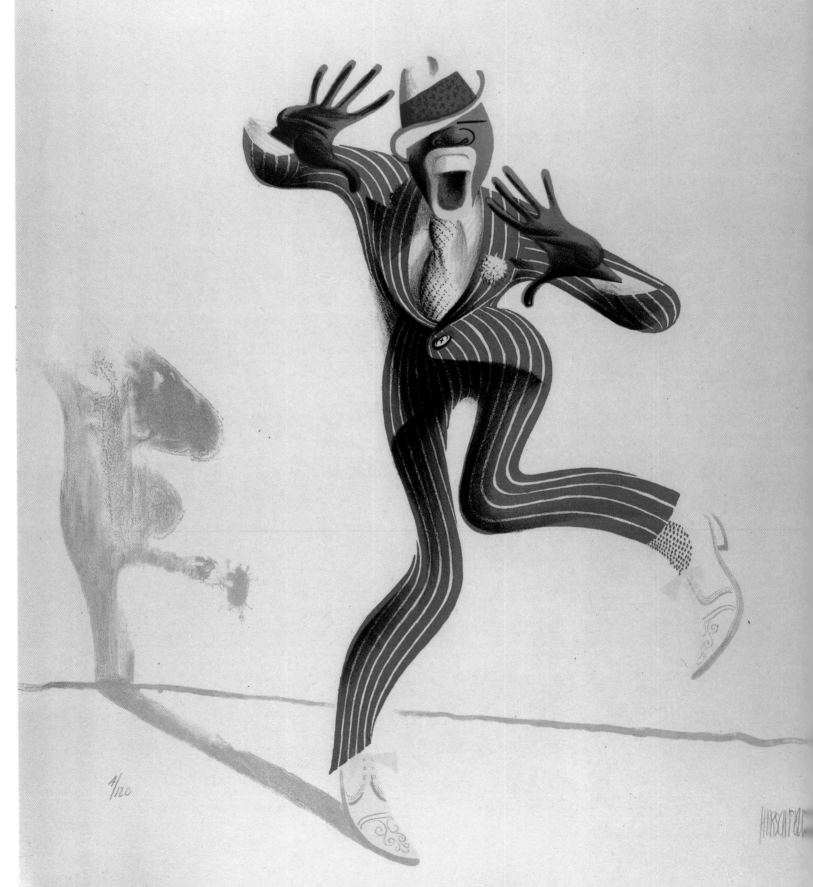

1/120

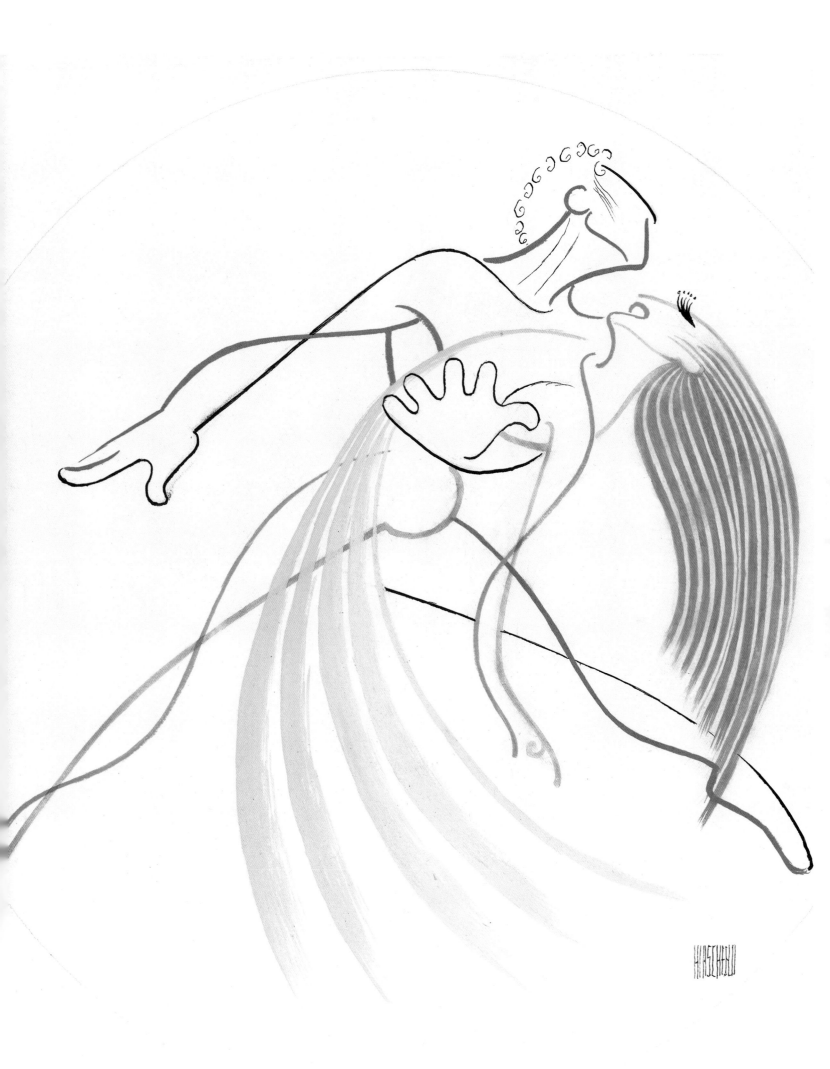

Another series of color lithographs, twelve in all,
observations on the Japanese Kabuki Theatre, Noh
and puppets ."

WATERCOLOR — YALTA, 1928 From my great Soviet Union excursion. A fruit stand in Georgia, U.S.S.R.

WATERCOLOR — TAHITI, 1932 Repairing a fishing net on the quay in Papeete.

BLAKE EDWARDS AND THE PINK PANTHER, 1991

Everyone familiar with film-director Blake
Edwards' great Pink Panther films knows that the
panther really is a flawed diamond. The drawing
was one I did for Mr. Edwards with his colorful
star from a videocassette he sent me. It's the kind
of dual portrait that's difficult to get with a cam-
era — when one of the parties is made of ink. A
caricature of a caricature is brain-picking of a
peculiar nature.

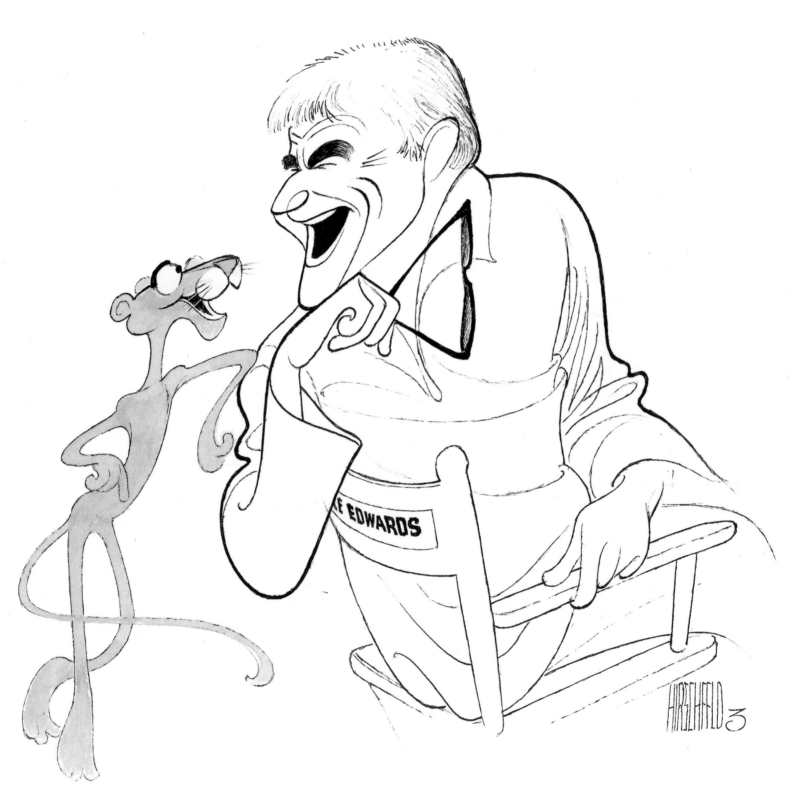

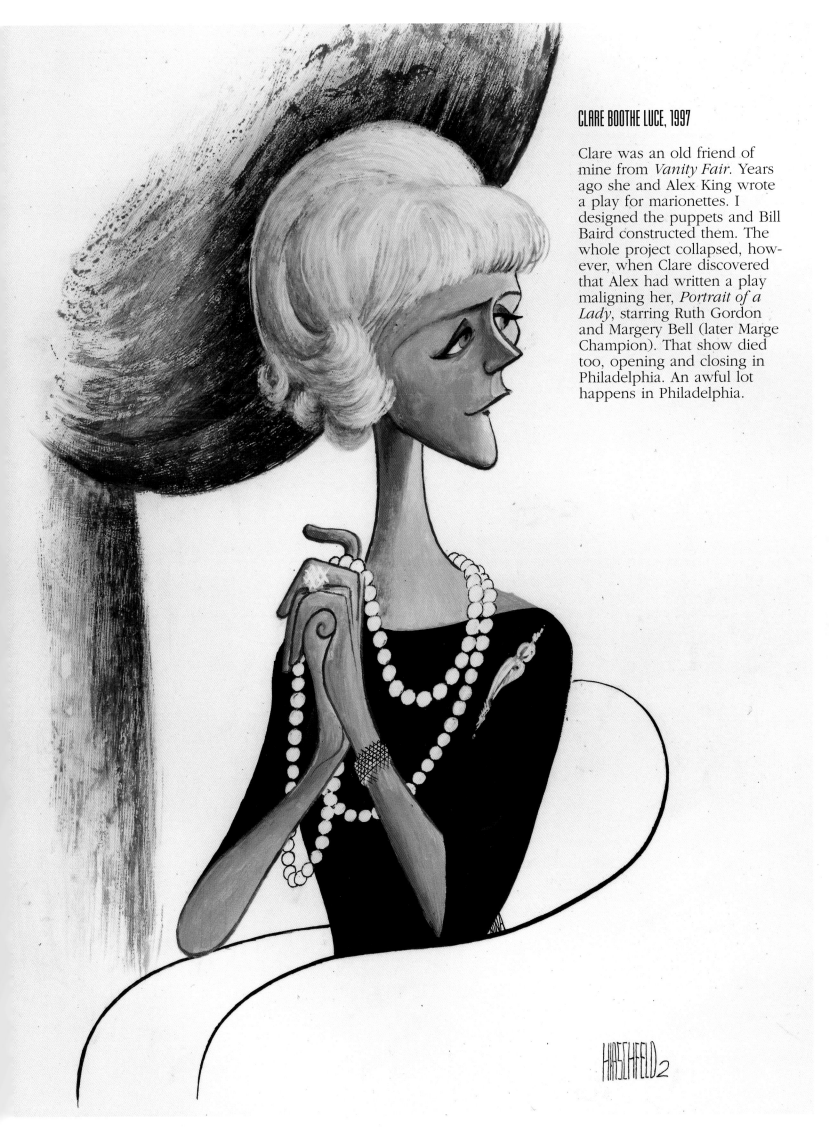

CLARE BOOTHE LUCE, 1997

Clare was an old friend of mine from *Vanity Fair*. Years ago she and Alex King wrote a play for marionettes. I designed the puppets and Bill Baird constructed them. The whole project collapsed, however, when Clare discovered that Alex had written a play maligning her, *Portrait of a Lady*, starring Ruth Gordon and Margery Bell (later Marge Champion). That show died too, opening and closing in Philadelphia. An awful lot happens in Philadelphia.

SILENT SCREEN

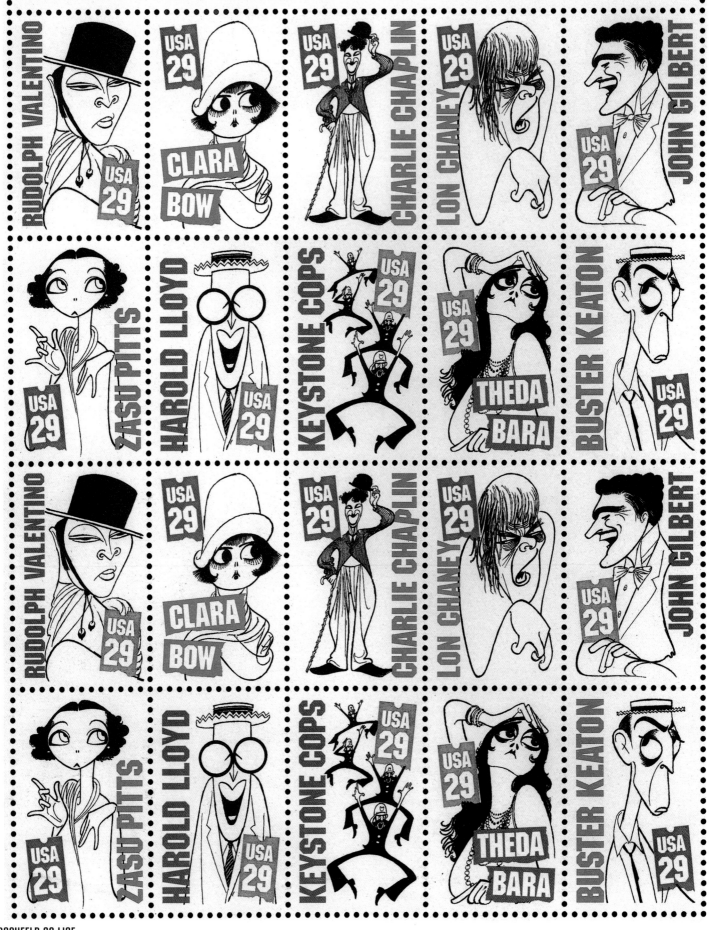

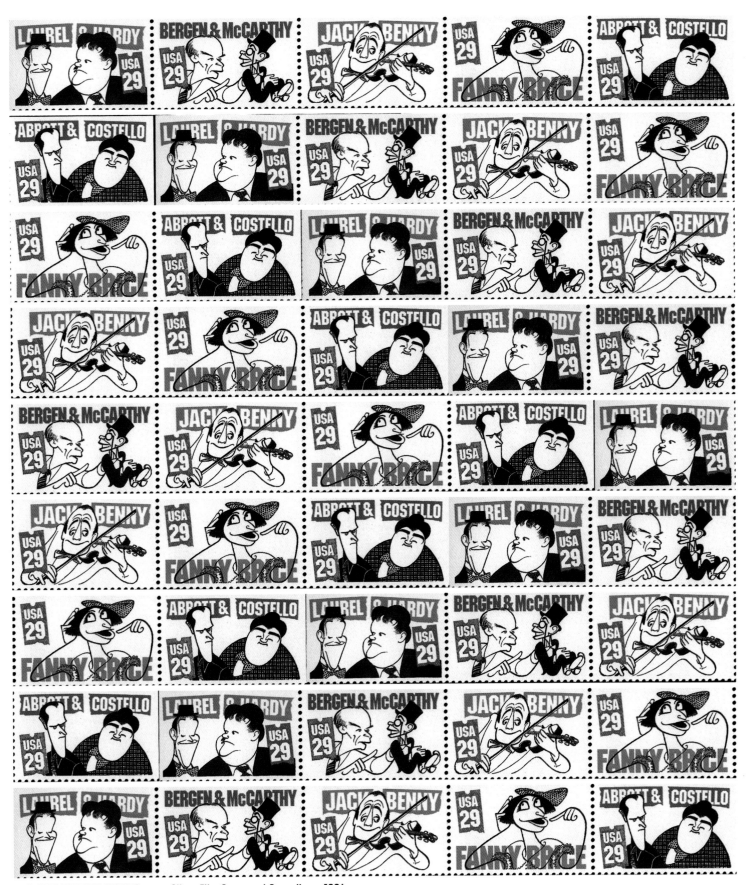

UNITED STATES POSTAGE STAMPS —— Silent Film Stars and Comedians, 1994

How often does an artist get an opportunity to lick his own drawings? Especially when he gets free samples from the U.S. Postal Service. I still use them on my own mail, and get a thrill out of it every time. Of course, it's just my luck the price of a first-class stamp has gone up since. Maybe I should do a series of three-cent stamps just to be consistent on my correspondence. The inclusion of Chaplin was, I think, the first British citizen to appear on a U.S. Postage Stamp. Don't write to me if I'm wrong.

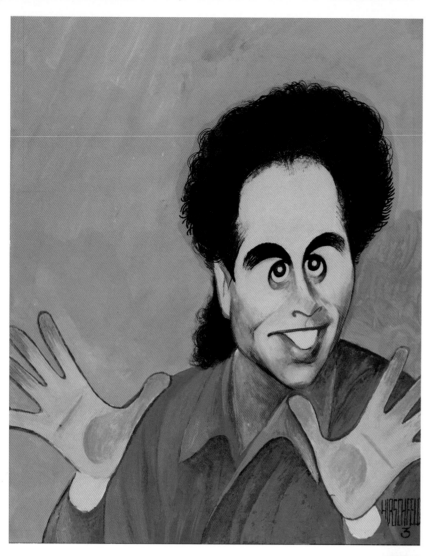

This is one time I got to use color while drawing from my TV set. These four covers of the four principals of the *Seinfeld* show — smug Jerry Seinfeld, misanthropic Jason Alexander, smarmy Julia Louis-Dreyfus, and loony Michael Richards (I'm referring to their characters) were for the show's big-deal final episode in Spring 1998. The Gab Four were printed on four different versions of *TV Guide* for that week. So fans could buy the copy featuring their favorite character, or, as I'm sure the marketing people at *TV Guide* hoped and prayed, collectors would buy all four and have the complete set. I believe this four-play was a fairly radical experiment for the normally staid magazine industry.

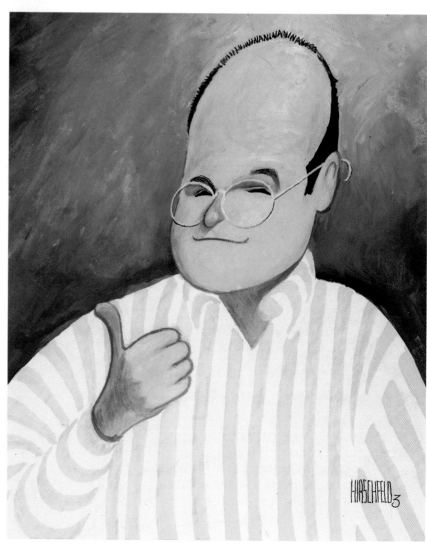

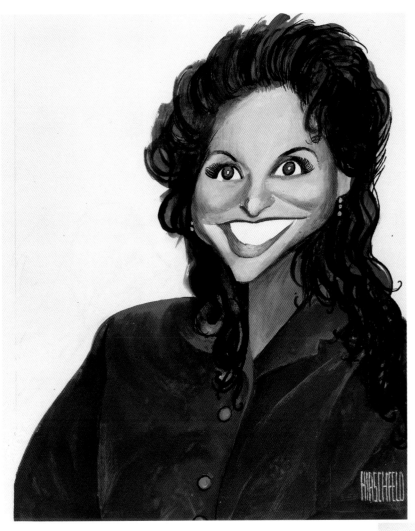
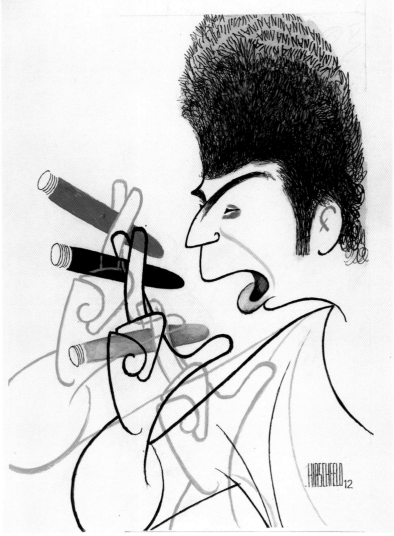

BEAUTY AND THE BEAST, 1994

This was a landmark production for me, for Broadway, and for Mickey Mouse. It was the Mouse's first crack at the Great White Way, and it was my first crack at color in that previously gray old lady, *The New York Times*. Frankly, I was disappointed at the color reproduction. The newspaper process just couldn't, or didn't, print color vividly. This is a very effective original drawing, but the way *The Times* printed it — well, the newsprint absorbed the ink, and the only thing that printed was the line drawing underneath! So much for progress. I think it may also have been the first time I was doing a drawing of what were, essentially, live cartoons on stage.

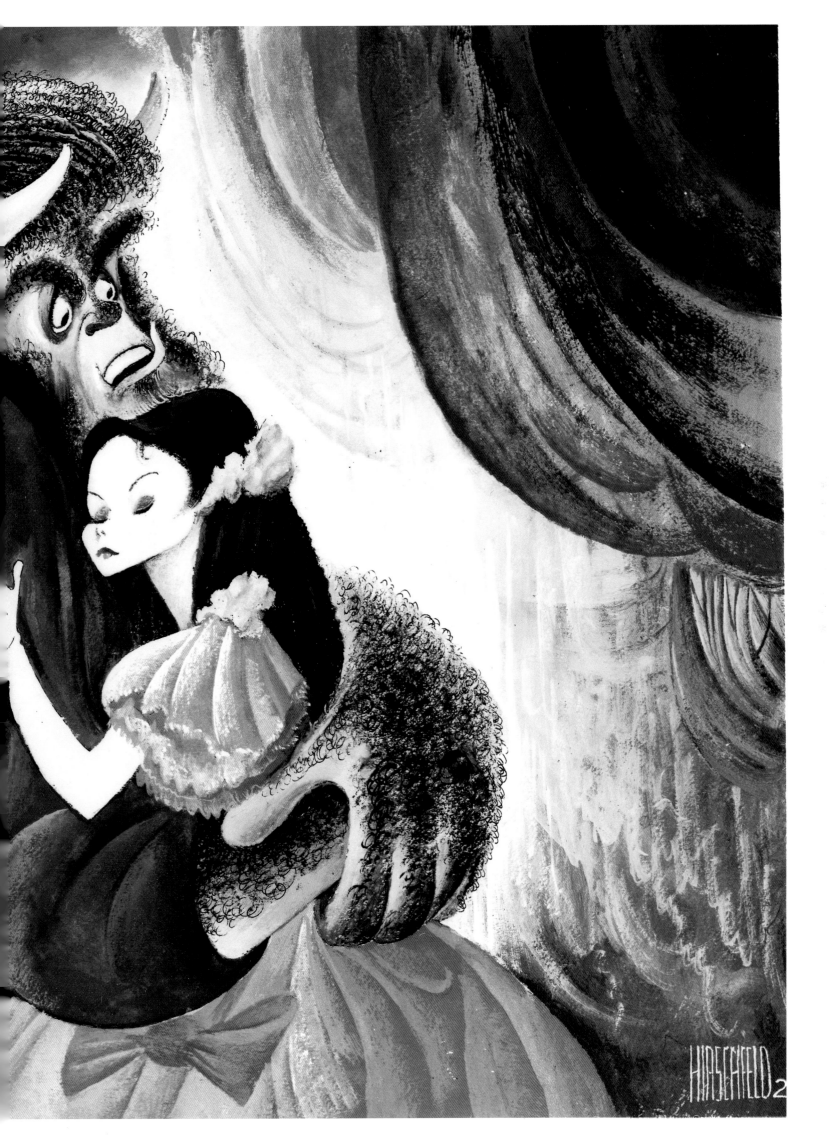

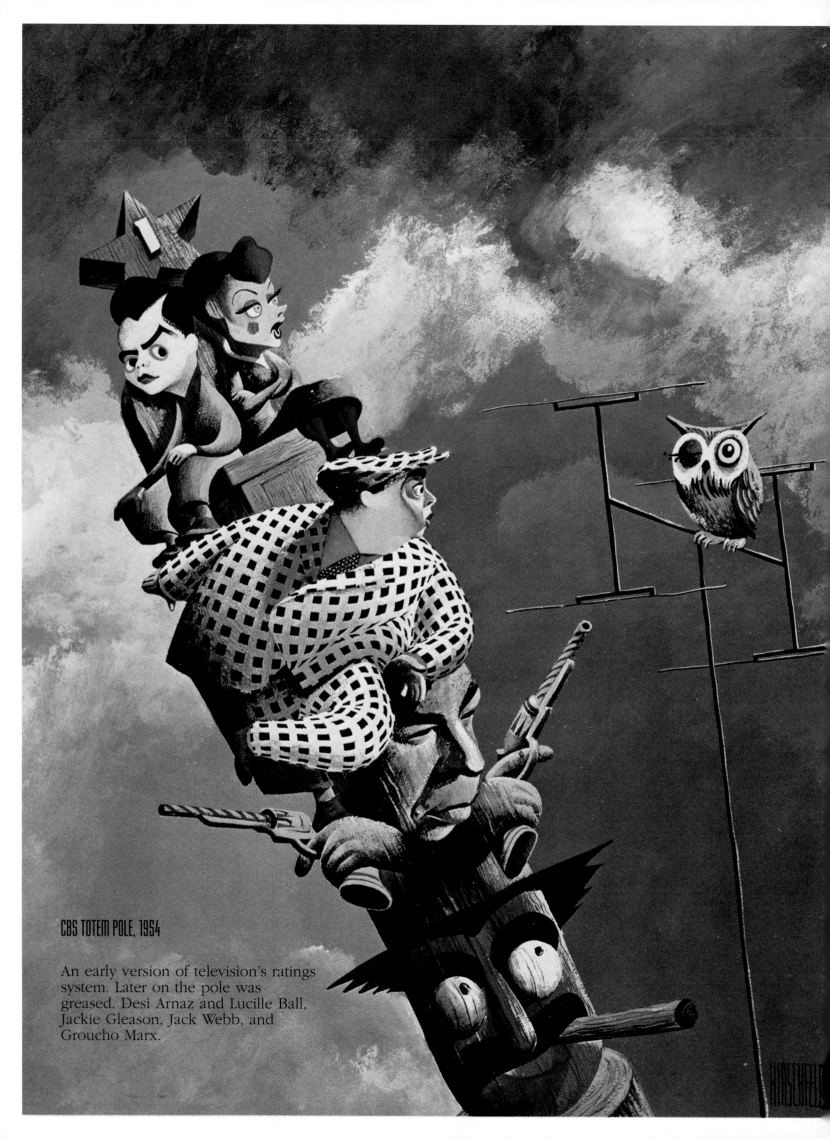

CBS TOTEM POLE, 1954

An early version of television's ratings
system. Later on the pole was
greased. Desi Arnaz and Lucille Ball,
Jackie Gleason, Jack Webb, and
Groucho Marx.

I was commissioned to do this color image for *Time* magazine, of the Cultural Icons of the Twentieth Century. All was hunky-dory until one of the editors opined that my depiction of the great Louis Armstrong — whom I'd been drawing for decades and unequivocally admired — was less than flattering. The fact that Mr. Armstrong had been chosen as one of five "cultural icons of the 20th century" along with Chaplin and Picasso et alia didn't seem to weigh in on the positive side. Nevertheless, I obligingly revised the drawing. This is my original version printed here. You be the judge of whether the King of Jazz would say I played him false.

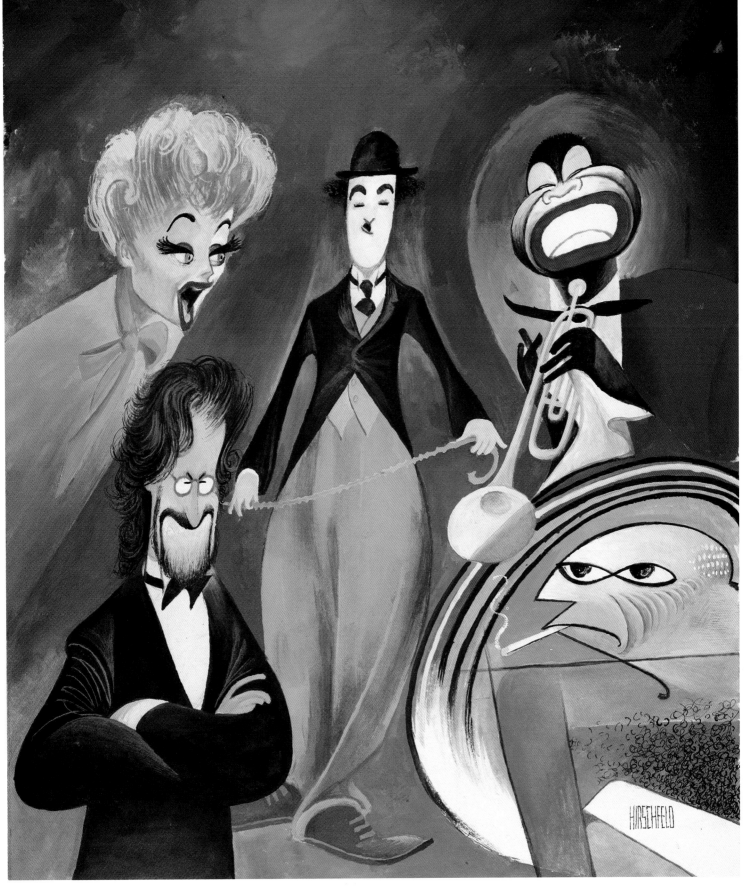

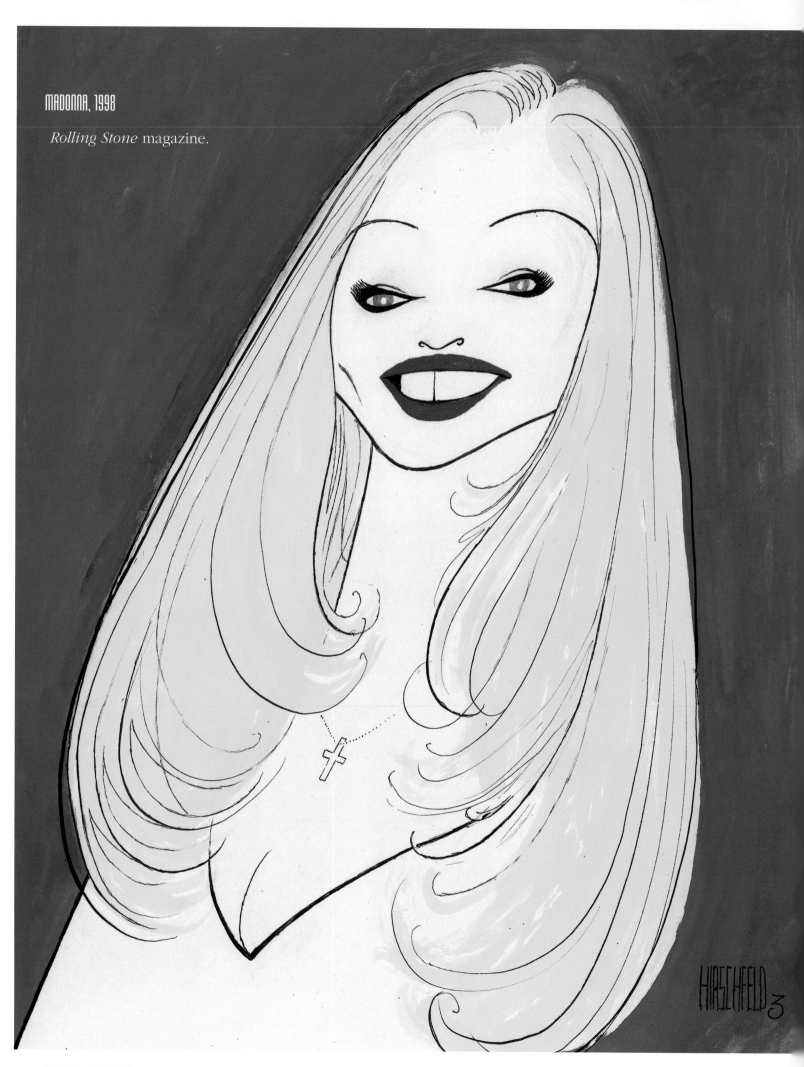

MADONNA, 1998

Rolling Stone magazine.

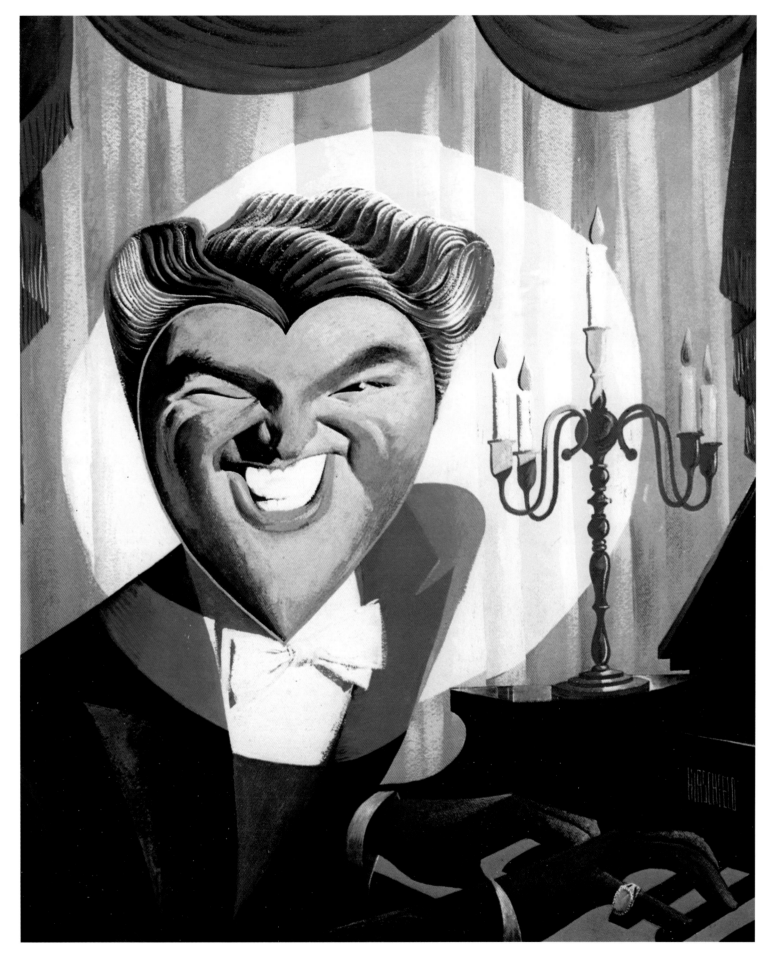

LIBERACE, 1954

I did this drawing for a cover of *Collier's* magazine, and it brought a fan letter from his agents in California. They'd telephoned *Collier's* and were informed that the original painting used on the cover had been returned to me, and they wanted very much to obtain it. I replied that the original could be purchased for what I thought a reasonable amount. By return mail I received a furiously worded letter apprising me of Mr. Liberace's great collection of paintings, all portraits of the master done by GREAT artists. Up to now not a one of these titans had ever asked for mercenary compensation. I responded immediately, apologizing for the misunderstanding and my seeming ingratitude. I promised faithfully to dispatch the original painting to Mr. Liberace posthaste without payment of any kind, to hang in his living room. On one condition — that they send me Mr. Liberace to hang in mine.

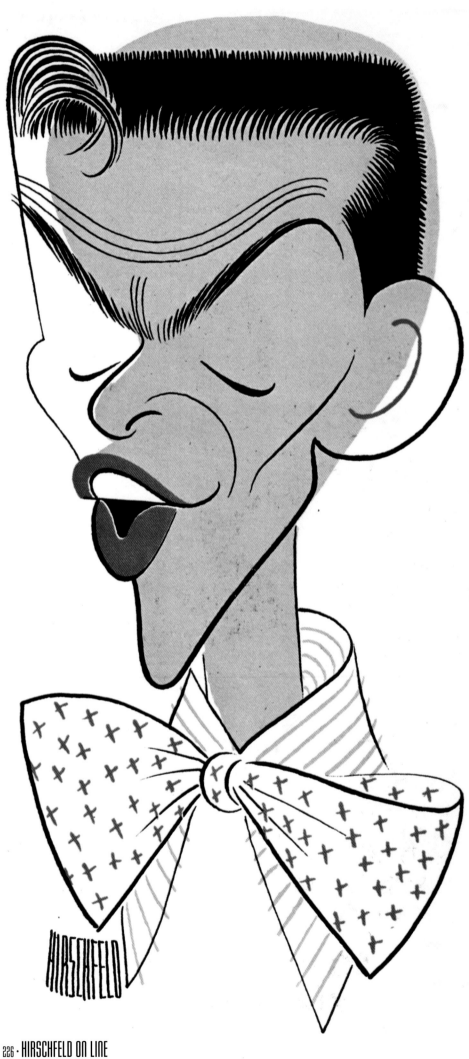

FRANK SINATRA, 1946

Frank gave a famous series of performances at the Paramount Theater in New York in the early Forties, and I was there. It was wild. The kids got up and started dancing in the aisles. This went on at every performance. The same sort of insanity would be duplicated twenty years later when the Beatles showed up at Ed Sullivan's theatre. I never quite understood what prompted that type of response to singers. Frank had a wonderful sense of timing, but what makes people go batty like that is a mystery.

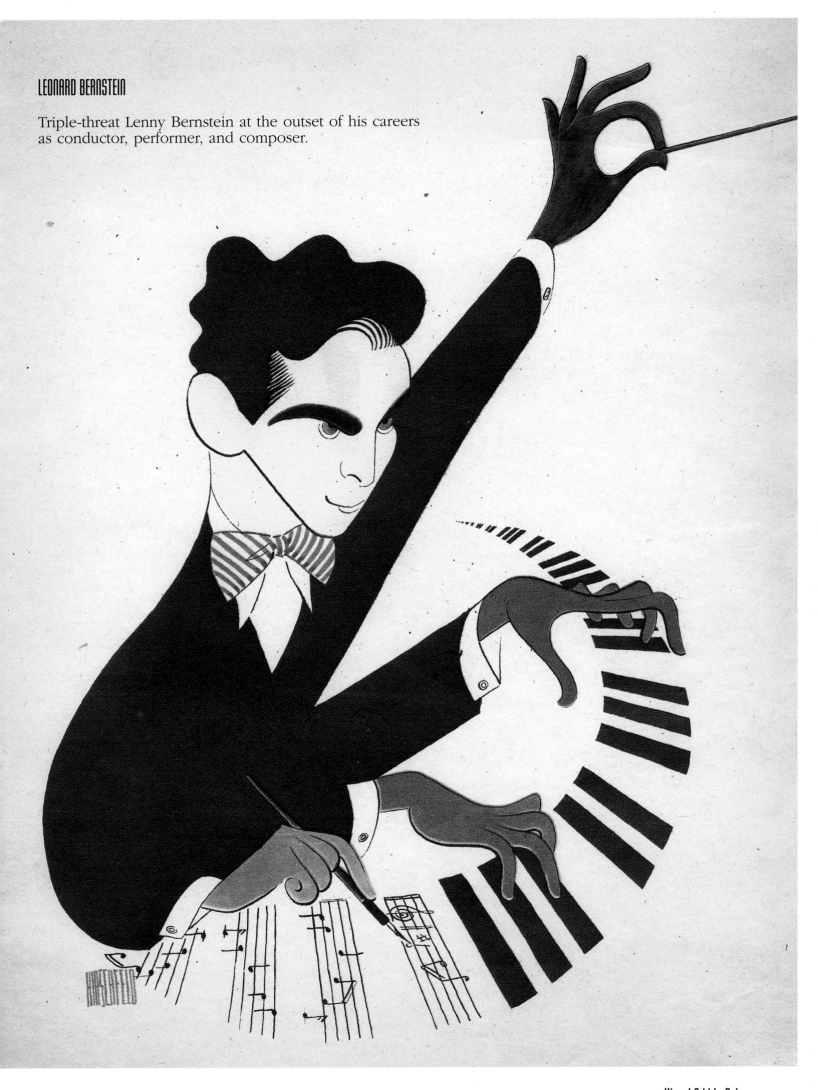

LEONARD BERNSTEIN

Triple-threat Lenny Bernstein at the outset of his careers as conductor, performer, and composer.

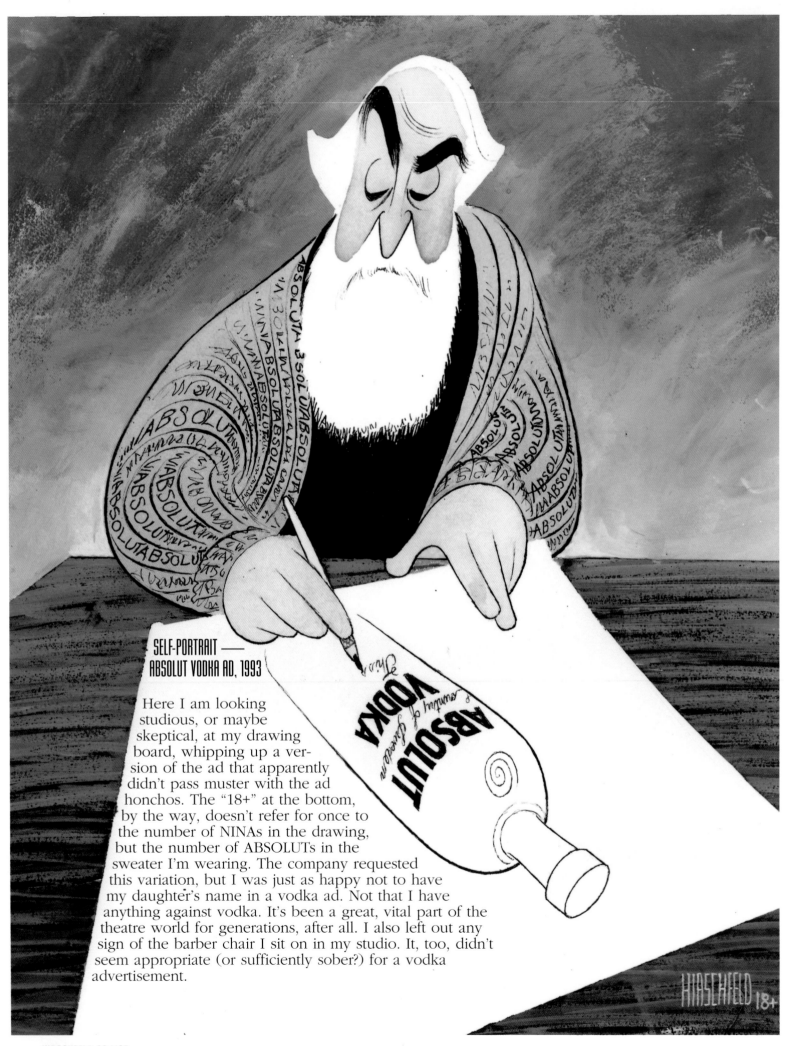

**SELF-PORTRAIT —
ABSOLUT VODKA AD, 1993**

Here I am looking studious, or maybe skeptical, at my drawing board, whipping up a version of the ad that apparently didn't pass muster with the ad honchos. The "18+" at the bottom, by the way, doesn't refer for once to the number of NINAs in the drawing, but the number of ABSOLUTs in the sweater I'm wearing. The company requested this variation, but I was just as happy not to have my daughter's name in a vodka ad. Not that I have anything against vodka. It's been a great, vital part of the theatre world for generations, after all. I also left out any sign of the barber chair I sit on in my studio. It, too, didn't seem appropriate (or sufficiently sober?) for a vodka advertisement.

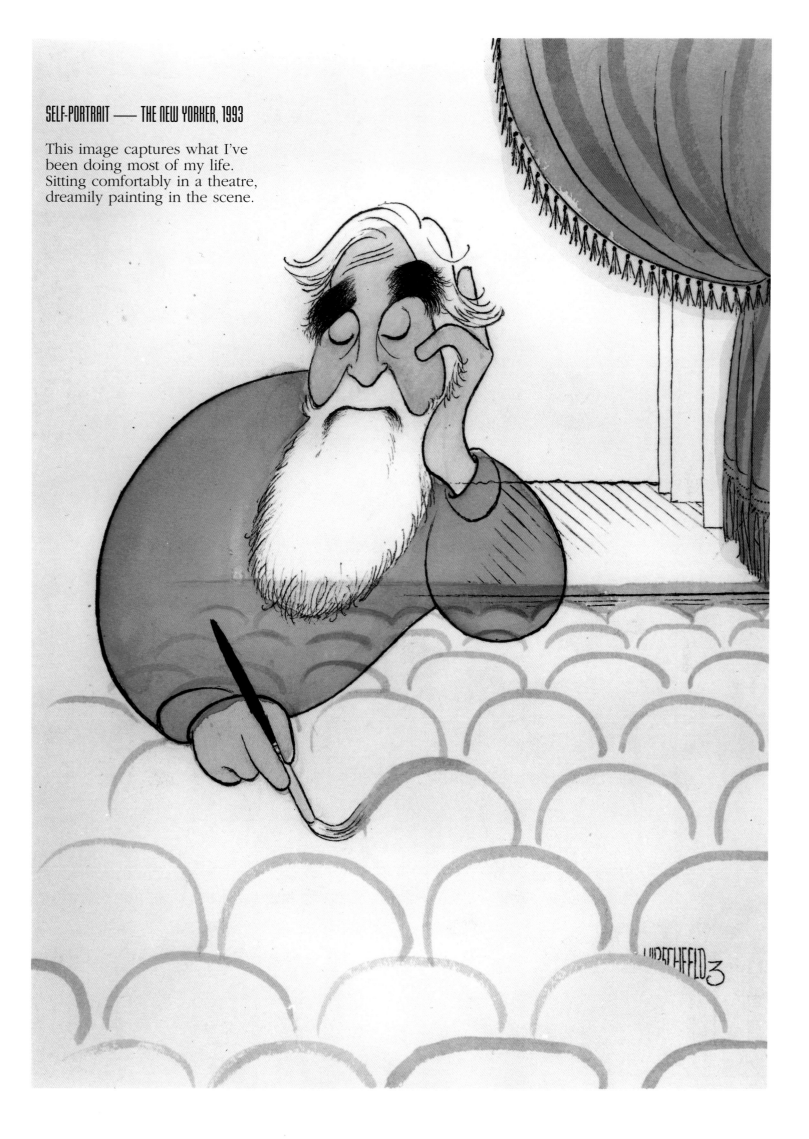

SELF-PORTRAIT —— THE NEW YORKER, 1993

This image captures what I've been doing most of my life. Sitting comfortably in a theatre, dreamily painting in the scene.

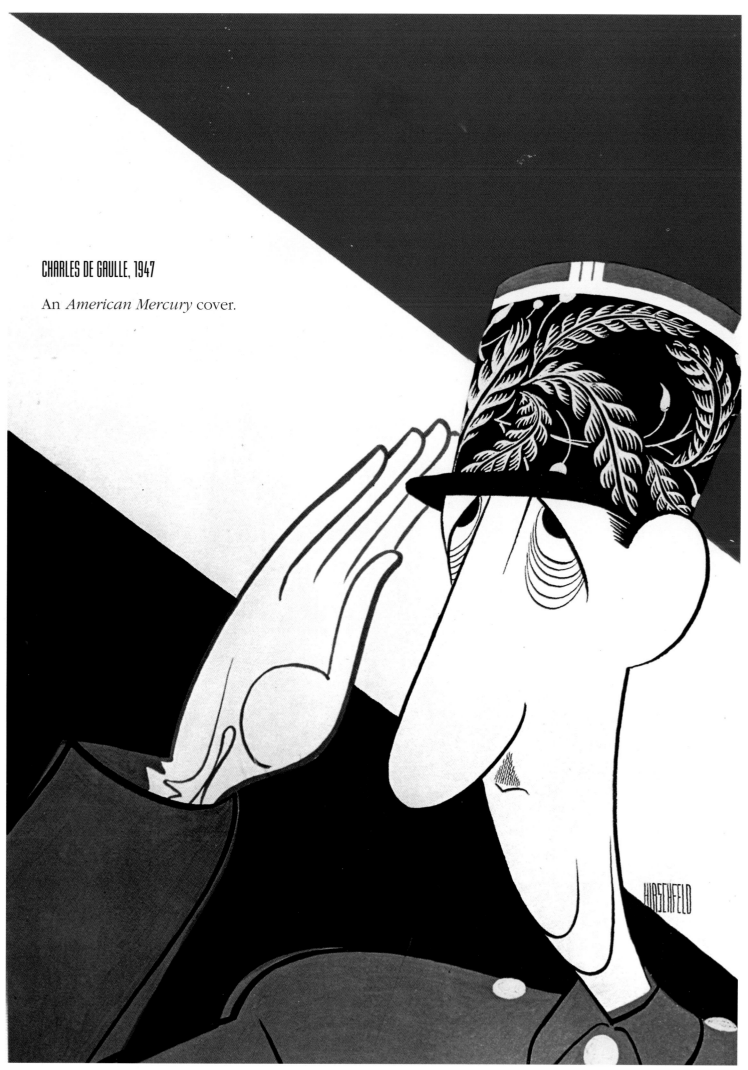

CHARLES DE GAULLE, 1947

An *American Mercury* cover.

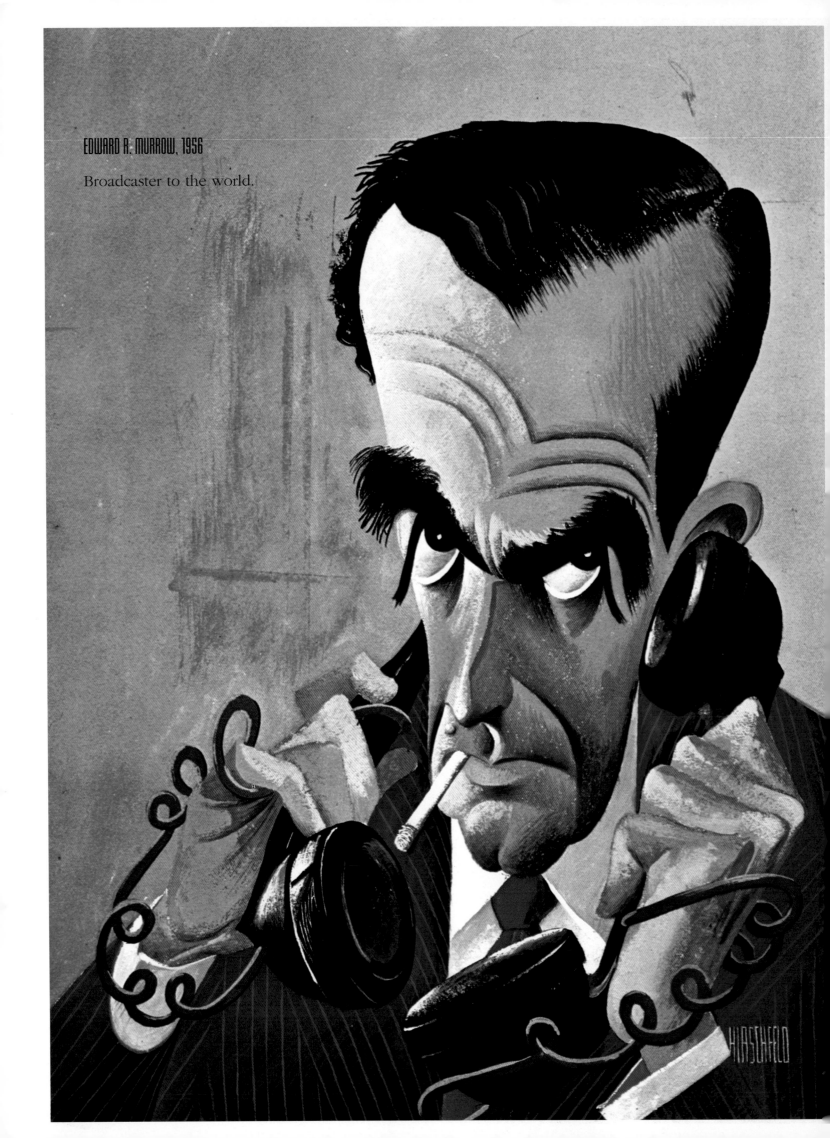

EDWARD R. MURROW, 1956

Broadcaster to the world.

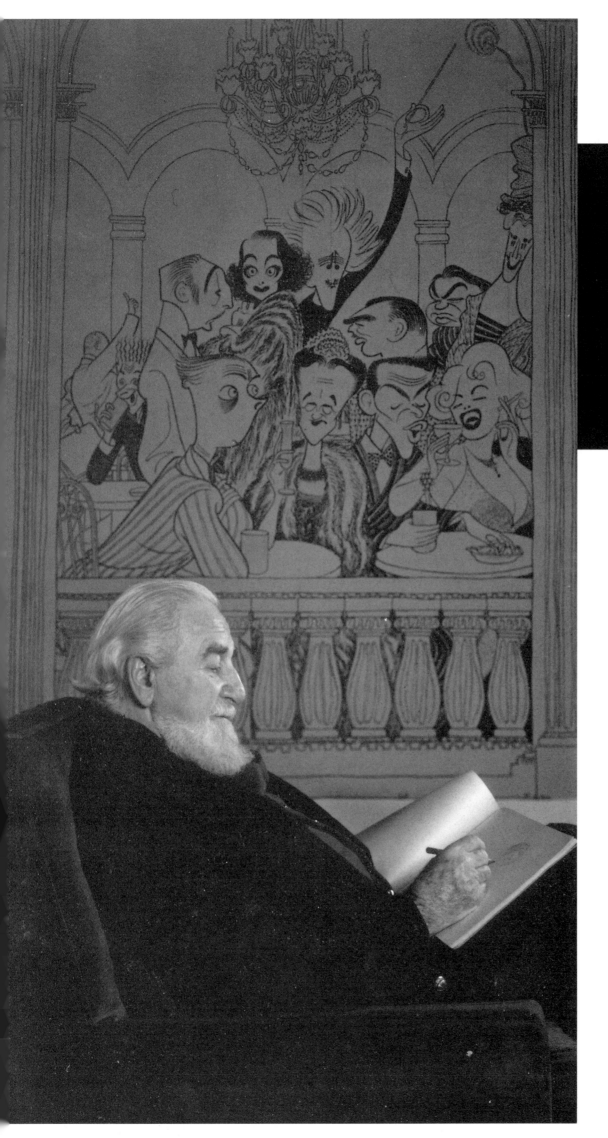

Top: A Hirschfeld Christmas card; Dolly, Al and Nina at Al's 90th birth-day party, at the Algonquin Hotel, in 1993.

Middle: Al alone after Dolly's death.

Bottom: Al and Louise in 1998; at Al's 95th birthday in Larchmont, NY: Tony Kerz; Louise; Nina; Jonathan, Susan and Nicole Kerz; Lisa Kerz with Kara and Kaylee; Al; Matthew Russel; Margaret West with Buddie.

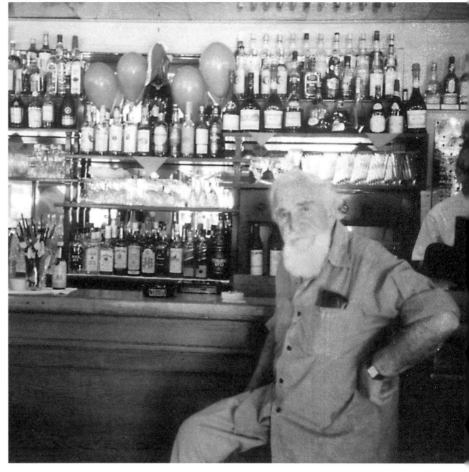

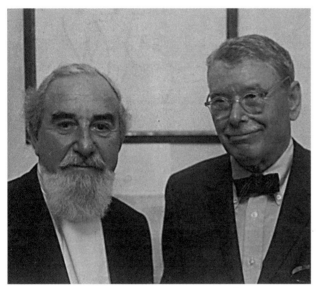

Top: Al with Sidney Kingsley; Al in his favorite Paris café, Flores, 1996.

Middle: With dear friend Brooks Atkinson.

Bottom: Al celebrates his birthday with Mayor Koch at Gracie Mansion in the mid-1980s— Margo Feiden is on right.

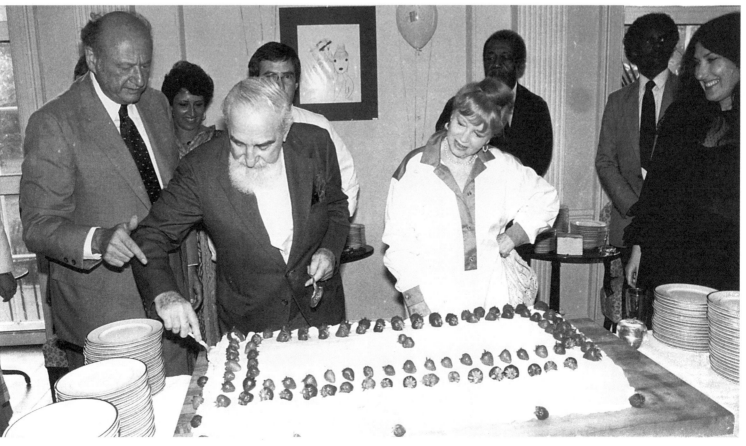

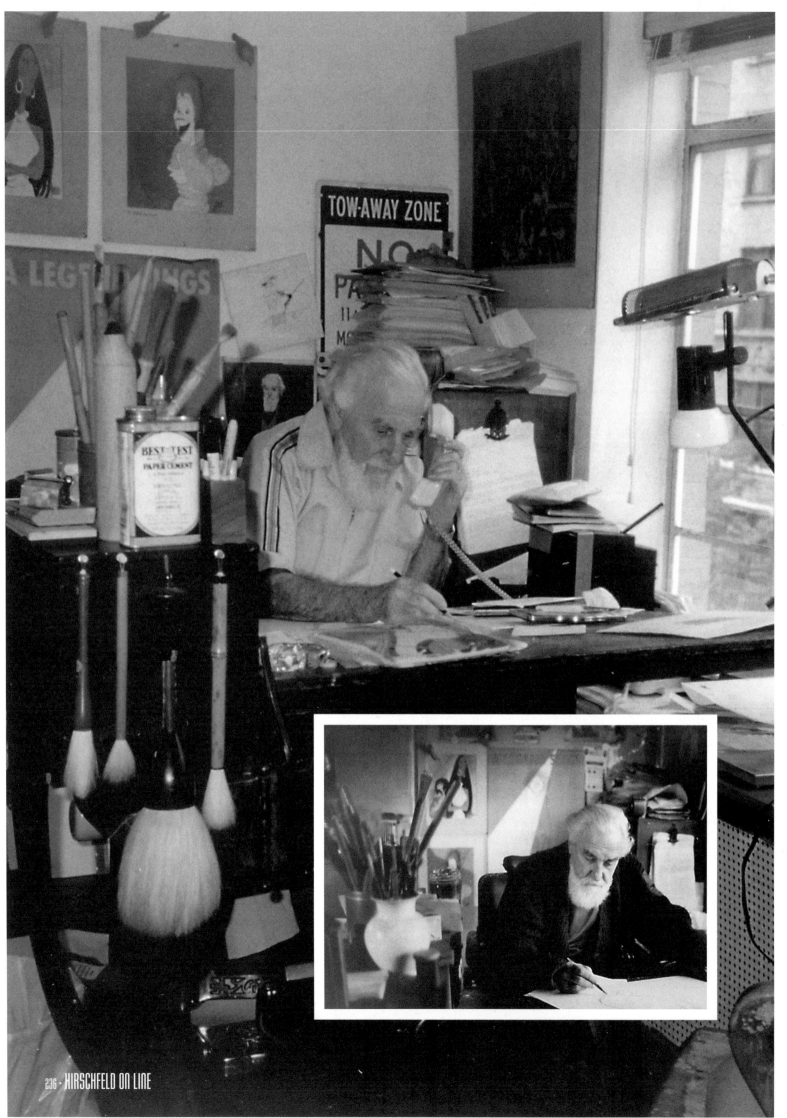

THIS PAGE: DIDIER LEPAUW; INSET, STILL FROM SUSAN W. DRYFOOS FILM *THE LINE KING: THE AL HIRSCHFELD STORY*, TIMES HISTORY PRODUCTIONS, DIVISION OF *THE NEW YORK TIMES* AND CASTLE HILL PRODUCTIONS. OPPOSITE PAGE: ARNOLD NEWMAN

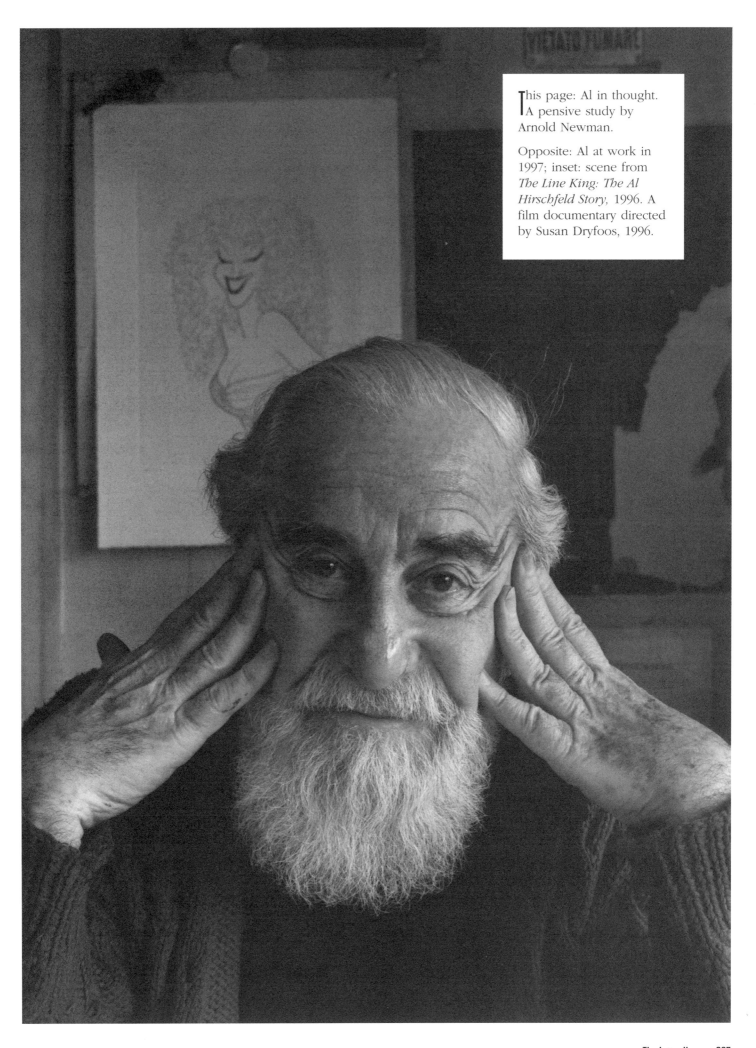

This page: Al in thought. A pensive study by Arnold Newman.

Opposite: Al at work in 1997; inset: scene from *The Line King: The Al Hirschfeld Story*, 1996. A film documentary directed by Susan Dryfoos, 1996.

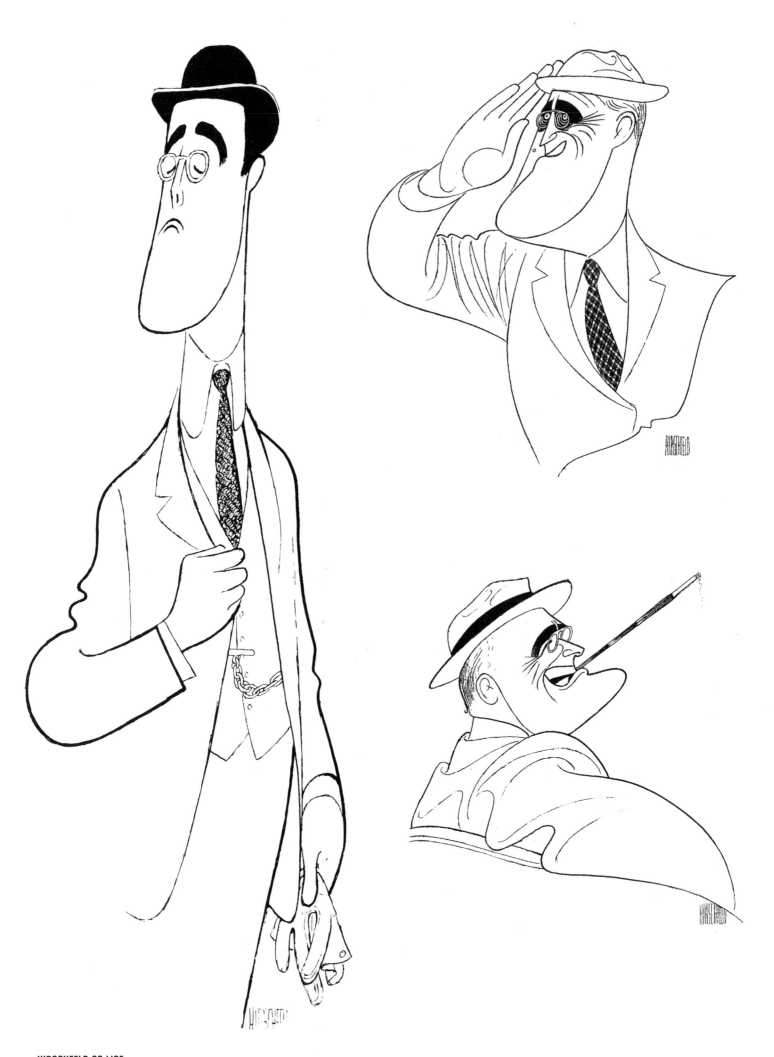

Franklin Delano Roosevelt, 1984 and late '30s

Five drawings that represent a lifetime of political influence, from a very young politician up to a very old man. I just worshipped him. I thought he was saving the country, really. I finally went to visit him in the White House towards the end. Usually I'm not impressed with most of the people I draw but with him it was almost like talking to an icon of another age. But I was also disappointed, because he was so aware of being drawn. He took out his cigarette holder and posed with it. I thought, "Why is he doing that?" Probably you should never meet the people you truly admire. It's too risky. You'll notice in the drawing of him as a young man, a young dandy really, he's standing, because he still had use of his legs then. Then, as he ages, the lines under his eyes sag, all the lines in the drawing sag. The weight of the world, and the World War, dragging him down. His face became a flag with stars for eyes and stripes for incredible lines sagging under those eyes.

The one with stars-and-stripes eyes I did in the late Thirties as a cover of *The Nation*. It was later used by F. D. R. as a logo for the aircraft carrier *U. S. S. Roosevelt*.

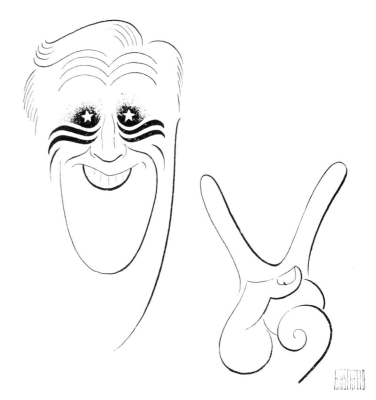

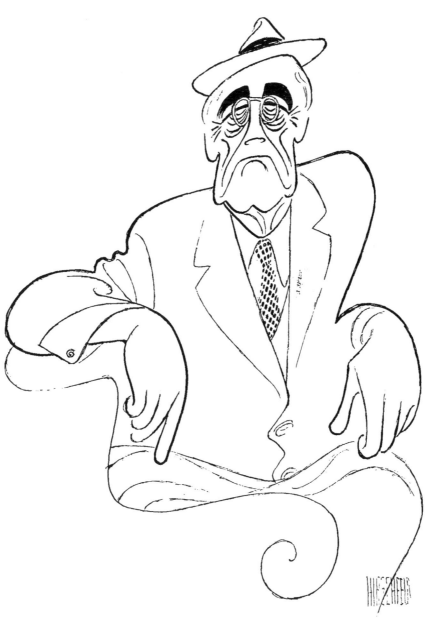

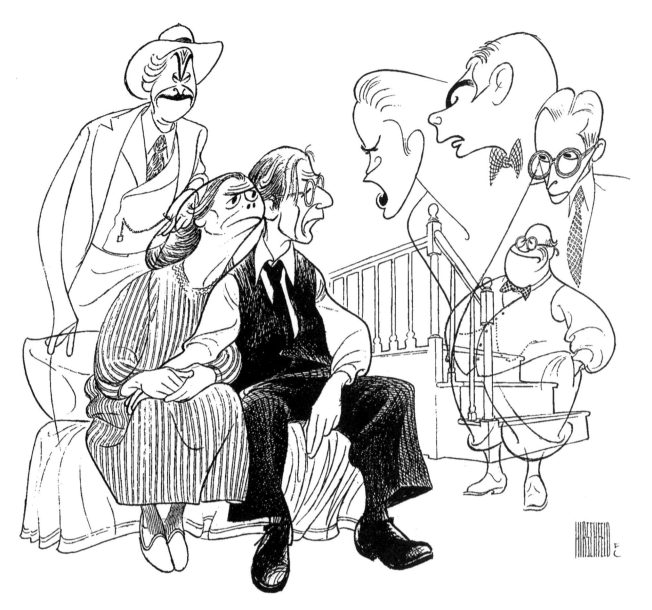

Death of a Salesman, 1984

(Dustin Hoffman)

It was a real challenge for Dustin Hoffman to step into this major role, one that had been so strongly identified with Lee J. Cobb since the landmark original production, but he made his thumbprint equally impressive. As did Kate Reed as his long-suffering wife. In the drawing I tried to capture all the forces influencing Willy Loman's character, and his actions—the two sons, his work, the constant pressure to succeed. Arthur Miller struck a wonderful theme, because everyone is a salesman in one way or another. Also in the cast: Louis Zorich, Kate Reid, John Malkovich, Stephen Lang, David Chandler, and David Huddleston.

English Playwrights, 1977

(Simon Gray, David Rudkin, Harold Pinter, Alan Ayckbourn, Trevor Griffiths, Peter Shaeffer, Tom Stoppard)

When I look at this drawing it looks like something from a laughing academy or an insane asylum instead of a group portrait of great British playwrights of the day. If I'd done this ten years later I suppose I would have had to sit them all in front of a word processor. Now the hair and the typewriter are museum pieces. I forget why they all look so angry. They're all collaborating, or not collaborating, on the same play, all trying to type at the same time. You can see it's Act One, page one. I doubt they got very much further. I drew this for the *New York Times* happily, because I think writers, playwrights included, aren't photographed, drawn, or celebrated enough, or quoted seriously, in modern communications.

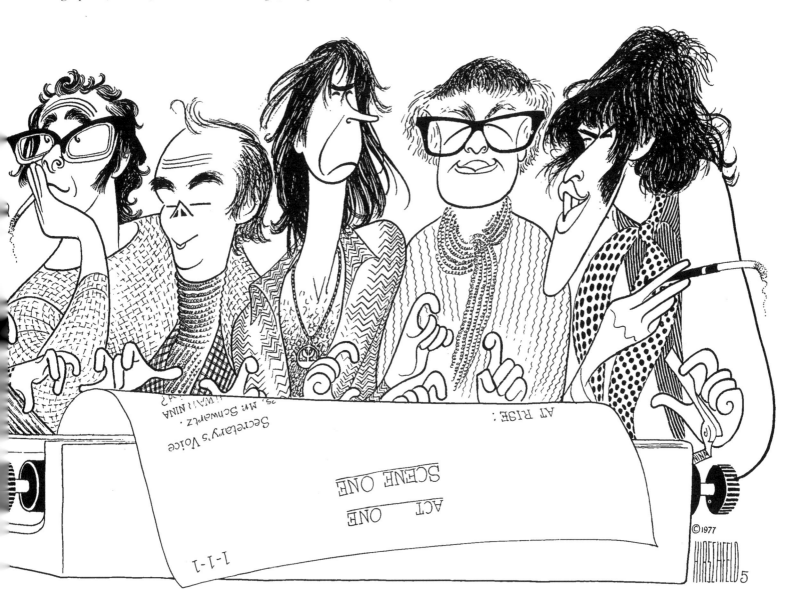

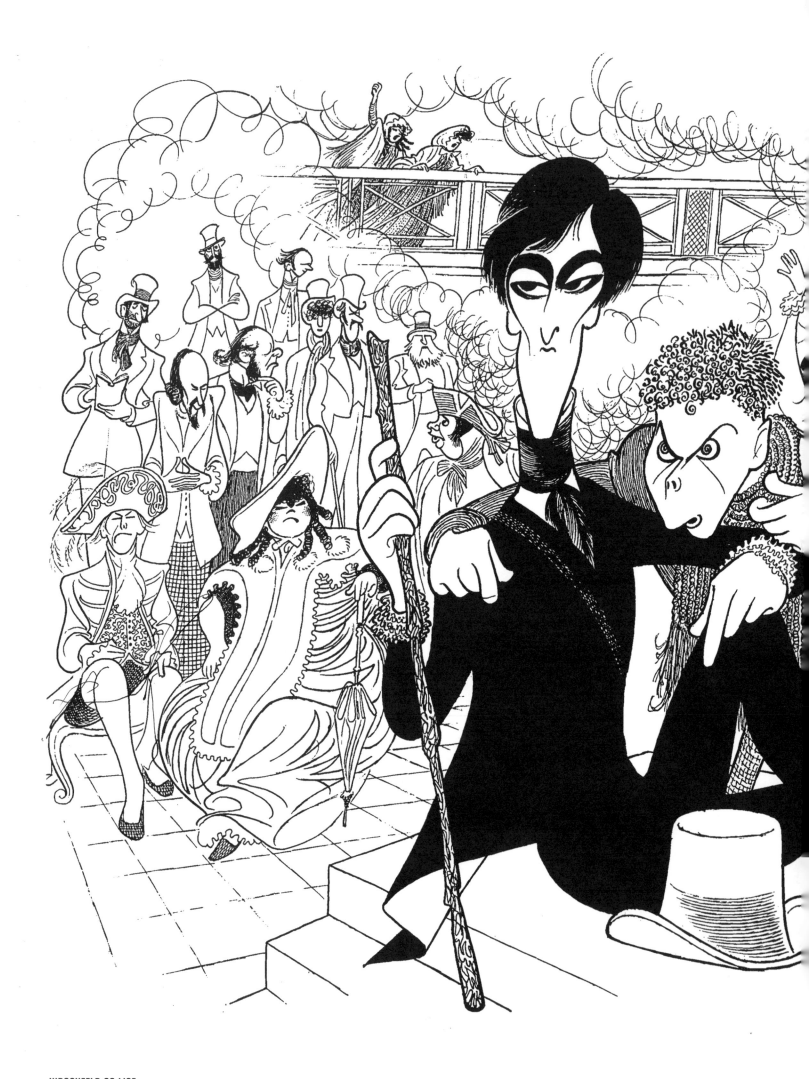

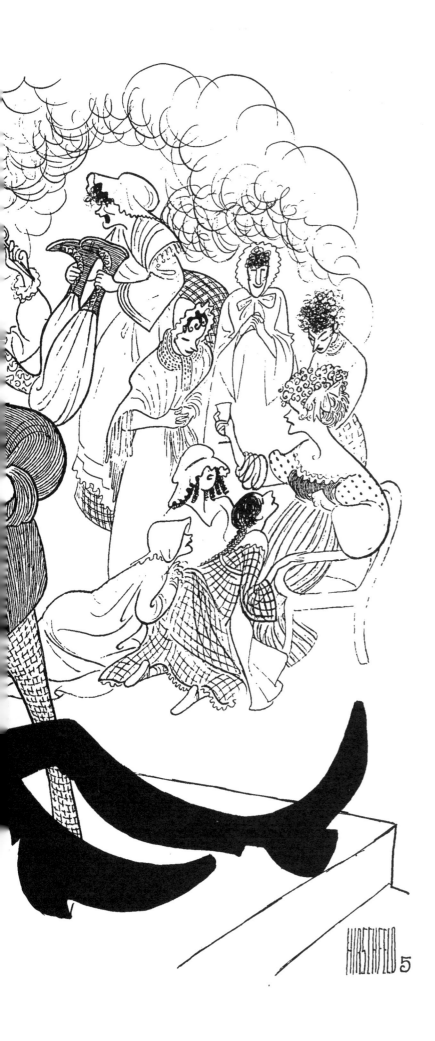

Nicholas Nickleby, 1981

Roger Rees, as the title character, and David Threlfall in a Royal Shakespeare Company production of Dickens's *Nicholas Nickleby*. The eight-hour-long show was almost as long as the novel, but nearly as wonderful too, beautifully costumed, with terrific period detail. One came out of the theatre a bit older but enlightened.

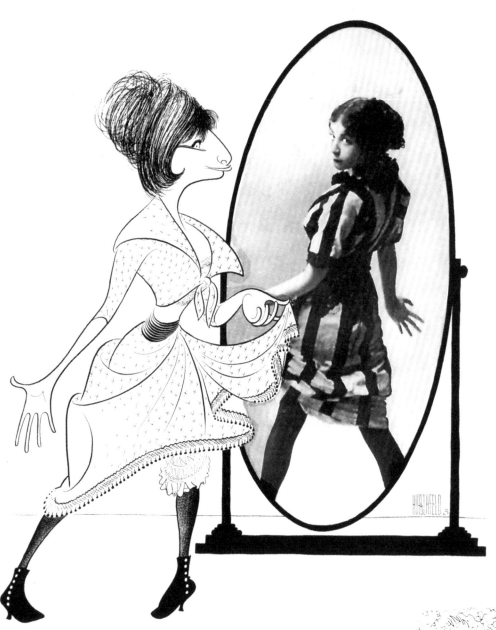

Barbra Streisand, 1964 and 1984

I have drawn Barbra many times, from *I Can Get It for You Wholesale* up to the present. She's like a tropical bird of some kind. The important thing is her eyes—they're penetrating and serious. Usually her nose is emphasized in every picture, but I deemphasized it. I did the same with Jimmy Durante. I once left his nose off entirely in one drawing. What would Streisand have been like in the Thirties and Forties, during Broadway's heyday? Her spectacular debut success in *Funny Girl* in the Sixties (for which I drew her, above, facing a photo of Fanny Brice in a mirror) was the very end of that era. She made the transition into film and records— but can you imagine George and Ira writing with Barbra in mind? Or Rodgers and Hart? Cole Porter? It would have been bigger than superstardom, it'd have been supernova-dom.

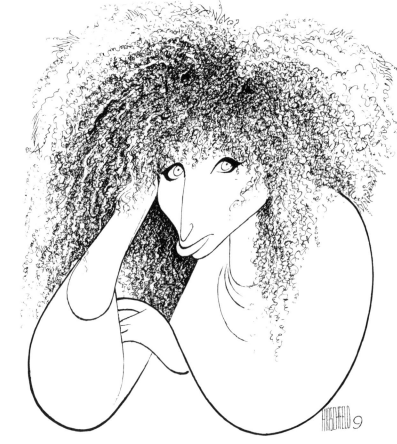

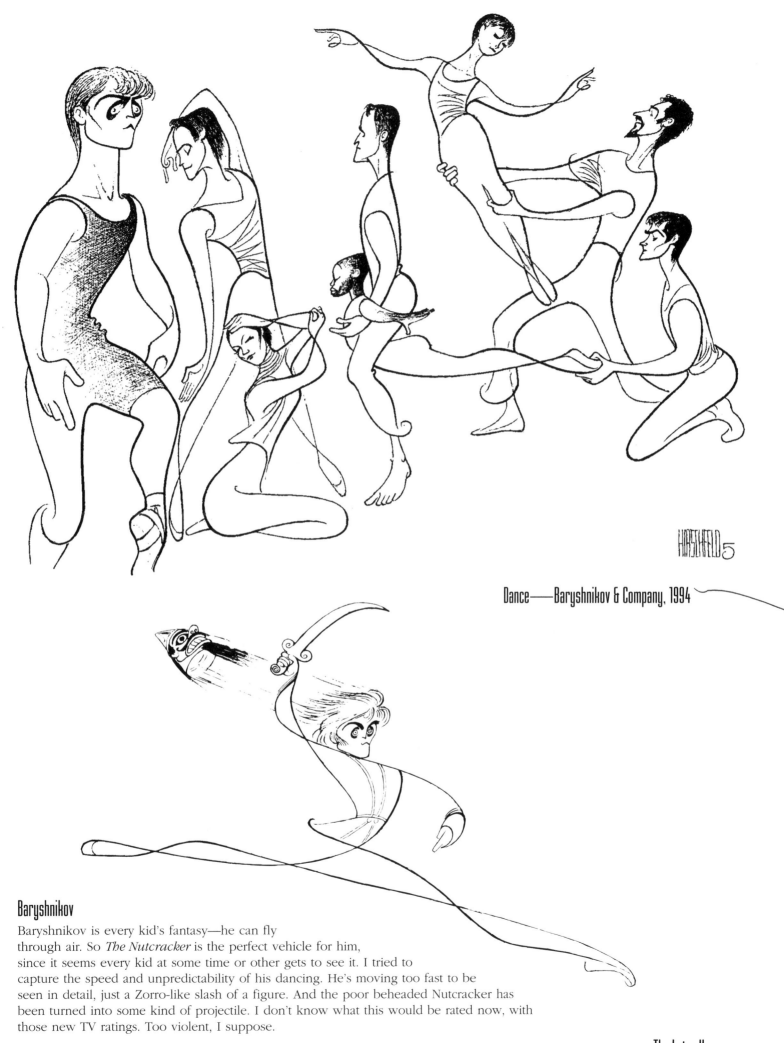

Dance——Baryshnikov & Company, 1994

Baryshnikov

Baryshnikov is every kid's fantasy—he can fly
through air. So *The Nutcracker* is the perfect vehicle for him,
since it seems every kid at some time or other gets to see it. I tried to
capture the speed and unpredictability of his dancing. He's moving too fast to be
seen in detail, just a Zorro-like slash of a figure. And the poor beheaded Nutcracker has
been turned into some kind of projectile. I don't know what this would be rated now, with
those new TV ratings. Too violent, I suppose.

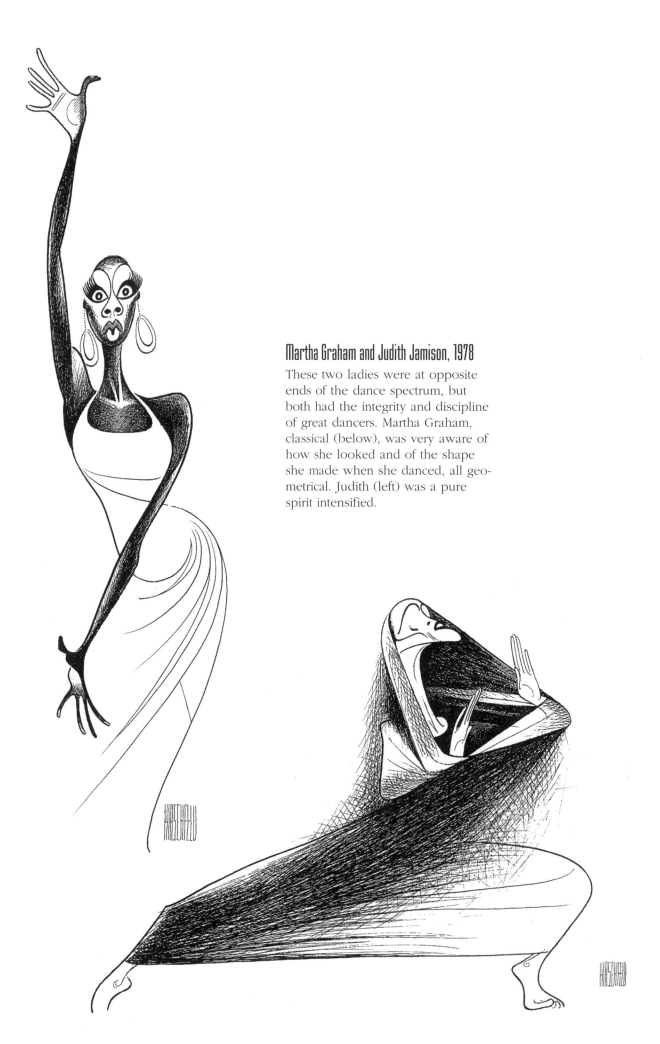

Martha Graham and Judith Jamison, 1978

These two ladies were at opposite ends of the dance spectrum, but both had the integrity and discipline of great dancers. Martha Graham, classical (below), was very aware of how she looked and of the shape she made when she danced, all geometrical. Judith (left) was a pure spirit intensified.

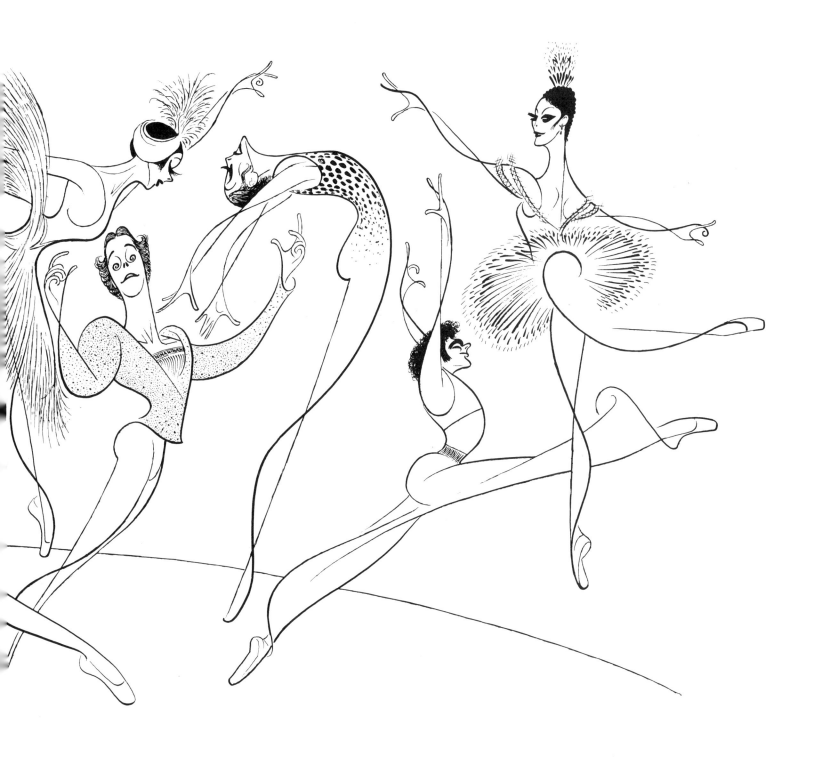

American Ballet Theatre, 1980

I had a lot more fun than usual doing this one. As I look at the visual motif now, the dancers look like treble clefs almost, or like musical instruments in the way they blend together. The sweeping line works beautifully in this drawing. Ballet, of course, has a lot of that boundless energy, that flying around the stage, that I like so much. In fact, the ground is only hinted at here with that one thin bending line—or maybe it's a horizon line, and who knows how high up in the air they might be cavorting about.

Jerome Robbins' Broadway, 1989

Jerry Robbins pointed the way for the American theatre for a long time. Here he is, a theatre giant surrounded by all the shows he choreographed: *On the Town*, 1944; *Peter Pan*, 1954; *Gypsy*, 1959; *West Side Story*, 1957; *Billion Dollar Baby*, 1945; *The King and I*, 1951; *Fiddler On the Roof,* 1964; *High Button Shoes*, 1947; *A Funny Thing Happened on the Way to the Forum*, 1962. He had just as much fun doing it all as he appears to be having here. Everything is vibrant, everything spectacularly costumed, everything full of the joy of life. Which are the joys of musical theatre at its sophisticated best. I vividly remember when he devised for *Fiddler* the dancing rabbis (balancing wine bottles on their heads while dancing a Russian folk Gazotski) in the tryout in Washington, D.C.—one week before the opening in New York. It became a show stopper.

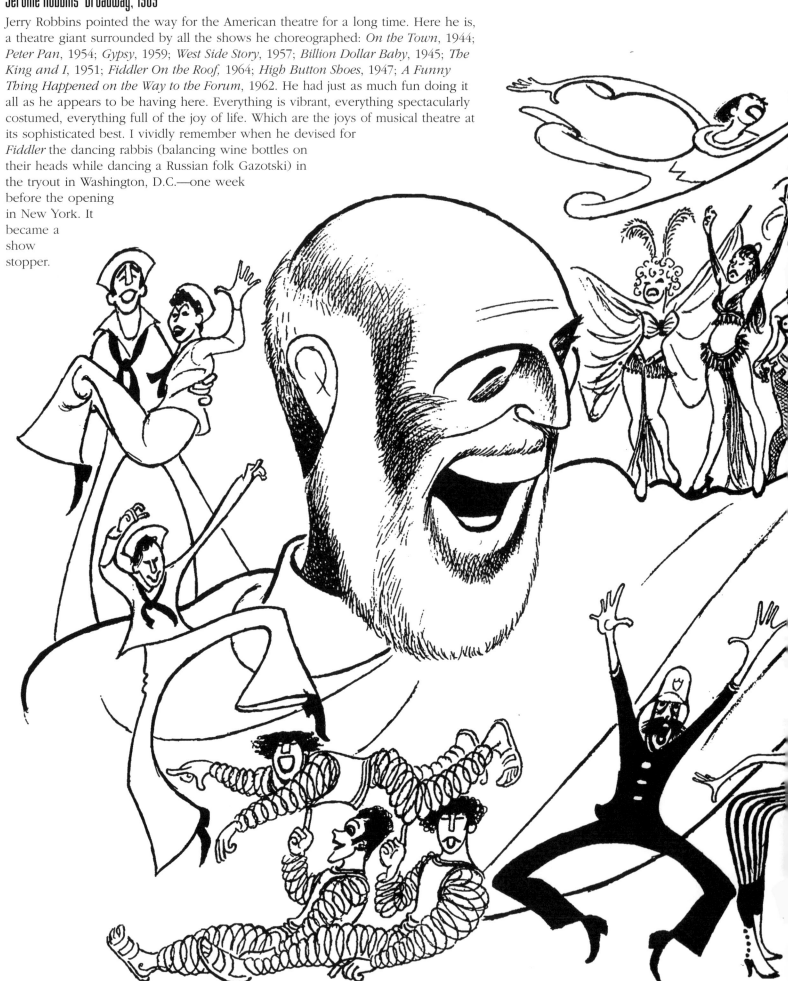

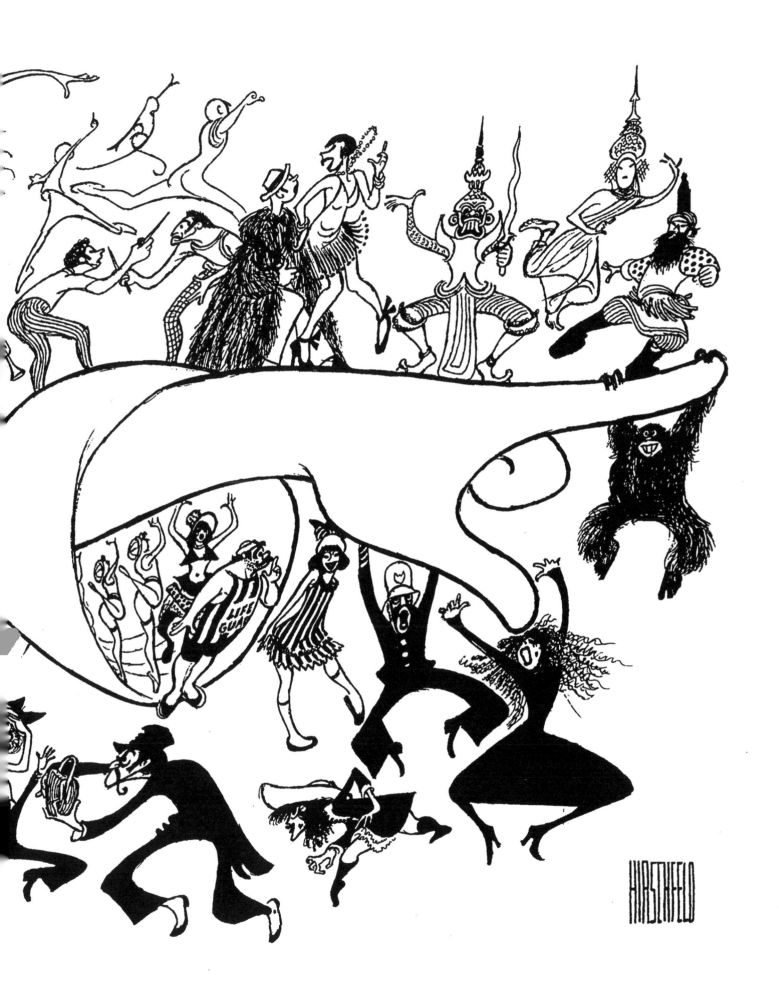

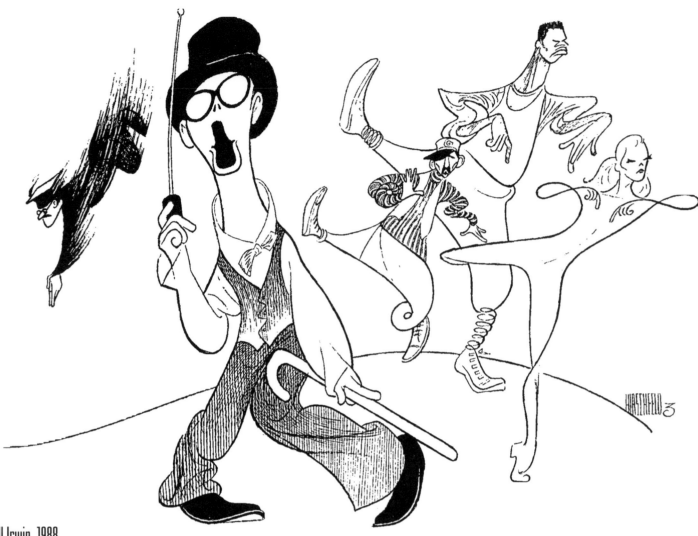

Bill Irwin, 1988

The most striking, memorable aspect of this show, *Largely New York,* and of this drawing, for me is that great, dynamic image of the cap-and-gowned professor diving headfirst from the stage into the orchestra pit! Wonderful visual comedy, in the great tradition of classic stage clowns. Bill Irwin brings it all back. It's comic ballet, really, just as important a tradition of the stage as any other choreography. And fun to draw, of course. Particularly Irwin, who seems to have noodles for bones, and Chaplin's genius for pantomime.

Laurel & Hardy, 1990

There's a kind of musical interruption occurring here. Stan Laurel and Oliver Hardy perform comedy together with the smoothness of a couple of chamber musicians. The two adults who never grew up. But they were also among the few great silent comedians who made the transition to sound. Stan came out of the same great tradition of English pantomime players that Chaplin did. "Babe" Hardy was just a contract player with Mack Sennett. Then one day the two paired up in the Sennett camp and it was a perfect match from the start. I saw them visually as the number "10." Laurel lent himself to the figure "1" and Hardy rotund as the numeral "0."

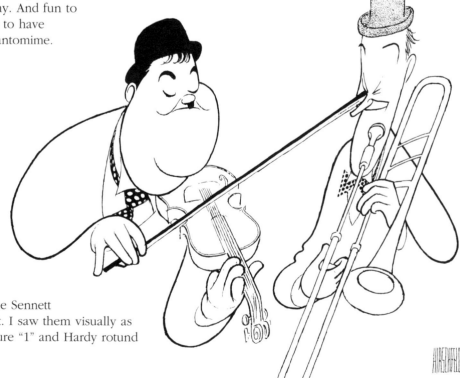

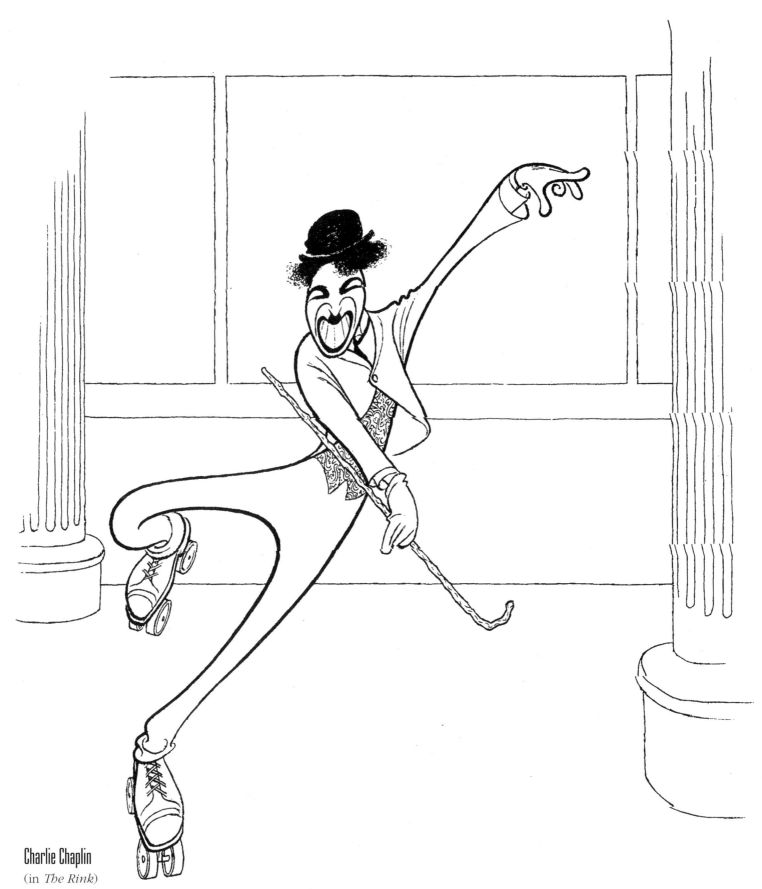

Charlie Chaplin

(in *The Rink*)

Chaplin was a master mime, the greatest I've seen. Here he is in his short film *The Rink* clowning around on roller skates. He could just as easily be log-rolling or flagpole-sitting; it didn't matter, his sense of balance and timing was so absolutely perfect that he could do anything. *The Rink*, like other short films of this period, were pure Chaplin, without the maudlin overtones he felt obliged to include in his features. Twenty minutes of Chaplin annoying the hell out of stuffed shirts was as good as film has ever gotten. I once did a graphicly descriptive drawing of him with both feet in the clouds.

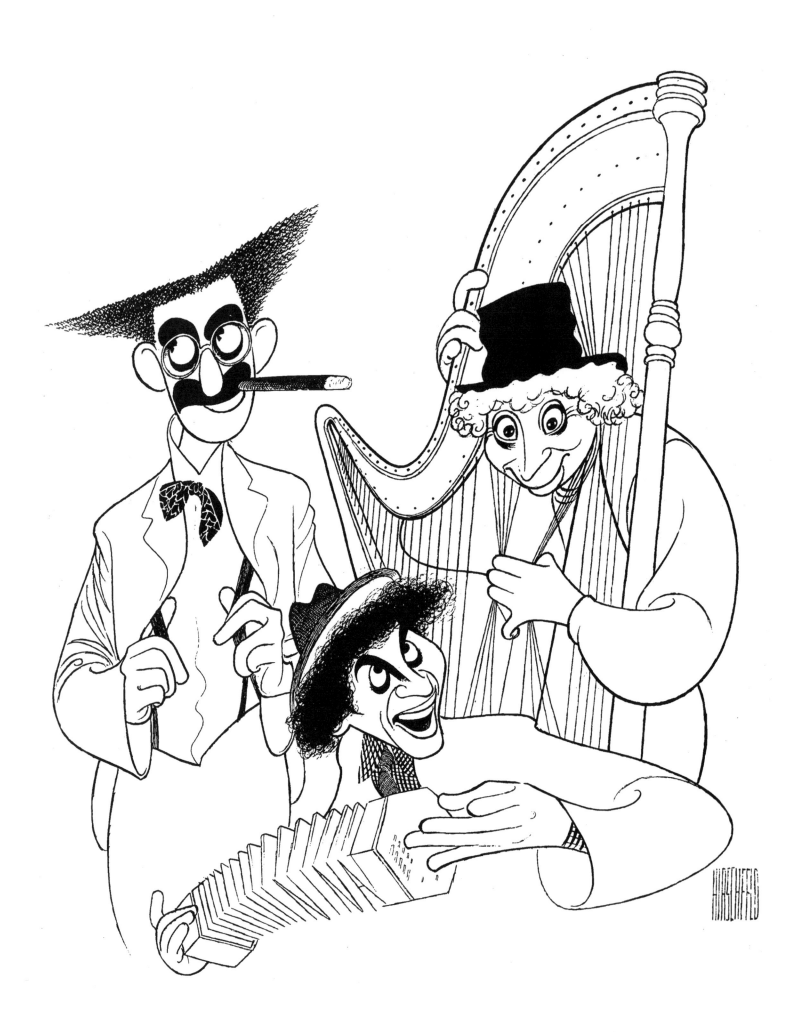

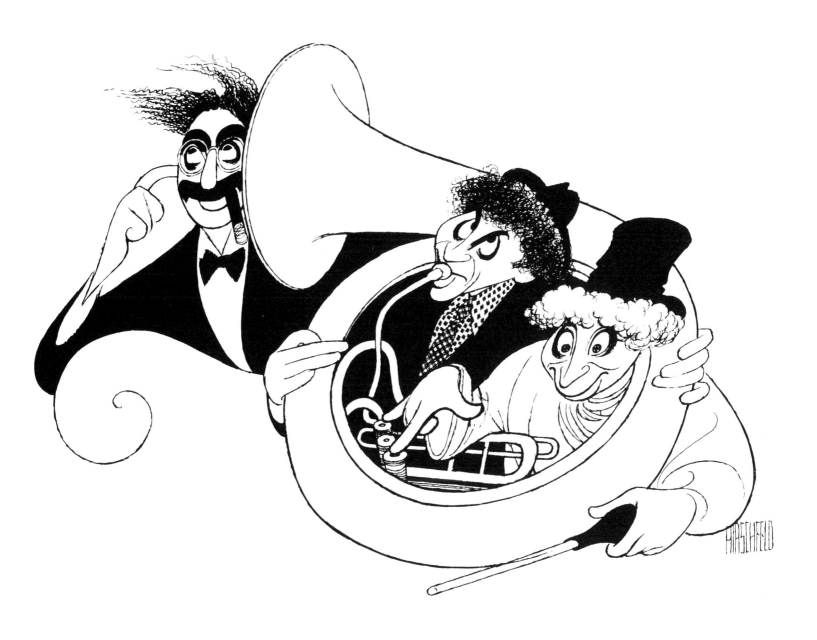

The Marx Brothers, 1989 and 1991

Here *(left)* are Harpo and Chico making sounds that aren't exactly music to Groucho's ears. They went from kids on the vaudeville circuit, to Broadway stars, to movie stars, and Groucho to television star on *You Bet Your Life*. Harpo's doing his famed goggle-eyed look which, according to legend, he copied from a cigar maker near his home on the Upper East Side of Manhattan. The cigar maker sat in the window and with each twist of the cigar wrapper his eyes would cross and bug out more and more and his mouth would gape wider and wider. Harpo called it the "Google."

The *above* comic image of them, graphically, is similar to the Laurel and Hardy drawing earlier. The tuba wasn't the preferred instrument of either Chico or Harpo, and it doesn't look like Groucho is enjoying this concert either. But uniting the three of them does make for a good zany image—the tuba encircling Chico and Harpo, and blasting Groucho. It's also a good "instrument" for me to play up their individual comic characters—irritated for Groucho, Chico blowing hard, and Harpo's fingers hitting every mischievous note he can reach.

Cats, 1983

(Betty Buckley)

Cats has been running for years, far longer than nine consecutive lives of most other Broadway musicals. It seems it will never close. Just what the attraction is defeats me, but it certainly provides for a lively and exotic subject. The music is by Andrew Lloyd Webber. The book is based on T.S. Eliot's *Old Possum's Book of Practical Cats.* I wonder how amused, or amazed, T. S. would be to know that, as one of the great poets of the 20th Century, he'd written the book to an ongoing tourist attraction of this magnitude. With indecipherable lyrics and actors dressed as cats harassing the audience.

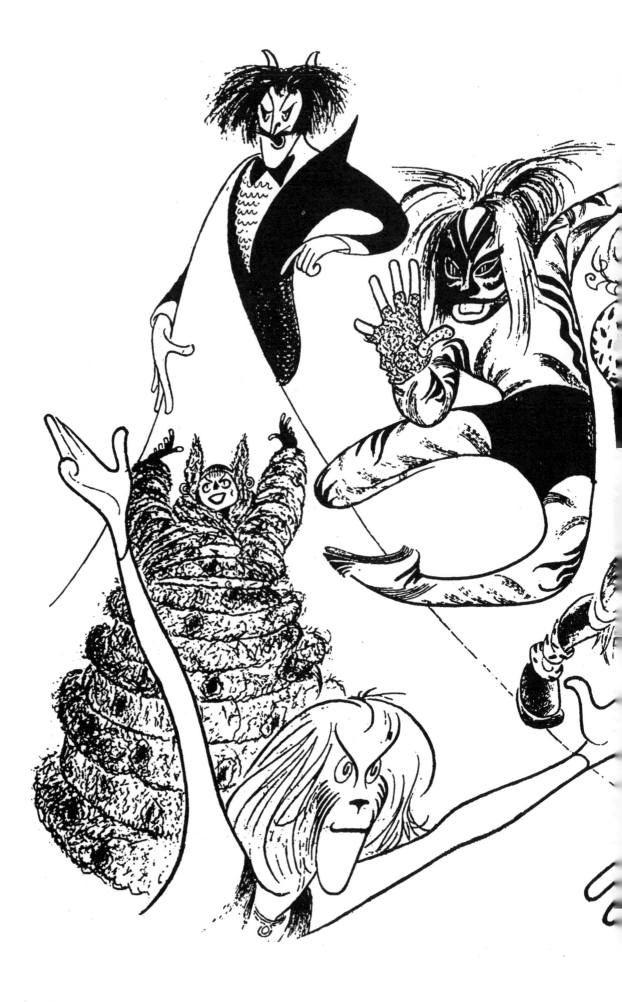

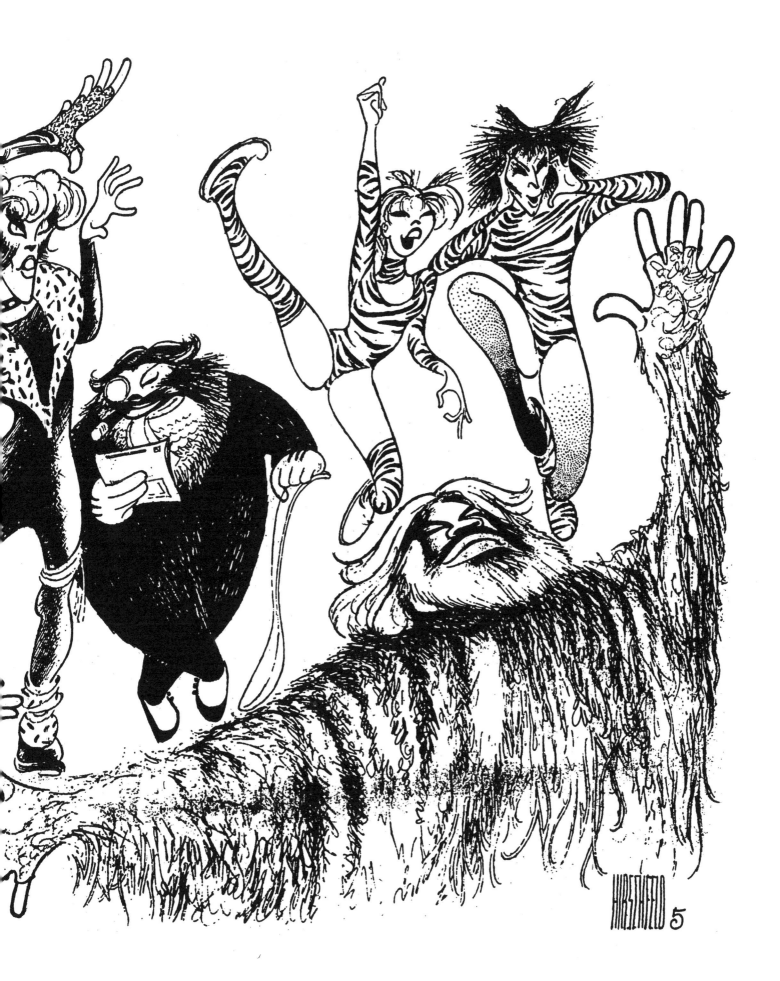

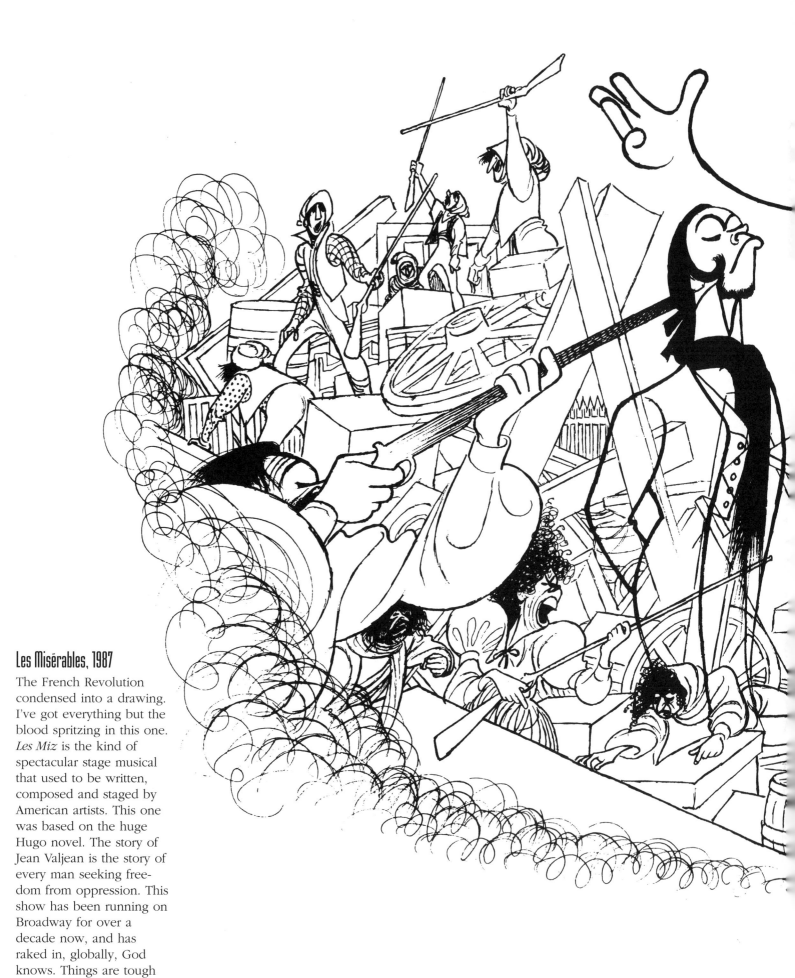

Les Misérables, 1987

The French Revolution condensed into a drawing. I've got everything but the blood spritzing in this one. *Les Miz* is the kind of spectacular stage musical that used to be written, composed and staged by American artists. This one was based on the huge Hugo novel. The story of Jean Valjean is the story of every man seeking freedom from oppression. This show has been running on Broadway for over a decade now, and has raked in, globally, God knows. Things are tough all over. (Starring Colm Wilkinson and Terrence Mann.)

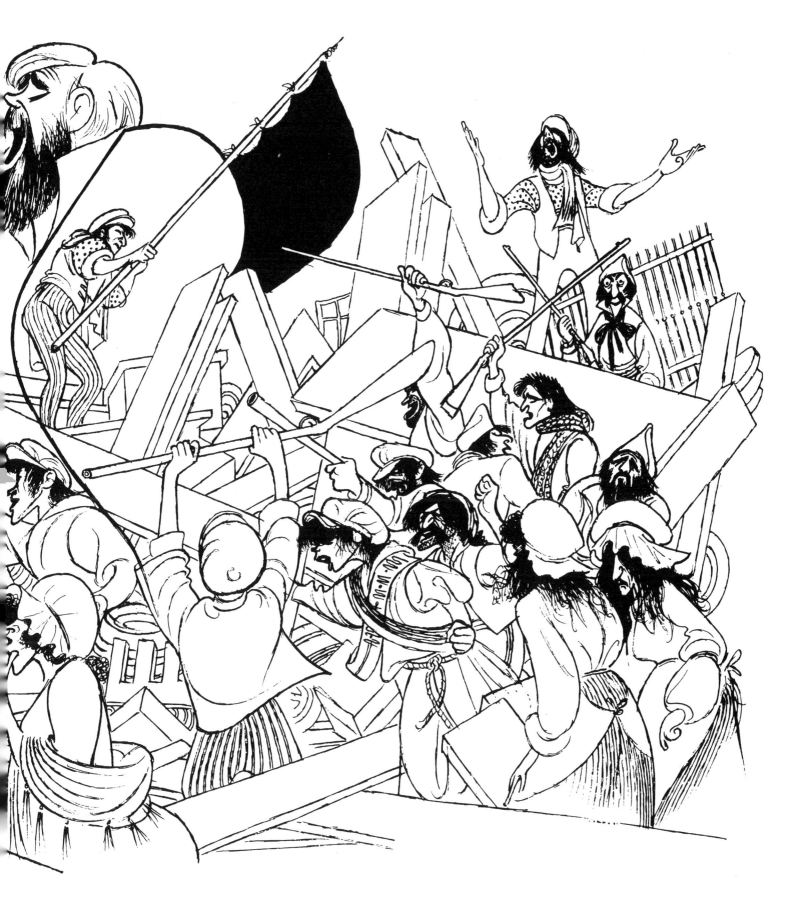

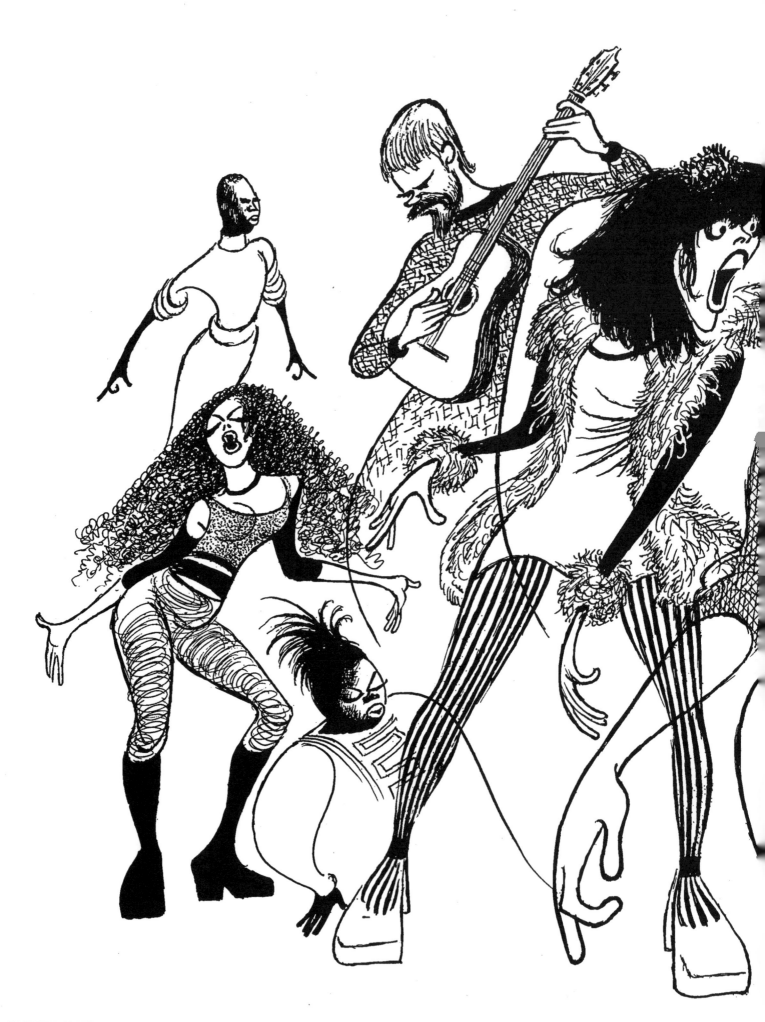

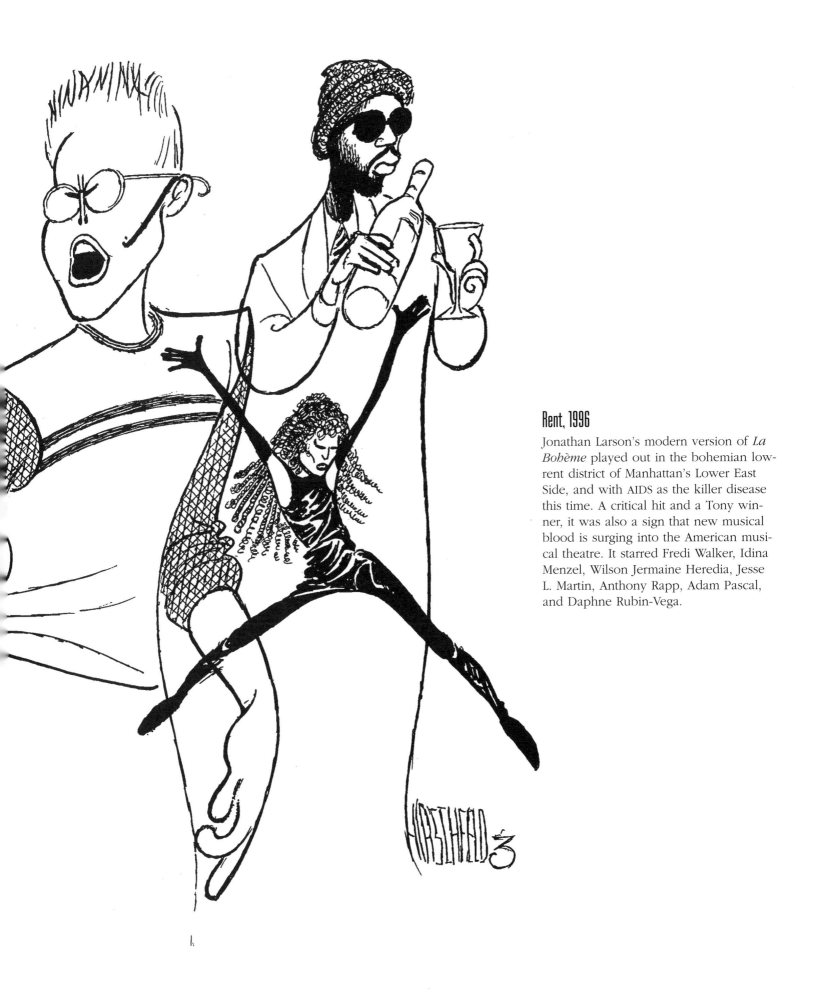

Rent, 1996

Jonathan Larson's modern version of *La Bohème* played out in the bohemian low-rent district of Manhattan's Lower East Side, and with AIDS as the killer disease this time. A critical hit and a Tony winner, it was also a sign that new musical blood is surging into the American musical theatre. It starred Fredi Walker, Idina Menzel, Wilson Jermaine Heredia, Jesse L. Martin, Anthony Rapp, Adam Pascal, and Daphne Rubin-Vega.

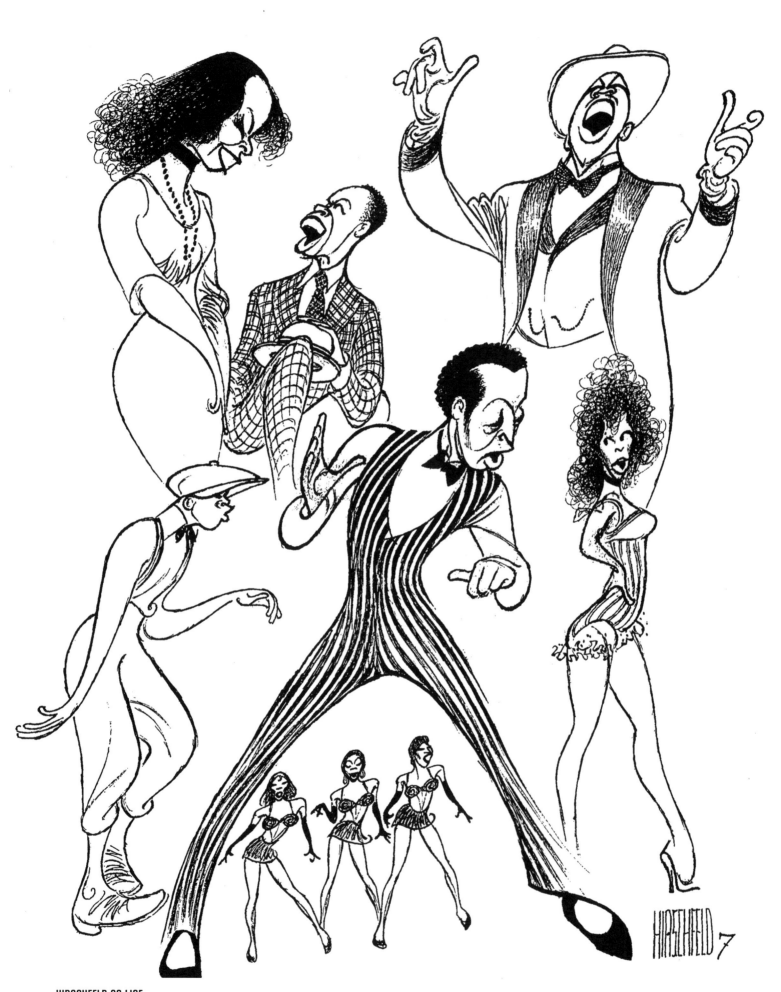

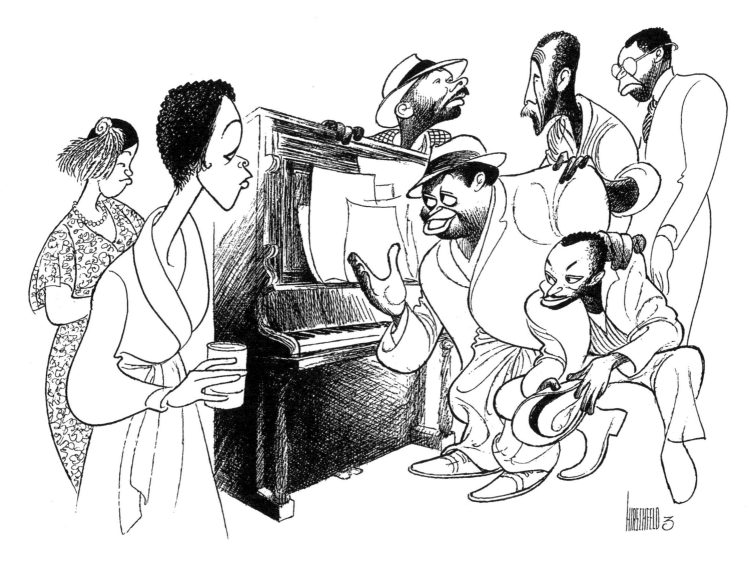

The Piano Lesson, 1990

The piano plays an important role in the exposition of August Wilson's play, and that's why I gave it an equally important role in the drawing. Not that the piano was the only great character on stage—left to right, Lisa Gay Hamilton, Epatha Merkerson, Lou Meyers, Charles S. Dutton, Carl Gordon, Tommy Hollis and kneeling in foreground, Rocky Carroll. August Wilson was part of a new Broadway during this era, depicting Americans and parts of American history that didn't quite make it to the boards during the Cole Porter highball years.

Jelly's Last Jam, 1992

In the drawing of black performers I don't usually make their faces black. I don't know why. It seems to me that the features delineate the character, while the color isn't terribly important. Gregory Hines is the one who touches upon all the other characters here, both in the drawing and in the production. Across the top, they're Tonya Pinkins, Stanley Wayne and Keith David. The bottom row is Savion Glover, Allison Williams, Stephanie Pope, Mamie Duncan Gibbs, and Brenda Braxton.

Miss Saigon, 1991

No, not a contestant in the Miss Universe Pageant, but a quite remarkable musical that takes place in Saigon at the close of the American involvement in the mid-Seventies. The sets and costumes, the background of this drawing, the crazily lighted GI Go-Go bar lining up against the austere Communist marchers, are very important to telling the story, but the figures in the foreground carry the full weight of this tough drama. Jonathan Pryce, as the Eurasian pimp, Lea Salonga and Willy Falk as the innocents who fall in love in the worst possible place. This was the show with all the brouhaha about an English actor playing an Asian character instead of an American Asian actor. Pryce had won raves in London, but ran into picket lines on Broadway. In the end, everyone worked it out—not that a little controversy is bad for the old box office.

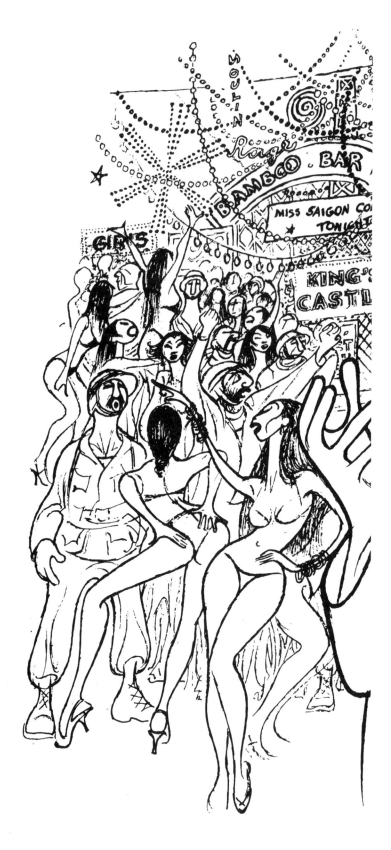

Show Boat, 1994

One of the advantages of having a long career in the theatre is getting to compare revivals to the original productions. This revival of *Show Boat* was as beautifully done as it was the first time around. More impressively, the music has stood up since Helen Morgan played the role of the half-caste Julie in 1927. The music was by Jerome Kern, the book and lyrics by Oscar Hammerstein II. Many people feel that this was the first "modern" American musical, a play with music as opposed to a series of musical vignettes. Directed by Harold Prince, the show won the Tony for Best Musical Revival, and starred Lonette McKee, John McMartin, Elaine Stritch, Michael Bell and Gretha Boston, and Rebecca Luker.

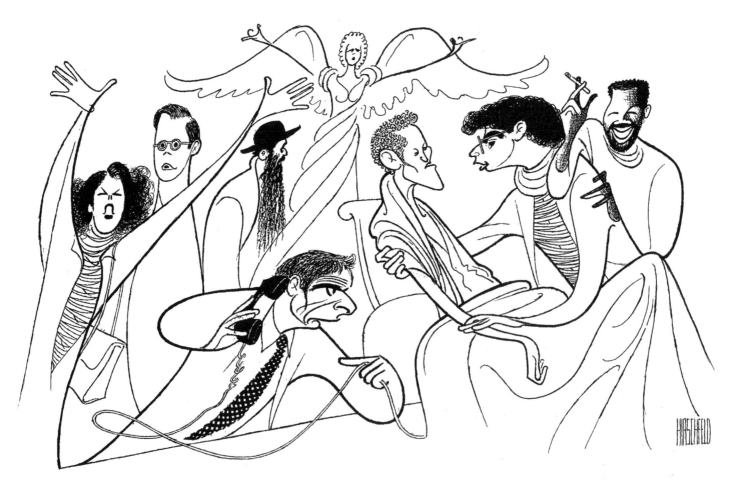

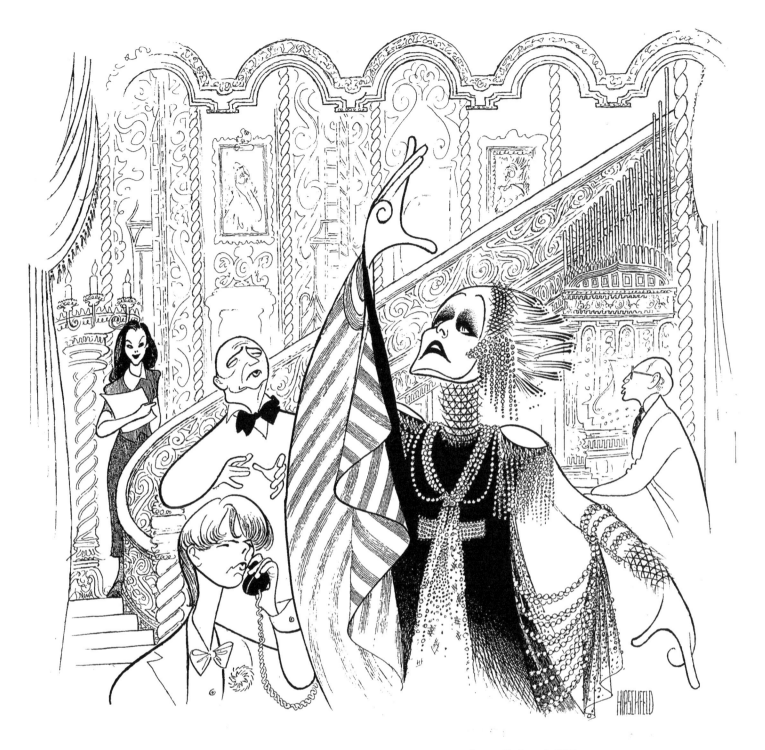

Angels in America, 1994

With Marcia Gay Harden, David Marshall Grant, Kathleen Chalfant, Ron Leibman, Ellen McLaughlin (as angel), Stephen Spinella, Joe Mantello, and Jeffrey Wright.

Sunset Boulevard, 1995

Glenn Close, as the fading silent film star, looks like a cross between an Anglican priest and an Indian chief here. But that's the way they dressed during the swashbuckling Fairbanks and Pickford days in Hollywood. More importantly, the elaborate costuming and stage sets were crucial to this production. For once, Broadway designers had to fear not going over the top enough. The musical was by Andrew Lloyd Webber, and the story based on the classic Billy Wilder film. Now there's a collaboration possibly more bizarre than Webber and T.S. Eliott. The other members of the household and the cast are Alice Ripley, Alan Campbell, George Hearn (as Max the butler), and Alan Oppenheimer. . . . And I liked the film better.

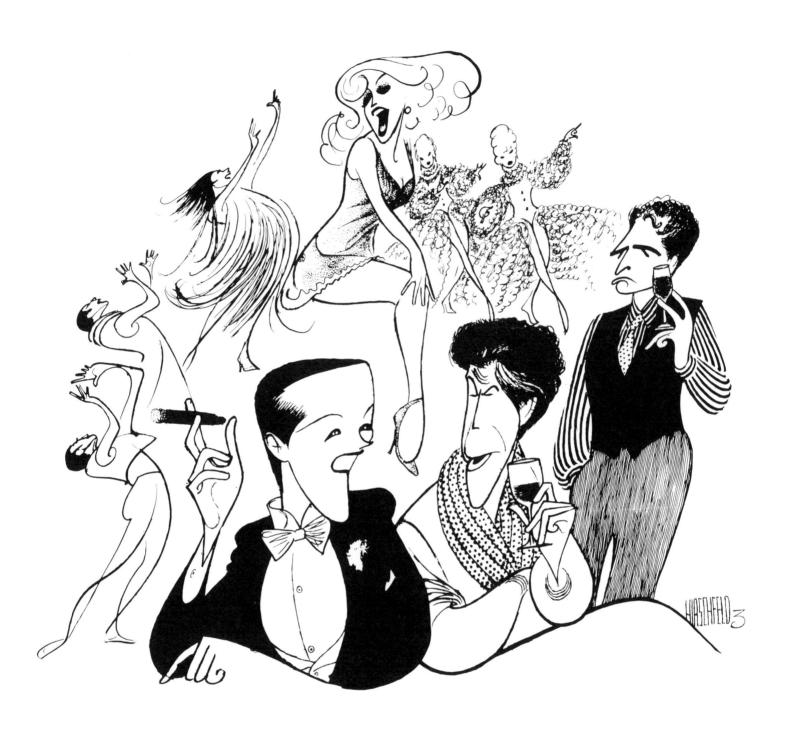

Victor/Victoria, 1995

Everyone else in the world remembers this as Julie Andrews returns to Broadway, but I remember it as my second attempt at color at the *Times*. But this time, I got smart. The color is confined to a little border around the corners and the entirety of the line drawing is preserved. Julie plays a woman playing a man playing a woman. I tried to say that in line here. Tony Roberts plays the tough gangster who is strangely drawn to this female impersonator. The show was based on a Blake Edwards movie. Blake also directed this show and sometime earlier wisely married Julie Andrews. That's not nepotism, however, that's genius.

Chicago, 1996

Continuing the Nineties pattern of reviving old shows came *Chicago*. In this case, though, it was a completely new interpretation of the former Bob Fosse show. I was particularly enchanted with Joel Grey's Cellophane Man. Those gloves are not an exaggeration. Bumping and grinding Joel are Ann Reinking and Bebe Neuwirth. The mobster is played by James Naughton. Here's the trivia question for your next party, though—Bob Fosse's production was a musicalized (by John Kander and Fred Ebb) version of a much older Broadway show of the same name. Written by Maurine Watkins, *Chicago,* the play, was produced at the Music Box Theatre in 1926.

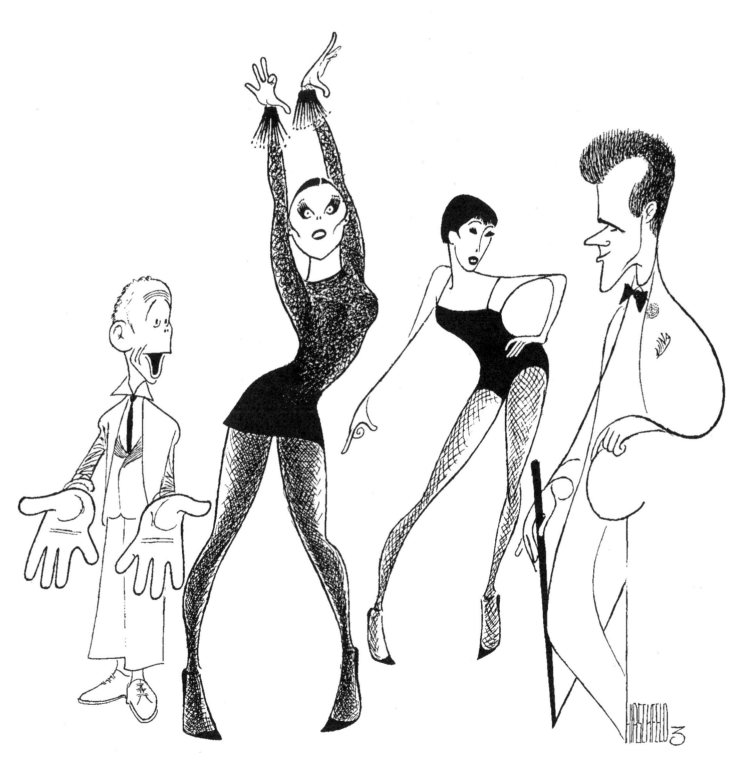

1776

(1997 revival)

July 3rd and already things were starting to heat up down there in Philly. This is a story about another one of those out-of-town tryouts that had a rocky road at first but then pulled in successfully to New York. This revival was also another masterpiece by designer Tony Walton, of Independence Hall. Jefferson is duking it out with John Adams over the Declaration of Independence, while Ben Franklin is trying to stick his bum foot in the door. With those long tablecloths the joint looks a bit like a Twenties nightclub with a Colonial motif, but the show and the production, both times, were high class. The production also had perhaps the greatest emotionally graphic ending of a play in my memory—an enlarged replica of the Declaration of Independence, projected on a translucent curtain. (With Brent Spiner, Pat Hingle, and Paul Michael Valley.)

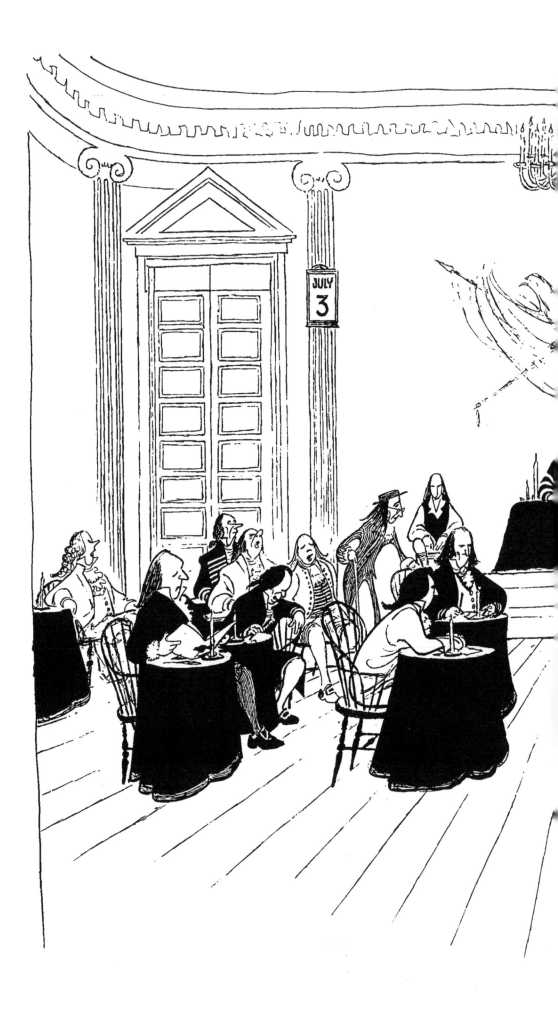

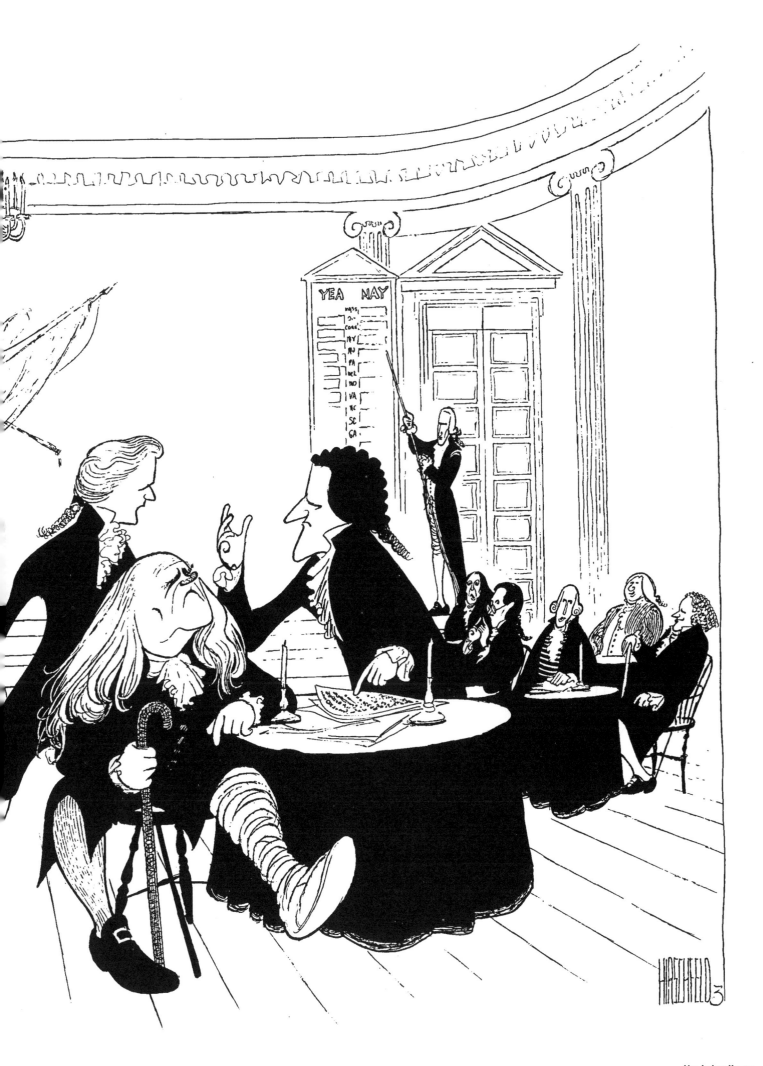

The Gin Game, 1997

Julie Harris and Charles Durning energetically, and rather courageously in my opinion, reviving D. L. Coburn's *The Gin Game*. I saw the original production with Jessica Tandy and Hume Cronyn, who were husband and wife of course, and I never thought anybody could replace them. They were latter-day Lunts. But the Harris-Durning interpretation was different and marvelous. I tried to capture the intensity of the by-play between them as well as the tenderness. But darned if they didn't draw the same exact hands as in the earlier production. I think the game was fixed.

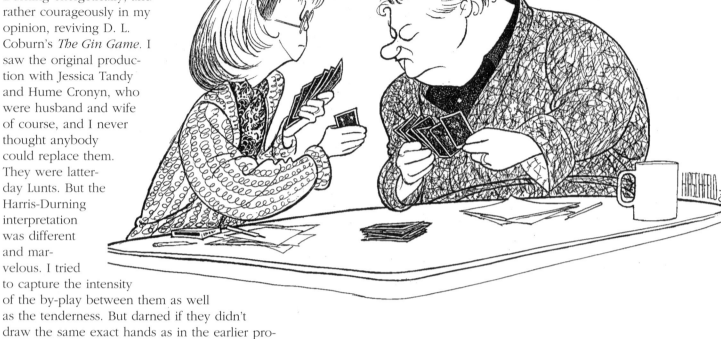

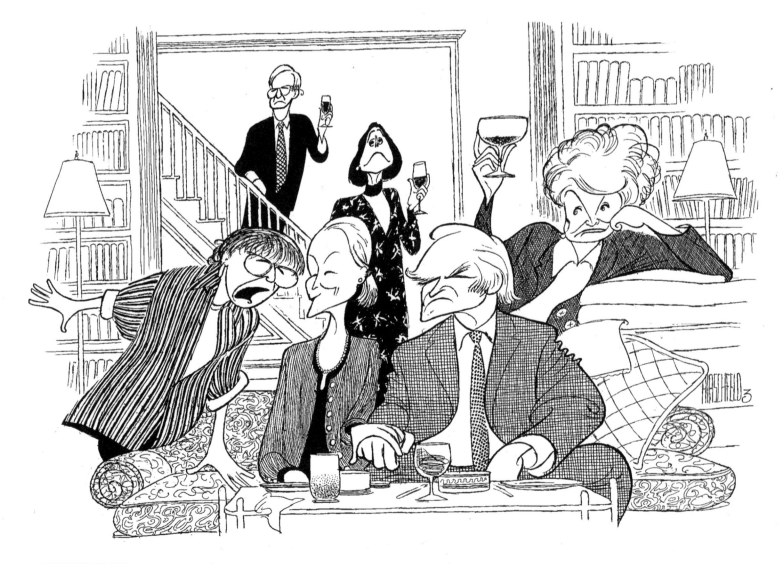

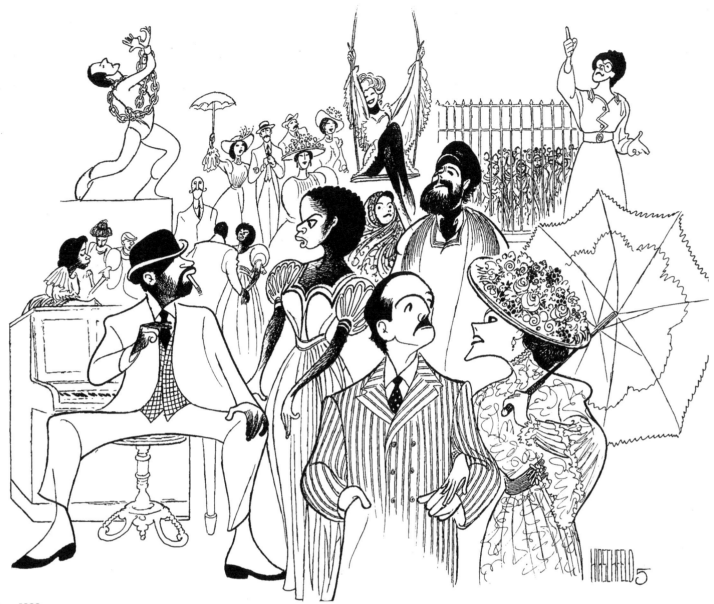

Ragtime, 1998

At last an original Broadway musical, and one of the most recent in this collection. The lavish production, based on the E. L. Doctorow novel, was just as bustling as this drawing. It was a pretty hectic time back there at the turn of the last century. You've got Houdini in chains, Evelyn Nesbit in her notorious red swing, Emma Goldman in her equally notorious defiant anarchist stance. In the front row you get the characters of the drama, the three couples the show follows as they struggle to enter the new world of the new century. (With Jim Corti, Lynette Perry, Judy Kaye, Brian Stokes Mitchell, Audra McDonald, Lea Michele, Peter Friedman, Mark Jacoby and Marin Mazzie.)

A Delicate Balance, 1996

It looks like most of the balancing going on here was of wine glasses, but this revival of a mid-Sixties Edward Albee play is really about balancing one's sanity. It's not one of my best drawings of a drawing-room comedy-drama. I'm entitled to one lousy drawing in this book. Anyway, the back row glass-hoisters are John Carter, Elizabeth Wilson, and Elaine Stritch. The front line is composed of Mary Beth Hurt, Rosemary Harris, and George Grizzard.

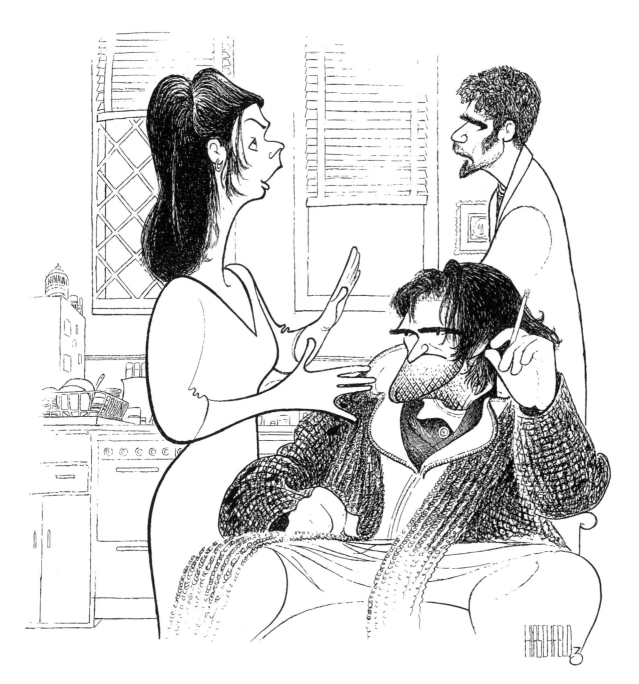

Wait Until Dark, 1998

Wait Until Dark is another, of course, revival. Some revivals, like inept CPR, don't always revive. This one relied on star casting to pull people in. Marisa Tomei as the blind girl and Quentin Tarantino as the criminal (with cohort Stephen Lang) tormenting her are movie stars playing in one of the theatre's best thrillers—a rare commodity on Broadway the past few decades. Tomei has to see with her hands, and thus it takes her a lot longer than the audience to "see" that Tarantino is a lowlife drug-dealing creep. At one point in the last act the lights go out altogether, which must have been a relief for everyone.

A Funny Thing Happened on the Way to the Forum, 1996

Well, what do you know, another revival. And, no, no funny things happened to me on the way to the theatre. Like so many of these revivals, though, you have so much fun you tend to forget that American Theatre is turning into Museum Row. Tony Walton did a beautiful job on the design for this show. He sure made my job a hell of a lot easier, and more fun. And Nathan Lane as the fast-talking slave looking for his freedom from his master's house while not getting enslaved by a new wife was hilarious. Here he's giving his master's naive son (Mark Linn-Baker) some advice about the courtesans who live next door. Forum is a brilliant revival of Roman comedies of two milleniums earlier, the characters, the set—but the music is pure Broadway. (Also pictured: Ernie Sabella and Lewis J. Stadlen.)

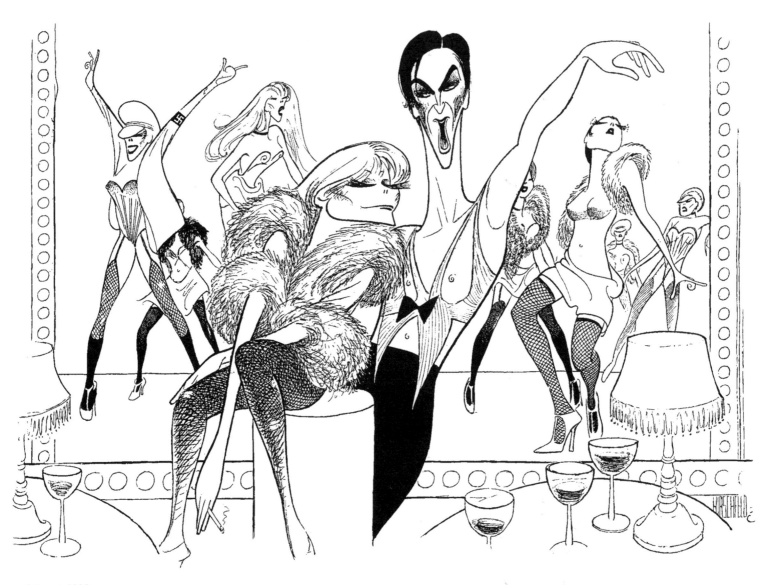

Cabaret, 1998

Natasha Richardson taking on the Sally Bowles part in a revival of *Cabaret*. This remake was a departure, however. They took the theatre and made it into a café, like the Berlin one in the story. You are there, in the drama. I admit this threw me, graphically, for a while. At the last minute, I set those tables in the foreground with the lamps and the glasses to convey the feeling you got in the café theatre. It was really a wonderful, decadent depiction of Germany during those times. And pretty hip these days. That's Alan Cumming in the role of the haunting emcee. The final curtain leaves the audience spellbound. I remember that during the Thirties many of the great cabaret entertainers from Berlin's "Katacomb Café" left Germany before the axe finally fell, as well as most of the actors, from the legit theatre to musicals, along with the playwrights and composers and directors and stage designers.

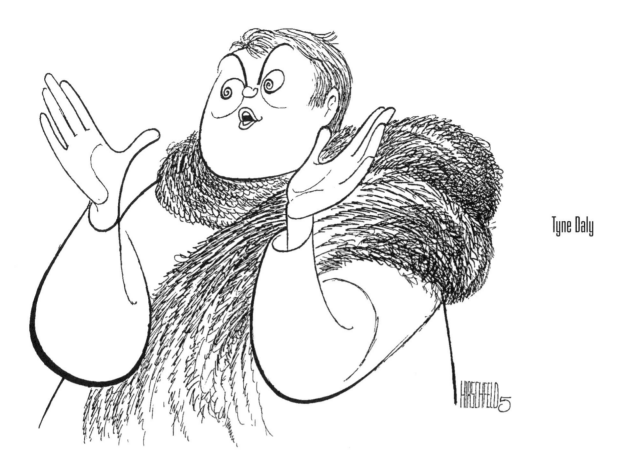

Tyne Daly

Art, 1998

This is my work of art about a play about a work of art. The same little framed picture I have here in the background is a very important part of the plot, which won the Tony for Best Play for the 1997-98 season. The painting is an abstract white-on-white number and the controversy it creates among three old friends (among them Alan Alda) tears the friendship apart, then puts it back together again. Similar to what an artist does to his subject. It was a very interesting, very amusing play. The drawing line here connects the three friends, as the painting does in the drama, but it's the faces that tell the story, and the painting, so everything else fades away into the whiteness of my page. Leaving to the audience's collected wisdom as to whether a painting of white on white is a work of art or a piece of garbage.

The Musical, 1997

This is a drawing I did to celebrate the American musical. In hot musicals like *Cabaret* and *Chicago,* the ladies are wearing little more than a G-string. I decided to cloak my leading lady a bit more fully in a G-clef. The fishnet stockings are as old a part of the musical theatre profession as they are of that other old profession. Your eye eventually makes its way from her to the very appreciative audience to the left, including one perhaps overly enthusiastic prop man in the stage right wing, and a rather distinguished couple in the front row on the lower left, my wife Louise and myself. This show looks to be playing to 100.1% capacity, which is about what these extravaganzas need to show a profit these days.

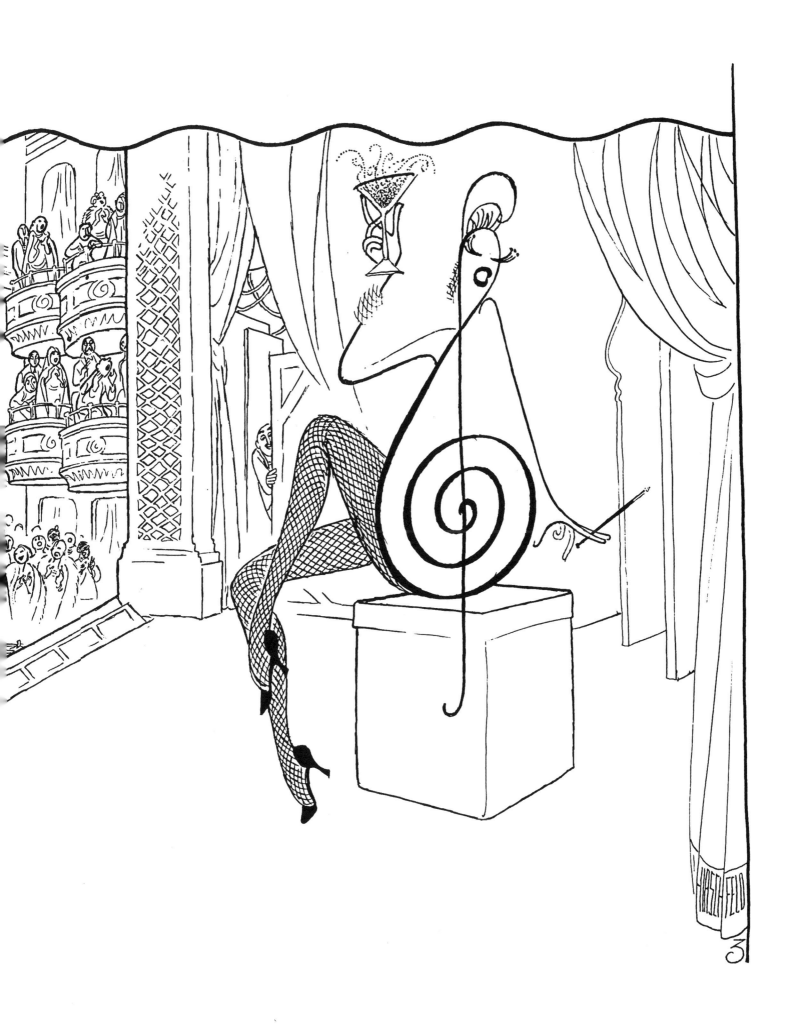

A London Sketchbook, 1996

This is a London theatre update I did in September 1996 when the new Globe Theatre was opened to the public. The Globe is at the top of the page here, where the media and other invited guests are trying to get into the act on stage. That's Paul Scofield in the bow tie and the sad eyes, a consummate actor in the great tradition of classic British theatre.

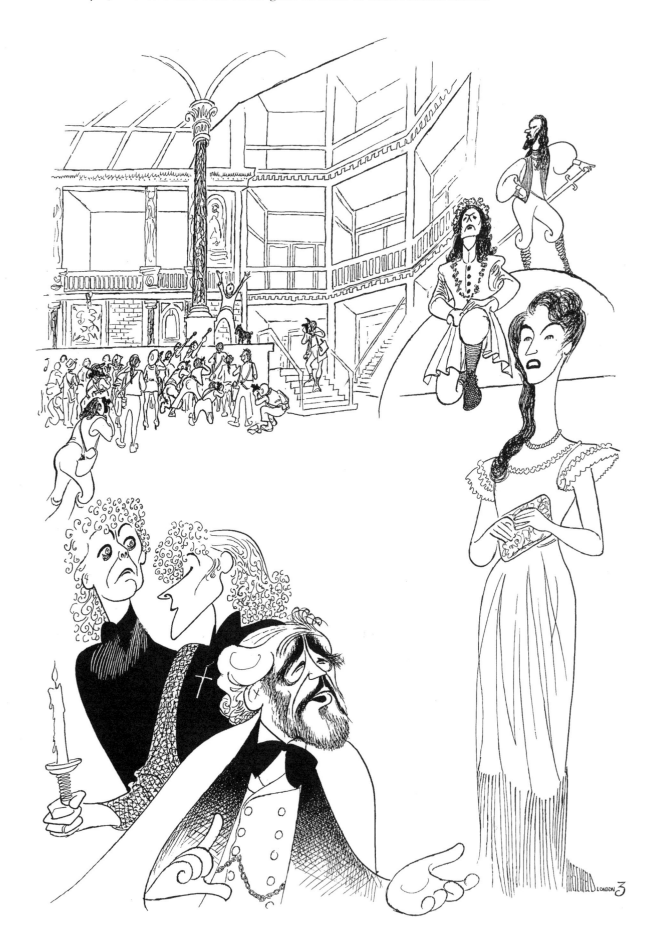

The Judas Kiss, 1998

Liam Neeson plays Oscar Wilde on the path to self-destruction in this play. Wilde seems to be going through one of those vogues, like Jane Austen and Henry James. But Oscar led too wild a life for producers today to care much about his plays. The biggest mistake Oscar Wilde made was not insulting the Marquis of Queensbury, but allowing his biography to over-shadow his writing. Neeson caught both the pathos and the pride of Wilde in his performance, and I tried to capture that in this drawing. Robert Morley, in an earlier production depicting Oscar Wilde's life, has, however, implanted himself so securely in my memory that any actor portraying Wilde becomes an impostor. Similarly, Raymond Massey remained Abe Lincoln to me no matter what part he later played.

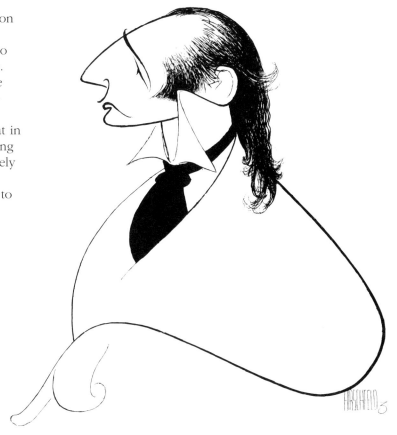

The Beauty Queen of Leenane, 1998

The playwright Martin McDonagh seems to have taken the great Irish playwright Synge, crossed him with *Pulp Fiction* and come up with a very enter-taining brand of raffish melodrama. The two women, mother and daughter, dominate the action, trying to dominate each other, and that's why they take center stage in the drawing as well. That cheap kitchen table is like an iron bar holding them apart and holding them together, like leg irons. You can always count on the Irish for a literate cat fight.

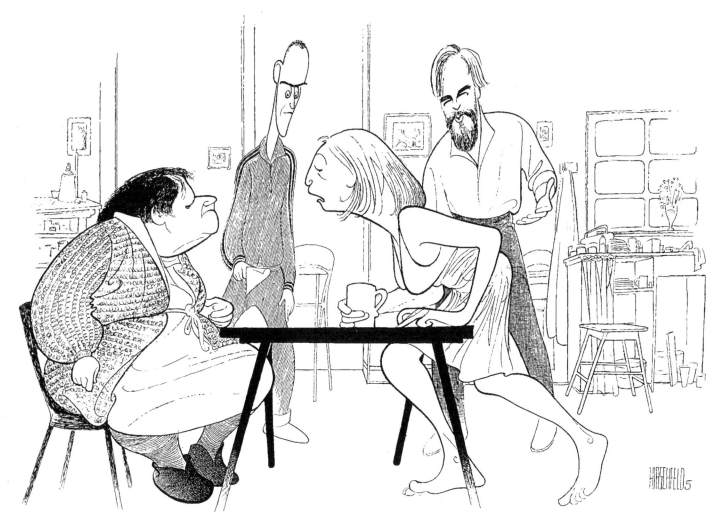

Brahms, 1997

I've gotten very skimpy with the settings of my portraits, just hinting at the piano and the rest of Brahms with an almost continuous, simple line. But it's character, the face, that continues to fascinate me. That's almost always where the story lies. The details are just for context. I worked from early prints to produce this drawing of composer Johannes Brahms. I got the crossed-over hands from the prints too. I never met the man. I haven't been on the beat that long. Johannes came out here looking like Orson Welles as a jazz musician, but maybe that's what the maestro would be up to if he were around now.

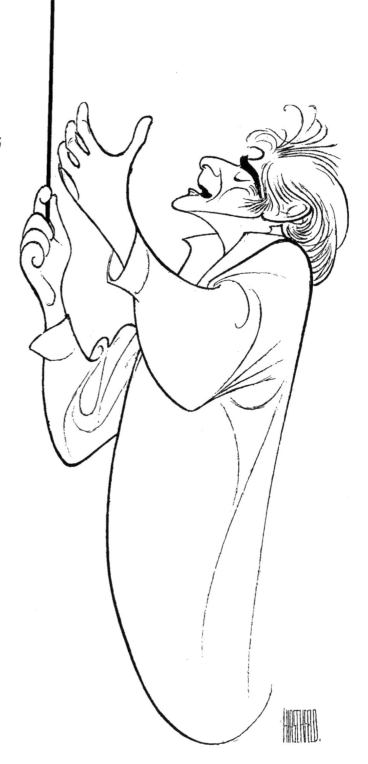

Leonard Bernstein, 1992

I've drawn Leonard Bernstein many times, but I especially like this one. He seems to be immersed in the music he's conducting. Though his mouth is open, he's not singing, he's living the sound of the music, ready to burst with the feeling of it. This is the part of a Broadway musical where the actor would break into song— only a conductor doesn't have that luxury. It's really just the hands, the arms and the head. That's all you need to see here to get the story. I knew him and attended a few occasions at his apartment in the Dakota, but my impression of him professionally was that he exploited his limitations to the fullest. He was a creative genius who accepted and understood the time he lived in.

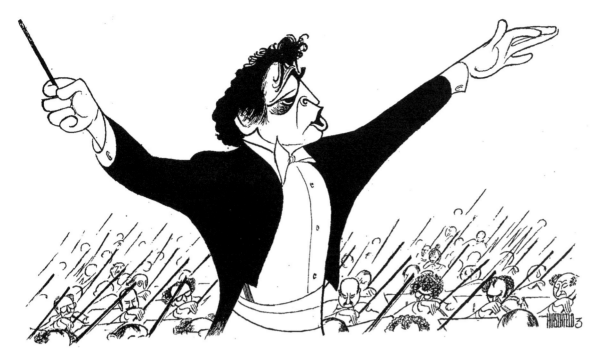

Zubin Mehta, 1991

Like Bruce Springsteen in rock music, Zubin is a powerhouse in front of a full orchestra. He too is very physical up there on the podium and that's what I tried to express in this drawing. Those rows of men in the string section beneath him look like soldiers marching with their rifles shouldered, and Zubin is just the dynamo to lead them to victory. Even his suspender strap looks about ready to snap.

Glenn Gould, 1992

Gould was a new kind of piano prodigy, wearing a baggy outfit instead of the traditional white tie; he's got on Fifties desert boots, the Beatnik hairdo, striped socks creeping down his legs, and he's got one leg crossed over the other. It's not too surprising that he gave up public performances to concentrate on studio recordings after not too long. God knows what he wore in the privacy of his recording sessions.

Kurt Masur, 1992

Masur has a professorial approach to his orchestra. He's urging them on to greater heights, his hands expressing his silent thoughts. His eyes are even closed, as though he's in a trance. His ears are doing the seeing, his hands the talking. And that eyebrow, with a life of its own, is so raised in the emotion of the moment, it's about ready to fly off his forehead.

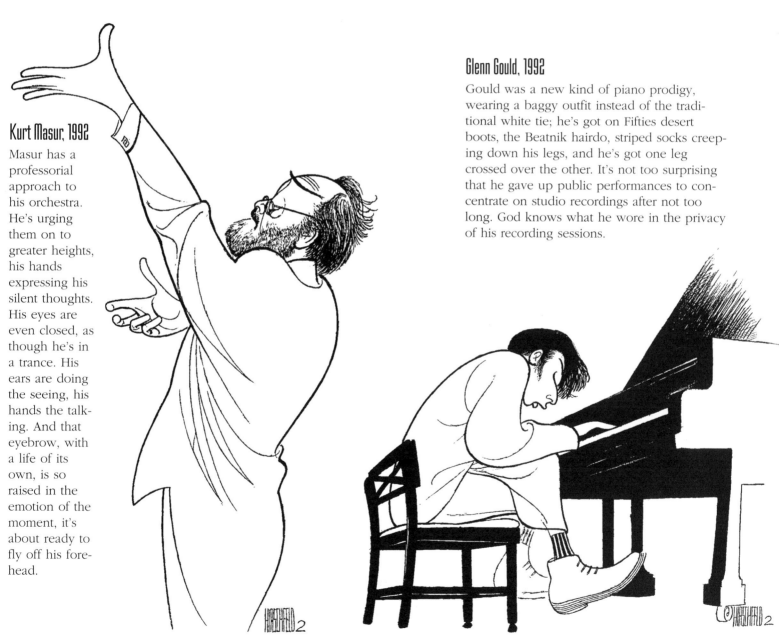

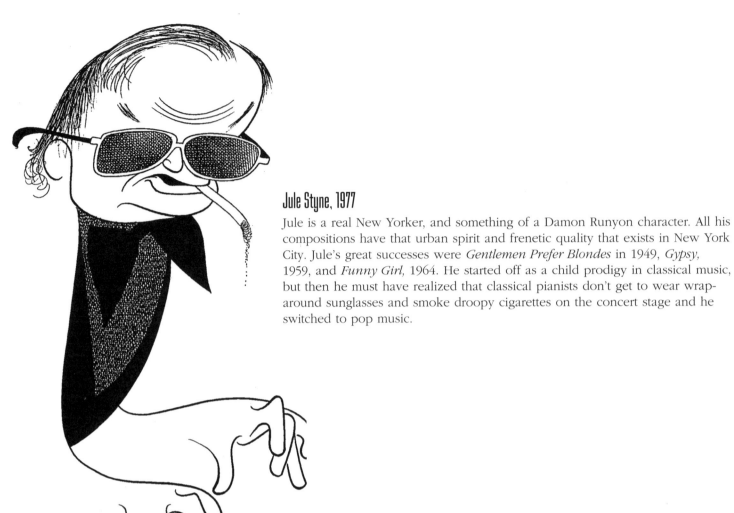

Jule Styne, 1977

Jule is a real New Yorker, and something of a Damon Runyon character. All his compositions have that urban spirit and frenetic quality that exists in New York City. Jule's great successes were *Gentlemen Prefer Blondes* in 1949, *Gypsy,* 1959, and *Funny Girl,* 1964. He started off as a child prodigy in classical music, but then he must have realized that classical pianists don't get to wear wrap-around sunglasses and smoke droopy cigarettes on the concert stage and he switched to pop music.

Cole Porter

This is a drawing of Cole, who I knew only slightly, on the 100th anniversary of his birth. He certainly looks put out about it. A hundred and he's still smoking, drinking martinis and sitting in a plush ornate chair. That's how I see him. For a guy with that much style, though, you'd think he'd enjoy some of it. The carnation in the lapel, the formal dinner suit, the unforced pose, they all telegraph sophistication. The treble clefs for his eyes conveniently get across his haggard, tired look and the notion that music was all he ever saw—*Night and Day,* as it were, music for Cole was the real one.

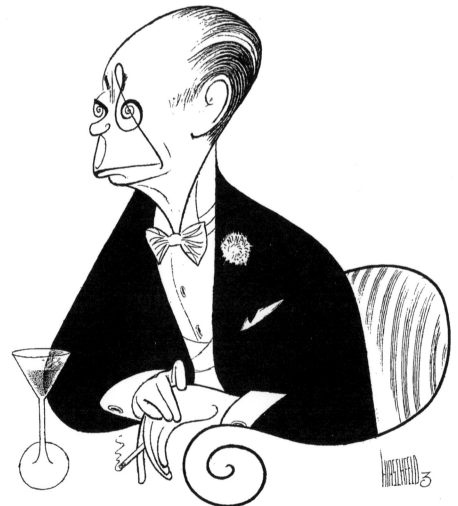

The Beatles, 1990

John, Paul, George, and Ringo were the reverse of the Marx Brothers and Laurel and Hardy. They were musicians who also could clown around expertly. I made this drawing of the Beatles from sketches I did of them when they first arrived in America in the early Sixties. I later correlated them into this design in the early Nineties. They really were just sweet young kids when they arrived, and I was just as enchanted with them as everyone else. I even enjoyed their music.

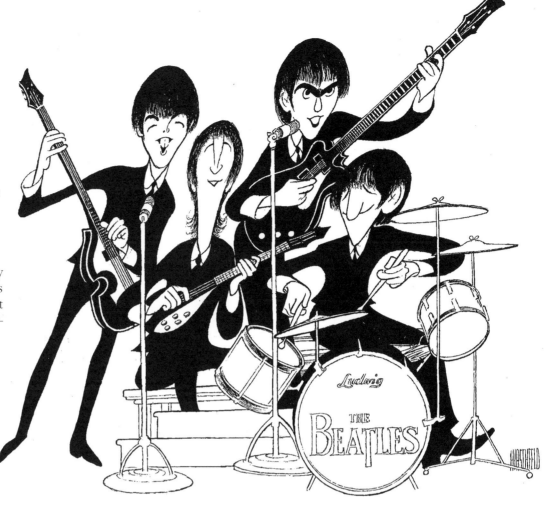

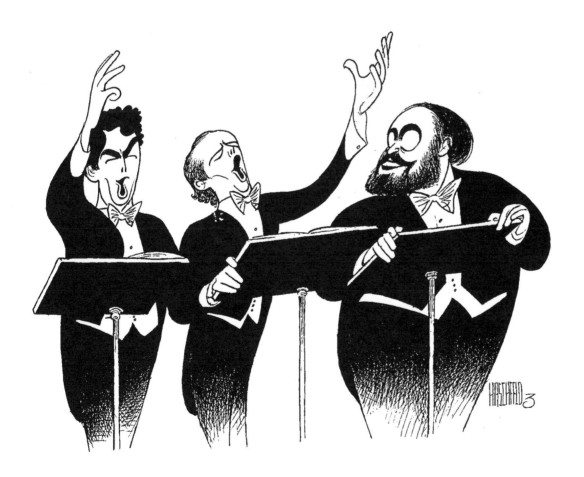

The Three Tenors, 1996

Opera has started to learn from rock stars and the movies. People like stars, they like extravaganzas, special events. The glitzier the better. How you can hear them sing half a mile away in the Rose Bowl is a mystery, but at least you can tell your friends you got in. For centuries nothing was more over the top than opera; now it comes across as low-key. Domingo and Carreras are trying to be extravagant, while Pavarotti is content with himself.

Bruce Springsteen, 1995

You can almost hear how loud and powerful Springsteen's music is by looking at those massive arms, and those Arc de Triomphe legs, spread to support the massive power chords. All the force of the lines converging on the stroke of the electric guitar, makes for an electric drawing. And then the joy of performance, in being in control of so much power, on his face. I like this one.

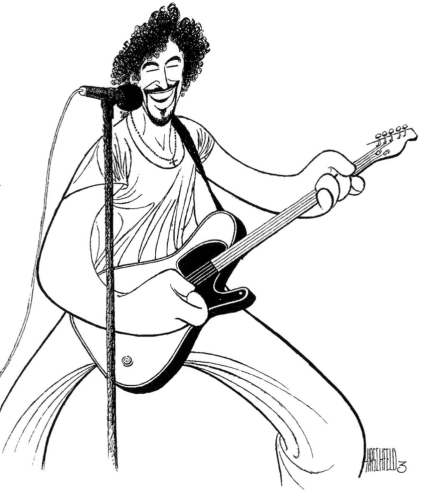

Ella Fitzgerald, 1993

Ella's laid-back stage presentation actually lends itself to an action drawing. Though she's at ease, with her elbow resting, her other hand casually holding the mike, she knows exactly what she wants to sing and how she's going to sing it. All the preparation's been done and she can calmly share it with her audience. Like a good storyteller putting his feet up and leaning back to tell a tale he knows so well, and knows will entertain his enraptured audience. I've followed Ella since she first appeared at the Apollo Theatre in Harlem in the Thirties, and I watched her develop into a phenomenon. I got a little cute here with the microphone cord, blending into my signature. I never knew what to do with the darn cord. It was like a string hanging from your jacket.

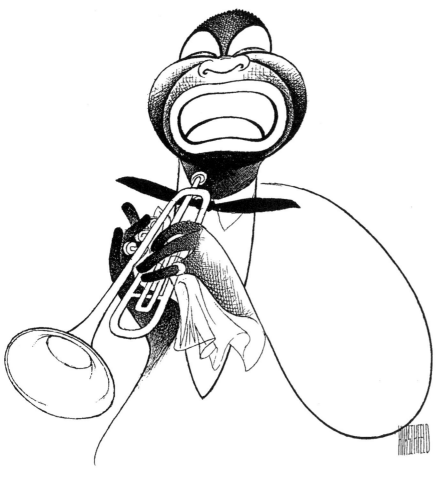

Louis Armstrong

Here's America's other Saint Louis, and jazz's. He had a lot of nicknames: "Pops," "Satchmo," but he was just an explosion on stage. He never really touched his trumpet; he always used his handkerchief on the trumpet to polish it and so his hand never touched the instrument, really, except for fingering the valves. He had some trouble late in life with his other valves, his heart, and had to cut back the horn blowing and concentrate on his almost equally remarkable singing, which duplicated his trumpet inventions and creative riffs. He's the one who brought improvisation to jazz, to American music. He came up the Mississippi from New Orleans and changed jazz along the way, from New Orleans jazz to modern Chicago jazz. Yet he still hasn't gotten his full due— he could really blow that trumpet, but was too shy to blow his own horn.

Prince, 1995

When I saw Prince perform I understood what they meant by a new generation. He seemed to have busted through all conventions. I figured I might as well try to bust up a few myself, or at least a few of my own, with his portrait. This is a much more exaggerated caricature, physically, than has been my custom. His head looks like it got stuck in a drain pipe. The Arabian Nights costume was his contribution to the weirdness. Like Sinatra, he also has fingertip control of his microphone. And the invention of the wireless stage mike meant I didn't have to cope with that damn cord.

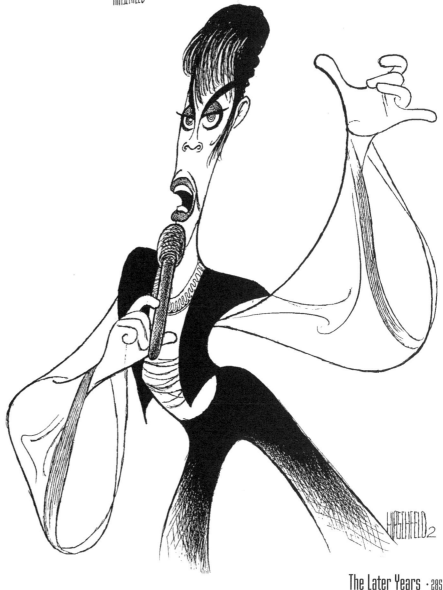

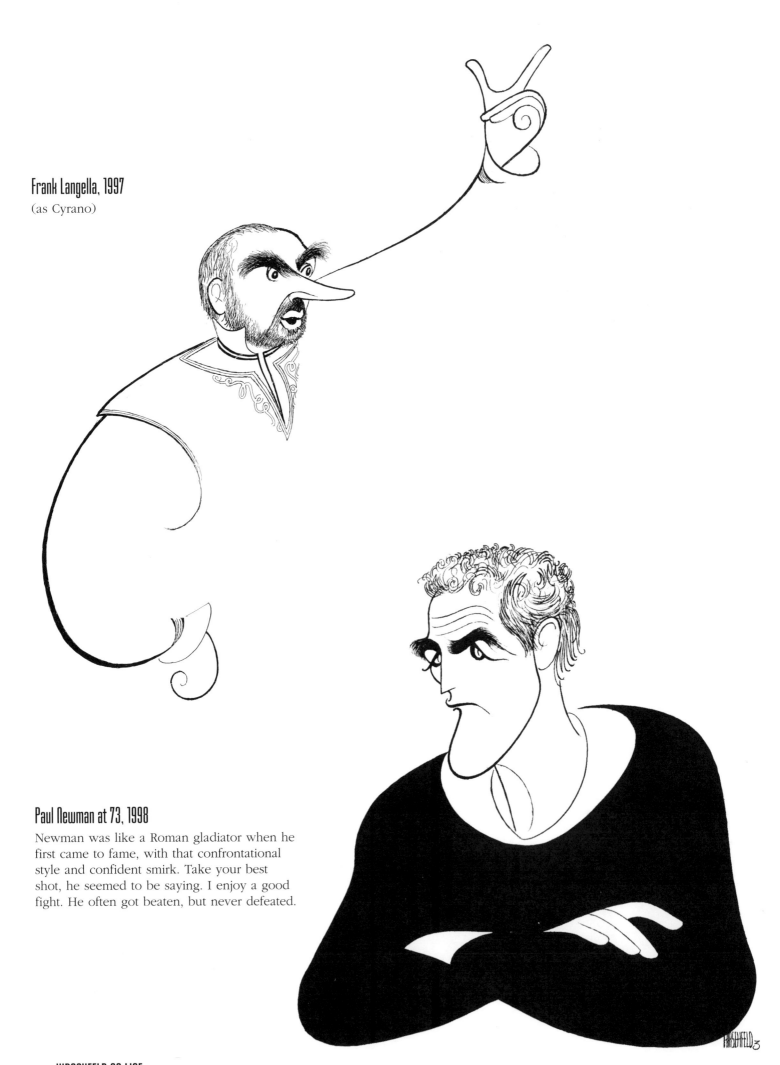

Frank Langella, 1997

(as Cyrano)

Paul Newman at 73, 1998

Newman was like a Roman gladiator when he first came to fame, with that confrontational style and confident smirk. Take your best shot, he seemed to be saying. I enjoy a good fight. He often got beaten, but never defeated.

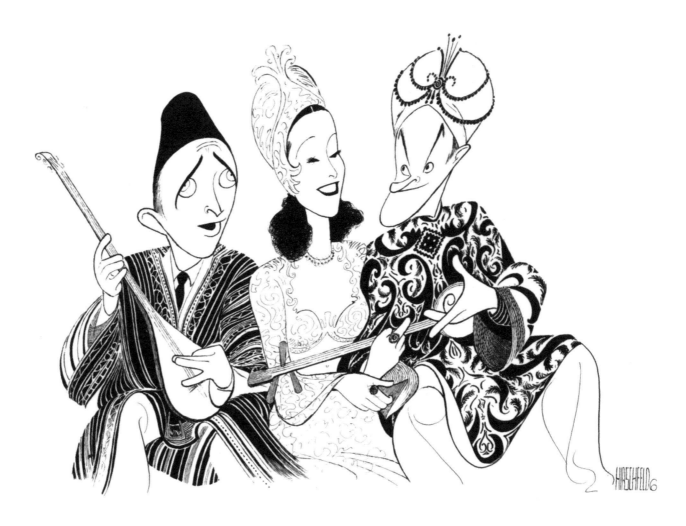

Bing Crosby, Dorothy Lamour & Bob Hope, 1998

Bing, Dotty, and Bob camping it up in *The Road to Morocco*. Or was it *Road to Bali*? Or *Road to Singapore*? Or *Road to Hong Kong*? Or does it matter?

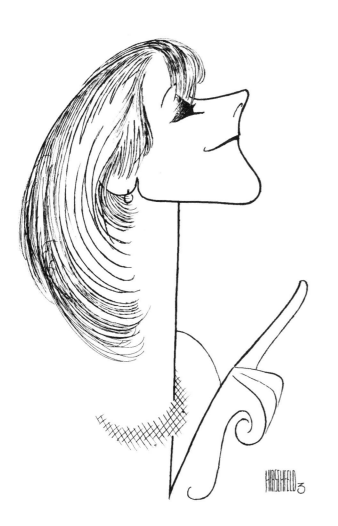

Vanessa Redgrave, 1997

A long, straight line for the neck establishes the kind of upper class, English actress she is, to the hilt. Actors always have to stick their necks out on stage. The British long ago figured out how to make a power-move out of it. She's also rather pleased with herself about something.

Orson Welles, 1997

Orson Welles was always a larger-than-life character, regardless of his weight. I remember when Orson first came to town, he was a mere slip of a youth, though he made some pretty big noises in the theatre. None greater than that beautiful booming voice of his. He always had the lungs of a 300-pound man; it just took his body a few decades to catch up. He blew in from Chicago with a Shakespeare textbook under his arm, one he'd recently completed and for which he did not only the editing but the pretty-good illustrations. Here, he not only is the size of a divan, he's got arms like one, curlicueing into his cane, as though it were one single, slim classical column. Something clearly has made him suspicious. He may be feeling that signature of mine he's backed into and nearly squeezed the life out of. The fedora and the cigar are the affectations of the arty director he would never part with even after Hollywood parted company with him.

Cher, 1996

She practically is a line drawing in real life. Here she is looking like a Mona Lisa who's more than willing to come down out of that painting and carry through on her sly smile. She's also got cheekbones like a doe. But it's the long hair and the lanky figure.

Patti Lupone, 1996

Zoe Caldwell came back to Broadway and put on an acting clinic in *Master Class*. She was a very tough act to follow, but the original Evita Perone, Patti Lupone, was not to be intimidated. When Zoe got tired of the part, Patti stepped in with a whole new interpretation and won everyone over again. I, on the other hand, was happy to get my hands on that hair. It's kind of chunky, and I had fun with it. She came out looking a bit like a character in *Lady and the Tramp,* but it was a very soulful performance. Hair, hands, and eyelashes.

Christopher Plummer, 1997

That paradigmatic Broadway leading man John Barrymore is brought back to intoxicated life here by Christopher Plummer. I've seen practically everything he's ever done (Plummer, not Barrymore), since he first appeared on Broadway, and he's really a much better actor nowadays. It's wonderful to watch someone really grow and come into his own on stage. He's got a right eyebrow here like a peacock's tail. I think you can tell from the drawing how much he ate up this role, as much as the public devoured his performance.

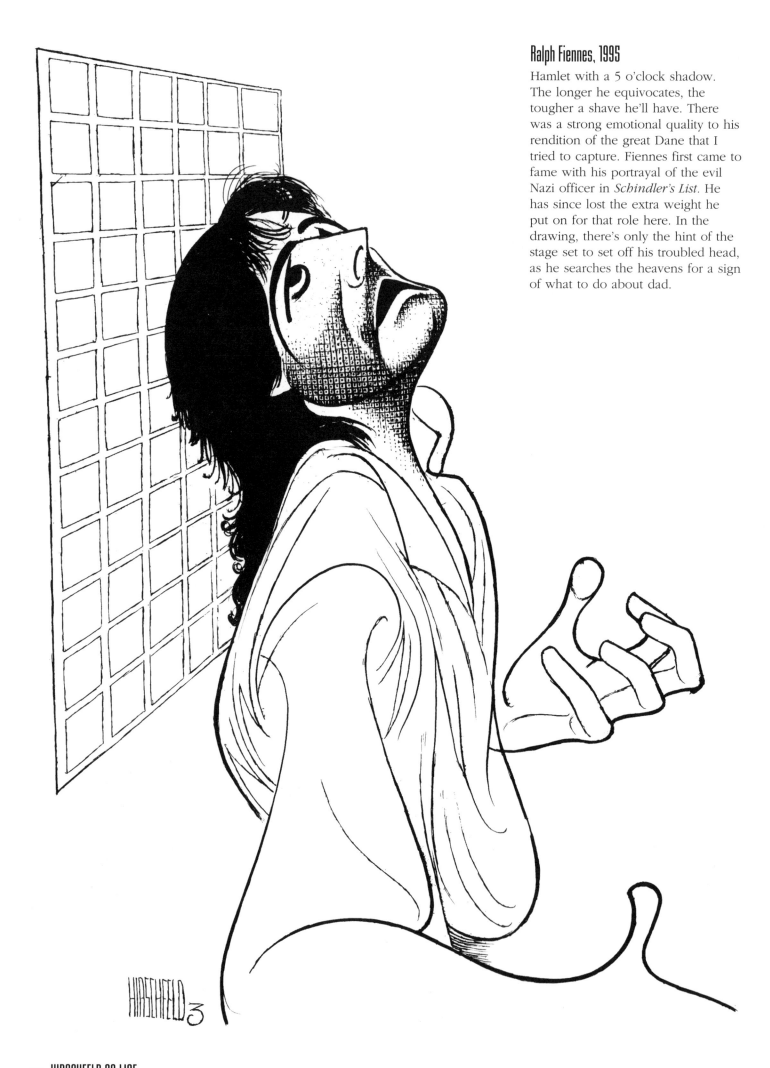

Ralph Fiennes, 1995

Hamlet with a 5 o'clock shadow.
The longer he equivocates, the
tougher a shave he'll have. There
was a strong emotional quality to his
rendition of the great Dane that I
tried to capture. Fiennes first came to
fame with his portrayal of the evil
Nazi officer in *Schindler's List*. He
has since lost the extra weight he
put on for that role here. In the
drawing, there's only the hint of the
stage set to set off his troubled head,
as he searches the heavens for a sign
of what to do about dad.

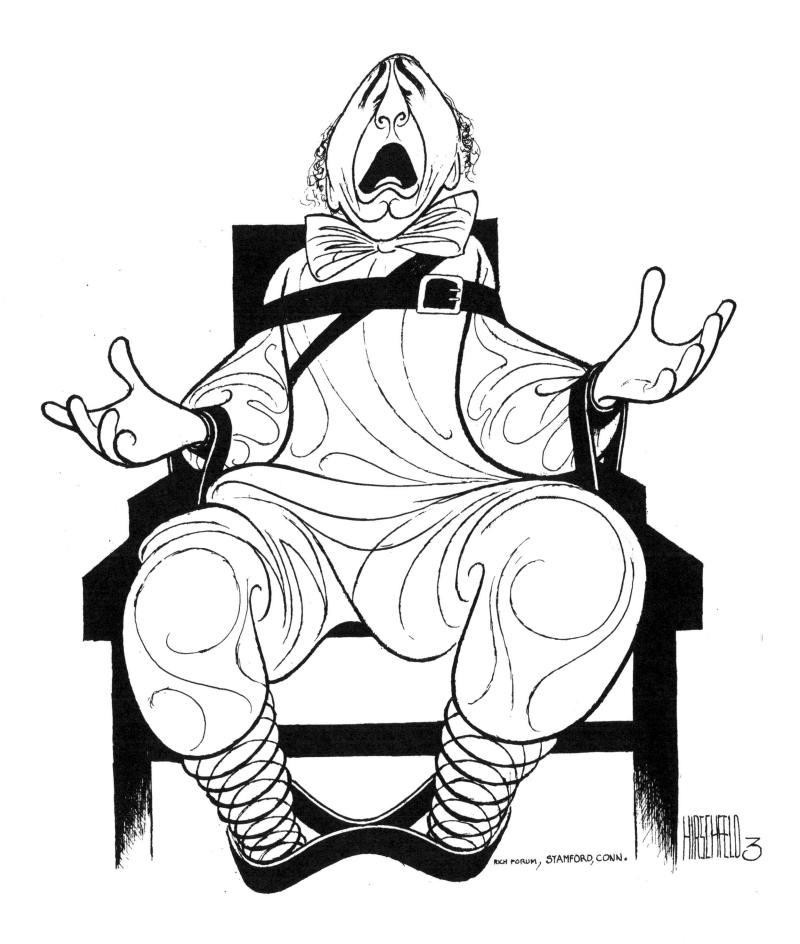

RICH FORUM, STAMFORD, CONN.

HIRSCHFELD 3

Nigel Hawthorne, 1993

This drawing is pure dark against light. The solid black of the chair versus the white of poor mad King George's flowing, colonial-era clothing. I did his stockings as springs, as though the mechanics of the chair had already started to dehumanize him. The big silk bow tie also gives him somewhat of a sad clown look, which is what he is in the story. They made a pretty good film, with Hawthorne, of this later too. It was so gratifying to see Nigel finally get the role in *The Madness of George III* that allowed him to strut his incomparable stuff onstage.

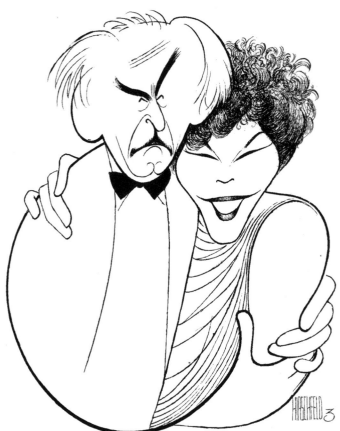

Eli Wallach & Anne Jackson, 1993

Eli and Anne are one of those rare Hollywood marriages that have lived up to their publicity. Eli is one of our more underappreciated character actors. One of his best performances was in the also underappreciated *Misfits,* where he played Guido to Clark Gable's Gay (only a first name in those days) and more than held his own with him, and with Montgomery Clift and Marilyn Monroe. Speaking of Hollywood marriages—Arthur Miller wrote *Misfits* for his new wife Marilyn and the high-profile marriage must have turned into something of a misfit in itself. Maybe Eli and Anne have made it because they're character actors—character actors are more adaptable. In any case, they really are as close as I've positioned them in this drawing. They're a lovely, happy couple and I love them.

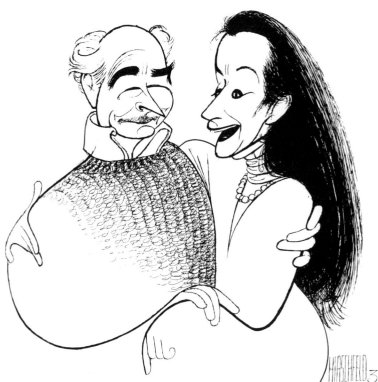

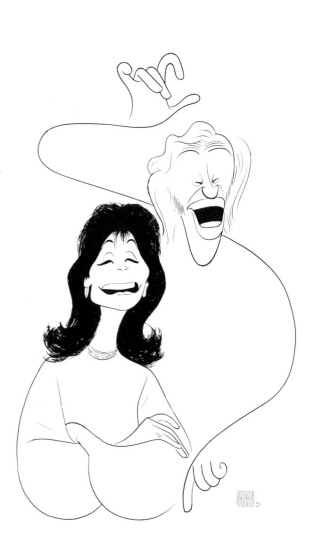

Betty Comden & Adolph Green, 1993

I remember Betty and Adolph when they first performed with Judy Holliday, down in a Greenwich Village nightclub, The Vanguard. They were quintessential New Yorkers then and have remained so ever since. Their greatest triumph as lyricists and librettists, and as actors, was in *On the Town* (music by Lenny Bernstein) in 1944. Rumor has it their partnership is the longest lived of its type in Broadway history. Betty was also, for the record, my neighbor, with her husband Steve Kyle, and she was good at that too. I miss them.

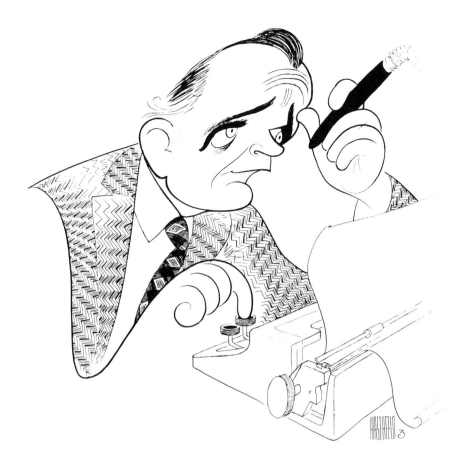

Walter Kerr, 1995

A great theatre critic first for the *New York Herald Tribune* and then briefly at *The New York Times* and, along with his charming wife Jean, another dear friend of mine. I don't intentionally befriend theatre critics but of course we do run into each other fairly regularly in our lines of work. Walter, like Brooks Atkinson before him, was a great character himself. Walter was also a stage scholar and a playwright and director. Jean is an equally renowned writer, a humorist. And theirs was another successful theatre-world marriage. The Kerrs' marriage got more recognition than most, of course, after Jean's humorous book, then film, and then television sitcom about their home life in the New York suburbs, *Please Don't Eat the Daisies*. Walter, for his part, made the theatre review a lively art. I've pictured him here with his cigar and his blue eyes, concentrating on what he's writing, caring about what he's writing, traits not always prevalent in theatre critics. He took his criticism as seriously as his style was lighthearted. And how many theatre critics do you see wearing jackets and ties in front of their word processors these days?

◄ Robert Whitehead & Zoe Caldwell, 1995

Mr. and Mrs. Theatre, at least as far as I'm concerned. Bob Whitehead is the last of the producers of the golden era of Broadway, of serious drama. His work always impresses me. His wife, Zoe, as she most recently proved in her starring performance in *Master Class,* is one of the great leading actresses of my time. Or maybe she'd prefer I say of her time! Another successful marriage of theatre people. Maybe it's not so rare at that. (And another bushy wool sweater.)

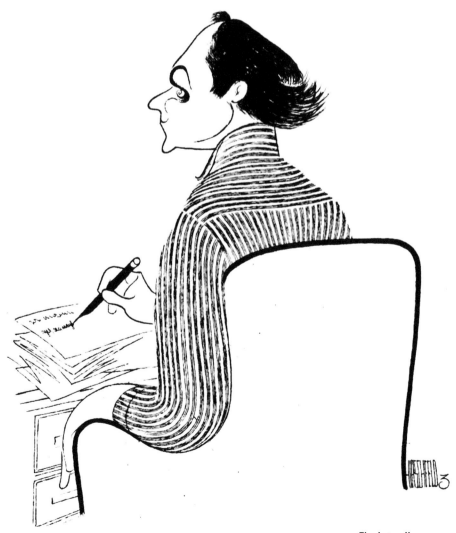

Frank Rich, 1993

Was this the "last" of the great, omnipotent *Times* theatre critics? And no PC, just a pen! Viewed from behind, as though from a few rows behind him at the theatre. He's since given up theatre reviewing for the Op-Ed page of the *Times*.

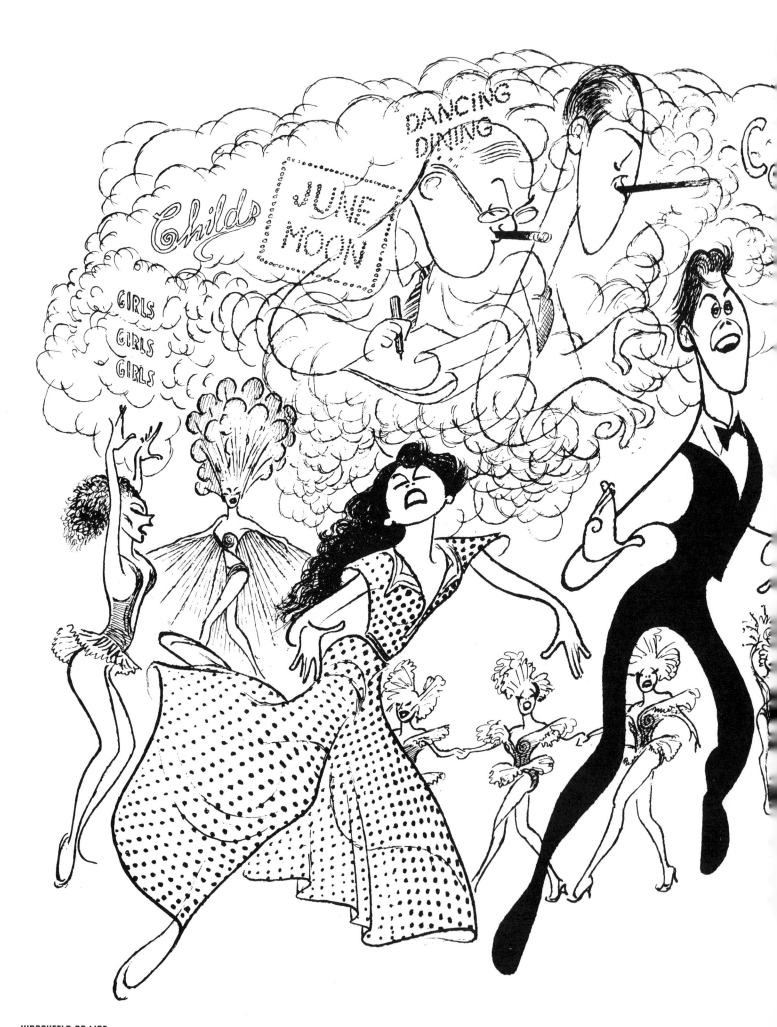

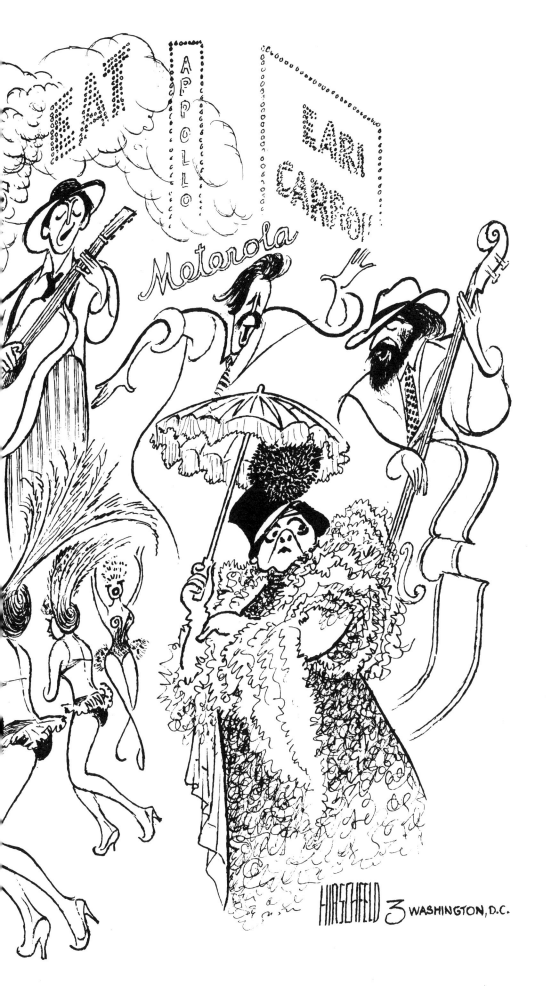

Crazy for You, 1991

An old-fashioned lollapalooza of a musical returns to Broadway in the early Nineties, lyrics and music by Ira and George Gershwin, in absentia, and mostly by way of the Gershwin *Girl Crazy.* Here the brothers are pictured in the clouds, still scribbling and tinkling busily away, which is, I guess, a lot of people's idea of heaven. (*Heaven!—The Musical!* Words and Music by George and Ira Gershwin! "It'll run forever!" critics claim.) The charming boy-meets-girl pastiche of *Crazy For You* may not have been heaven on earth, but it was a lot of fun, as well as a welcome blast from the past after a decade of imported musical extravaganzas that were more like a ride at the Epcot Center than musicals. Up there in the clouds with George and Ira are some reminders of their past triumphs. Down below on stage are the energetic players of *Crazy.* The boy and girl leads are Jodi Benson and Harry Groener. The band in back, The Manhattan Rhythm Kings (Hal Shane, Tripp Hanson and Brian Nalepka). Jane Connell is the alarmed one in all the fringe. And showgirls galore.

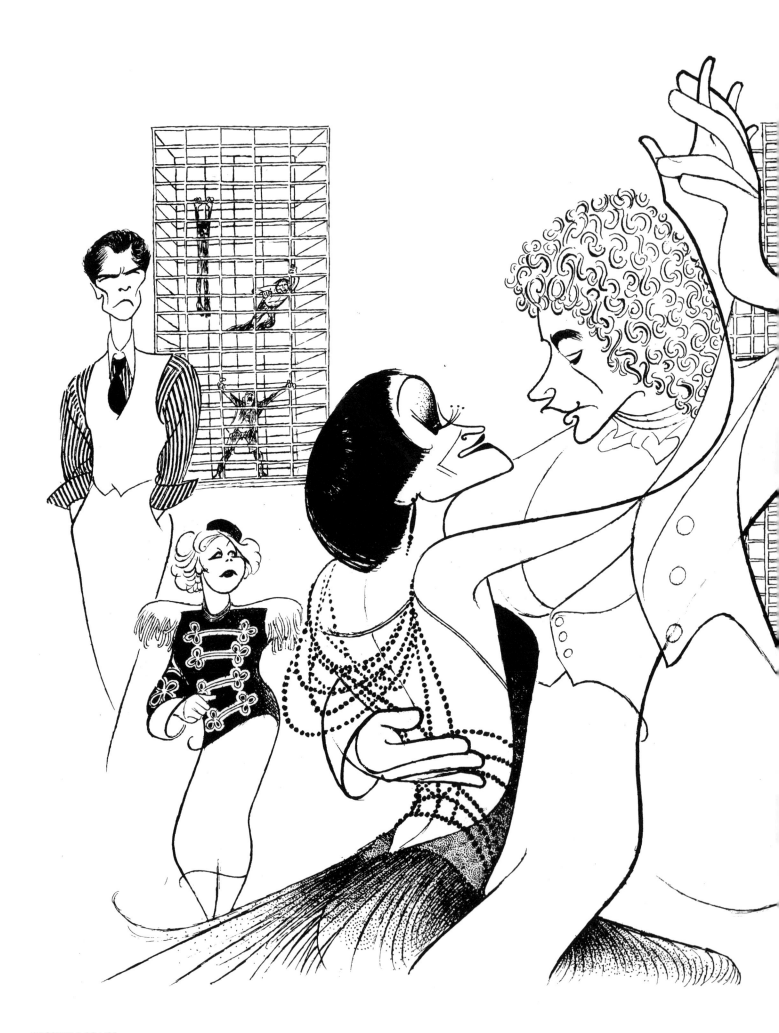

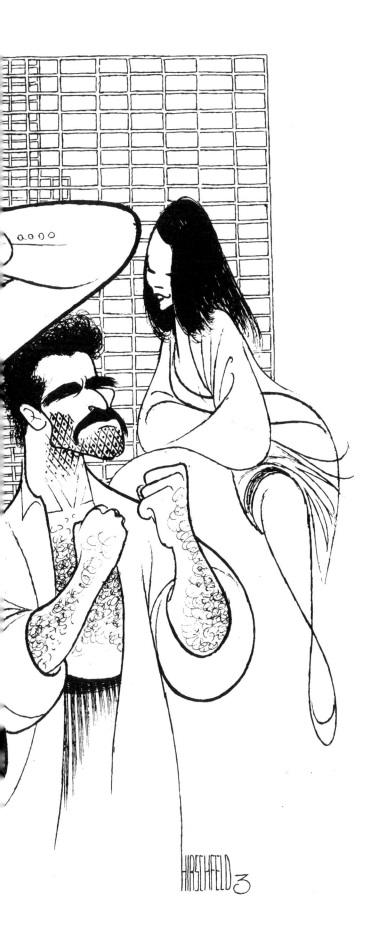

The Kiss of the Spider Woman, 1992

Part of the trend of turning movies into musicals; it used to be the other way around. With Herndon Lackey, Merle Louise, Chita Rivera, Brent Carver, Anthony Crivello, and Kirsti Carnahan.

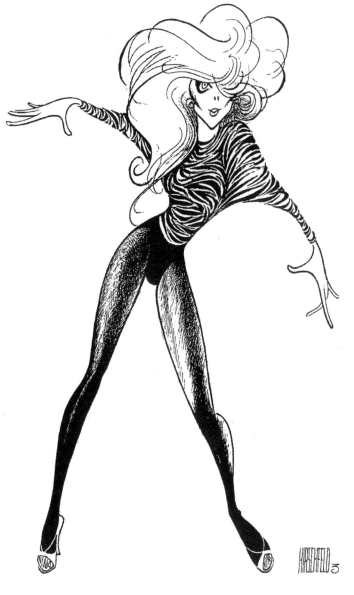

Ann-Margret, 1991

Her legs seem to be shooting right out of her shoulders, in the powerful upper part of her body and the equally powerful and dynamic hair. If she isn't the original Sixties sex kitten, she should have been. I've even got her in tiger stripes. She has a real dancer's body and movements, which of course I like. She fell off the scaffolding during an act once, broke herself up and still came back as vibrant and sexy as ever. The only co-star to wake Elvis up in that string of goofy drive-in movies he made. A woman for whom stretch fabrics seemed to be invented, she's so breathless a personality even her name's hyphenated for greater speed.

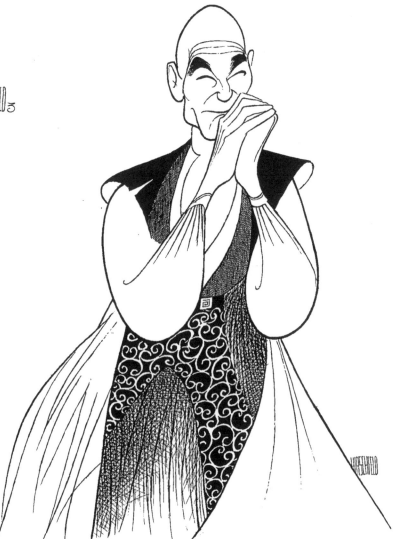

Patrick Stewart, 1995

You can see the influence of my Balinese days in the design of the fabric and in the simplicity of the line accompanying it. It's pattern juxtaposed against pattern to build up a rich, intriguing texture on the page. All the lines leading up like the features of a mountain to the brooding, bald head. He's looking very Buddha-like here, that's for sure. Stewart is best known as the second captain of the Starship Enterprise, but how many people remember him as one of the villains in the British television version of *I, Claudius?* He's also been playing Scrooge at Christmastime a lot lately, one of those actors lucky enough to get work as both hero and villain.

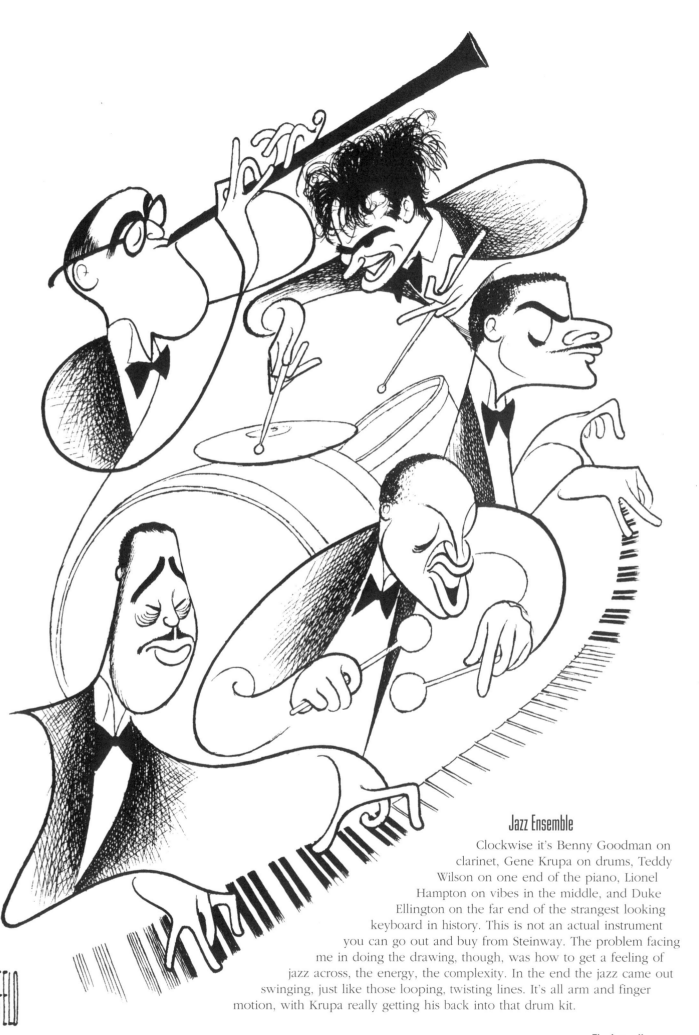

Jazz Ensemble

Clockwise it's Benny Goodman on clarinet, Gene Krupa on drums, Teddy Wilson on one end of the piano, Lionel Hampton on vibes in the middle, and Duke Ellington on the far end of the strangest looking keyboard in history. This is not an actual instrument you can go out and buy from Steinway. The problem facing me in doing the drawing, though, was how to get a feeling of jazz across, the energy, the complexity. In the end the jazz came out swinging, just like those looping, twisting lines. It's all arm and finger motion, with Krupa really getting his back into that drum kit.

HIRSCHFELD

Rodgers & Hammerstein Album Cover

On assignment from my Gallery, I drew this for the cover of an album of hits from their past musicals. Researching my former drawings of them, and with help from a failing memory, I managed to cook up this design.

Tommy Tune

Is that his real name? Seems too convenient a theatre handle to be true. And is that his real height? Watching him is like seeing the world's most graceful, smiling giraffe trotting about the stage. And he's almost as limber and thin as I've depicted him here. He came out recently with a rather shocking, to some, stage autobiography. It's hard to believe people can still be shocked by stage biographies. You'd think by now people in general would know that stage people tend to be outgoing, daring types. It helps to be that tall in front of an audience of a thousand people night after night.

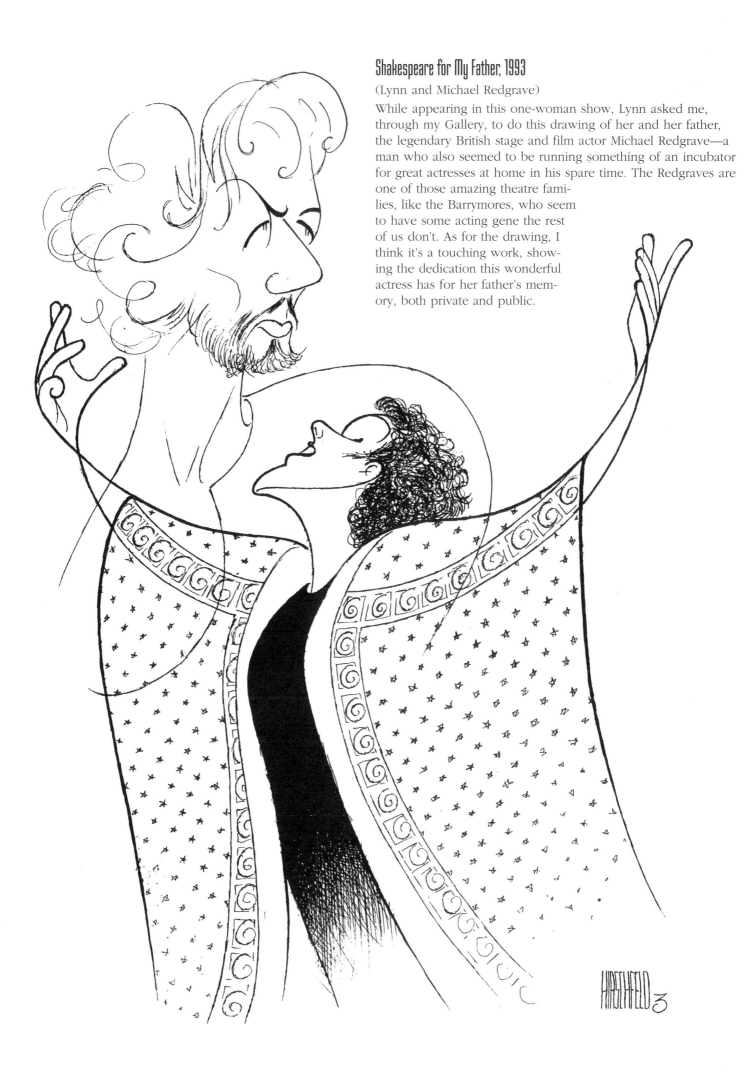

Shakespeare for My Father, 1993

(Lynn and Michael Redgrave)

While appearing in this one-woman show, Lynn asked me, through my Gallery, to do this drawing of her and her father, the legendary British stage and film actor Michael Redgrave—a man who also seemed to be running something of an incubator for great actresses at home in his spare time. The Redgraves are one of those amazing theatre families, like the Barrymores, who seem to have some acting gene the rest of us don't. As for the drawing, I think it's a touching work, showing the dedication this wonderful actress has for her father's memory, both private and public.

Arthur Miller and Steve Martin

Here's an interesting pairing of playwrights—Arthur Miller and Steve Martin. The comparison, I feel, is more flattering to Mr. Martin. Arthur got the short end of the graphic stick here, I'm afraid. But he's had a pretty good career so he can't complain. He's a marvel, still turning out interesting, challenging plays and during a time when most people don't want to hear interesting or challenging anymore. Steve has also written a few intriguing plays, including an Off-Broadway hit about Picasso at the Lapin Agile. Here they both have sweaters on! Is it me or do all theatre people pose in sweaters? Maybe it's those drafty New York rehearsal halls.

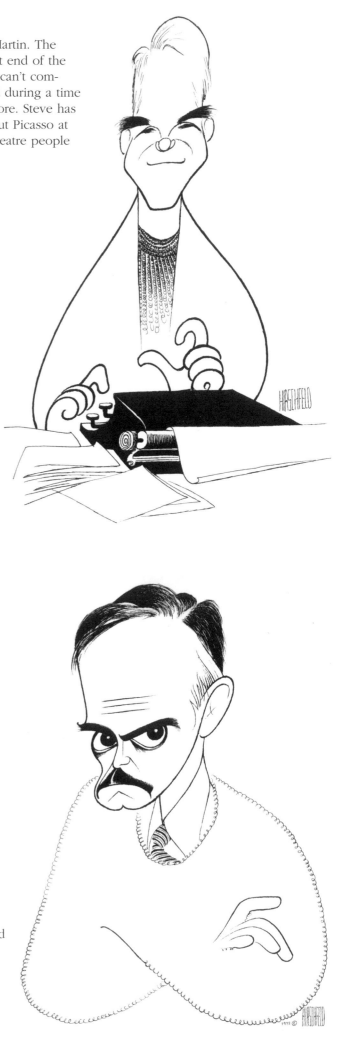

Eugene O'Neill

He was an old, dear friend. He used to love piano—swing piano. I remember we used to go to swing joints on 52nd Street with Sonny Aronberg, who was O'Neill's lawyer, and another great swing fan. We'd go to a speakeasy three nights a week to listen to those wonderful piano players.

Edward Albee, 1993

I drew this one of Edward from some sketches I made when I dropped in on him out in East Hampton in August of '93. I was visiting him in the company of an equally accomplished author, Paul Osborne, famed screenwriter and playwright, who is also a dear friend. We dropped in unexpectedly on Ed actually, and spent a wonderful summer afternoon with him. What the hell that has to do with this drawing, I don't know. He's looking awfully angular and droopy here, almost like one of his talking sea creatures in his 1975 play *Seascape*. That hand is disturbingly flipper-like. But maybe that's a natural transformation when you live that long out at the beach.

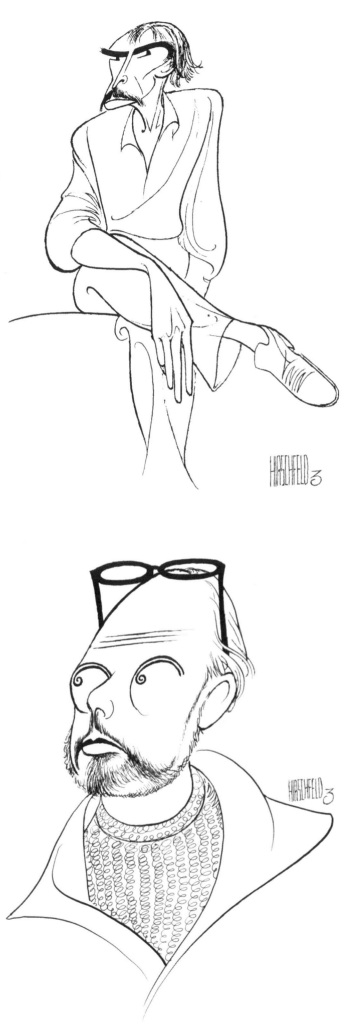

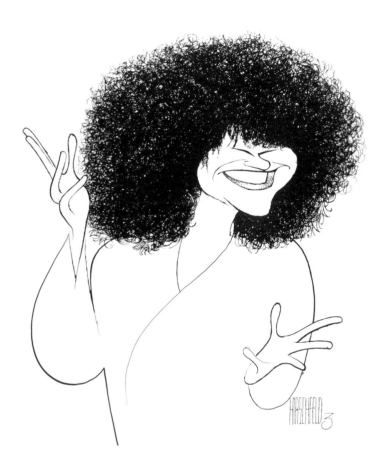

Wendy Wasserstein and Harold Prince

Wendy, wonderful, funny, quirky playwright that she is (i.e., *The Sisters Rosensweig*) and Tony-award winner to boot, nonetheless looks like she could use the eyeglasses that, as usual, Harold is disdaining. Harold is one of the Broadway greats and unlike most of the others is still, happily, directing and producing. Those glasses must be a prop he likes, because his eyes miss nothing on a stage whether the specs are up or down. Wendy also appears to be in competition with Barbra for Wildest, Bushiest, Curliest Hair on Broadway. That's what connects these two drawings, really, the same texture in Wendy's hair and Harold's sweater.

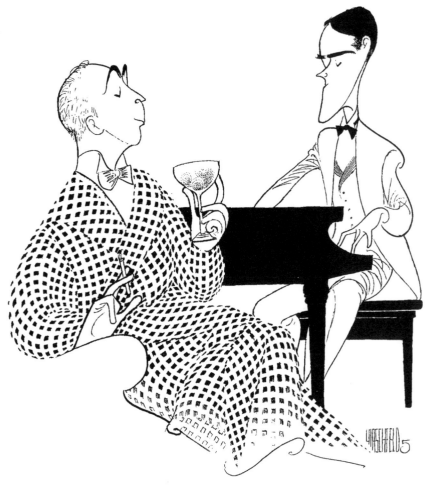

Present Laughter, 1997

(with Frank Langella)

This is Steve Ross's first appearance in the theatre—he normally plays piano professionally in clubs in London, although he got his start here in New York at the famed Algonquin. I did this drawing while the two of them were still in rehearsal. I went backstage and Frank put that robe on for me. Then, later, he decided to wear it in the play too.

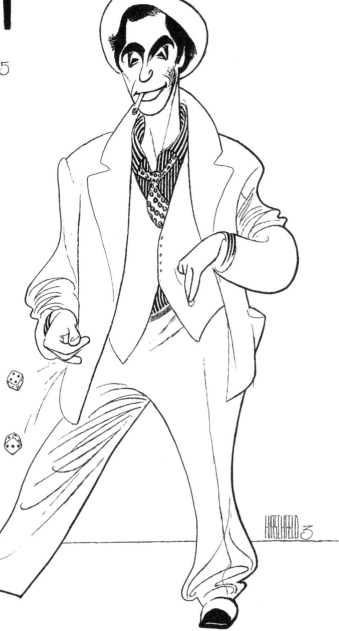

Al Pacino, 1996

(in *Hughie*)

Al Pacino in the title role of *Hughie,* an obvious escapee from *Guys and Dolls.* Except of course that this is one of Eugene O'Neill's raffish street people, not Damon Runyon's. *Hughie* was produced posthumously for the first time in 1964, an extended one-acter. Three decades later, though, Hughie met his match. Pacino was spectacularly, poignantly and hilariously dissolute in this production, a tour de force for one of our best "young" actors. And I think I captured most of that in this drawing. The stage always produces more adrenaline than the bit acting essential to movies. Hughie's got a seven working already in that crap throw, but ten to one it comes up boxcars when it comes to rest.

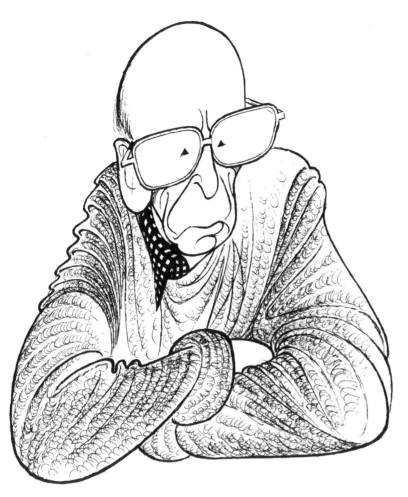

George Abbott at 101, 1989 (10-8-89)

George Abbott used to be the only one in the theatre older than me. I suppose I'm the oldest now. He looks in pretty good shape for a centenarian here, though not especially happy about it. One thing scientists might be able to deduce from George is that irascibility doesn't affect longevity—unless it helps. What can I say here about a New York stage career of acting, writing, directing, producing that began in 1913? He's not a book in himself, he's a boxed set. I'll leave the synopsis to the *Encyclopedia Brittanica*. Let it just be said he was one of the greats.

Marc Connelly

Marc Connelly (the one with the glasses) was a dear old friend of mine, but when he died I don't know what became of a solo portrait of him I'd done, one which I particularly liked and treasured. I couldn't resist drawing this most gentle man of my generation and I made a gift of it to him. There was never any mention when his estate was settled of the fate of the original artwork, however, so I don't know who has it now. We'll all, then, have to make do with this one of him, appearing with his pals Robert Sherwood and Irving Berlin. Marc was a great host, and I admired him very much. He was an early collaborator of George S. Kaufman's, and over the years wrote and directed some wonderful productions. *Green Pastures*, to name one.

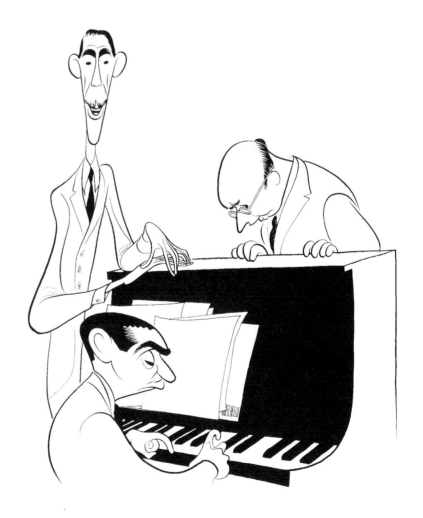

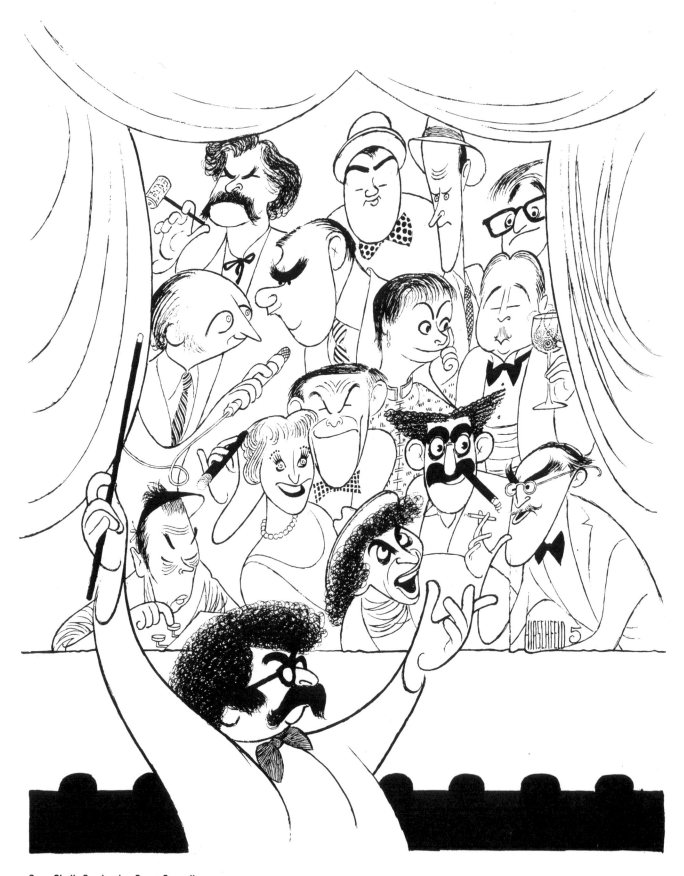

Gene Shalit Conducting Great Comedians

Mark Twain is the only one in this drawing I never met. The rest are done from a variety of drawings over the years. Media critic Gene Shalit, with the Groucho-like facial hair, is getting them all to sing for us. In the back row with Twain are Abbott and Costello and Woody Allen. Below them it's Bob and Ray doing their classic radio bits, Dorothy Parker and Robert Benchley trading quips at the Algonquin probably. Next aisle down it's Burns and Allen, Groucho and Chico and S. J. Perelman with the cigarette. Being the party pooper at his typewriter is Fred Allen. This would have made one hell of a stage show in real life. I did the drawing, by the way, for the book jacket of Gene's biography.

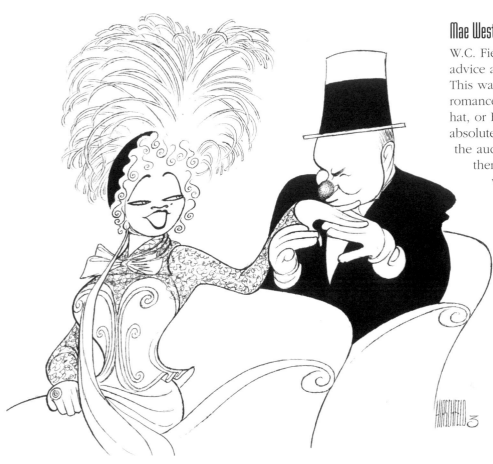

Mae West and W. C. Fields

W.C. Fields here takes Horace Greeley's famous advice about going West in *My Little Chickadee*. This was not one of your long lasting stage romances. Both had star egos bigger than Mae's hat, or Fields's too for that matter. Theirs was an absolute love affair on screen nonetheless, from the audience point of view, eating the two of them up. They were both crazy, both marvelous. Mae's hourglass figure was running low on sand at this point, and W.C.'s nose rivaled Rudolph's, but both were great outrageous comic stars of stage and screen. He was an enemy of water and inanimate objects. She taught sex to sophisticates.

Jack Benny (at 39)

If Jack Benny is 39 years old here, then George Abbott is 160. George Burns summed up Jack best. George said all Jack had to do to make him laugh was say, "Hello." Though he's received congratulations on 39 here, you can tell Jack's dwelling on his real age, glumly. The palm on the cheek was his signature double-take. The "Steven" and "Lori" (the +2) are references to friends of Jack's. He was my friend too, though I didn't dare tell him I caught his vaudeville act when I was a kid.

Abbott and Costello

Bud and Lou discuss "Who's on first," a classic misunderstanding of the English language.

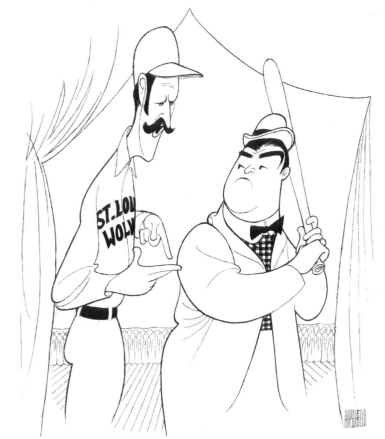

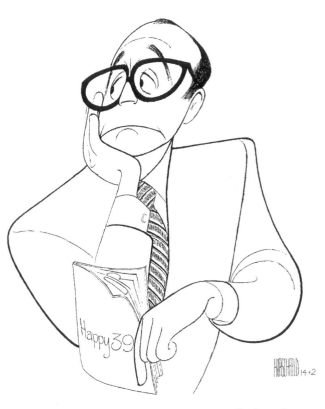

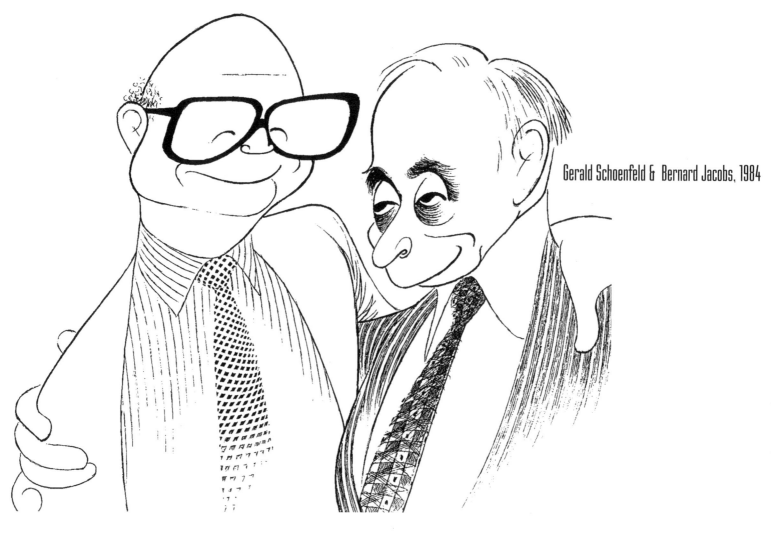

Gerald Schoenfeld & Bernard Jacobs, 1984

Rocco Landesman, 1995

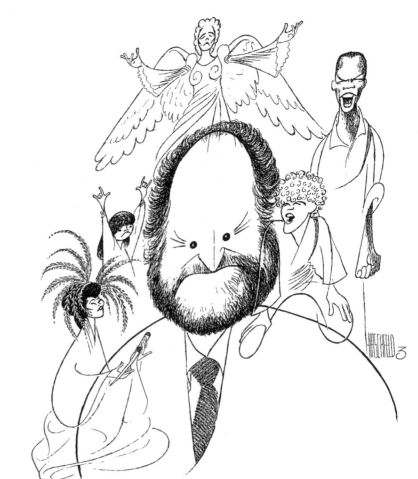

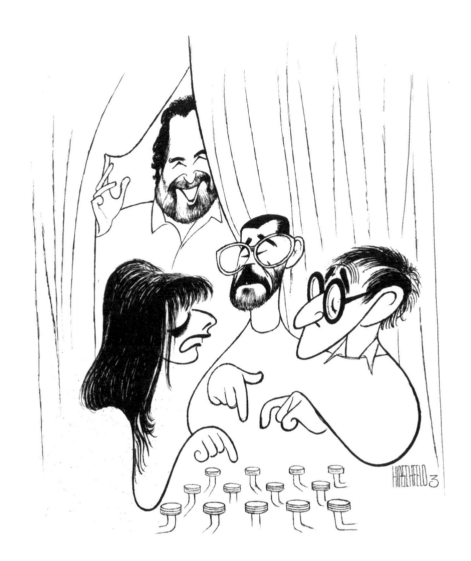

Julian Schlossberg, 1995

(with Elaine May, David Mamet
and Woody Allen)

Julian's not quite behind the scenes directing
his three writers, Elaine May, David Mamet and
Woody Allen, for an evening of one acts not
too long ago, one act per writer. It looks as
though they're all searching for the right type-
writer key here, eyes shut, a literary stab in the
dark. Which all too often putting a show on is.
Julian's the only one who's happy because he's
got all that talent at his disposal.

Alexander H. Cohen, 1997

One of the few producers left to take
chances on his own appraisal of a new
play by an unknown playwright—usually
wrong. Alex is also a great host with his
wife and collaborator Hildy Parks. They
cook the best corned beef and cabbage in
New York. Both are unpredictable and
wild entrepreneurs in a wild and unpre-
dictable business. Most notably, Alex pro-
duced *An Evening With Mike Nichols and
Elaine May* and *Beyond the Fringe*. He
also was the producer of the *Tony Awards*
on TV for years.

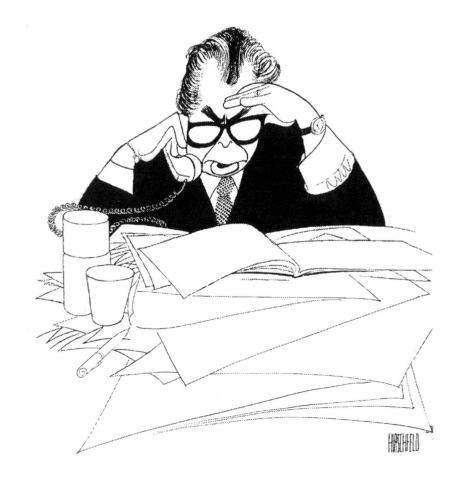

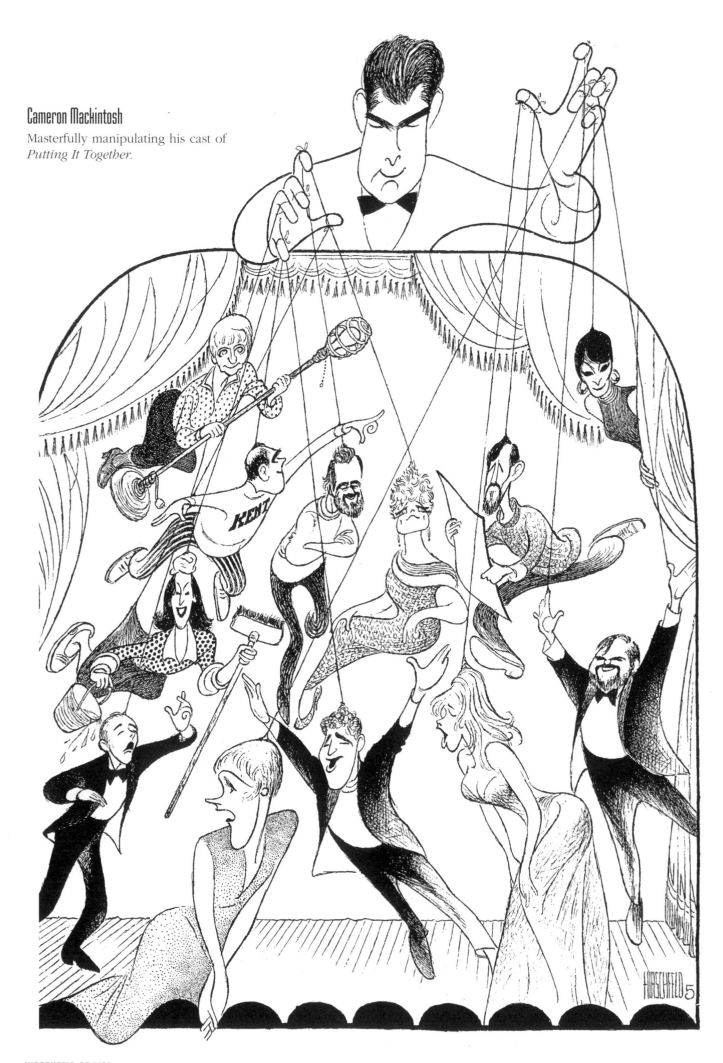

Cameron Mackintosh

Masterfully manipulating his cast of
Putting It Together.

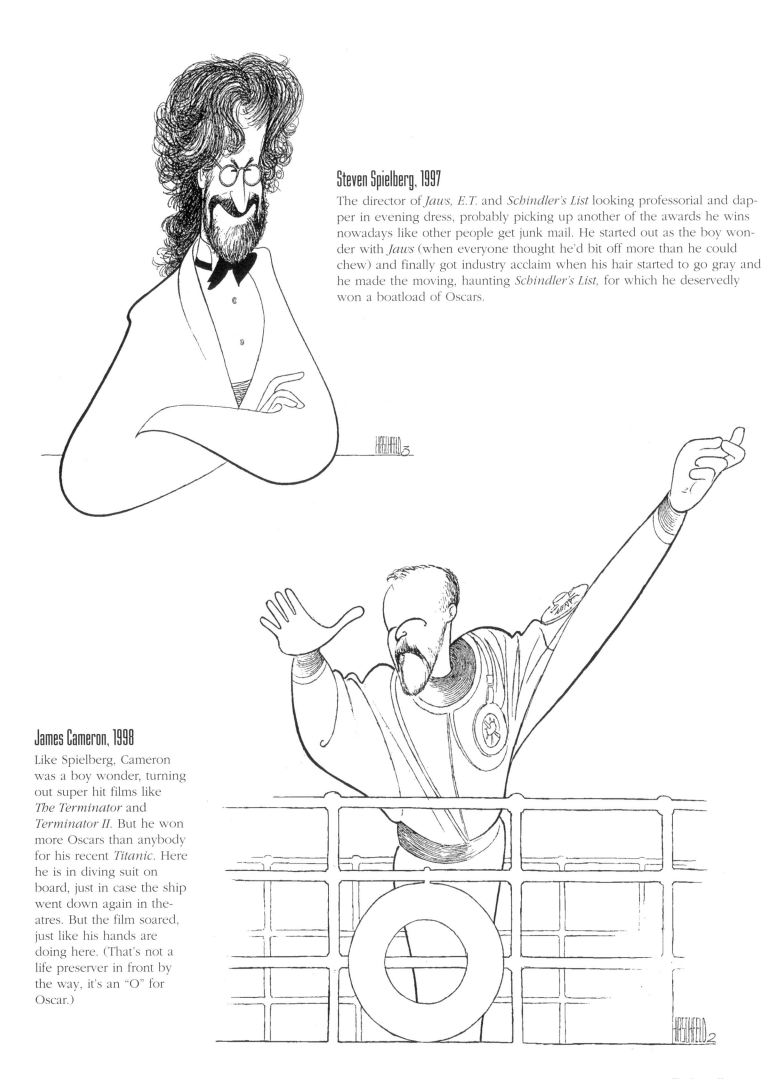

Steven Spielberg, 1997

The director of *Jaws, E.T.* and *Schindler's List* looking professorial and dapper in evening dress, probably picking up another of the awards he wins nowadays like other people get junk mail. He started out as the boy wonder with *Jaws* (when everyone thought he'd bit off more than he could chew) and finally got industry acclaim when his hair started to go gray and he made the moving, haunting *Schindler's List,* for which he deservedly won a boatload of Oscars.

James Cameron, 1998

Like Spielberg, Cameron was a boy wonder, turning out super hit films like *The Terminator* and *Terminator II*. But he won more Oscars than anybody for his recent *Titanic*. Here he is in diving suit on board, just in case the ship went down again in theatres. But the film soared, just like his hands are doing here. (That's not a life preserver in front by the way, it's an "O" for Oscar.)

Ross Perot, 1992

Ross Perot reminds me of a loving cup in some ways. His ears lend themselves like handles on a cup. His tie sums him up, though—the superpatriot. Ross had some good points to make during the past couple of Presidential elections, but he's such a character of modern technology. He made his billions there and then used them to buy his way onto TV. Maybe he's only the first (okay, Steve Forbes too) of a long, odd string of billionaires plastering themselves and their ideas all over our TV screens during elections.

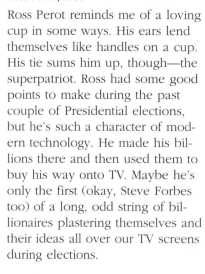

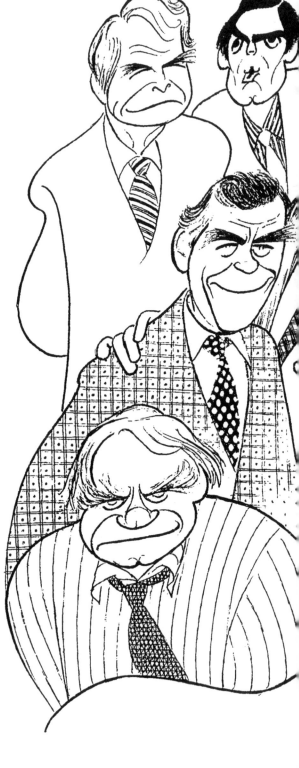

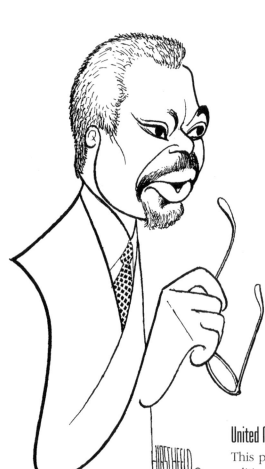

United Nations Secretary General Kofi Annan, 1998

This portrait I did for a U.N. (WFUNA) First Day of Issue Cover, and limited-edition silk-screen print. I'd also drawn the first U.N. Secretary General, Trygvi Lee, years ago.

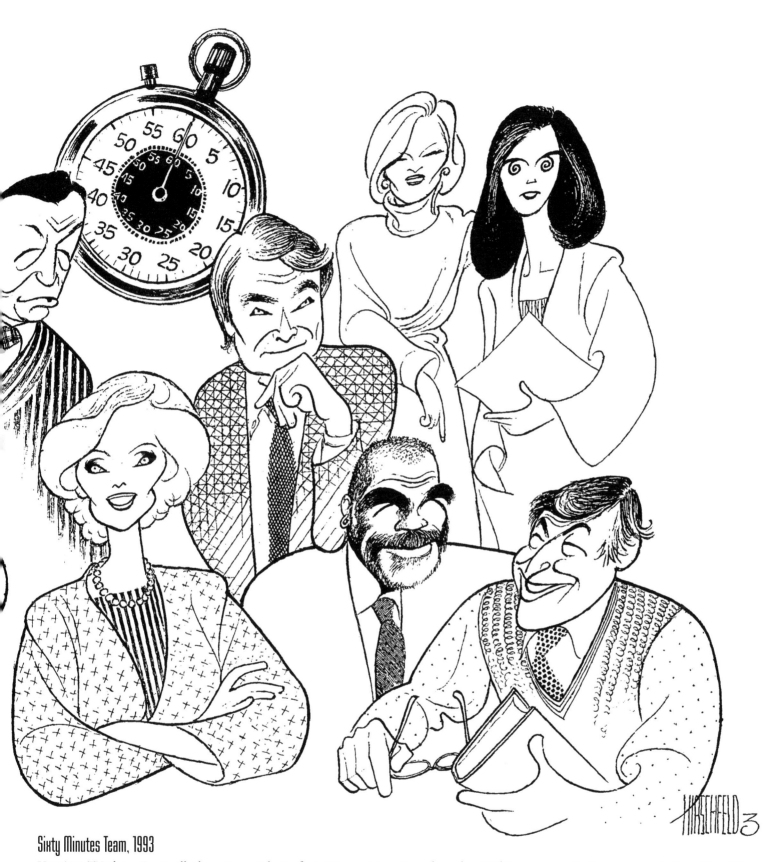

Sixty Minutes Team, 1993

Here's a TV show I actually love to watch. In fact, I try not to miss a broadcast. This group portrait was commissioned by Ed Bradley. He came up to my studio and asked me to do one of the whole team at that time. Morley Safer had interviewed me for a *Sixty Minutes* segment about five years prior to that. Thank God it wasn't Mike Wallace doing the interview. He probably would have gotten me to confess to the McKinley assassination or something. I'd also met Andy Rooney, but this again is a composite drawing from the TV screen. In other words, these people all didn't appear in a single shot on the show just like this. Even the stopwatch is a pretty good likeness. (Pictured: Andy Rooney, Morley Safer, Harry Reasoner, Dan Rather, Mike Wallace, Leslie Stahl, Steve Kroft, Diane Sawyer, Meredith Viera, Ed Bradley, and the show's producer Don Hewitt.)

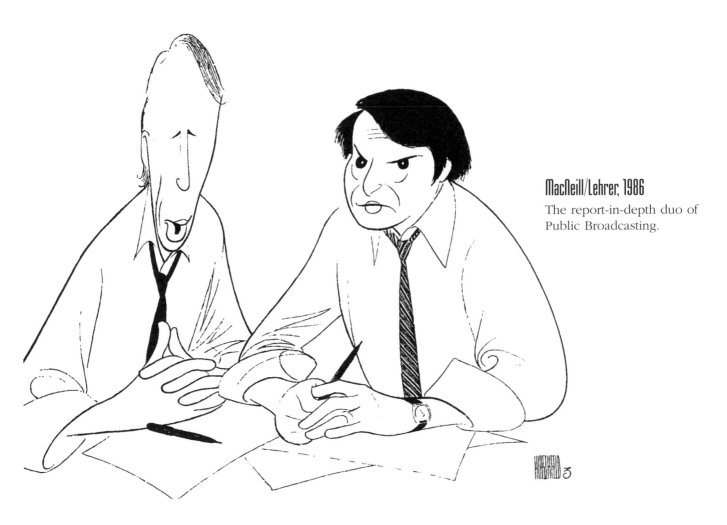

MacNeill/Lehrer, 1986

The report-in-depth duo of Public Broadcasting.

Charlie Rose, 1993

I was on Charlie's PBS talk show, but here the table has been turned and he's the subject on my show. I'm more interested in drawing him than in him trying to draw me out anyway. I wanted to show what it is that makes him such a gifted interviewer. I've boiled it down to the wry expression and the hands—once again they're the telegraphers, graphically, of inner character. Charlie's hands are particularly expressive. He uses them like a concert conductor during his discussions, to egg on or hold up a particular thought, or guest. His expressive face also tells his interviewee what he's asking and what he's happy and not happy to be hearing. He's a great traffic cop of talk. But he does it all with that great Southern charm, so you gladly surrender to his superb conducting. And his eyebrows and hair always are that unruly—though they might just be a casualty of the Public Television production budget.

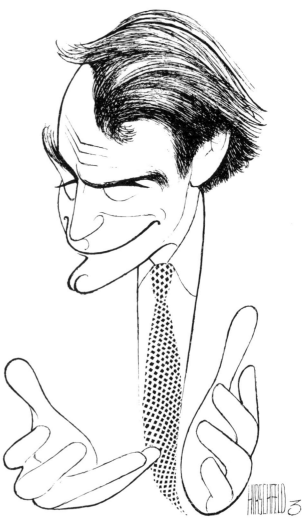

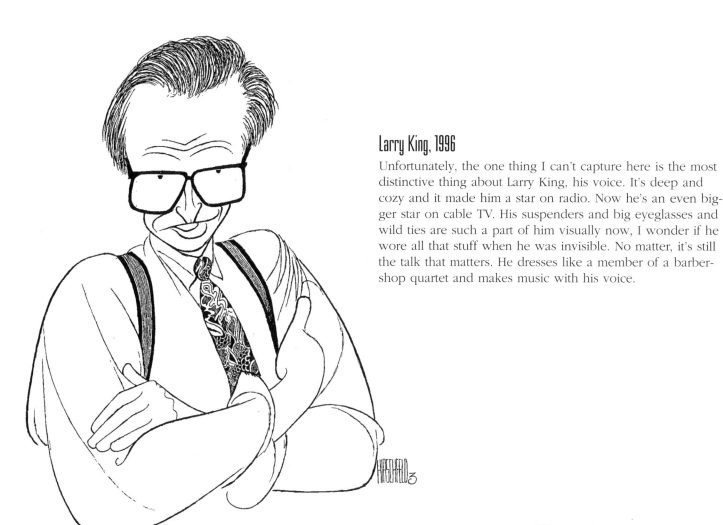

Larry King, 1996

Unfortunately, the one thing I can't capture here is the most distinctive thing about Larry King, his voice. It's deep and cozy and it made him a star on radio. Now he's an even bigger star on cable TV. His suspenders and big eyeglasses and wild ties are such a part of him visually now, I wonder if he wore all that stuff when he was invisible. No matter, it's still the talk that matters. He dresses like a member of a barbershop quartet and makes music with his voice.

Barbara Walters, 1996

Another expert television interviewer, and also with an uncontrollable coif. Although ABC surely hires Barbara the most expensive makeup and hair people available. Again you see the emphasis on the head and the hands. Is that her left shoulder or a wire directly connecting her head with that pensively posed right hand? The casually propped up elbow is misleading—Barbara is as tough an interviewer as there is, no matter how folksy she presents herself. The arched, looping, inquisitive eyebrows here tell you how this interview is going—she's very interested, and equally skeptical so far. Personally, our paths have only crossed at Elaine's, the renowned artists' restaurant on Manhattan's Upper East Side.

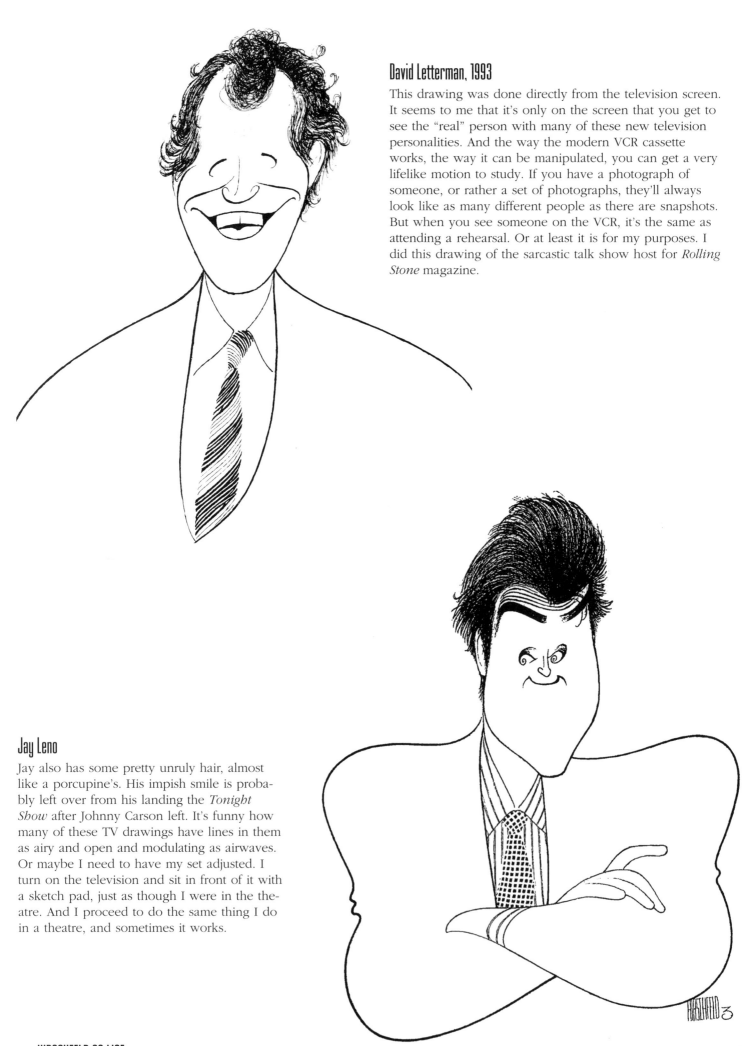

David Letterman, 1993

This drawing was done directly from the television screen. It seems to me that it's only on the screen that you get to see the "real" person with many of these new television personalities. And the way the modern VCR cassette works, the way it can be manipulated, you can get a very lifelike motion to study. If you have a photograph of someone, or rather a set of photographs, they'll always look like as many different people as there are snapshots. But when you see someone on the VCR, it's the same as attending a rehearsal. Or at least it is for my purposes. I did this drawing of the sarcastic talk show host for *Rolling Stone* magazine.

Jay Leno

Jay also has some pretty unruly hair, almost like a porcupine's. His impish smile is probably left over from his landing the *Tonight Show* after Johnny Carson left. It's funny how many of these TV drawings have lines in them as airy and open and modulating as airwaves. Or maybe I need to have my set adjusted. I turn on the television and sit in front of it with a sketch pad, just as though I were in the theatre. And I proceed to do the same thing I do in a theatre, and sometimes it works.

Susan W. Dryfoos and Daniel Selznick, 1997

Susan is the director of the documentary on me, *The Line King*. Danny is the grandson of the first man who hired me as an artist, L.J. Selznick. So the two of them go back a long way, genetically at least, in my career. As a matter of fact, for my 85th birthday the *Times* had a small gathering for me on one of their upper floors and Danny crashed the party. Where he met Susan and, not much later, they married. Still later, I received a chef's apron from Danny printed with the slogan, "I met my wife through *The New York Times*." Susan, by the way, is the great-granddaughter of Adolph Ochs, the founder of the *Times*. This drawing of them working the phones looks more like *The Paper Chase* than *The Line King*. Theirs was a match made in call-waiting heaven.

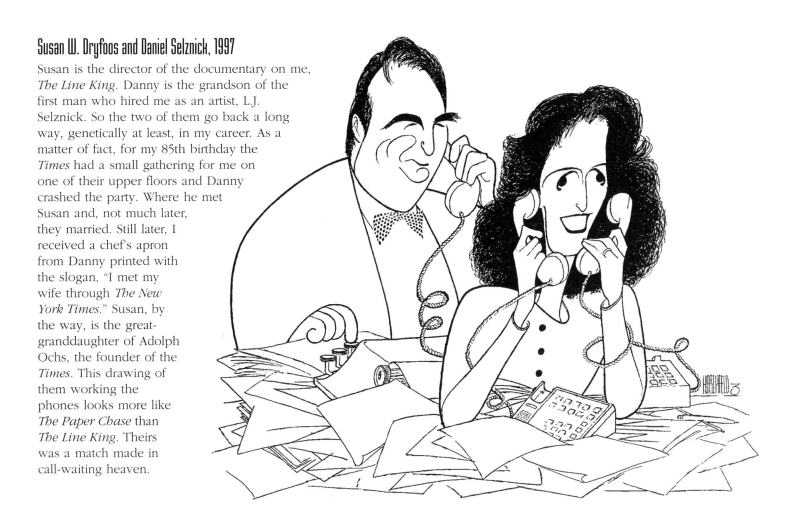

Adolph Ochs, 1996

This one of the publisher of *The New York Times* is, I hope, sufficiently flattering for a man largely responsible for my paychecks for the past seventy years. The portrait was commissioned by the Times Company to adorn their 1996 annual report. The image of Mr. Ochs itself is drawn from photos of him. I knew him personally, of course. Nice fellow.

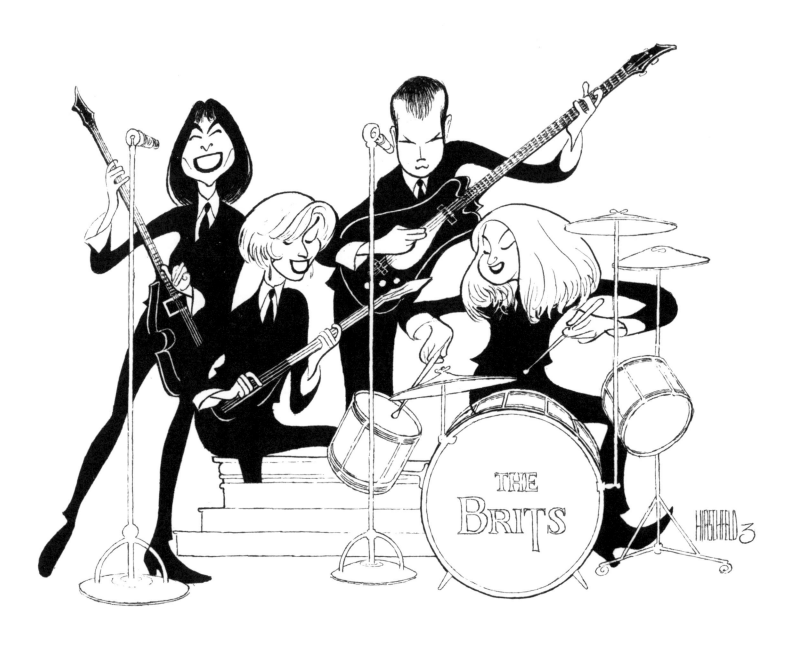

The Brits, 1992

In 1992 a group of British magazine editors stormed over to New York to take up some important posts, so I did them as The Beatles, a new kind of British invasion. Left to right they're Anna Wintour (who came over from British *Vogue* to take the helm of American *Vogue* from Grace Mirabella; Tina Brown, who left London's *Tatler* to take over *Vanity Fair* and later *The New Yorker*; plus, Andrew Sullivan and Liz Tilberis, who I'm not sure, frankly, what they took over.

Dr. William Cahan, 1994

Dr. Cahan is the former director of Memorial Sloan-Kettering Cancer Center on the Upper East Side of Manhattan. It's one of the great cancer hospitals and research facilities in the world. He's looking typically pensive and wry here. Notice the no-smoking sign dangling from his right hand. I already like his bedside manner just looking at this drawing, and the hearts in the tie are representative of how much loving care is still a part of cancer treatment and rehabilitation.

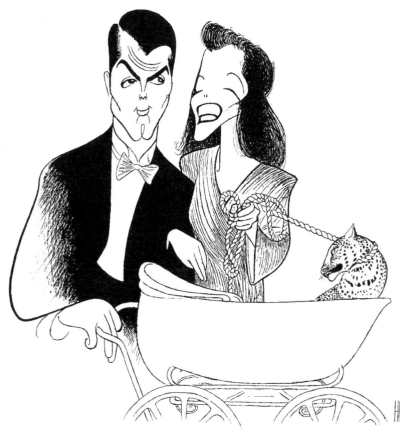

Cary Grant and Katharine Hepburn, 1998

Cary and Kate in *Bringing Up Baby*. While Grant was a mainstay of Thirties screwball comedies this was Hepburn's only screwball role. The leopard, though, is the one playing the title role.

Dr. Vartan Gregorian, 1994

The former president of the New York Public Library, Dr. Gregorian is a man I very much admire, for the wonderful job he did. Even better, he has fun hair to draw. In fact, it looks a little like the manes of those famous lions sitting on the front library steps. Maybe the hair style goes with the post. Even the NINAs look like they went through the curling iron. His eyes do look kind of baggy, but that's undoubtedly from all that reading. My own work has appeared in group showings at the Library, but never a one-man exhibition.

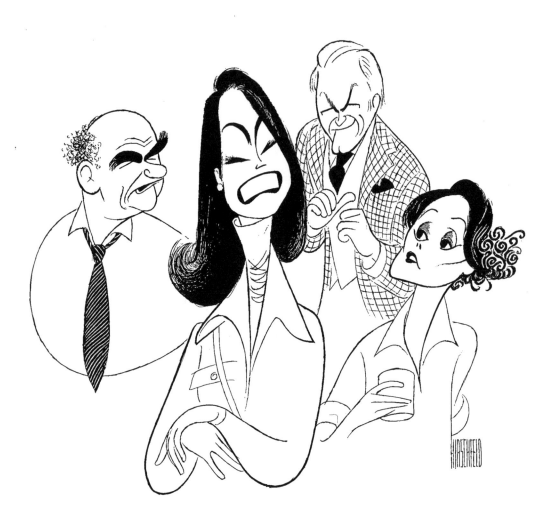

The Mary Tyler Moore Show, 1987

Good old Lou, Mare, Ted and Rhoda—the core of that sitcom in its great early years. (Namely, Ed Asner, Mary Tyler Moore, Ted Knight, and Valerie Harper.) Even Mary's hairstyle and turtleneck date this one to the Seventies. I tried to encapsulate what was so quirkily entertaining about each of these wonderful actors—irascible Lou, chirpy Mary, pompous Ted, and frustrated Rhoda. One of those rare cases when the ensemble acting in a TV show rivaled that of a great, long-running stage comedy. Mary Tyler Moore once presented me with a Tony Award in 1983, one of those few times when I got to climb out of my aisle seat, put my sketch pad down and walk up on stage to take the spotlight. Aside from the stage fright, I thoroughly enjoyed it.

The Golden Girls, 1991

The Golden Girls, four retired ladies (Rue McClanahan, Bea Arthur, Betty White, and Estelle Getty) yukking it up in Florida—the fate I mercifully have escaped by continuing to work. Actually, it was a funny show, with some terrific comic actresses. I've given them a cheese-cake to eat here that their real-life, or even TV-show life, would probably never allow them. I was commissioned by the producers of the show to do this one, also off the TV screen. I watch enough of the show until I'm satisfied I know what each character demands in the drawing. I am the most demanding critic of my own work.

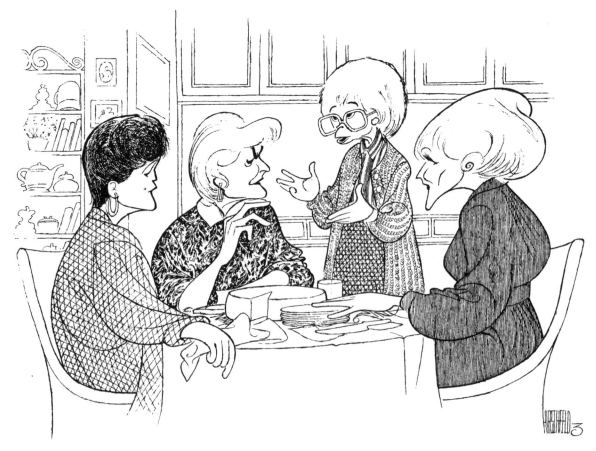

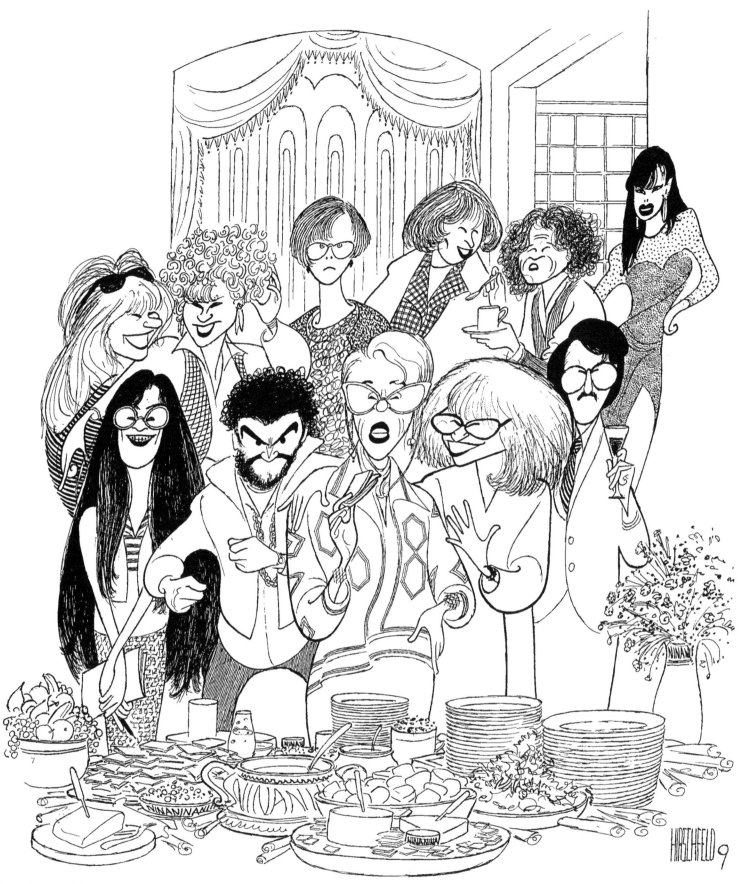

Tracey Ullman, 1998

(as 11 characters)

One of the great advantages the art of drawing has over other modern visual media, such as film and computer graphics, is that special effects are easy to fit into the budget. Here's a multiple exposure of the great British comic actress Tracey Ullman, on her show, as eleven different characters. Sure you could get some computer whiz at Pixar to do this on CGI—for about a million dollars. I just draw them in one after the other, pausing for my afternoon tea break. I have no idea who all these people she's impersonating are—you'll have to buy *her* book to find that out.

Audrey Hepburn, 1997

Though I did this drawing recently, I've got Audrey in her ultra-chic Sixties style. She was the fashion designer's muse back then. She was as thin as her cigarette holder, as sophisticated as her diamond jewelry and as mischievous as her eyebrows. She'll always be best remembered as Holly Golightly in Truman Capote's *Breakfast at Tiffany's,* the world's most gold-hearted gold digger. The joke was that she'd have a cardboard cup of coffee gazing into

Tiffany's window after she was dropped off by her sugar daddy early each morning. The jewelry store got bugged about it by curious, hungry customers so much, though, that they did start serving breakfast in some of their stores.

Bette Midler, 1992

My wife, Dolly Haas, went to Central Park one day to hear a concert. She came back and told me she'd just seen a star. It was Bette Midler. That indescribable quality that makes a star was evident in her first appearance in the park. Here she is doing the hootchy coo and showing a little gam in her role for the film *For the Boys,* which was about the USO performers during World War II. Bette is like a reincarnation of one of those old-time stage stars. She sings, she dances, she acts! Only she could have stepped into Ethel Merman's shoes, and mouth, in the uncut TV version of *Gypsy.*

Julie Andrews as Mary Poppins, 1990

Julie made a practically perfect Mary Poppins, the super nanny. She floats in to her new assignment on her umbrella, magic carpet-bag in hand, then flies away when the troubled, pampered upper-class Brit kids have grown up. It was a story rightly set in Victorian times. If Ms. Poppins had tried this recently, she would have been popped off the screen by a couple of intercept missiles. It was a much more innocent era in general back then, of course. Now the British upper classes have European au pair girls who get into tabloid scandals.

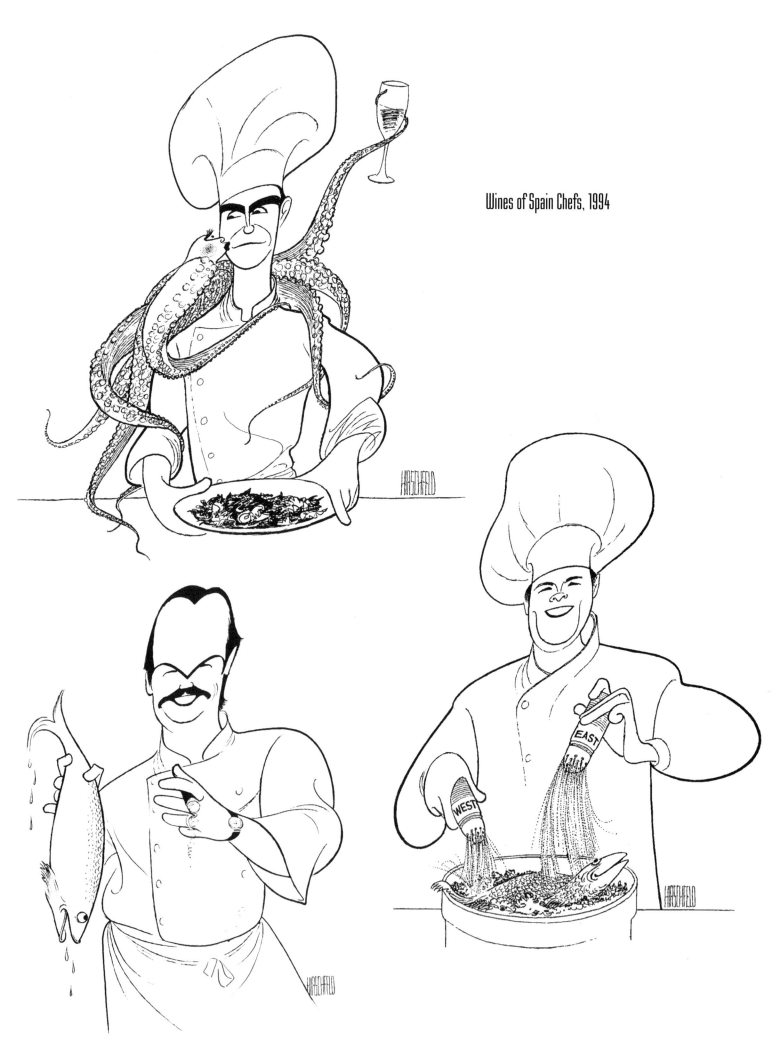

Wines of Spain Chefs, 1994

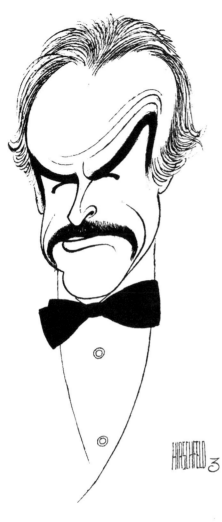

Sean Connery

Connery is the original, the only, James Bond, neither shaken nor stirred. Dressed apparently for another night at the casino. He's got those great eyebrows, like an eagle's wingspan, and that Scottish one-sided sneer. And a nose like a bottle opener. Ian Fleming's ideal for his character James Bond was Hoagy Carmichael, who looked—not surprisingly—just like Ian Fleming. Connery made the role entirely over in his own image. Others have been trying to catch up ever since.

Andrew Lloyd Webber

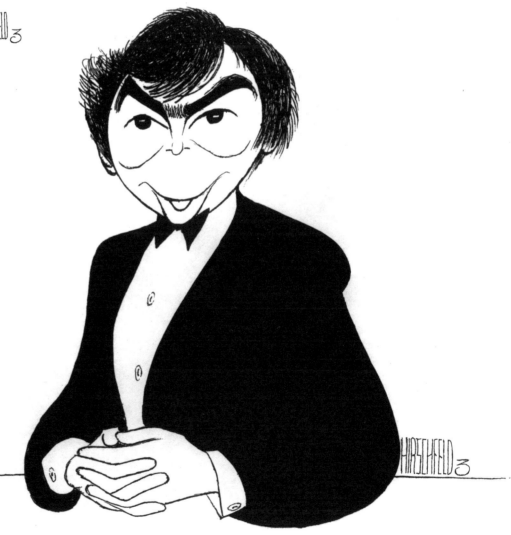

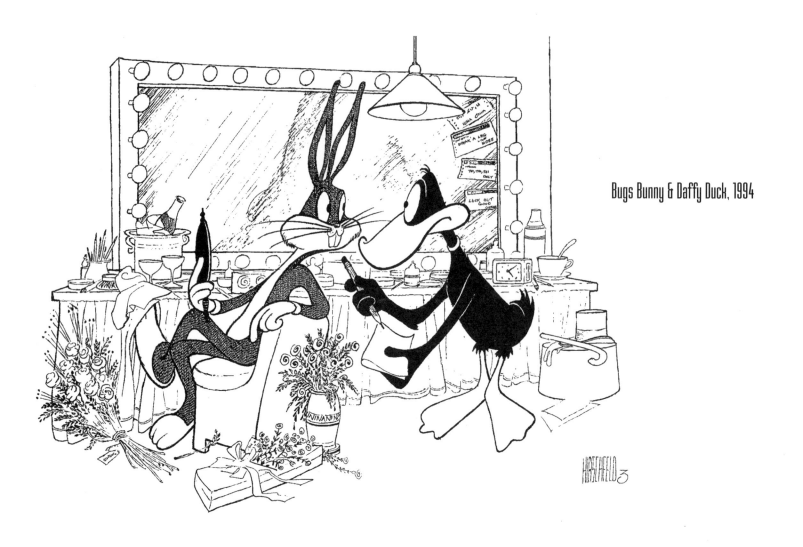

Bugs Bunny & Daffy Duck, 1994

Opening Night, 1994

(Warner Bros.)

Most of the talk lately has been about Disney moving into Broadway, but here it's those Warner Bros. Bugs Bunny and Daffy Duck in Bugs' dressing room *(above)*, with Daffy exasperatingly playing second fiddle to the star as usual.

The other drawing has a dapper Bugs and Daffy crossing paths in front of the theatre, with Yosemite Sam, Porky Pig and Wile E. Coyote behind them. I don't think they're going to see *The Lion King,* though. Both were done for Warner Bros., as limited editions for collectors.

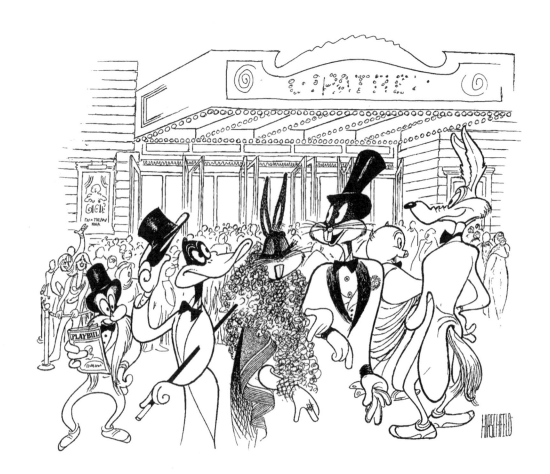

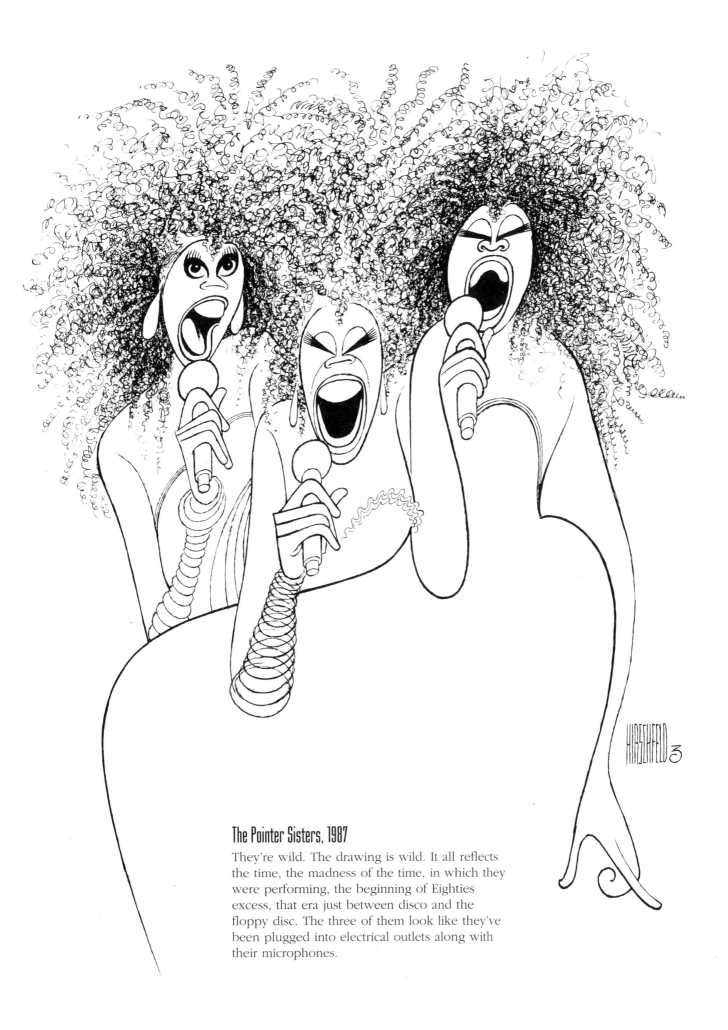

The Pointer Sisters, 1987

They're wild. The drawing is wild. It all reflects the time, the madness of the time, in which they were performing, the beginning of Eighties excess, that era just between disco and the floppy disc. The three of them look like they've been plugged into electrical outlets along with their microphones.

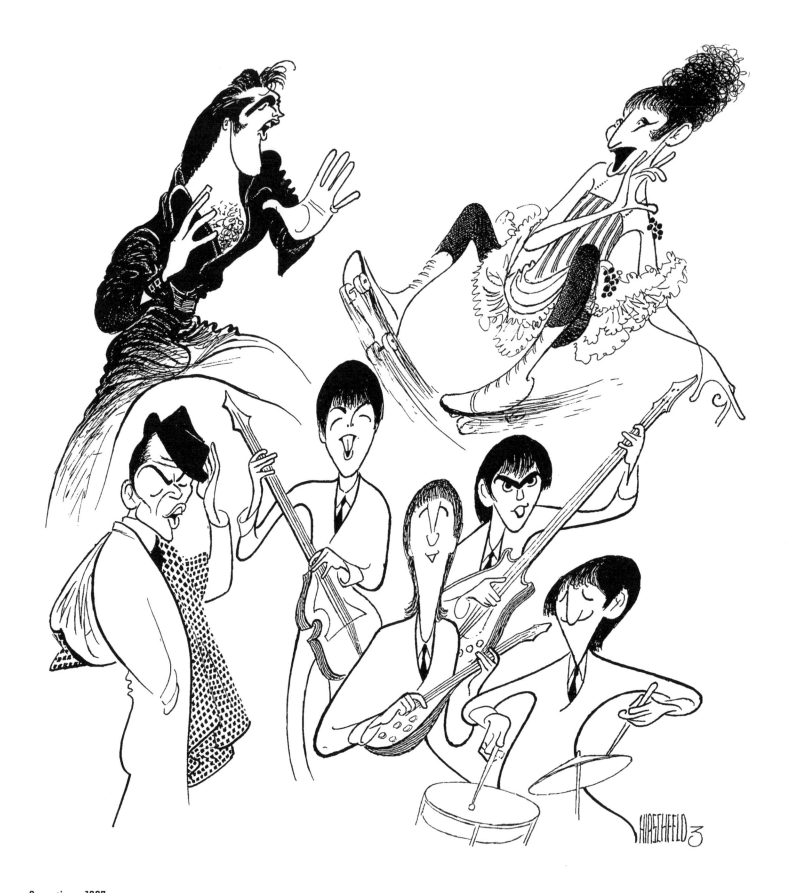

Sensations, 1997

(The Beatles, Elvis Presley, Frank Sinatra, Barbra Streisand)

The four different singing styles are what vary this drawing. Elvis swinging his pelvis in the upper left, with Barbra, in a scene out of *Funny Girl*, trying not to run into him on those roller skates. Below, the Beatles exude charm while Frankie exudes cool. If you count the vaudeville act Barbra is performing, you've got about eighty years of American popular music styles represented. Though God knows what this would sound like if you heard them all crooning at once.

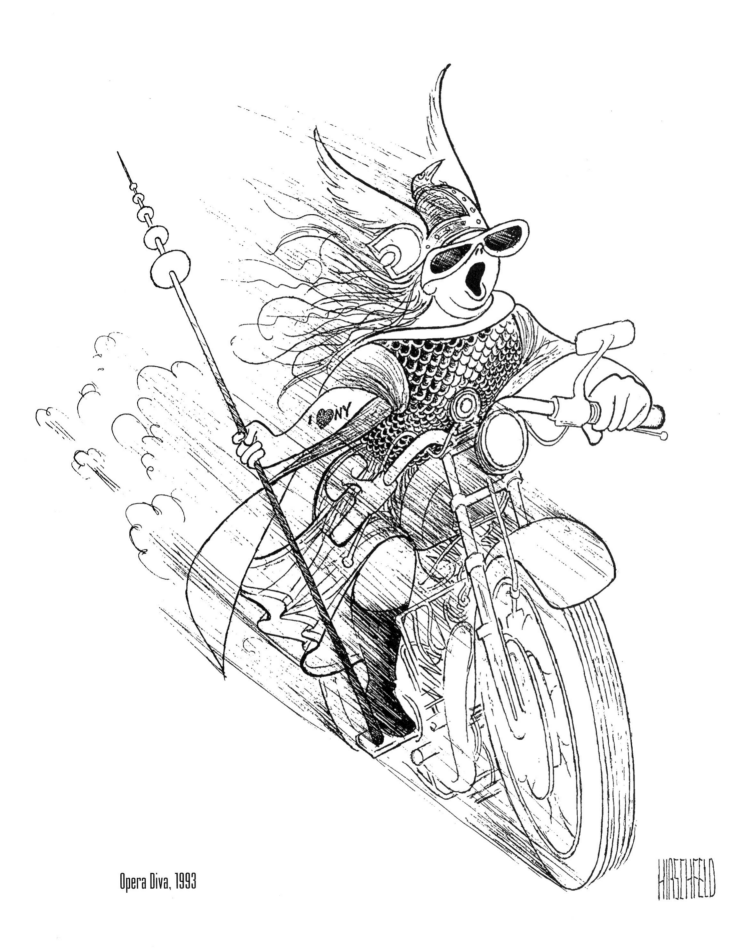

Opera Diva, 1993

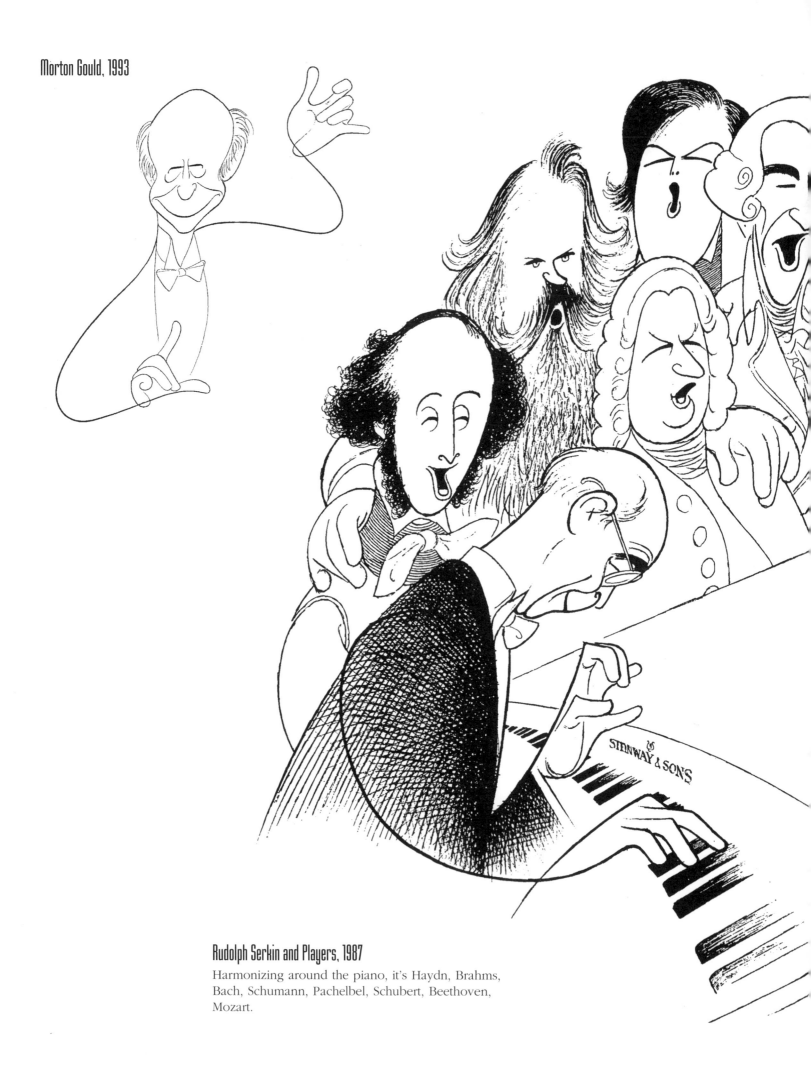

Morton Gould, 1993

Rudolph Serkin and Players, 1987

Harmonizing around the piano, it's Haydn, Brahms, Bach, Schumann, Pachelbel, Schubert, Beethoven, Mozart.

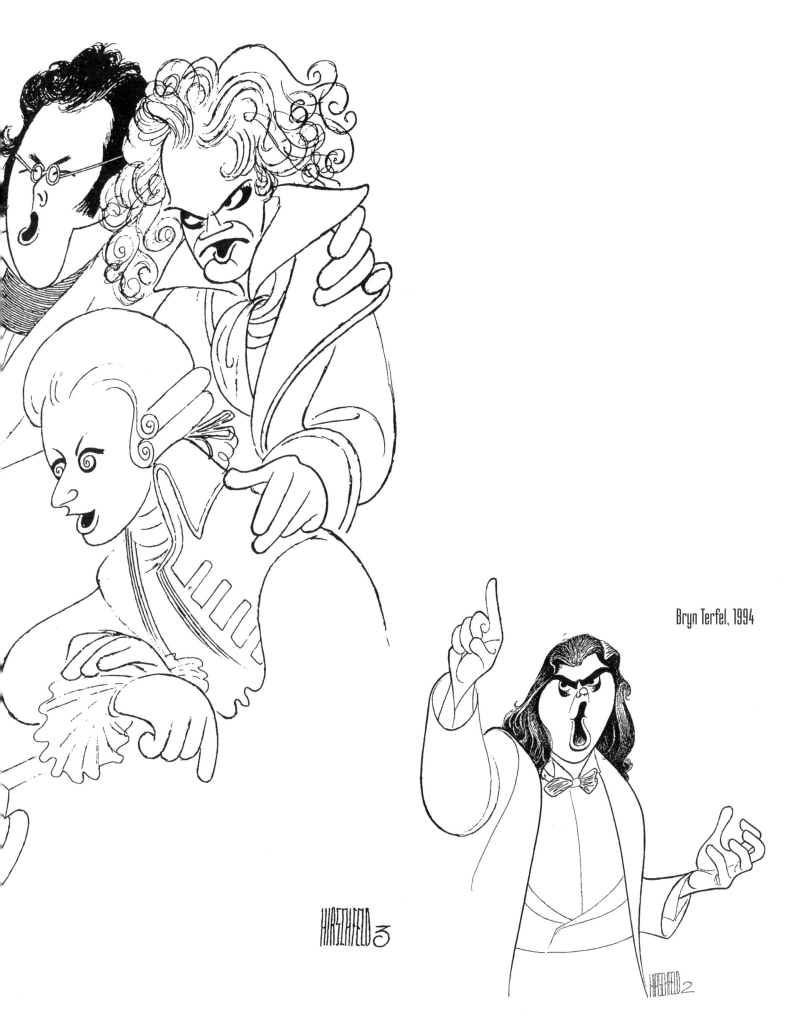

Bryn Terfel, 1994

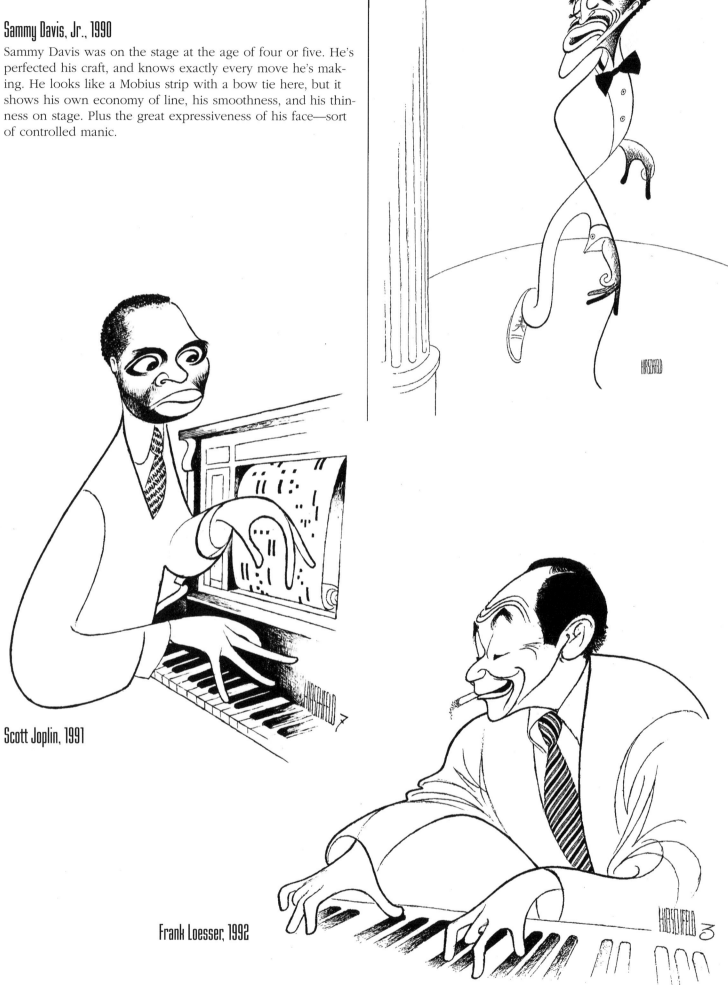

Sammy Davis, Jr., 1990

Sammy Davis was on the stage at the age of four or five. He's perfected his craft, and knows exactly every move he's making. He looks like a Mobius strip with a bow tie here, but it shows his own economy of line, his smoothness, and his thinness on stage. Plus the great expressiveness of his face—sort of controlled manic.

Scott Joplin, 1991

Frank Loesser, 1992

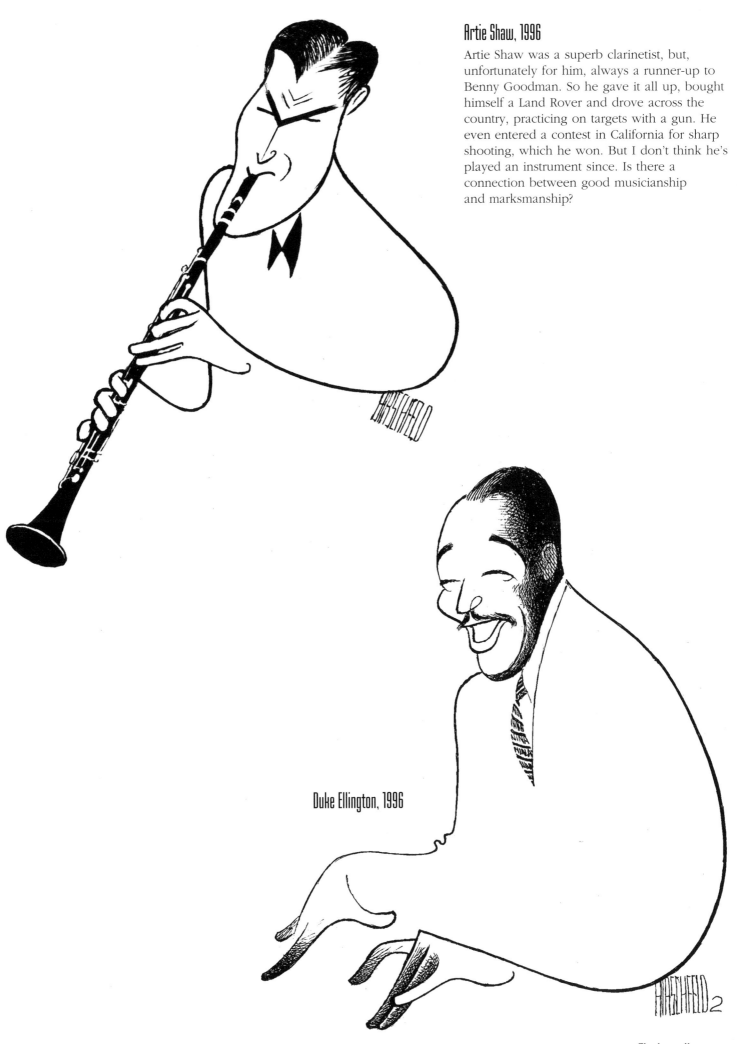

Artie Shaw, 1996

Artie Shaw was a superb clarinetist, but, unfortunately for him, always a runner-up to Benny Goodman. So he gave it all up, bought himself a Land Rover and drove across the country, practicing on targets with a gun. He even entered a contest in California for sharp shooting, which he won. But I don't think he's played an instrument since. Is there a connection between good musicianship and marksmanship?

Duke Ellington, 1996

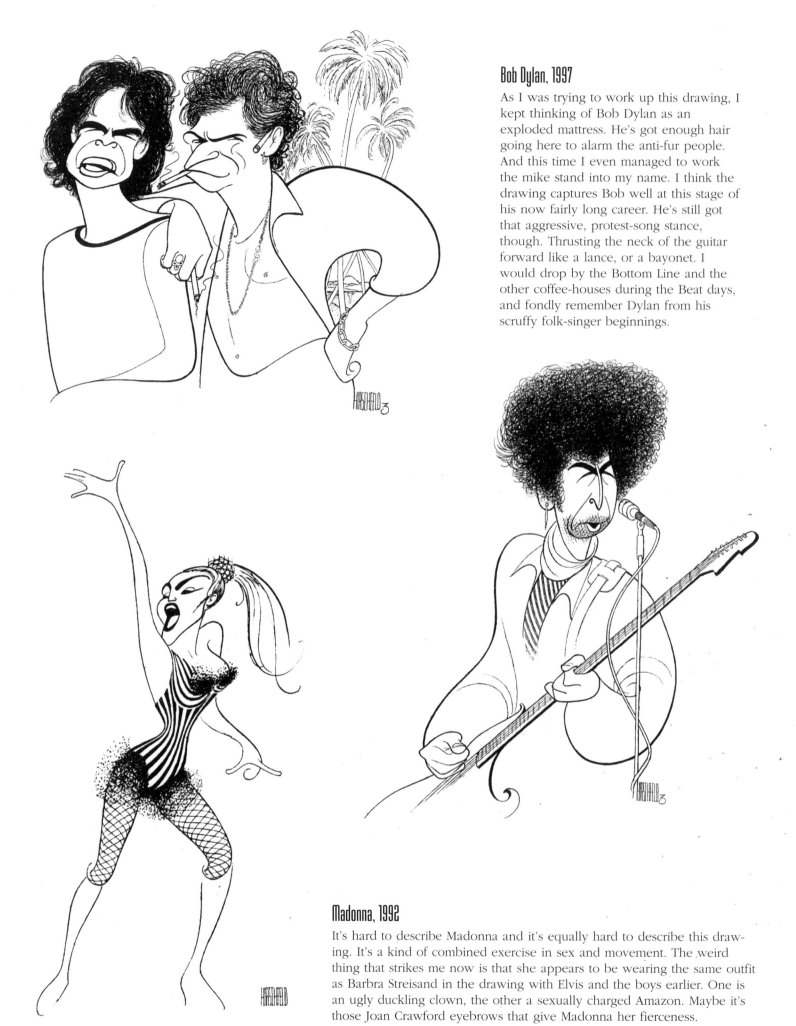

Bob Dylan, 1997

As I was trying to work up this drawing, I kept thinking of Bob Dylan as an exploded mattress. He's got enough hair going here to alarm the anti-fur people. And this time I even managed to work the mike stand into my name. I think the drawing captures Bob well at this stage of his now fairly long career. He's still got that aggressive, protest-song stance, though. Thrusting the neck of the guitar forward like a lance, or a bayonet. I would drop by the Bottom Line and the other coffee-houses during the Beat days, and fondly remember Dylan from his scruffy folk-singer beginnings.

Madonna, 1992

It's hard to describe Madonna and it's equally hard to describe this drawing. It's a kind of combined exercise in sex and movement. The weird thing that strikes me now is that she appears to be wearing the same outfit as Barbra Streisand in the drawing with Elvis and the boys earlier. One is an ugly duckling clown, the other a sexually charged Amazon. Maybe it's those Joan Crawford eyebrows that give Madonna her fierceness.

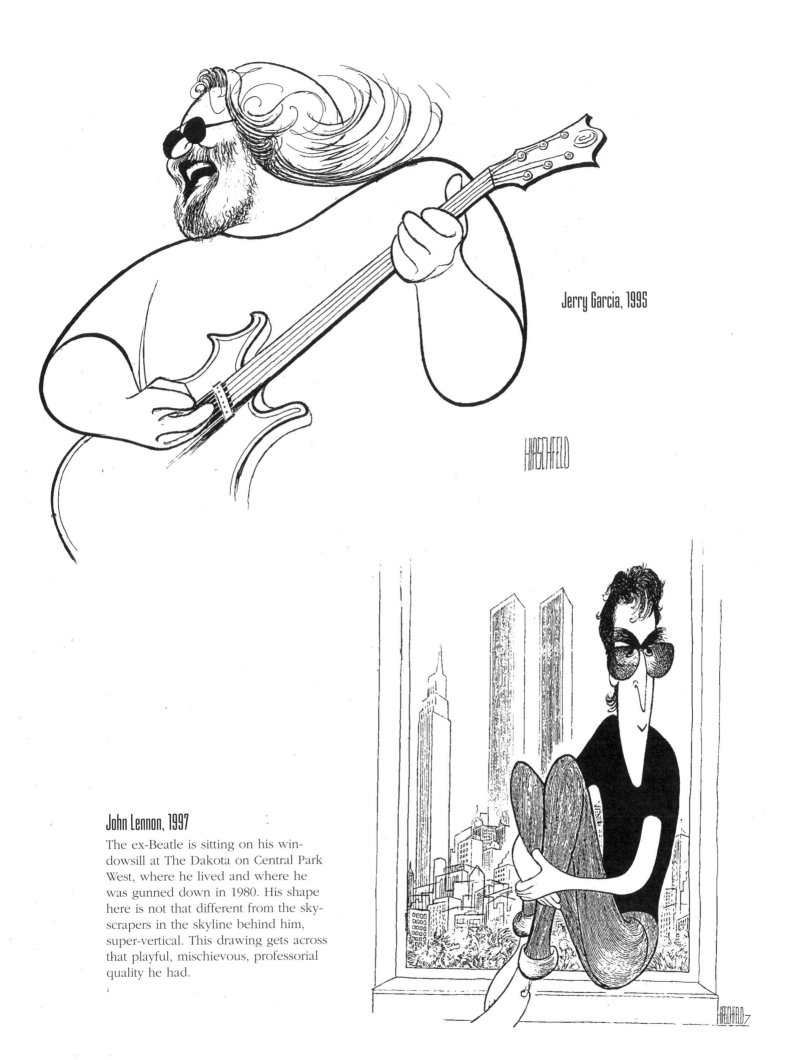

Jerry Garcia, 1995

HIRSCHFELD

John Lennon, 1997

The ex-Beatle is sitting on his windowsill at The Dakota on Central Park West, where he lived and where he was gunned down in 1980. His shape here is not that different from the skyscrapers in the skyline behind him, super-vertical. This drawing gets across that playful, mischievous, professorial quality he had.

Dance! Swing!, 1993

Designed as a curtain and blown up to the gigantic proportions of the Radio City Music Hall stage, this drawing served as a rather effective backdrop to the dancers of a show. Left to right, the three hot-hoofer couples are Cyd Charisse and Gene Kelly, Fred Astaire and Ginger Rogers, and Donald O'Connor and Debbie Reynolds. I tried to capture the distinctive individual styles of all these great, mostly screen, dancers. The exotic quality of Cyd, the sophistication of Fred and Ginger, etc. Overall, though, the idea was to convey great movement.

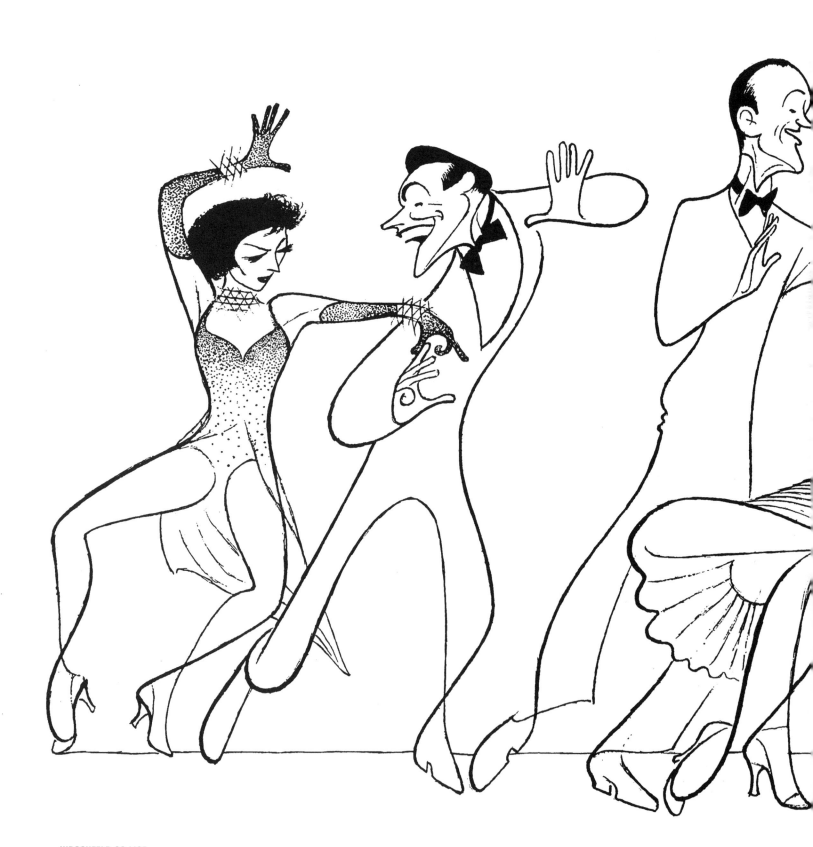

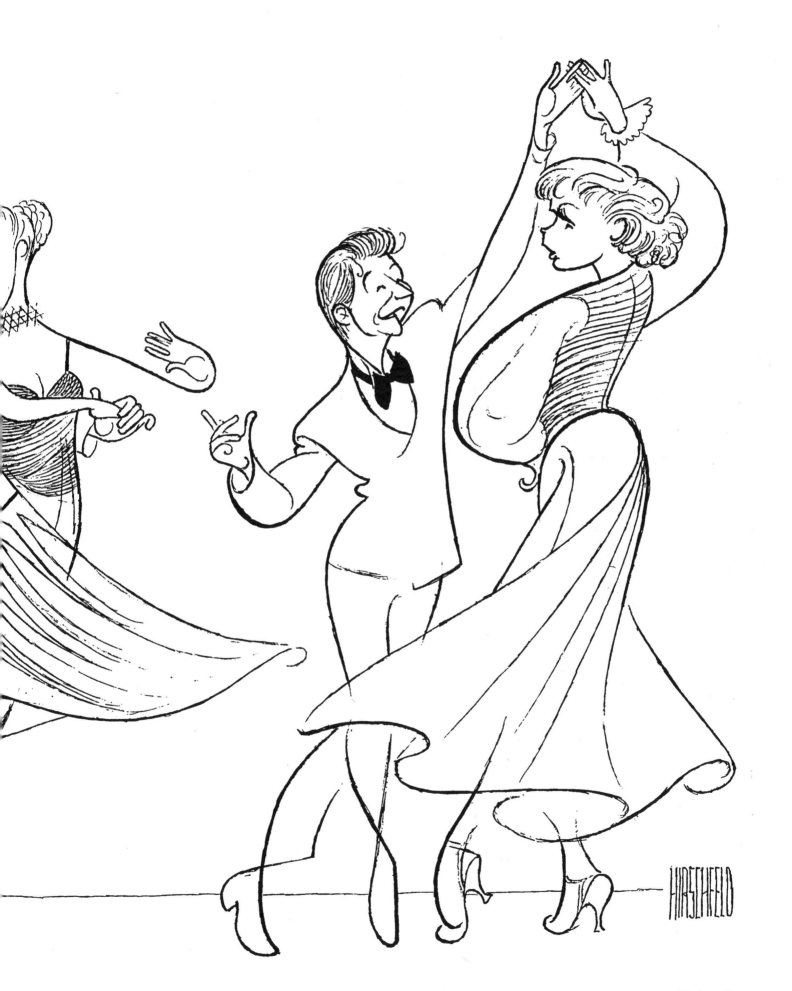

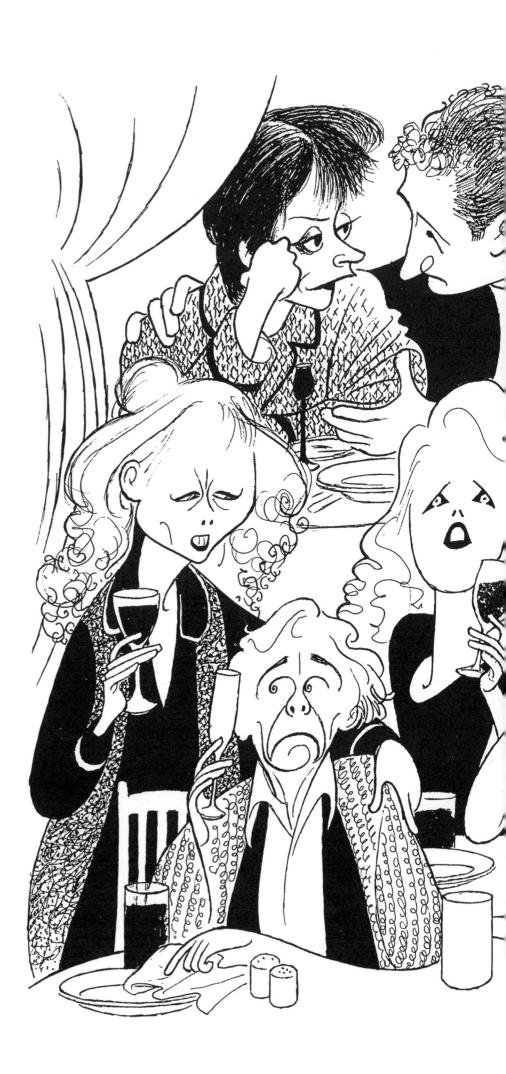

Tony Award Nominees, 1998

Back row: Patti Lupone and Peter Riegert in *The Old Neighborhood*; Anthony LaPaglia and Allison Janney in *A View From the Bridge*. Front row: Geraldine McEwan and Richard Briers in *The Chairs*; Emily Skinner and Alice Ripley in *Side Show*; Natasha Richardson and Alan Cumming in *Cabaret*; Anna Manaham and Marie Mullen in *The Beauty Queen of Leenane*.

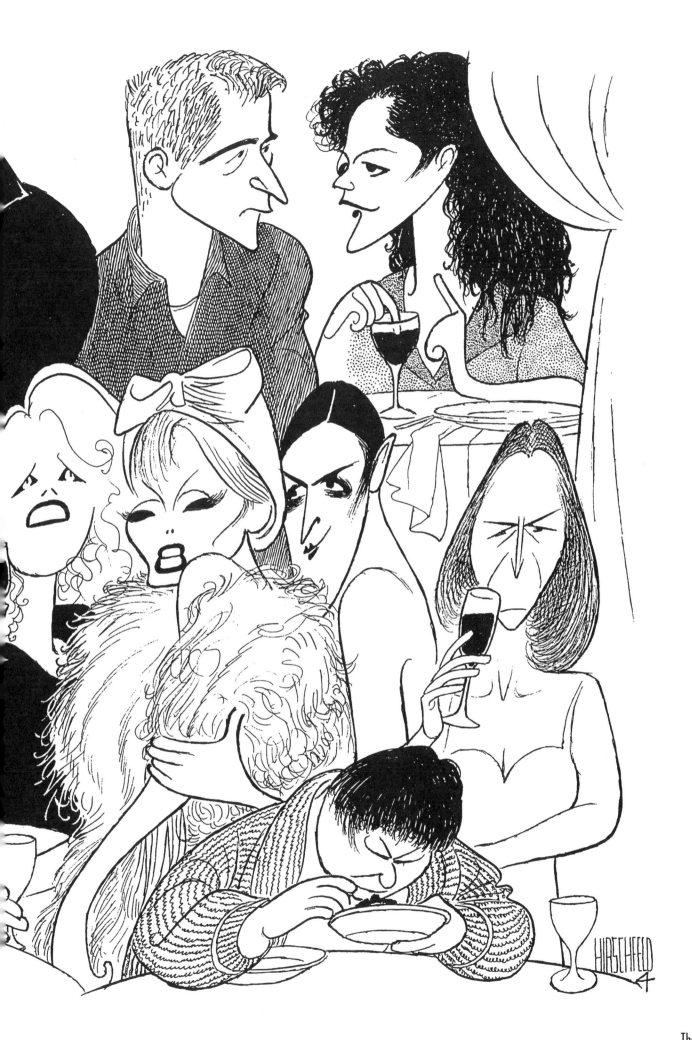

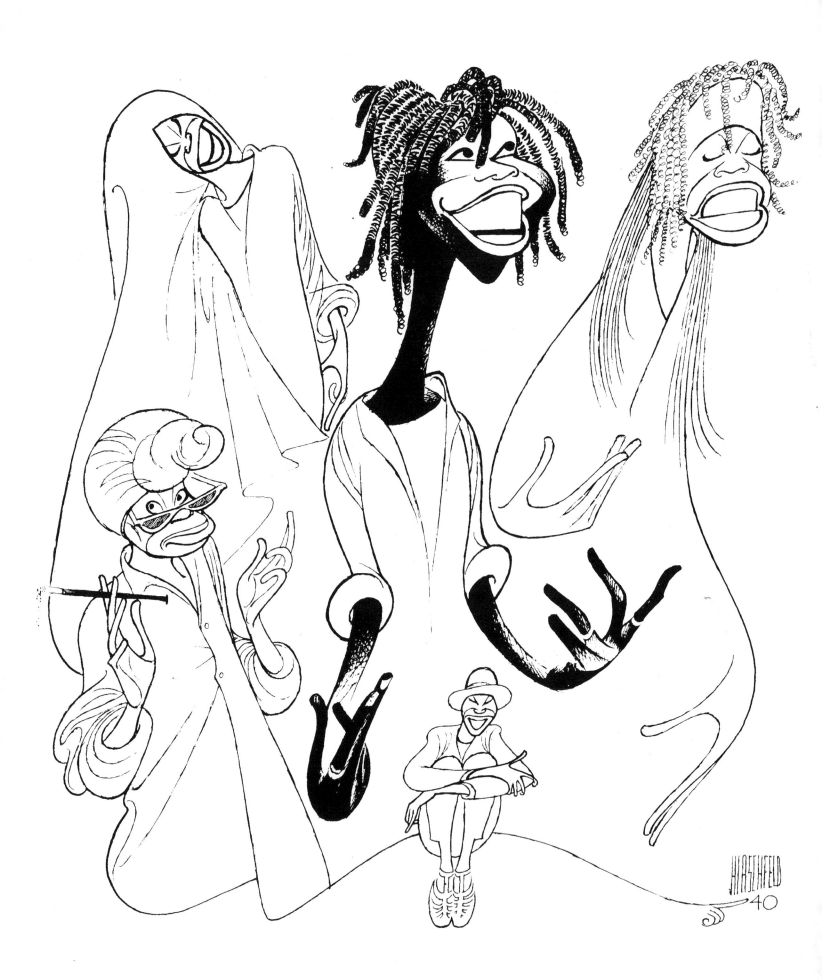